THE
ENIGMA
OF THE
OWL

An *illustrated* natural history

Mike Unwin and David Tipling

Foreword by *Tony Angell*

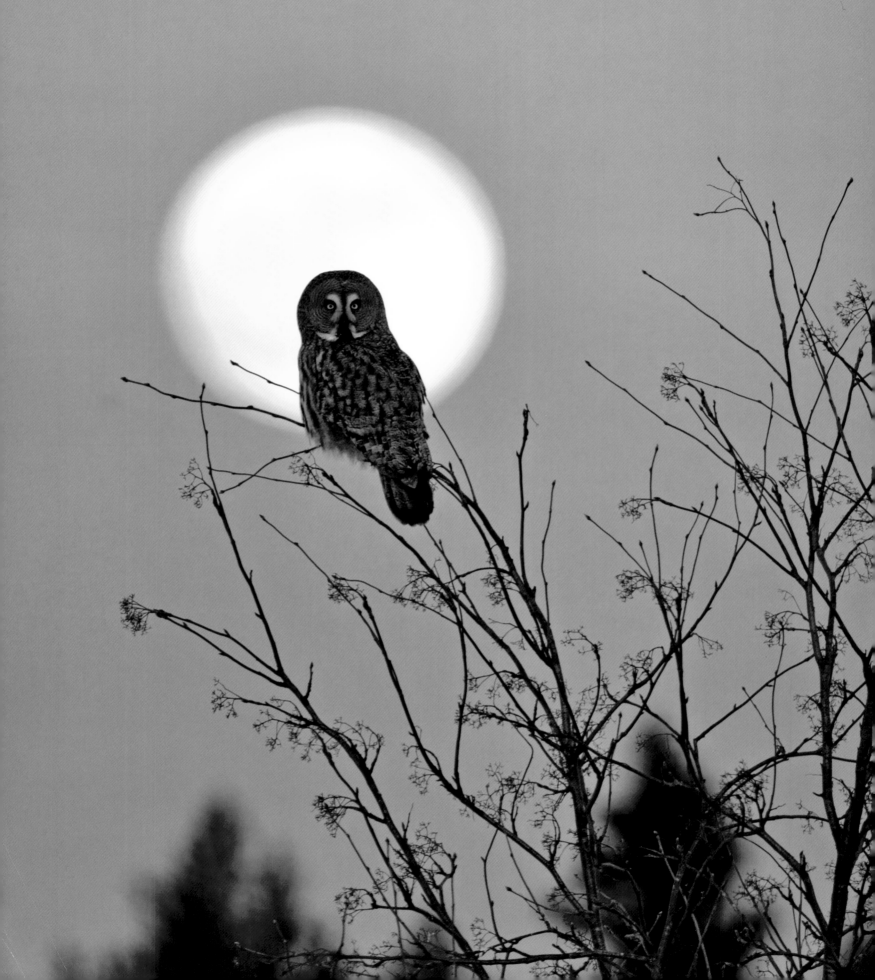

THE
ENIGMA
OF THE
OWL

An *illustrated* natural
history

Mike Unwin and David Tipling
Foreword by *Tony Angell*

Yale UNIVERSITY PRESS

New Haven and London

Published in association with
Yale University Press
P.O. Box 209040
New Haven, CT 06520-9040
yalebooks.com

This book was designed and produced by
Quintessence Editions
The Old Brewery
6 Blundell Street
London N7 9BH

Senior Editor	Elspeth Beidas
Designer	Michelle Kliem
Editor	Rebecca Gee
Production Manager	Anna Pauletti
Editorial Director	Ruth Patrick
Publisher	Philip Cooper

Colour reproduction by Bright Arts
Printed in China by 1010 Printing International Ltd.

ISBN 978-0-300-22273-9

Library of Congress Control Number: 2016942340

10 9 8 7 6 5 4 3 2 1

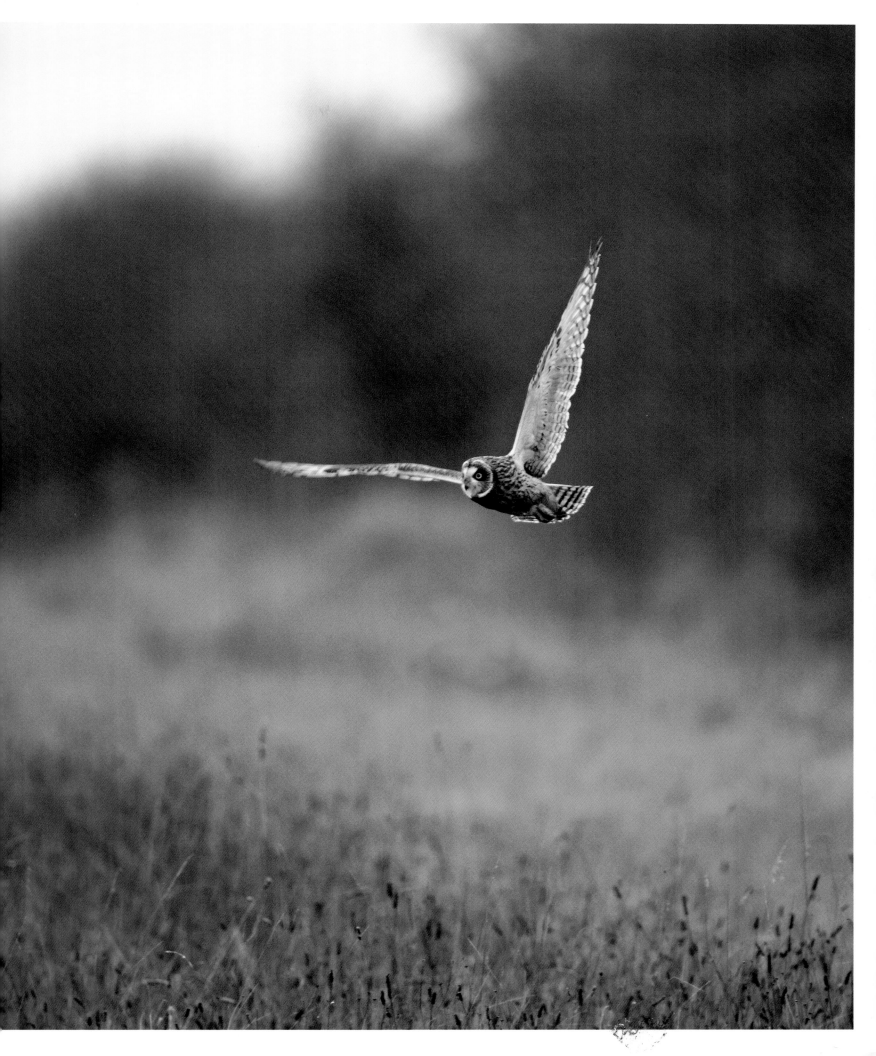

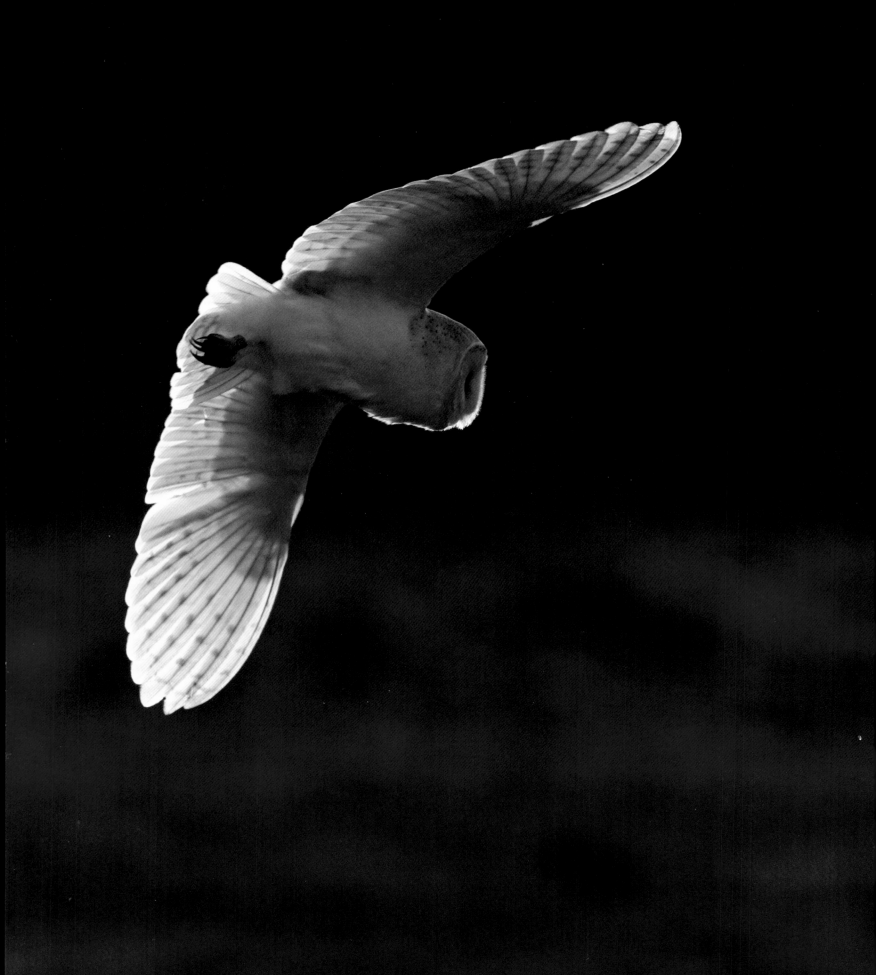

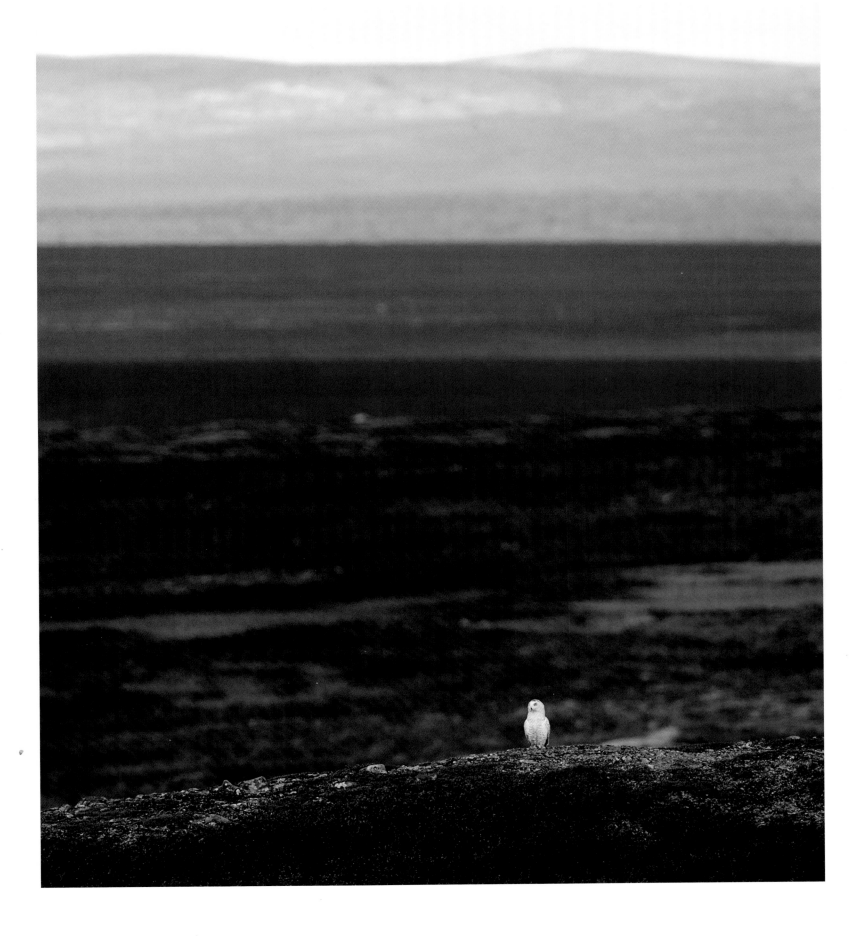

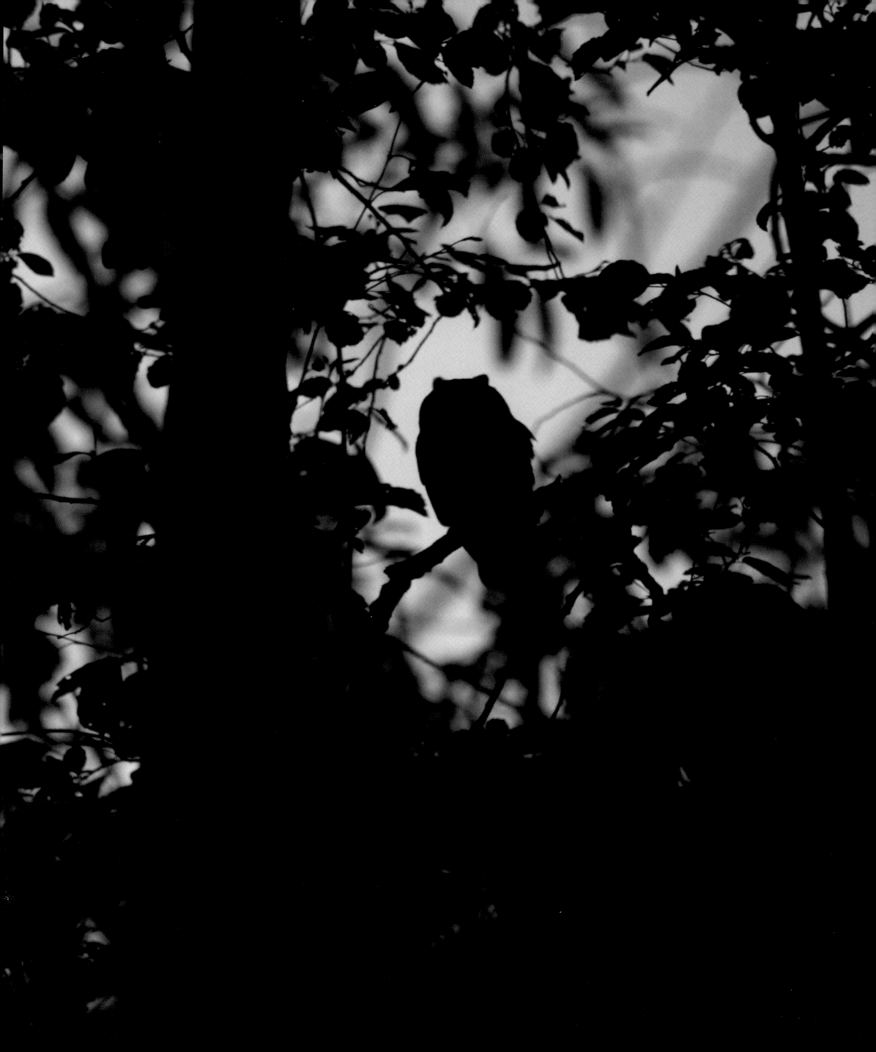

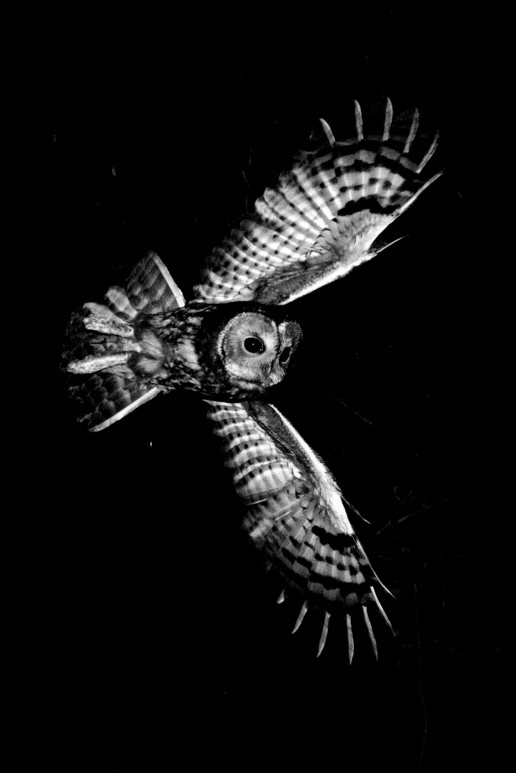

CONTENTS

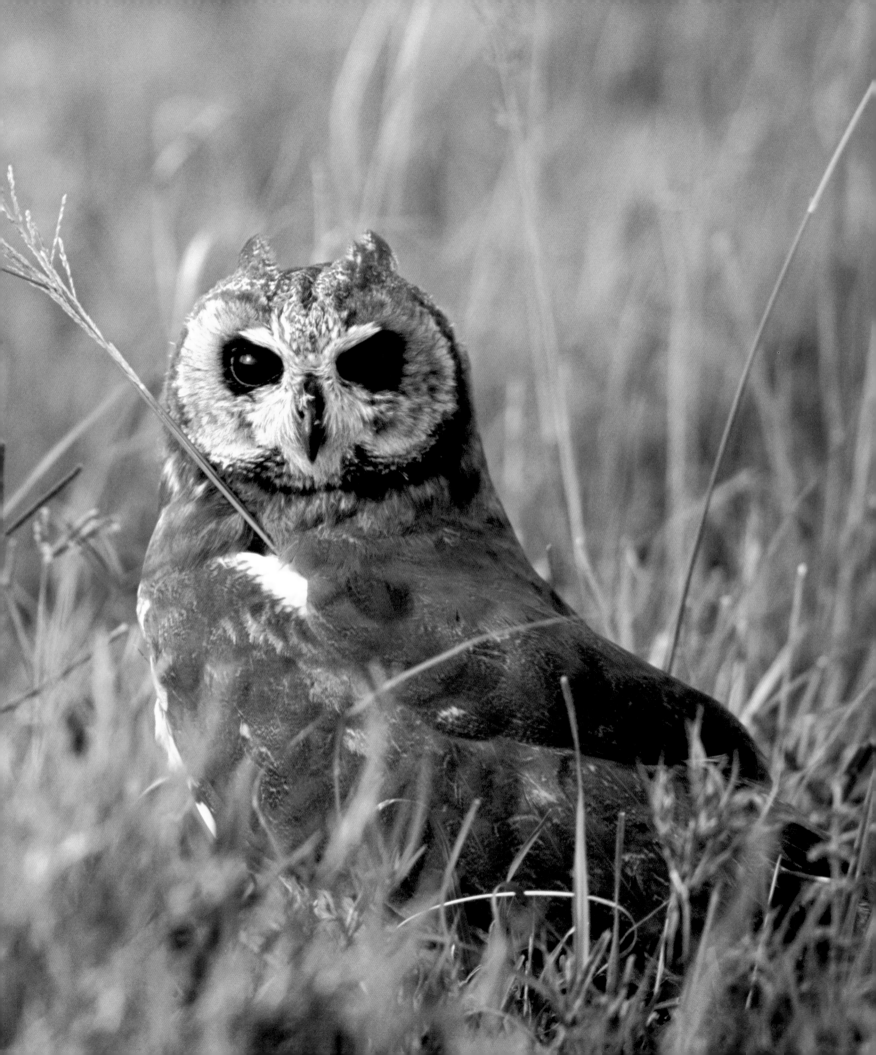

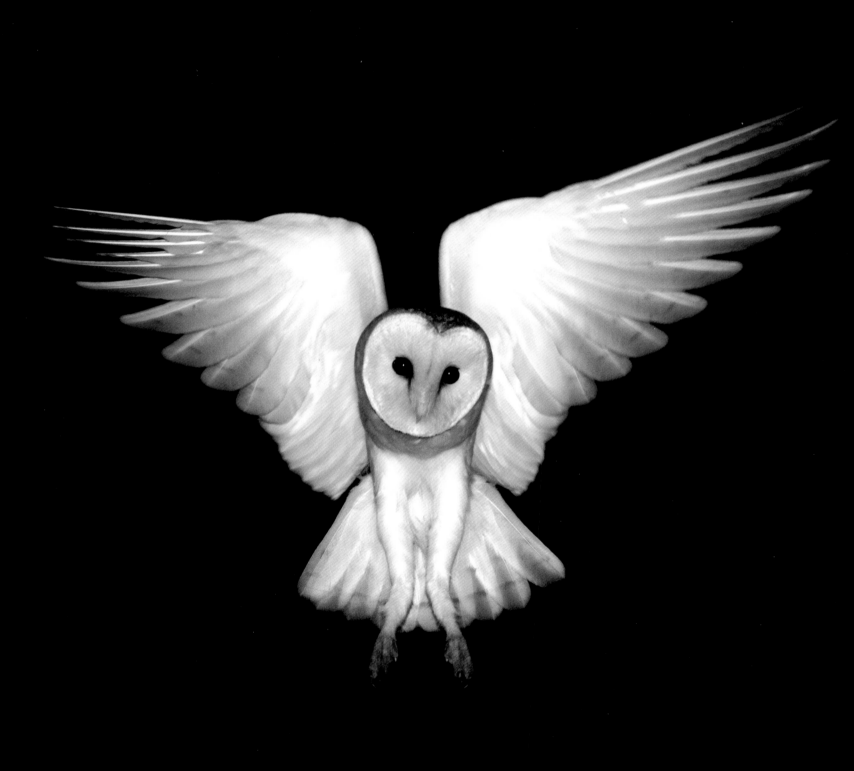

FOREWORD

TONY ANGELL

Author and Illustrator of The House of Owls

I have had the pleasure of living in the company of owls for most of my life. I have sketched, painted, carved, modeled, and written about them. My creative response has certainly contributed to my understanding of owls, but despite such familiarity they remain mysterious to me. Ironically, the more I learn about their behavior, physiology, and beauty, the more enigmatic they become. One discovery leads to another! In this well-written and beautifully photographed book, Mike Unwin and David Tipling have gained considerable ground in solving some of the mysteries.

Among the 240 species of owls are birds that are astonishing in their contrasts and capabilities. From the past and even to this day cultures around the world both revere and fear them. They range in size from the diminutive Elf Owl, weighing little more than a hen's egg and no larger than a song sparrow, to the enormous Blakiston's Fish Owl, larger than many eagles and equally powerful. Owls are versatile hunters; their prey can range from scorpions and termites to crocodiles and king salmon. Some owls scamper road-runner style to capture prey, whereas others snatch a meal from the air. Their habitats range from alpine mountains and subzero Arctic tundra to lowland deserts, tropical jungles, and isolated islands. They are equipped with unique sensory apparatus: some owls can hear, locate, and capture their quarry, even if it is concealed beneath a layer of snow or ground litter. Their nocturnal habits require a visual acuity allowing them to detect movement and shape in light conditions equivalent to a blackout.

By grouping the selection of owls geographically within six bioregions, Unwin and Tipling enable better appreciation of their unique adaptive capacities. I found I was on a worldwide tour and savoring each species group! Descriptions of the owls that occupy the vast archipelago of the South Oceanic Islands were particularly fascinating, because many of them are endemic. The Palau, for example, has a range of only 170 square miles (440 sq km). Compare this limited range with the Northern Hawk Owl, which occupies portions of the millions of square miles of the boreal forest of the northern hemisphere.

Many owls are uniquely adapted to their habitats, which are vulnerable to the ever-expanding effects of human intrusions. Climate change certainly looms large as one effect, but others are even more direct and immediate. Pesticides remain a threat, because they travel up the food chain to weaken owls or kill them outright. Birds hunting along the highway borders are routinely killed in collisions with vehicles. Expanding agriculture and forestry remove and fragment land and wooded habitat. Feral and invasive animals compete with or kill owls. For example, in the Pacific Northwest, the population of Northern Spotted Owls continues to decline nearly three percent each year and not just as a result of the fragmentation of its old growth habitat. Within the past half century, the aggressive, opportunistic, and adaptable Barred Owl has moved west across North America to invade the compromised forests of the Pacific Northwest. In doing so, the Barred Owl has displaced and even killed the Northern Spotted Owl. The solution has been to remove the Barred Owls lethally, but this solution may be futile if there is continued fragmentation of old growth forests without restoration.

Despite the threats and declines to owls, this book illustrates there is hope for the future. There are strategies and models for restoring and sustaining owl communities: nest boxes, placement of sighting snags, and restoration after timber removal can help sustain healthy populations.

Owls, like people, have adapted to successfully leverage the resources of a wide range of environments. Some, such as the Barn and Barred Owls, have even exploited human enterprise for their own benefit. Unlike people, however, owls generally have little latitude to quickly change or adjust habits or food preferences when faced with change to their home territories.

If owls are to be part of our future, we must acknowledge their presence and significance to us. As an artist and naturalist, I cannot imagine life without them. This book gives us a better understanding of how important owls are to the integrity of humans and in nature.

Opposite: A Barn Owl captured in a seemingly angelic pose
as it approaches the nest.

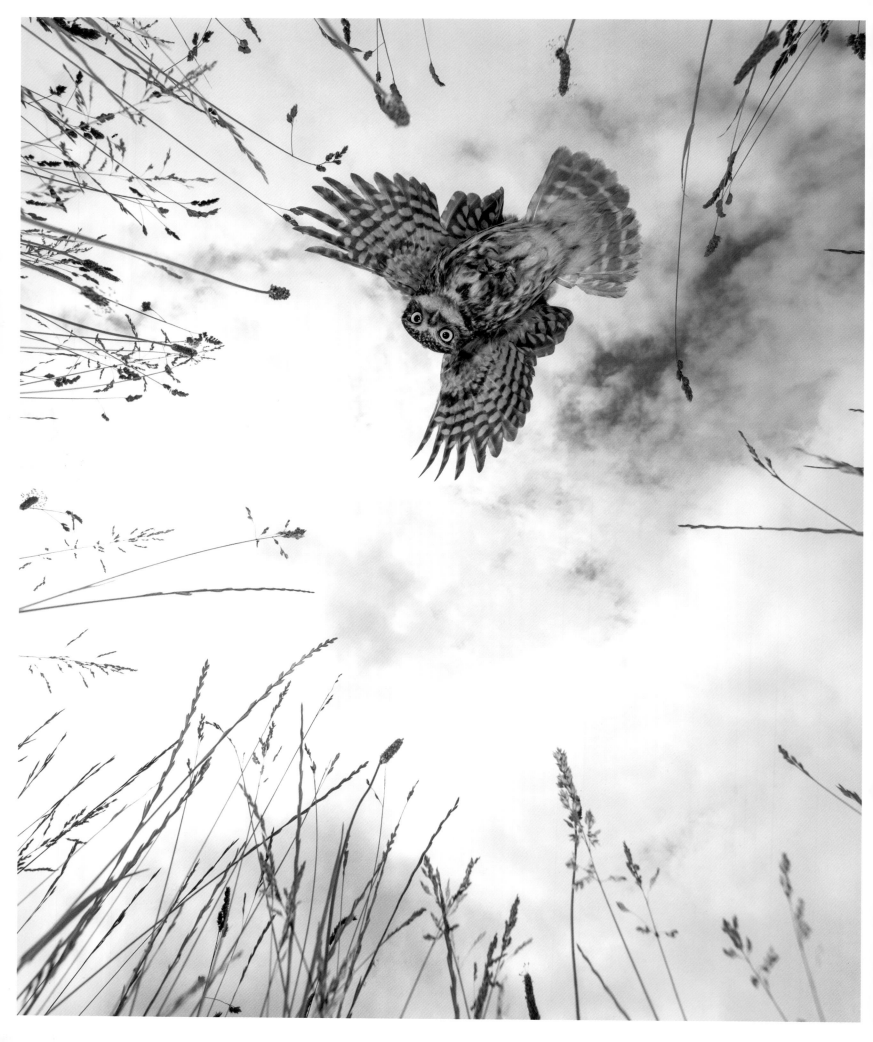

INTRODUCTION

OWL ENCOUNTERS ARE ALWAYS SPECIAL. My most memorable came while camping on a remote island in the Okavango Delta, Botswana. After whiling away the midday heat by stick-scribbling in the sand some of the wildlife I hoped to see — a hippo, a giraffe, and a big-eyed bird — my guide, a fisherman who spoke little English but who had clearly been paying attention, beckoned me to follow him. We tramped through a shallow lagoon to a tangle of forest, where he stopped and pointed up into a towering sycamore fig tree. It took me two minutes with binoculars before I spotted what his sharper eyes had seen immediately: a huge, ginger-orange owl staring from its roost, its inky-black eyes wide in suspicion. It was my first Pel's Fishing Owl (P. 187), the African birder's holy grail.

Owl encounters need not be deep in the African bush. My childhood in the United Kingdom was littered with memorable moments: hearing the shrill hoot and "kiwick" of duetting Tawny Owls (P. 120), a bird I had hitherto encountered only in books, outside my bedroom window; and watching Short-eared Owls (P. 141) quartering a winter marsh, then finding their pellets beneath a fence post and carefully extracting four perfect vole skulls. Something about these enigmatic birds commands attention and fires the imagination, which is why owls have loomed large in human culture across the ages.

That "something" is not hard to break down. First, owls are largely nocturnal and so carry all the mystery of creatures that move unseen in darkness, betrayed only by their unearthly calls. Second, when owls make themselves visible, their large, forward-facing eyes give them more of a "face" than other birds: a face upon which we cannot resist bestowing such human qualities as anger, surprise, and wisdom. And third, perhaps, are their hunting skills, deployed in pitch darkness with such stealth and perception that it fills observers with awe. In some places, awe has become fear. Traditional cultures have long associated owls with sinister forces. Similar myths recur, from African villages to Mediterranean olive groves: typically, that an owl's presence, or even just its call, near a human dwelling foretells a death in the family or some such disaster. Elsewhere, though, owls have come to embody more positive qualities, including wisdom and prosperity. This association runs from the ancient Greek reverence for the Little Owl (P. 114) as companion of the goddess Athene to the role of owls in such literary classics as Edward Lear's *The Owl and the Pussycat* and J. K. Rowling's *Harry Potter* novels.

Today, the allure of the owl is also reflected in the work of many wildlife photographers who are drawn to this challenging subject. It is an allure celebrated here in David Tipling's stunning images, and those of the other photographers he has assembled. Famously, it is a calling that also led to the loss of an eye for pioneering British photographer Eric Hosking, attacked by a female Tawny Owl whose nest site he was trying to photograph. Owls may be beautiful, but you underestimate them at your peril.

Owls in order

An owl — to allay the fears of the superstitious — is simply a bird. However, it is a bird uniquely adapted to the challenges of a predatory and mostly nocturnal lifestyle. In scientific terms, owls make up the Strigiformes, one of twenty-eight orders of bird. Although equipped with piercing talons and hooked bills, they are unrelated to diurnal birds of prey, such as eagles and hawks, which belong to the Falconiformes, an entirely separate order. The fossil record suggests that owls first appeared some 65 to 56 million years ago, and are among the oldest known groups of non-Galloanserae land birds (the Galloanserae are the game birds and wildfowl that emerged even earlier). Many species have since come and gone: one barn owl from the Pleistocene stood 3 feet (1 m) tall and may have weighed twice as much as today's largest eagle owls.

Opposite: A Little Owl may look cute to the human observer, but to a mouse in the grass it is a terrifying predator.

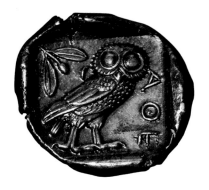

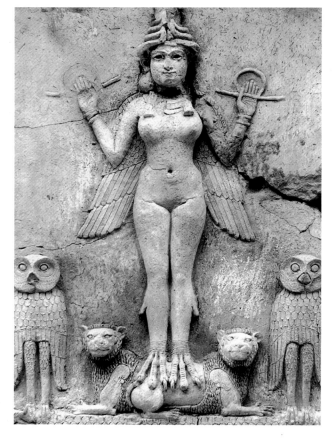

Today's owls fall into two families: the barn owls (Tytonidae) and the typical owls (Strigidae). Between them, these comprise some twenty-six genera and up to 250 species. The taxonomy has undergone extensive revision since the advent of DNA sequencing, producing new genera and prompting the movement of numerous species between existing genera. For example, the African fishing and Asian fish owls, each once assigned its own separate genus, are today grouped with eagle owls in *Bubo*. Conversely, the New World screech owls, once classified alongside Old World scops owls in *Otus*, now have their own genus, *Megascops*. Molecular studies and improved analyses of vocalizations have also brought to light the existence of many new species and have led scientists to elevate to full species status many owls that were previously thought to be geographical variations (subspecies) of existing species. The whole business of taxonomy is complex and contentious, and it remains a work in progress. This book reflects the taxonomy that is accepted by most authorities at the time of going to print, but new owl species are added to the list as research continues.

Taxonomy aside, you need not be a scientist to appreciate the extraordinary variety among owls. They range in size from the bijou Elf Owl (P. 63), which at 1.4 ounces (40 g) is no larger than a sparrow, to the formidable Eurasian Eagle Owl (P. 103), which, at a top weight of 10.1 pounds (4.6 kg), is big enough to kill a young deer. Owls occur on every continent except Antarctica, with 68 percent of species found in the southern hemisphere. The majority are forest birds, adapted to hunting among trees, which also provide them with nest sites and roosts. However, owls also thrive in savannas, deserts, and even the Arctic tundra, each with its own particular survival adaptations. Some species have evolved to live alongside humans, in agricultural and even urban landscapes; the Barn Owl (P. 127) gets its name for a reason.

Owls up close

It is easy to recognize an owl. Although individual species may be hard to tell apart, the big head, round face, and forward-facing eyes make all owls instantly recognizable as such and immediately distinguish them from other birds. In order to appreciate just how unusual these predators are, however, you need to take a closer look.

An owl's distinctive face holds several clues to its unusual way of life. The eyes are proportionally among the largest of

Above: Owls depicted as cultural icons in a *Punch* cartoon from 1888, an Ancient Greek coin, and a clay plaque from Iraq, c. 1792–1750 BCE.

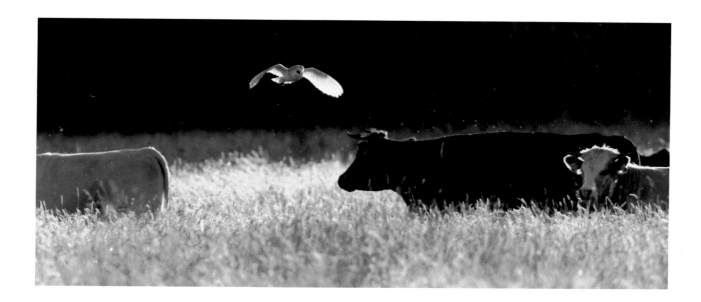

any animal—up to 2.2 times the size of those of similar-size birds—and, in the largest species, larger even than our own eyes. They are more tubular than spherical, thereby allowing the maximum area for the retina, which is packed with the rods that allow the acute low-light sensitivity required to operate in near-darkness (although owls do not have high-resolution color vision). Forward-facing, like human eyes, these eyes also provide the binocular vision essential for depth perception when targeting prey. You will often see an owl bob and weave its head, in order to improve this focus. However, you will not see it turn its eyes, as they are locked into their sockets by sclerotic rings of bone. Instead, therefore, owls have evolved the celebrated ability to turn their heads by up to 270 degrees in order to view objects around and behind them.

Perhaps even more impressive than an owl's eyesight is its hearing. This is powered by unique adaptations, of which the most obvious is the facial disk: the circular arrangement of feathers, bordered by a raised rim, which forms a concave saucer around each eye and gives an owl its distinctive face. The facial disk works like a satellite dish, capturing sound and directing it to the ears. These are not the feathered tufts on top of the head, however, but large vertical openings at either side of the facial disk, hidden from view by feathers. Not only are they proportionally the largest ear openings of any bird, with an exceptionally large inner ear, but they are also—unusually among vertebrates—positioned asymmetrically, with one higher than the other. This produces a time lag in the auditory signals reaching an owl in both the vertical and the horizontal plane, thus giving the bird an exceptional ability to pinpoint the direction of a sound. The hearing of a Barn Owl is at least ten times more powerful than our own,

and laboratory experiments have proven that it can locate and strike prey in pitch darkness by sound alone.

Contrary to popular belief, owls do not use echolocation, the technique employed by bats to navigate in darkness by bouncing sounds off their surroundings. Owls have no need with such astonishing hearing. A Great Grey Owl (P. 150) perched on top of a tree can hear the movement of an invisible vole beneath a layer of snow, 30 feet (10 m) below, and swoop down to it, through the snow, with unerring precision.

An owl's hunting weaponry is similar to that of a diurnal raptor. The beak is longer than it appears, concealed behind a spray of fine feathers. Its sharply hooked tip serves both to kill prey with a bite and to tear it into pieces. It is set a little below eye level, and tilted downward to avoid impeding the binocular vision. The talons have long, needle-sharp claws, which seize, crush, and kill prey, and also provide a vice-like grip while the bill gets to work. Larger owls have frighteningly powerful feet: the talons of a Great Horned Owl (P. 48) may exert a pressure that is around the same as the bite of a Rottweiler and at least eight times stronger than a human hand. Owls' toes have a zygodactyl arrangement, with two facing forward and two facing back, unlike most other birds, which have three forward and one back. Some owls' feet have specific adaptations: the toes of fishing owls, for example, are lined with sharp scales called spicules, which help to grip their slippery prey.

This hardware is protected by feathers, and an owl's plumage is remarkable for various reasons. Most species sport cryptic camouflage markings, with a complex tapestry of spots, bars, streaks, and vermiculations in various tones of brown, gray, ocher, and cream that serve both to replicate the birds' background—typically a roosting spot against fissured,

Above: A Barn Owl hunting over a cattle pasture proves that owls can thrive in human landscapes, if suitably managed.

lichen-covered bark in dappled forest light—and to obliterate any impression of form. The ear tufts of many species, which can be lowered or erected as required, are thought to enhance this camouflage by increasing the "broken stump" appearance. It has been suggested that they make the owl's outline appear more like that of a potentially dangerous mammal, such as a marten, and may also help to express mood. Some owl species come in different color morphs, typically brown, gray, and rufous, which tend to reflect geography, the gray morphs occurring further north. Alongside this camouflage, owls also have markings that are designed to be seen. Bold white eyebrows and black eye-rings make the facial expression all the more intimidating, while a white throat puffed out while calling may help attract a mate and deter a rival. Some species in the *Glaucidium* genus of pygmy owls even have false eye-markings on their nape, creating an occipital face that may give a potential predator pause for thought.

An owl's plumage also has some very practical adaptations. Many species have tarsi (lower legs) feathered down to the toes, which protects them both from the bites of their prey and from the extremes of the cold climate in which they hunt. Fine hair-like feathers around the bill, called filoplumes, provide extra tactile sensitivity in tackling prey. In addition, and uniquely among birds, the flight feathers of most owls have special sound-proofing modifications—fine feather filaments that dampen onrushing air and a downy surface layer that absorbs high-frequency sound—that enable them, like silent assassins, to approach prey noiselessly. The wings of many species are long and broad, giving them the low-wing loading (body weight to wing area ratio) necessary to stay airborne while slowly quartering the ground for prey.

How owls live

Owls, famously, fly by night, although not exclusively and not all of them. Some 69 percent of species are primarily nocturnal. Many others are more crepuscular, hunting by dusk and dawn, while 3 percent are properly diurnal. By day, most hide away in a roost, usually individually or in pairs, but a few species, such as the Long-eared Owl (P. 146), form small colonies outside the breeding season. Most owls are also sedentary, remaining more or less in the same place all their life. A few northern species are nomadic, however, making irregular seasonal movements if the weather turns against them or if their prey disappears, and a few are full migrants, including the Common Scops Owl (P. 159), which migrates every year between southern Europe and central Africa.

Most owls hunt either by swooping down from a perch upon unsuspecting prey or by flying slowly over open ground and dropping upon anything that their sharp hearing and eyesight detect. There are numerous other techniques: some species use agile flight to capture moths, bats, and even birds in flight; others pluck insects and frogs from the forest foliage or pull earthworms from the ground. Fishing owls are especially adapted for their task, watching for the ripples of their slippery prey, then pouncing into the shallows to grab it; these owls have bare legs, to prevent water-logging, and no full facial disk, as they do not need hearing to make a catch.

The variety of prey taken across the owl group is extraordinary, ranging from flying ants to mammals as big as foxes and birds as large as eagles. Many species take prey larger than themselves, with the smallest owls punching well above their weight when targeting birds such as doves.

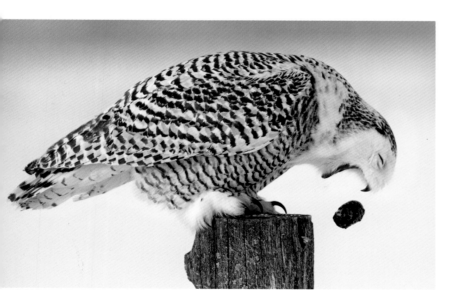

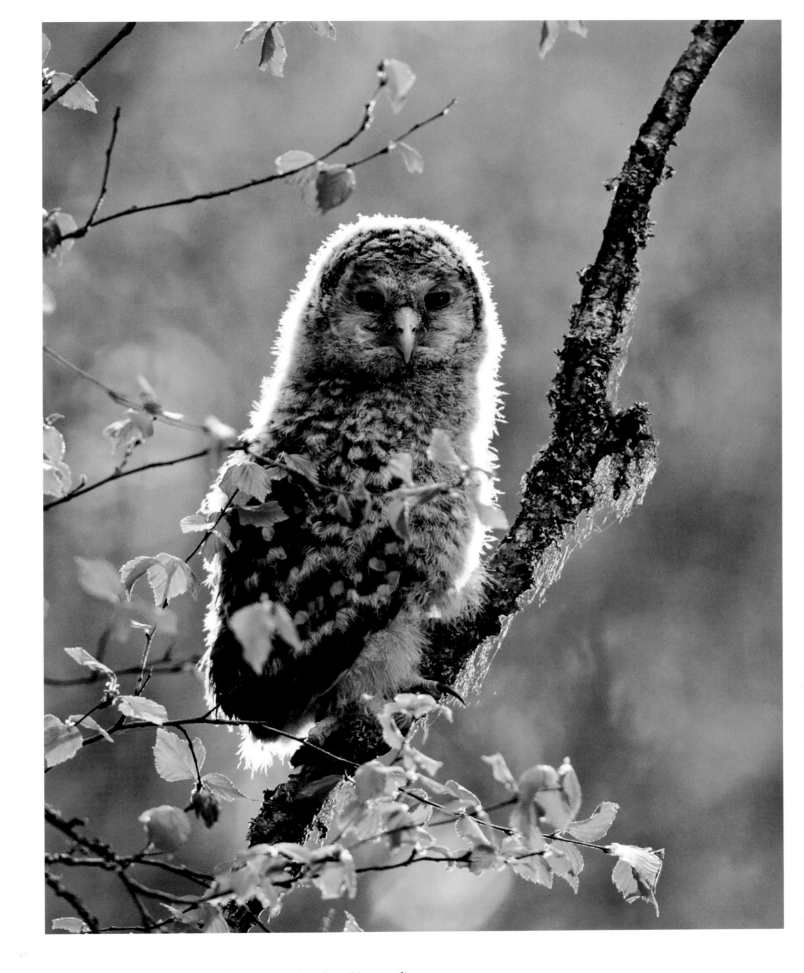

Opposite: A Snowy Owl coughs up a pellet containing the indigestible parts of its prey.
Above: A fledgling Ural Owl still in its downy juvenile plumage.

The availability or otherwise of certain prey species can be critical to owls' fortunes, none more so than voles, which in northern regions provide the staple diet for species such as the Short-eared Owl. In vole "boom" years, owl populations may soar; conversely, in "bust" years, they may crash, with the owls failing to breed or moving away en masse in search of food.

Among the more surprising items on the owl menu are other owls, with species such as the Tawny Owl and Eurasian Eagle Owl frequently preying upon smaller relatives, such as the Long-eared Owl. The practice of one predatory bird feeding upon its cousins is known as intraguild predation, and certain owls—notably the Eurasian Eagle Owl, again—are notorious in this respect, often taking hawks, buzzards, and other diurnal raptors from their nighttime roosts. Owls tend to swallow smaller prey in a single gulp, while larger prey is dismembered using the bill and talons. Either way, they cough up the indigestible parts—bones, fur, feathers, insect heads and wing cases—in a sausage-shape pellet, which takes about six hours to form. Regular owl roosts and nest sites are often betrayed by the piles of pellets that accumulate beneath. They can prove very useful to scientists, both identifying the species and shedding light on its prey and feeding habits.

Being nocturnal, many owls are more often heard than seen. The best-known calls are the hoots of the eagle owl (*Bubo*) and wood owl (*Strix*) genera, notably the Tawny Owl, whose fabled "too-whit too-whoo" has become the universal voice of spooky graveyard thrillers. However, many owls do not hoot at all. Other sounds vary from the hissing screams of barn owls to the insect-like chirruping of scops owls, the metronomic whistles of pygmy owls and the dog-like yapping of the aptly named Barking Owl (P. 246). Calls are unique to each species and, for the scientist and birdwatcher, they provide diagnostic clues to an owl's identity.

Owls are unusual among birds in that most do not visibly open their bills when calling but rather inflate their throats, like a frog. They are most vocal at the start of the breeding season, as males reclaim their territories and attract females. Most species are monogamous, and many form lifelong pairs, retaining the same territory and nest sites for numerous years. In addition to calls, pairs consolidate their bonds with mutual preening, gifts of food from male to female, and choreographed courtship rituals, including wing-clapping display flights.

Males show their mates around potential nest sites, but females generally make the choice. Most nest in tree holes, especially those excavated by woodpeckers, but some use crevices among rocks and tree roots. Many will also reappropriate the old stick nest of another bird, such as a crow or raptor, and a few even nest in a crude hollow on the ground,

trampled into the long grass. None constructs a nest, and few provide any kind of lining. Owls' eggs are generally white and quite spherical in shape, with the clutch size ranging from one or two in many species to an amazing dozen or more, during peak years, for those whose breeding is tied to the abundance of prey such as voles. The female generally incubates the clutch, while the male hunts to provide for her. Once the hatchlings have grown strong enough, both parents hunt together in order to provision their voracious brood. Although owls may be poor nest builders, they are excellent nest defenders, and species such as the Tawny Owl and Ural Owl (P. 160) are notorious for the attacks they launch on intruders. Other tactics are deployed, including puffing up the feathers to exaggerate their size, and feigning injury to distract an approaching predator away from the vulnerable chicks.

The youngsters grow quickly and generally leave the nest before they are fully fledged, hanging around for a while in a downy mesoptile stage before they perfect their flying and start to hunt for themselves. The young of some larger owls may remain with their parents for several months, sometimes long enough to prevent the parents from breeding the following year. In many species, especially those found in colder northern regions, breeding success is dictated by weather and food supply, and in poor years they may not attempt to breed. Once an owl gets through its tricky early years, many species go on to live long lives. Longevity records among captive owls have topped fifty years for both the Eurasian Eagle Owl and the Great Horned Owl.

Owls and people

Owls have played a significant part in human culture since before recorded history, their all-seeing eyes inspiring both fear and reverence, and prompting their symbolic depiction as, variously, harbingers of doom and emblems of wisdom and prosperity. They appear in French cave paintings dating back 15,000 to 20,000 years and in the hieroglyphics of the ancient Egyptians. In the United Kingdom, the spectral appearance and eerie call of the Barn Owl has led to numerous ghost stories, while in Jamaica the presence of a Jamaican Owl (P. 262) outside a house has occupants reciting an incantation to avert disaster. In Japan, conversely, Blakiston's Fish Owl (P. 167) is revered by the Ainu people as "The God that Protects the Village."

Whatever we think of owls, humans have given them plenty to contend with. In some parts of the world, owls have suffered direct persecution, either killed to ward off evil spirits or hunted for the pot. More serious, however, is the damage done to their environments. Deforestation, commercial agriculture, and river pollution have robbed owls of the habitats they need for breeding and hunting, while the use of

rodenticides and other toxins have not only depleted the owls' prey but often caused secondary poisoning to the birds themselves. Modern hazards also include man-made obstacles such as power lines and road traffic. Today, the International Union for the Conservation of Nature lists six owl species as Critically Endangered, twenty-six as Endangered, and another forty-three as Vulnerable or Near Threatened. As indicator species of a healthy environment, it is therefore the disappearance of owls, rather than their presence, that we should fear as a harbinger of doom.

Conservationists are doing their bit. BirdLife International and its partners are working hard to protect owls, whether through increased protection for their habitats or lobbying and education to prevent their persecution. More enlightened landowners, realizing that owls themselves are the farmer's best natural rodenticide, are managing land for owls, setting aside rough pasture and other key habitat features they require, and providing nest boxes. Meanwhile, owls continue to bring great pleasure to numerous people, from fanatical "owlaholics" who devote their lives to collecting anything that depicts the birds, to hardened "world listers," who race around the globe trying to tick off as many of its owl species as they can manage. Furthermore, there are those of us who simply love the wild, for whom that haunting voice in the darkness or unexpected flare of silent wings over a moonlit hedgerow represents all that is magical about these most enigmatic of birds.

BIOGEOGRAPHIC REGIONS (ECOZONES)

This map shows the world's principal biogeographic regions as reflected in chapters one to five of this book. Chapter Six (Oceanic Islands) comprises parts of several other regions.

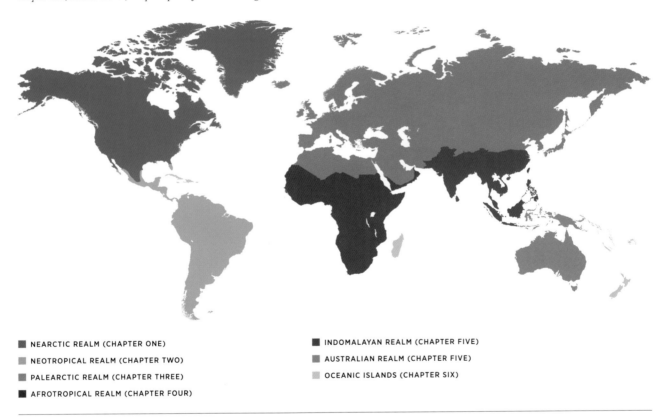

■ NEARCTIC REALM (CHAPTER ONE)

■ NEOTROPICAL REALM (CHAPTER TWO)

■ PALEARCTIC REALM (CHAPTER THREE)

■ AFROTROPICAL REALM (CHAPTER FOUR)

■ INDOMALAYAN REALM (CHAPTER FIVE)

■ AUSTRALIAN REALM (CHAPTER FIVE)

■ OCEANIC ISLANDS (CHAPTER SIX)

A note about the selection of owls

This book is a photographic celebration of the world's owls, and the fifty-three species accounts describe the appearance, distribution, behavior, and something of the cultural associations of each owl. The selection aims to offer a broad picture of owls as a group, with the representatives drawn from most key genera, and covering all continents and all habitats in which they are found. However, it is impossible to strike a perfectly representative balance: the best-known owls—to science and recorded culture—tend to be found in the northern hemisphere, especially in Europe and North America. Northern parts of the world are therefore better represented than some tropical regions, which may have a greater diversity of owls, but offer less information with which to tell their story. The final chapter bucks the trend in that it is not a single biogeographical area. Instead, it comprises a particular suite of shared environmental conditions and challenges to which the owls that live on Oceanic islands, from the Caribbean to the South Pacific, have evolved and adapted in similar ways.

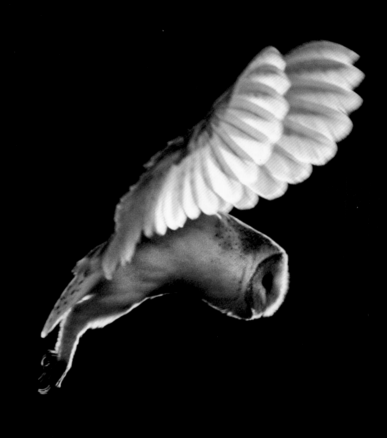

Left: A hovering Barn Owl trains all its senses on prey below.

INTRODUCTION

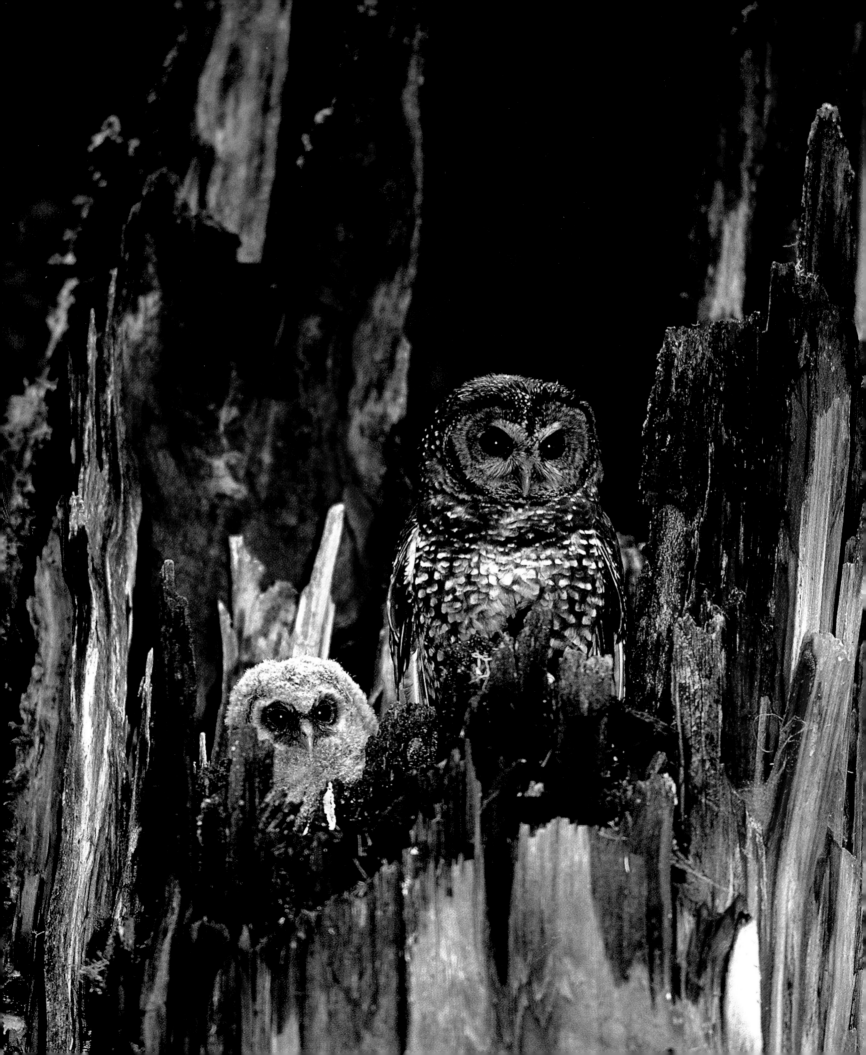

01 | NORTH AMERICA

THE FIRST EUROPEAN SETTLERS TO MAKE IT across the Atlantic could have been forgiven for thinking "New World, same old owls." Although connected by land to South America, North America shares many features of its natural environment with Europe, including some of its owls.

The explanation lies in geological history. South America was once part of the ancient southern supercontinent Gondwana, splitting from Africa some 135 million years ago, whereas North America was part of the northern continental landmass Laurasia, and was therefore once connected to Europe, sharing its recent glaciation history. Indeed, it was only three million years ago that North and South America came together at the Isthmus of Panama, and they now constitute separate biogeographical regions, each with its own evolutionary history.

Nowadays, North America is the world's third-largest continent, extending all the way from the Canadian Arctic to southern Mexico and covering approximately 9.5 million square miles (24.7 million sq km). At least thirty-eight owl species are found there, although a significant proportion occurs only in the extreme south of the region, where biodiversity is boosted by the influence of tropical Central America. Indeed, Mexico is home to a greater number of bird species in general (±1,040) than the United States and Canada combined, including typical Central American families such as toucans, motmots, and trogons that are thought to have originated in South America and subsequently extended their range northward.

While the first settlers may have brought with them their European ideas about owls, the indigenous peoples of North America already had a rich heritage in which owls figured prominently. The Cherokee, whose name for the Great Horned Owl (P. 48)—*tskili*—means "witch," considered owls to be the embodiment of ghosts and as a result dreaded their nocturnal hoots as omens of evil. Others had more positive associations. For example, Sierra Nevadan Indians believed that the Great Horned Owl transported the souls of the dead to the afterlife, whereas Newuk Indians believed that after death the brave would become a Great Horned Owl but the wicked would become a Barn Owl (P. 167). Pima Indians gave owl feathers to the dying, perhaps to help ease their passage into the afterlife where the owls awaited their souls. Tlingli warriors even hooted like owls as they charged into battle.

As in Eurasia, many of North America's owls are adapted to, and thus largely restricted to, particular biomes. These follow a series of broad north to south bands. The northernmost is the Arctic tundra, which carpets much of Alaska and northern Canada, including Baffin Island, Victoria Island, Ellesmere Island, and the rest of the Canadian Arctic Archipelago. This harsh, largely treeless terrain, blanketed with snow and ice in winter, is home to the Snowy Owl (P. 31), a true Arctic specialist, whose circumpolar range also extends across Eurasia. Although this largely white bird is supremely adapted to its snowy environment, it may move south during winter according to the fluctuation of its food supply, chiefly rodents such as lemmings.

Opposite: The Spotted Owl, one of North America's rarest species, breeds in old-growth forests in the Pacific Northwest.

South of the Arctic are the boreal forests, which cover much of Canada's northern and mountainous regions. Species here include the Boreal Owl (P. 39), Great Gray Owl (*Strix nebulosa*), and Northern Hawk Owl (*Surnia ulula*), all of which also occur in the boreal forests of northern Eurasia. As these forests extend further south across the continent, with a greater variety of forest types, more species occur, including the diminutive Northern Saw-whet Owl (*Aegolius acadicus*) of largely deciduous forests, the Western Screech Owl (P. 57) of the Rockies and west coast, and its eastern equivalent the Eastern Screech Owl (*Megascops asio*). The rapacious Barred Owl (P. 69) has a penchant for moist and swampy forest, including the Everglades and bayous of the south. Perhaps the rarest of North America's owls, the Spotted Owl (P. 66), finds refuge in the old-growth temperate rain forests of the Pacific Northwest.

Other habitats support specialized owls. A significant amount of the prairies—the great grassland plains that once covered much of central North America—has been lost to agriculture, but the pockets that remain harbor the Burrowing Owl (P. 43), one of the world's most charismatic and distinctive species, whose ecology is closely tied to that of the prairie dogs and other burrowing mammals with which it cohabits. Further south and west, in the arid regions, the diminutive Elf Owl (P. 63) has adapted to life in the desert, finding perfect nest holes among towering saguaro cacti. Further south still, into Mexico, a greater variety of owls reflects the tropical influence of Central America, which is responsible for a broader general biodiversity. These include pygmy owls (*Glaucidium*) and South American species such as the Spectacled Owl (P. 76) and Crested Owl (P. 95), which extend a toehold into the region.

North America's landscapes, like those of Europe, have been heavily modified by human activities. Some species have shown an impressive adaptability: the Great Horned Owl, for example, is not only the continent's most rapacious species but also among its most common and widespread, finding a perfect niche in suburbia, where it terrifies the neighborhood cats and dogs when they venture too close to its nest. Screech owls, both Western and Eastern, also readily adapt to human habitation and are easily encouraged to stick around if suitable nest boxes are provided. The American Barn Owl (*Tyto furcata*), now recognized by some authorities as a separate species from the Common Barn Owl (P. 127), also finds a home in farming landscapes, providing that they are not managed too intensively and still provide enough rough pasture and old buildings for hunting and breeding.

Nonetheless, the ongoing loss of habitat is taking its toll on some species. The best known of these is, perhaps, the Spotted Owl, whose conservation became a *cause célèbre* during U.S. elections in the 1990s, when the needs of the owl were pitted against those of the loggers who believed that their livelihoods depended upon felling precious old-growth forests. Today, a variety of conservation groups, both local and national, are working to protect owls wherever they occur.

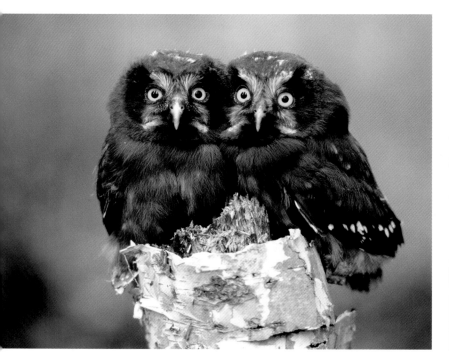

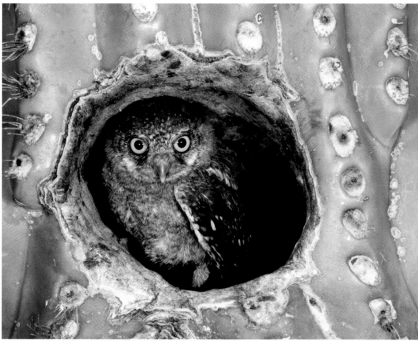

Above left: Two Boreal Owl fledglings near their forest nest.
Above: A young Elf Owl peers from its cactus nest in a desert.

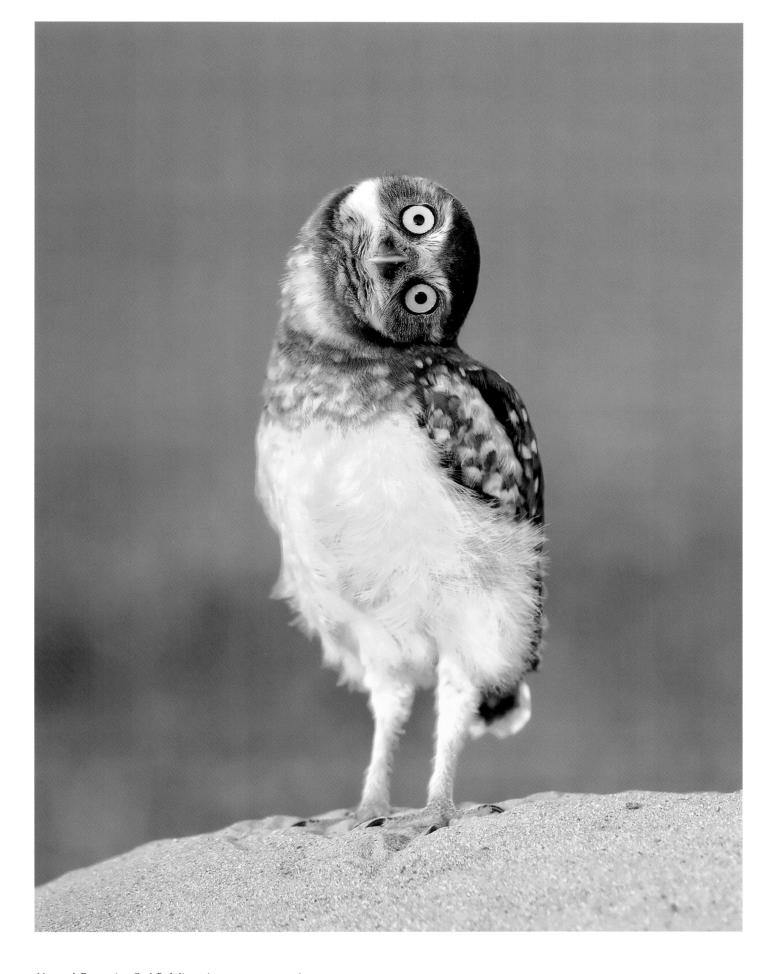

Above: A Burrowing Owl fledgling tries out new perspectives
on the world outside its burrow.

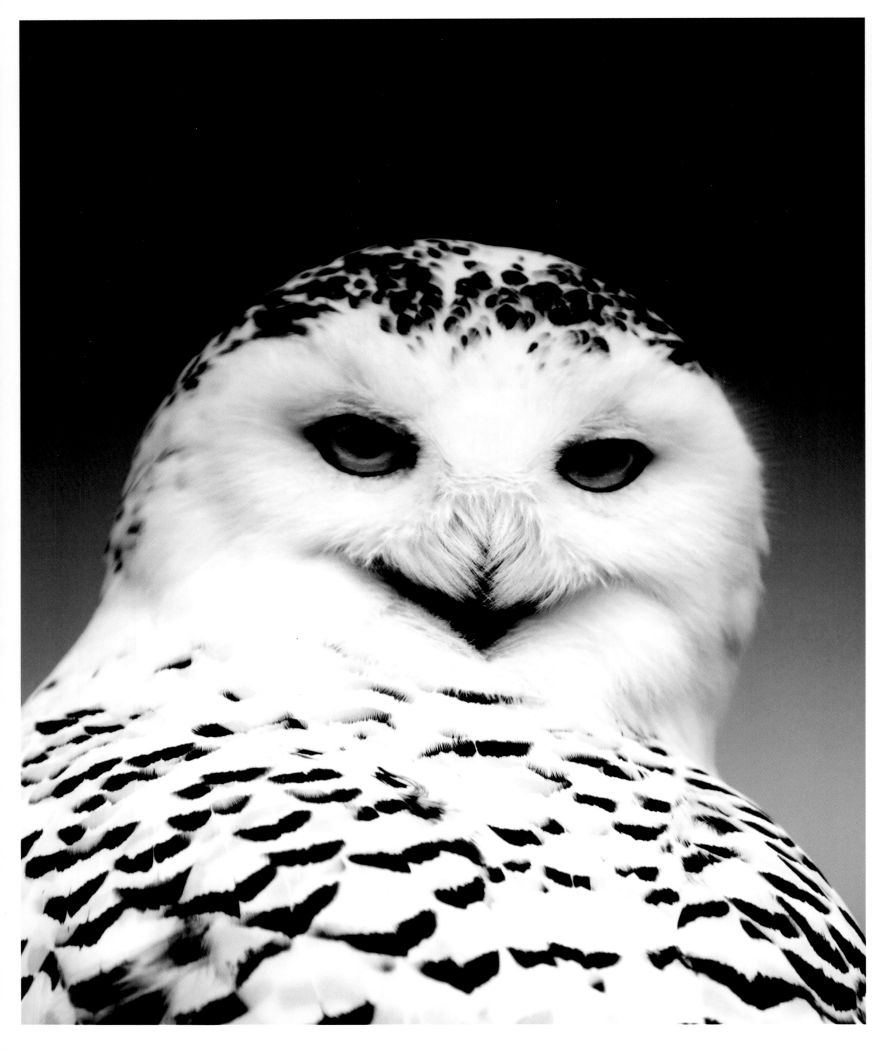

SNOWY OWL

NYCTEA SCANDIACA (BUBO SCANDIACUS)

APPEARANCE

Large to very large white owl; female distinguished from almost pure white male by more extensive dark barring on upper parts, crown, and flanks; yellow eyes; black bill almost covered by white facial disk; heavily feathered feet; long wings, with dark banding on tips of flight feathers.

SIZE

length 20–28 in. (52–71 cm)
weight 3.5–6.6 lb (1.6–3 kg)
wingspan 49–59 in. (125–150 cm)

DISTRIBUTION

Circumpolar range across Old and New World Arctic: in North America, from the Western Aleutians east to northern Quebec and Labrador; in Eurasia, from Lapland east across Arctic Russia; winters further south: in North America, southern Canada, and the northern United States; in Eurasia, Kazakhstan, Mongolia, and northern China.

STATUS

Least Concern

THE INUIT CALL THIS BIRD OOKPIK, and at one time they used its feathers to fletch their hunting arrows. Fans of J. K. Rowling will know it as Hedwig, the messenger owl that carries post to Harry Potter. Whatever you call it, the Snowy Owl is not only the world's most unmistakable owl, but also one of its most impressive birds. The scientific name "*scandiaca*" reflects the fact that it was first described to science in Scandinavia. However, this circumpolar Arctic owl has its largest population in North America and is, today, the official bird of Quebec.

"Big and white" is the only description needed in order to identify this owl. It is between the Eurasian Eagle Owl (P. 103) and the Great Horned Owl (P. 48) in size, and its snow-white plumage is unlike that of any other species. The black-rimmed yellow eyes seem particularly dazzling against the white face, and the feet are as thickly feathered as you would expect for an animal that lives most of its life in the snowy Arctic. In addition to its unique coloration, the Snowy Owl is one of the most sexually dimorphic of owls. Mature males are almost totally white, with the exception of a few dusky spots on the crown and dusky barring on the tips of the flight feathers, but the larger females are more heavily marked, with dark brown spotting and barring on the crown and upper parts, the flight feathers, tail feathers, and flanks. Despite their markings, however, females still appear predominantly white.

Although long placed in the *Bubo* genus, along with eagle owls and the Great Horned Owl, many taxonomists today assign the Snowy Owl to its own genus, *Nyctea*. Whatever the taxonomy, its white plumage and thick feathering are both adaptations to life in the Arctic—just like the similar adaptations of the Arctic fox (*Vulpes lagopus*), snowshoe hare (*Lepus americanus*), and rock ptarmigan (*Lagopus muta*). It ranges right across the Arctic regions of both the Old and New Worlds, but despite this wide distribution, the Snowy Owl is a monotypic species, with only one race recognized.

This bird is nomadic, moving south when conditions become too harsh or the rodent population crashes. In North America, this means heading into southern Canada and the northern United States, with some birds traveling as far as Texas and Georgia. In Eurasia, the wintering quarters extend to Kazakhstan, Mongolia, and northern China. Young males make the longest journeys and older females the shortest. Long-distance travelers may make a series of stop-offs as they head south, defending a temporary territory in each. The Snowy Owl's nomadic existence means that it moves between different habitats. Its tundra breeding grounds comprise largely treeless terrain, coated with mosses and lichens and punctuated with boulders and patches of snow that remain throughout the summer. Moving south in winter, it exchanges this barren terrain for lake shores, marshes, coastlines, and fields.

A diurnal predator, the Snowy Owl is active between dawn and dusk. On its breeding grounds, it is often seen perched on small tundra mounds or flying low from one perch to the next. Its flight is powerful, with deliberate rowing beats of its long wings and long glides in between. The main hunting strategy is sit and wait: the owl scans the open tundra and then, when a target is spotted, attacks in a long, shallow glide. Voles and lemmings—the small rodents that breed prolifically during the Arctic summer—are its principal prey. It may also take larger mammals, such as snowshoe hares, and targets birds,

Opposite: A Snowy Owl's bill is almost completely hidden by its feathers.

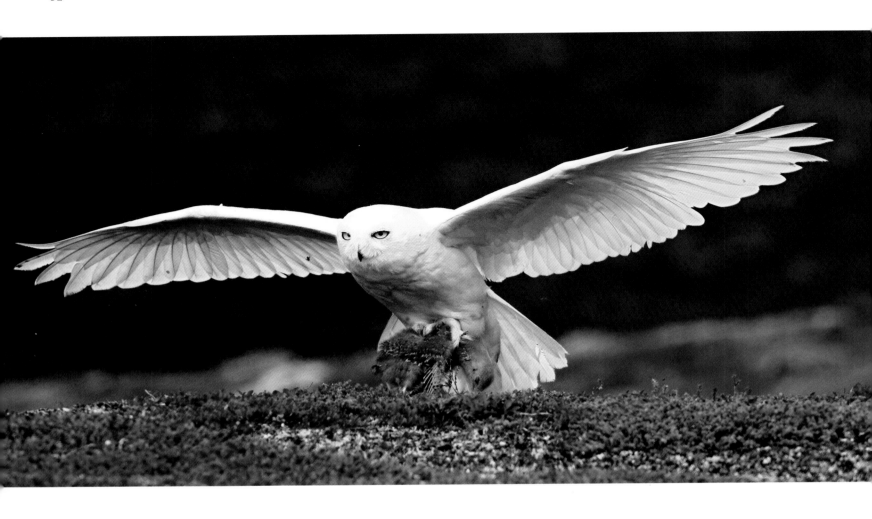

including ducks and geese, taking them in flight or from the water's surface. In addition, it may use those sharp talons to pluck fish from the water.

The Snowy Owl is seldom monogamous. Its changing terrain and long journeys mean that it often finds itself setting up a new territory with a new partner, although pairs have been known to stick together for up to five years. During courtship, the male calls with a booming "hoo hoo"—up to six repeated notes—to which the female responds with harsher, higher calls. He backs up his vocal performance with an impressive display, flying in undulating circles with exaggerated moth-like wingbeats, then descending to bow and strut on the ground, feathers fluffed out, tail cocked, and wings drooping or held up like an angel's. The nest is made on the ground; there is little choice in the Arctic tundra. A site is chosen that is free from snow and in a productive hunting area, with a good view of the surrounding landscape. The female uses her feet to scrape a shallow depression on top of an elevated mound, which she then lines with a little vegetation and a few feathers.

The clutch size of the Snowy Owl varies from an average of five to eight eggs to an astonishing fourteen or more in peak lemming years. The female lays her eggs at two-day intervals, then incubates them while the male brings food and stands guard. During this period, the parents toil hard. The growing chicks eat two lemmings per day, and a single family may consume up to 1,500 lemmings before the young disperse. Meanwhile, the male defends the nest vigorously. The open terrain means that approaching enemies are easily visible, and the owls have been known to attack Arctic foxes at least 0.6 miles (1 km) away from the nest. If an intruder breaches the male's defenses, the female will attempt to lure it away with a distraction display. The owls do not hunt immediately around their nest. This means that birds such as the snow goose (*Chen caerulescens*), which might otherwise be prey, often nest near the owl in order to gain its protection from foxes and other nest raiders.

Numbers of Snowy Owls fluctuate wildly, according to prey availability: the birds become locally abundant in a boom year, then almost disappear the next. Their greatest threat may be climate change, which in bringing about the slow "greening" of the Arctic tundra in some areas may deprive the Snowy Owl of the very habitat for which it is so beautifully evolved.

Above: A male Snowy Owl arrives at the tundra nest with his prey.
Opposite: Snowy Owls may make use of farmland during their winter journey south.

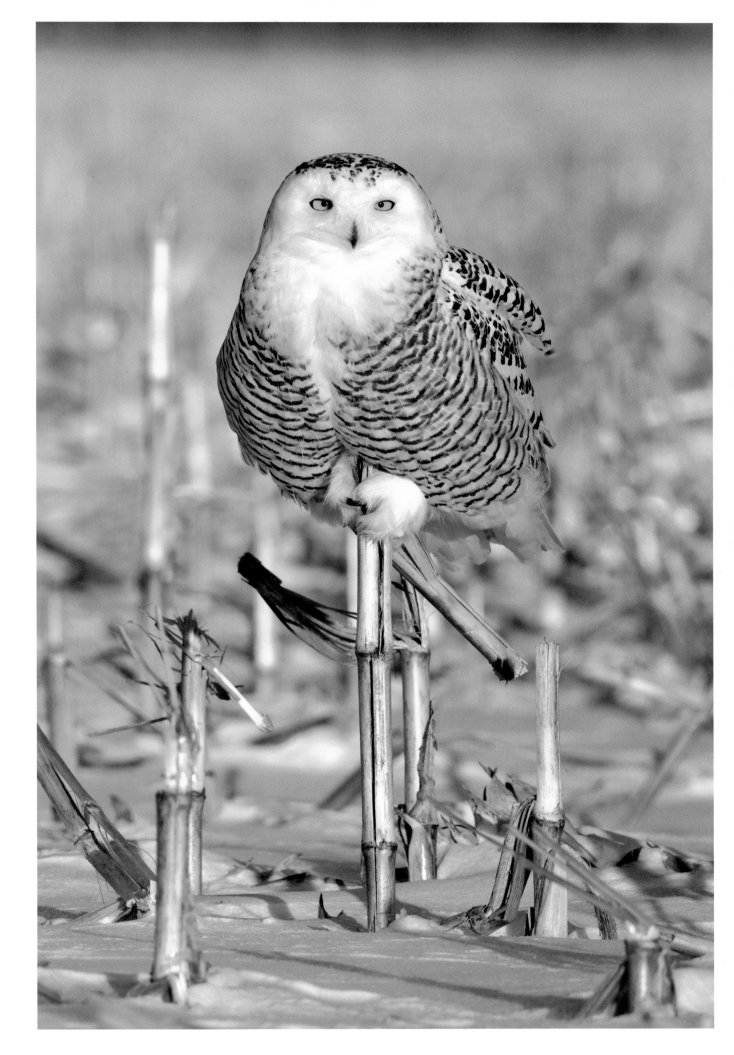

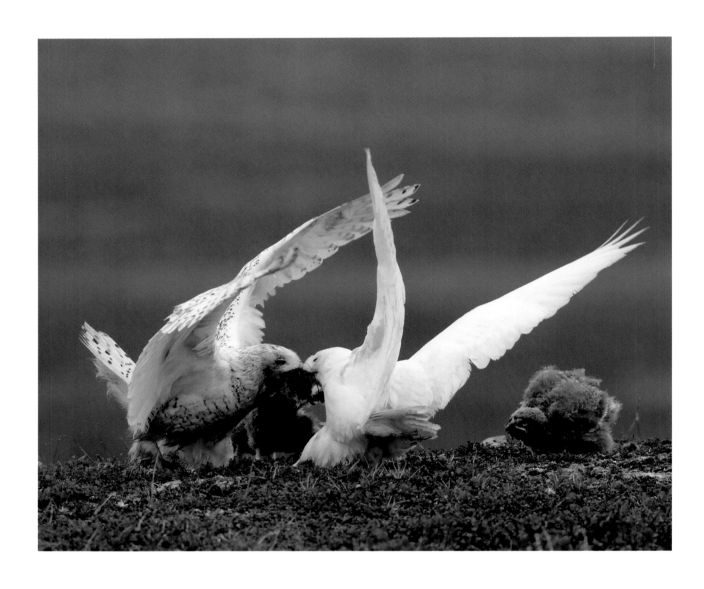

Above: A male Snowy Owl passes food to the female while the youngsters look on.
Opposite: The heavy dark barring on this Snowy Owl, plus its greater size, identifies it as a female.

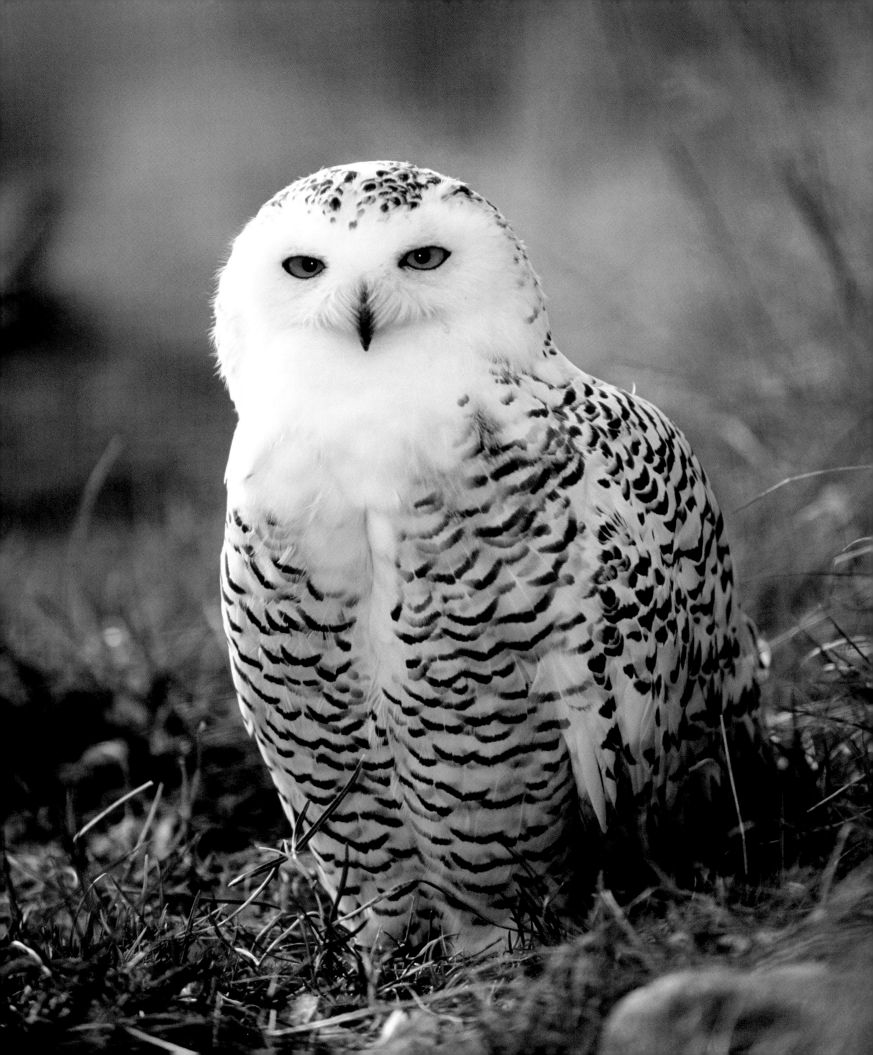

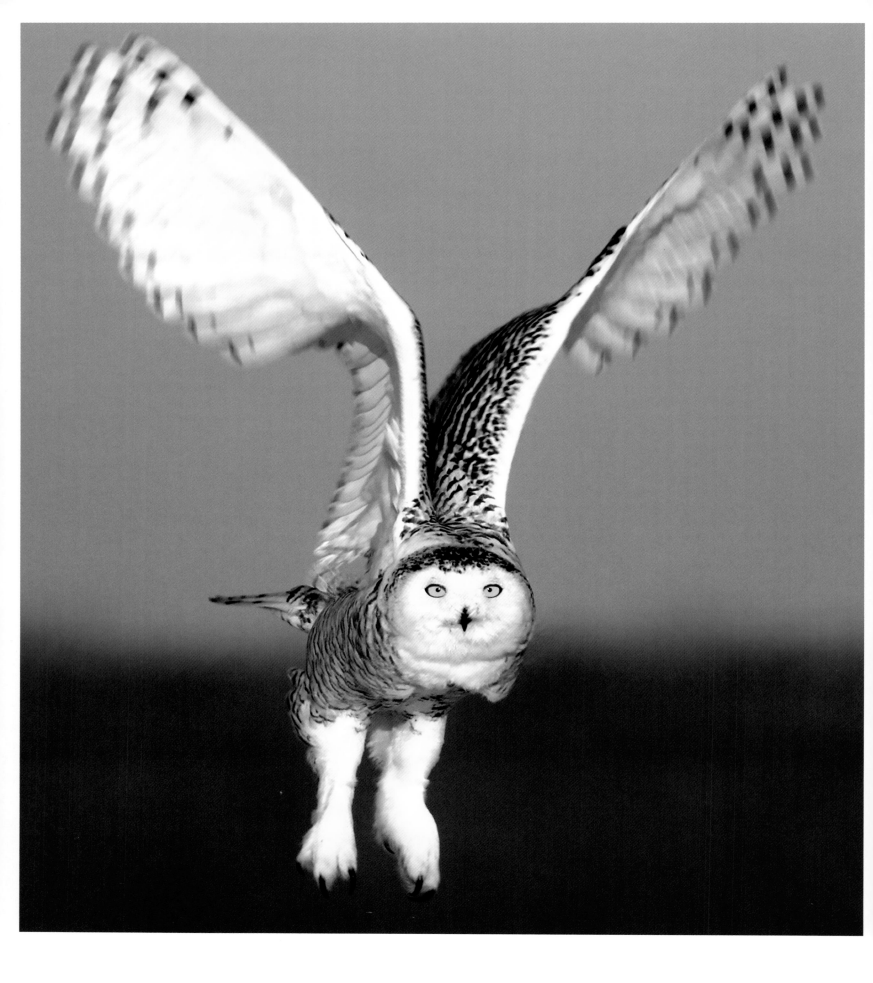

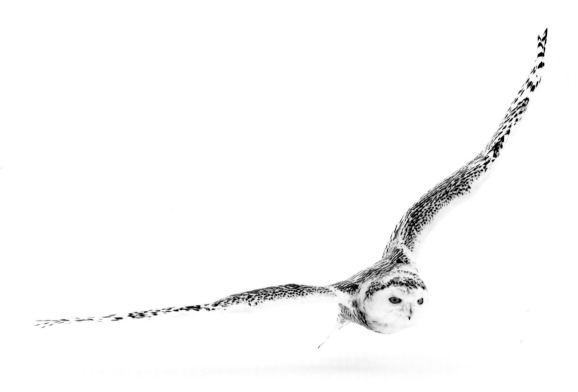

Above: The Snowy Owl approaches prey in a low glide, often hidden by the contours of the ground until the last, fatal moment.
Opposite: A female Snowy Owl taking flight reveals feet that are more thickly feathered than in any other owl species.

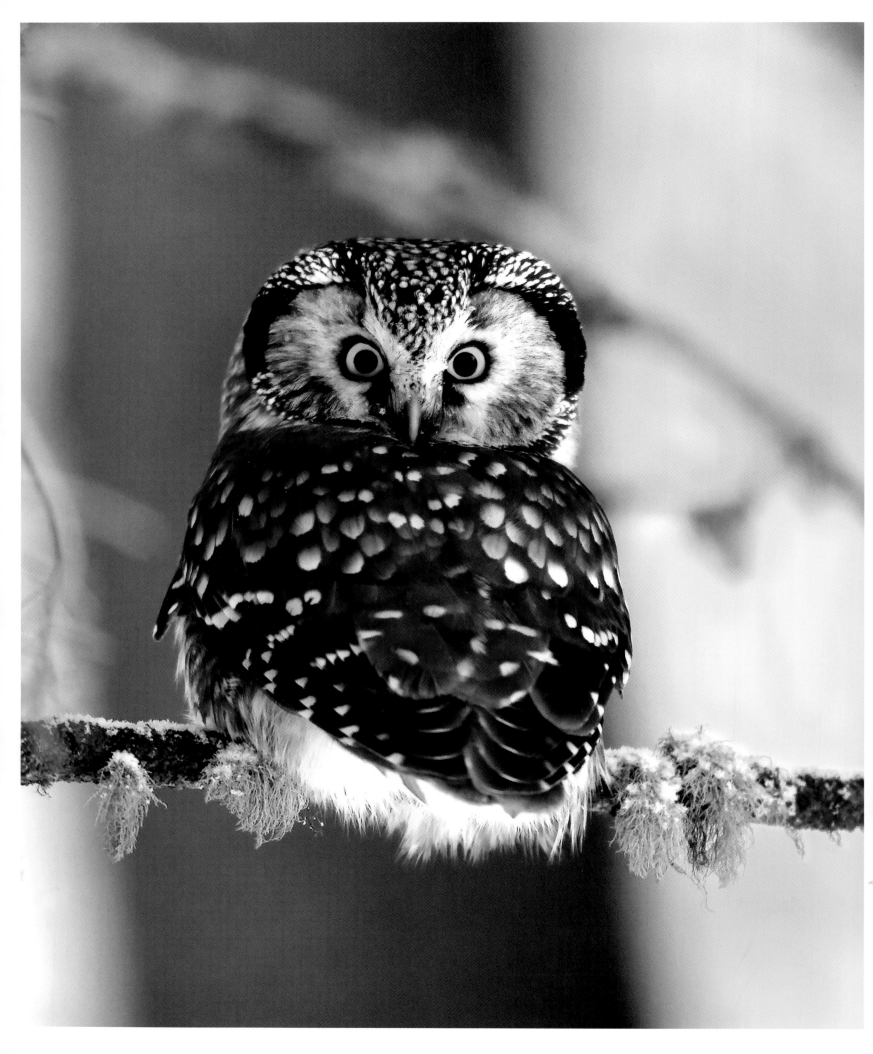

BOREAL/ TENGMALM'S OWL

AEGOLIUS FUNEREUS

APPEARANCE
Small, with large head and cat-like face; dark marks above eyes and bumps on facial disk give expression of surprise; coloration varies from reddish-brown to gray; upper parts dark with white spots; under parts pale and streaked; in flight, shows short tail and broad wings.

SIZE
length 8.7–10.6 in. (22–27 cm)
weight 3.3–7.6 oz (93–215 g)
wingspan 20–24 in. (50–62 cm)
female much larger than male

DISTRIBUTION
Northern coniferous belt in Old and New World; in North America, from east to west coast, and down the Rocky Mountains to New Mexico; in Eurasia, from Scandinavia to Pacific coast; isolated populations in central Europe,w including southern France.

STATUS
Least Concern

"SURPRISED" IS THE WORD OFTEN USED to describe the facial expression of this small owl. The dark markings above its bright yellow eyes and the two bumps atop its facial disk convey a certain raised-eyebrows astonishment. You might be surprised, too, if you manage to spot one. This nocturnal bird inhabits deep woods and is very wary of people.

The Boreal Owl—known in Europe as Tengmalm's Owl, after Swedish naturalist Peter Gustaf Tengmalm—is the size of a starling. It does not have true ear tufts but, when alarmed, compresses its facial disk to produce two bumps. The dark upper parts are boldly spotted in white (hence the Finnish name "pearl owl") and pale under parts are streaked with arrowheads, providing excellent camouflage at its tree trunk roost. Females are much larger than males, showing the most extreme sexual dimorphism of any North American owl.

The deep boreal forests where this bird lives vary from pure coniferous in the north of its range to pure deciduous further south. In northern regions, the bird is more nomadic, making southward journeys of up to 620 miles (1,000 km) when conditions dictate. Males are less inclined to move than females, preferring to safeguard their breeding territory in readiness for the next year. In southern regions, this bird also inhabits high subalpine forests.

The Boreal Owl operates almost entirely between dusk and dawn, and voles make up the bulk of its diet. Its standard hunting technique is to perch on a low branch and move its head slowly from side to side to pinpoint the movement of a rodent by ear. This species has the most pronounced ear asymmetry of any owl, an indication of the exceptionally powerful hearing with which it finds food in dark forests. Once prey is located, the bird swoops down to secure the prize, sometimes plunging through layers of leaf litter or snow. It may also take other small mammals, including shrews, mice, and moles, and in poor vole years it will more regularly target small birds. Like some other owls, this species may cache food in a tree crevice larder. It has even been observed thawing out frozen prey by crouching on it, as though brooding chicks.

Although hard to see, the Boreal Owl is easily heard; the male's courtship song is audible for 2 miles (3 km) on a still night. It comprises a series of six to ten "poop" notes, which resemble the call of a hoopoe (*Upupa epops*) and are repeated with three- to four-second breaks. This song varies between individuals in pitch and speed, so each male in a given area is easily identified. Once a female approaches, the male's call becomes more stuttering and develops into a long trill as he shows her to a potential nest site. The female's song is weaker and higher pitched. Both sexes also utter various barks, croaks, and other softer calls. Pair bonding is seasonal, with the male defending a small territory but finding new mates each year. The nest is often an old woodpecker hole, but natural cavities will also do and nest boxes are readily accepted. A female lays three to eight eggs, one day apart, and incubates her clutch for twenty-eight to twenty-nine days, while the male provides food. In good years, a pair may have a second brood.

With an estimated global population of two million, the Boreal Owl is classed as Least Concern. However, numbers are hard to assess and it is declining in some areas. Nesting birds often fall prey to martens, and other predators include the northern goshawk (*Accipiter gentilis*) and the Tawny Owl (P. 120). Nevertheless, habitat loss through deforestation is a much greater threat.

Opposite: The facial markings of the Boreal Owl give an impression of permanent surprise.

Right: A Boreal Owl peers out from its nest hole beneath the ever-changing night sky.

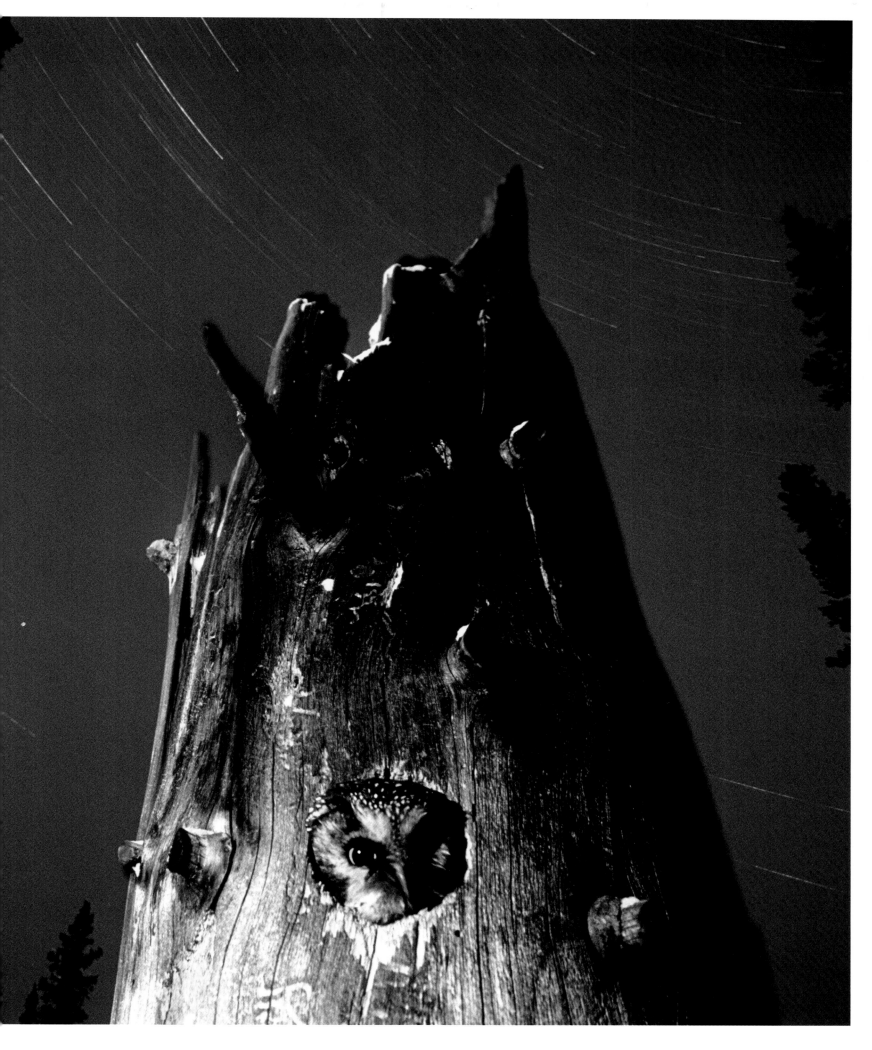

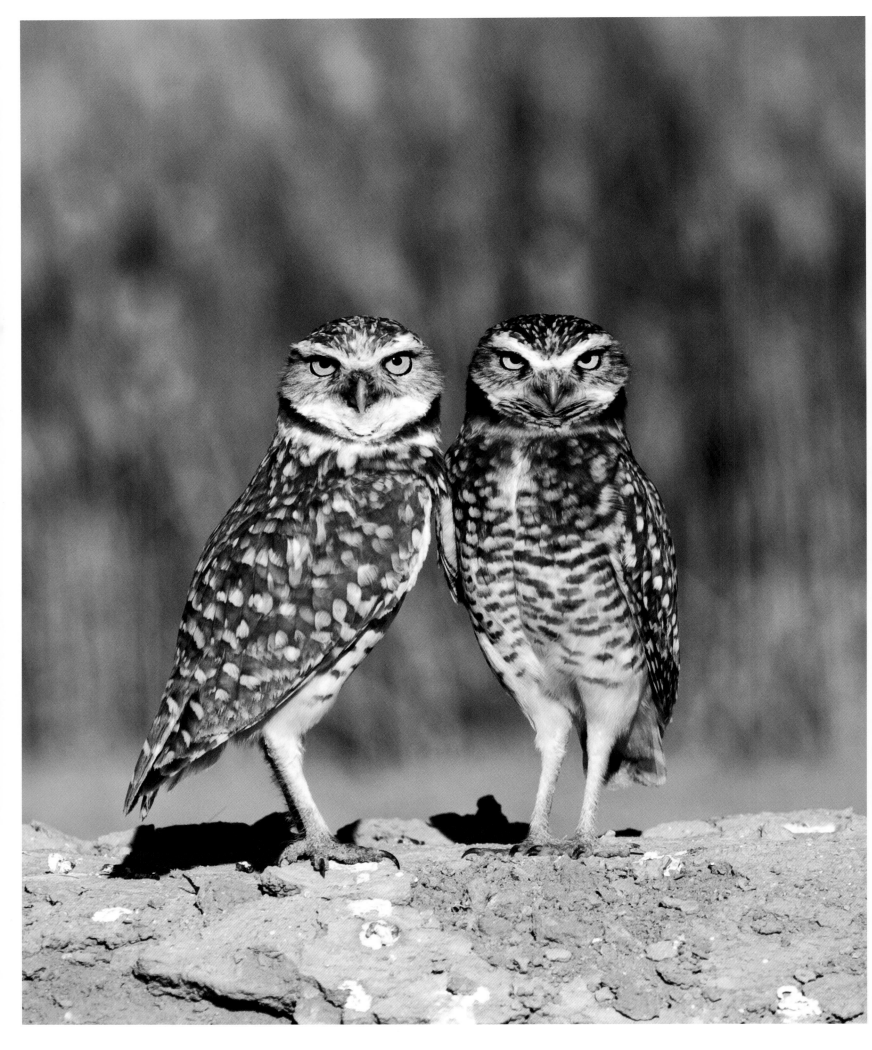

BURROWING OWL

ATHENE CUNICULARIA

APPEARANCE
Small, with round head, long legs, and upright stance; pale yellow eyes, brownish facial disk, white eyebrows and white throat band; under parts pale to brownish, spotted in white and dusky-brown; upper parts and crown brown with whitish streaks and dots; short tail and barred, rounded wings.

SIZE
length 7.5–11 in. (19–28 cm)
weight 4.9–8.5 oz (140–240 g)
wingspan 20–24 in. (50–61 cm)
female slightly larger than male

DISTRIBUTION
In North America, all states west of Mississippi Valley, north to southern Canada, and south into Mexico and Florida; also in South America, Central America, and the Caribbean; birds from northern North America migrate south to Mexico and Central America.

STATUS
Least Concern

IF EVER A BIRD WAS DESTINED to feature in a cartoon strip, it is this charismatic little owl. Typically, it appears from a hole in the ground, stands tall on stilt-like legs, bobs its head up and down, and fixes you with a furious glare. Small wonder that the Burrowing Owl continually pops up, so to speak, in children's fiction, recently as a band of Mexican Mariachi musicians in the animated movie *Rango* (2011).

This is the most terrestrial of the world's owls: it not only spends much of its time on the ground, but also, as the name suggests, nests beneath it. Although capable of digging its own burrow, this owl generally reappropriates the burrow systems of ground-dwelling mammals, such as prairie dogs (*Cynomys*). The two are often seen in close proximity and inhabit the same terrain: open grasslands, from the prairies of North America to the pampas of South America. Other favored habitats range from semidesert to pinyon and ponderosa pine scrub, and this owl will happily take to farmland and other human landscapes, too, including golf courses and airports, if conditions are suitable.

The Burrowing Owl is one of the most widely distributed owls in the Americas. However, it avoids mountains and forest. In South America, for example, it is found discontinuously in all suitable habitat as far south as Tierra del Fuego, but is absent from the Amazon Basin and the high Andes. Birds toward the north of the North American range are migratory, but the South American population is largely sedentary.

This species was once assigned its own genus, *Speotyto*. Today, most taxonomists group it within *Athene*, along with Eurasia's Little Owl (P. 114), which it closely resembles. The fragmented distribution has produced up to twenty-two subspecies, with the nominate race, *A. c. cunicularia*, found on the eastern side of South America. These vary in markings, but the Burrowing Owl's distinctive habits and posture — small, round head and long-legged silhouette atop an anthill or fence post — mean that confusion with other owls is unlikely. In fact, it is one of the easier owls to observe up close; it is both diurnal and reasonably approachable, especially where it is used to human disturbance. A good view reveals pale yellow eyes set in a brownish facial disk. The strong white throat band stands out above a brownish upper breast, which is spotted in white to differing degrees according to subspecies. The tarsi are long and white, the tail is short, and the heavily barred wings appear broad and rounded in flight. Males are generally lighter in color, especially toward the end of the breeding season, when their guard duties outside the burrow expose their plumage to the bleaching of the sun.

The Burrowing Owl is seldom seen far from its burrow, and often perches at the entrance or on a nearby perch. When alarmed it will bob up and down excitedly, and if threatened it will fly away low, with irregular, jerky wingbeats between long glides. Although visible throughout the day, the bird becomes most active at dusk. Its prey changes with season and location, but the staple diet in most areas is large arthropods, including beetles, grasshoppers, and scorpions. However, this owl will also turn to small vertebrates, from reptiles and amphibians to small mammals, as well as birds up to the size of the eared dove (*Zenaida auriculata*), which is its equivalent. Birds in different areas specialize in a particular food type: in southern Brazil, for example, the delicate vesper mouse (*Calomys tener*) is a favorite. The usual hunting technique is to watch for prey,

Opposite: Burrowing Owls are often seen in pairs or family groups near the entrance to their burrows.

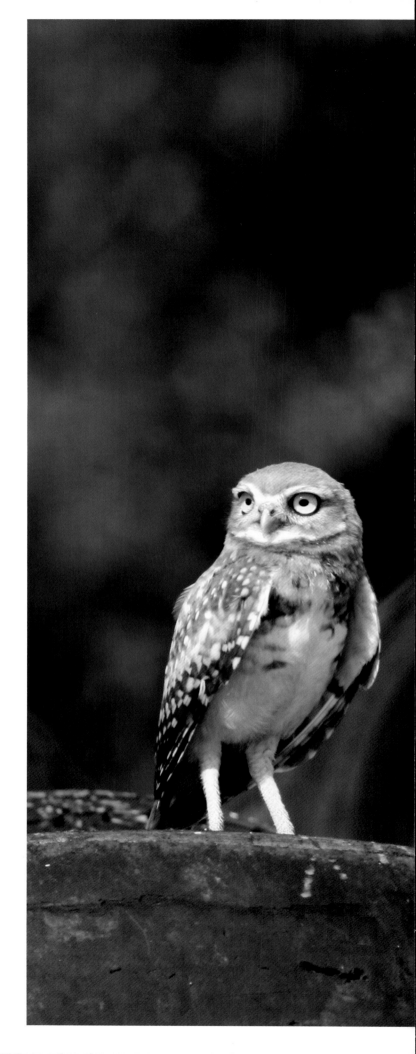

then glide silently toward it and snatch it from the ground with talons. However, the Burrowing Owl is a versatile little predator and will also chase insects on foot or hawk them in midair. When feeding young, it may hunt around the clock.

In the northern hemisphere, courtship starts in March and April. Generally, this species forms monogamous pairs, although polygyny—one male mating with and providing for two or more females in separate burrows—is occasionally recorded. Activity starts with the male's distinctive two-syllable call, a hollow "cu-cuhooh." This song varies according to individual and mood. The female's call is similar but higher, and both sexes have a repertoire of harsh and curious calls. The male backs up his vocal performance with a choreographed courtship display, in which he coos, bows, and scratches the ground, flashing his prominent white throat and eyebrows. He may also rise in a brief hovering display flight, hanging above the female, then flying in a circle around her.

A pair will return to the same nesting burrow, or one close by, for many years in succession. Once settled, the female lines the burrow with dry material, including cattle dung. Indeed, the pair will often deposit dung outside the burrow entrance: once thought to be a means of repelling predators, this is now believed to encourage dung beetles and other insects on which the owls can feed. The female lays six to nine eggs (a maximum of twelve), one day apart, which she incubates for twenty-eight to thirty days. The male, meanwhile, provides food and aggressively defends the small area around the burrow.

In productive habitat, the Burrowing Owl may form loose colonies. This enables it to cooperate in sounding the alarm and warding off predators. Another ingenious defense system is deployed by the young chicks in the burrow: if disturbed, they make a harsh alarm call that sounds uncannily like the warning rattle of a rattlesnake. This is a prime example of Batesian mimicry, in which a vulnerable animal imitates a more dangerous one in order to deceive a potential predator. And this species certainly has many predators, from larger owls and other raptors to badgers, skunks, armadillos, and even domestic cats and dogs.

Globally, the Burrowing Owl is classed as Least Concern, with an estimated population of two million individuals. However, its wide distribution belies the fact that it is declining in many areas. Today, it is endangered in Canada, threatened in Mexico, and of special concern in Florida. Among the threats it faces are the loss of habitat to agricultural intensification, pesticides, and control programs for prairie dogs. Conservationists try to relocate Burrowing Owls whose burrows are threatened by a development project by enticing them to new burrows and perches constructed on safe alternative quarters nearby.

Right: Burrowing Owls often find a home in human environments.

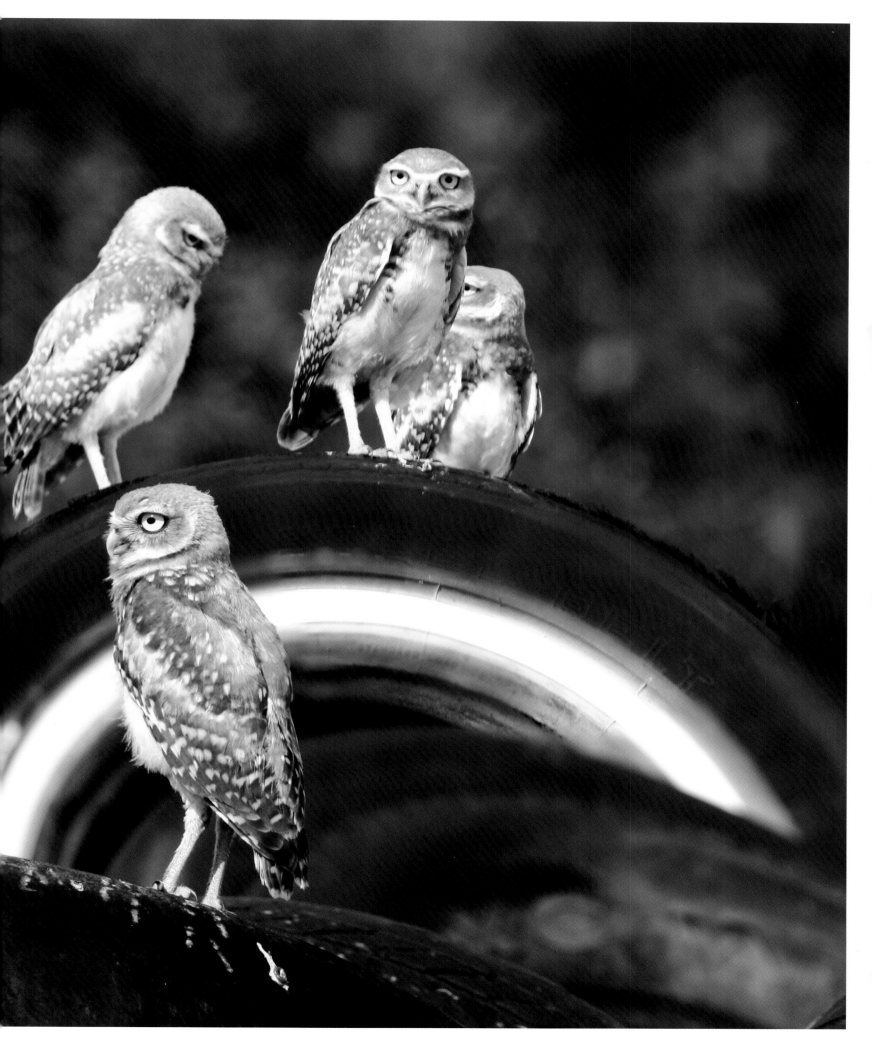

Above: A Burrowing Owl drives an American Badger away from its nesting burrow.
Opposite: Frogs feature among a wide variety of prey for this species.

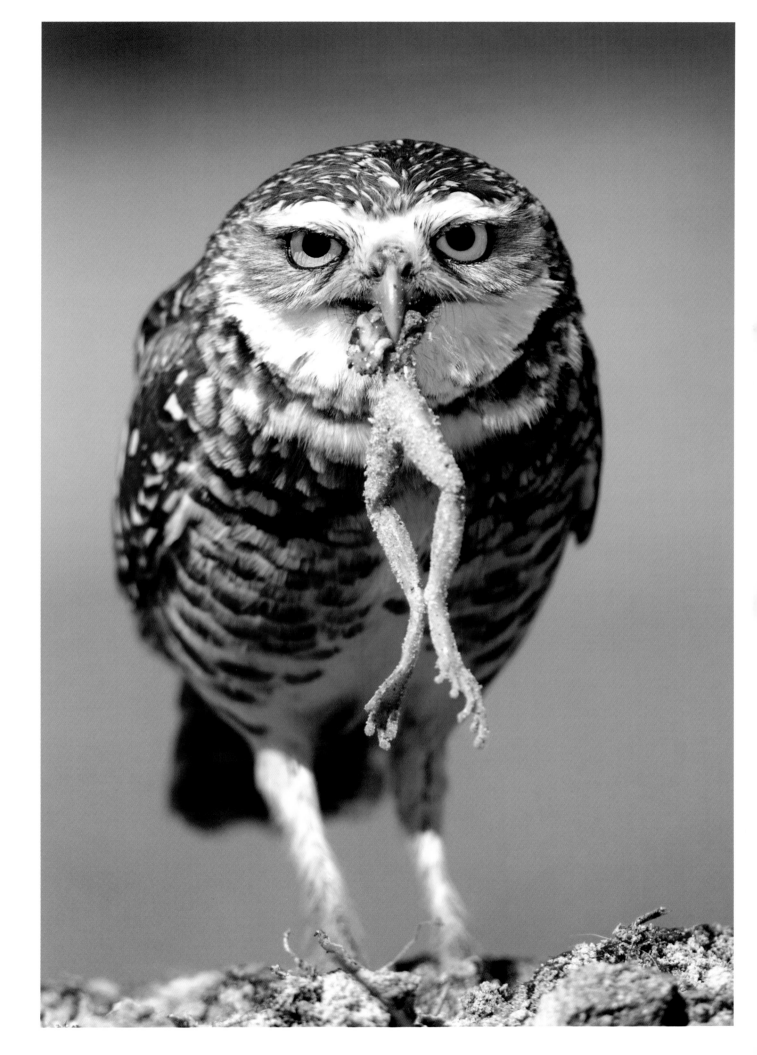

GREAT HORNED OWL

BUBO VIRGINIANUS

APPEARANCE
Medium-large to large owl with prominent ear tufts; plumage variable across its range; rusty-brown to ocher facial disk, with blackish rim, whitish eyebrows, yellow-orange eyes, and white throat; upper parts warm brownish-buff, patterned in gray, black, and white; crown, tail, and flight feathers strongly barred; under parts brownish buff, with blackish blotches and crossbars and sometimes a white stripe down the center.

SIZE
length 17–25 in. (43–64 cm)
weight 2.6–5.5 lb (1.2–2.5 kg)
wingspan 3–5 ft (91–153 cm)

DISTRIBUTION
All of North America south of the northern treeline; Central America into northern South America, from coastal Venezuela to Peru; discontinuous population south of the Amazon Basin in southern and eastern Brazil and Argentina.

STATUS
Least Concern

THE SIZE, FEROCITY, AND BEAUTY of this impressive owl made it a subject of veneration among many Native American peoples. In the southwest, the Pima believed that it was a reincarnation of slain warriors who fly about by night, whereas the Arikara of the Great Plains conducted mystical initiation ceremonies, wearing facial masks adorned with its wing and tail feathers. For others, it was a spiritual intermediary in matters of love or crop fertility, and the Hopi used its feathers in a winter solstice ceremony in the hope of summoning the heat of summer. Today, it remains North America's best-known owl, and it is the provincial bird of Alberta.

Within North America, the Great Horned Owl is unmistakable. Resembling a slightly smaller version of the Eurasian Eagle Owl (P. 103), it is a typical member of the *Bubo* genus, with a large powerful body, broad wings, and prominent ear tufts. Its only rival for size on the continent is the slightly heavier Snowy Owl (P. 31) and, like its Arctic cousin, it is an apex predator wherever it occurs. First described to science by early settlers in the Virginia colonies, hence its scientific name *virginianus*, it is also known as the "hoot owl" and "winged tiger"—the latter a reference to its strong, stripe-like barring. In general, this owl has a rusty-brown to ocher facial disk, with a prominent rim and eyebrows that accentuate the stern

expression of the bright yellow-orange eyes. Its ear tufts are long and tousled, and held erect when alarmed or roosting. Upper parts are a warm brownish-buff, finely marked and mottled in gray, black, and white; under parts are brownish-buff, paler toward the belly, with strong blackish blotches and crossbars. The white throat is especially prominent when inflated during the bird's territorial calling, and it may continue as a whitish stripe down the center of the breast.

The Great Horned Owl occurs across the entirety of North America and down through Central America into northern South America. In southern and western South America, it is replaced by the similar but slightly smaller and paler Magellanic Horned Owl (*Bubo magellanicus*), with which it was once thought to be conspecific until DNA research proved otherwise. Taxonomists recognize up to twenty subspecies, which differ in size and markings. Birds in forested regions tend to be darker and those in northern regions larger, thereby following Bergman's rule, which states that individuals of any species tend to be larger in the colder parts of its range, because a higher body mass to surface area ratio helps to preserve heat. Northernmost populations may migrate south in winter, depending on weather conditions.

This species has a very wide habitat tolerance, found from dense forests to desert fringes, from open plains to city parks, and ranging up to 14,700 feet (4,500 m) in the Andes. Wherever it occurs, however, the Great Horned Owl requires mature trees for roosting and nesting and open ground or clearings in which to hunt. It generally becomes active around dusk and roosts by day, typically against a tree trunk, where its camouflage patterning is highly effective. In some regions, it may be out and about in the early morning or late afternoon.

The Great Horned Owl takes a variety of prey, which is one explanation for its success. Small to medium-sized mammals are at the top of the menu: typically, rabbits and hares, but also everything from small rodents to bats, squirrels, armadillos, raccoons, muskrats, porcupines, and domestic

Opposite: The Great Horned Owl held an iconic status among the native peoples of North America.

cats. Birds are also taken and range from crows, pigeons, and woodpeckers to grouse, herons, turkeys, and raptors, including all other North American owls except the Snowy Owl. Its standard hunting technique is to watch from an elevated perch, then swoop down with wings folded, before swinging its lethal talons forward to grab the prey. It may also hunt by quartering the ground like a Short-eared Owl (P. 141). Such is the power of this owl—with feet that can exert 300 pounds of pressure per square inch (136 kg per 6.5 sq cm), about five times that of a human hand—that it can kill prey weighing up to three times its own weight. It is also highly versatile and has been known to wade into water to capture fish or even walk into an open hencoop to seize a chicken. Observations suggest that for hunting it relies more on eyesight than hearing, and indeed its eyes are almost as big as those of a human.

The Great Horned Owl is largely monogamous, with a pair defending the same breeding territory for up to eight years. Outside the breeding season, however, it is solitary and does not get together with its mate until late winter to renew its bond. The male's courtship song is a sequence of deep mellow hoots, with an emphasis on the central one: "hoo hoo HOOO hoo hoo." He may call from dusk to midnight, and again just before dawn. The female responds with a similar but higher-pitched call. When the pair are close, the male will perform a bowing display, with wings drooped and white throat fluffed out. Among other noises in this owl's broad vocal repertoire are various grunts, meows, and shrieks, and a growling "krooo-oo" given when attacking intruders.

The nest is usually an old abandoned stick nest of another bird, typically a crow, raptor, or heron. Tree hollows, rocky caves, and abandoned buildings are sometimes also used. The female lays two to four eggs, which she incubates for twenty-six to thirty-five days. The male roosts nearby by day and hunts for his mate and young at night. At six to seven weeks, the young start roaming outside on nearby branches, and by nine to ten weeks they can fly. A pair of owls is extremely aggressive while rearing young and will attack intruders until they are killed or driven away. This species has a particularly fractious relationship with the red-tailed hawk (*Buteo jamaicensis*), whose breeding territory it shares.

Although the Great Horned Owl seldom lives more than thirteen years in the wild, it has topped thirty in captivity. It has few natural threats, although occasionally falls victim to the golden eagle (*Aquila chrysaetos*). Of more concern are human threats, which, in addition to the ongoing loss of habitat to development and agricultural intensification, include collisions with road traffic and power lines. Nonetheless, with a population estimated to be at least five million individuals, this species is classified as Least Concern.

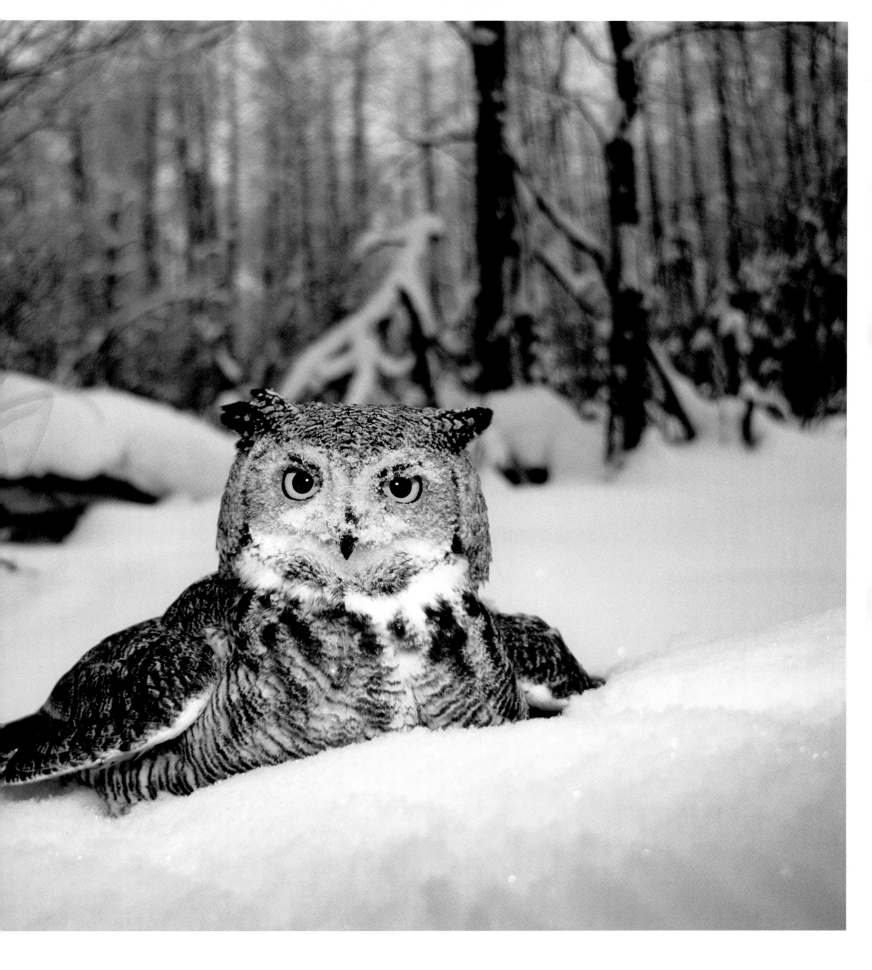

Above: The Great Horned Owl is a species of all terrain, from the
cold forests in the north of North America to the deserts in the south.

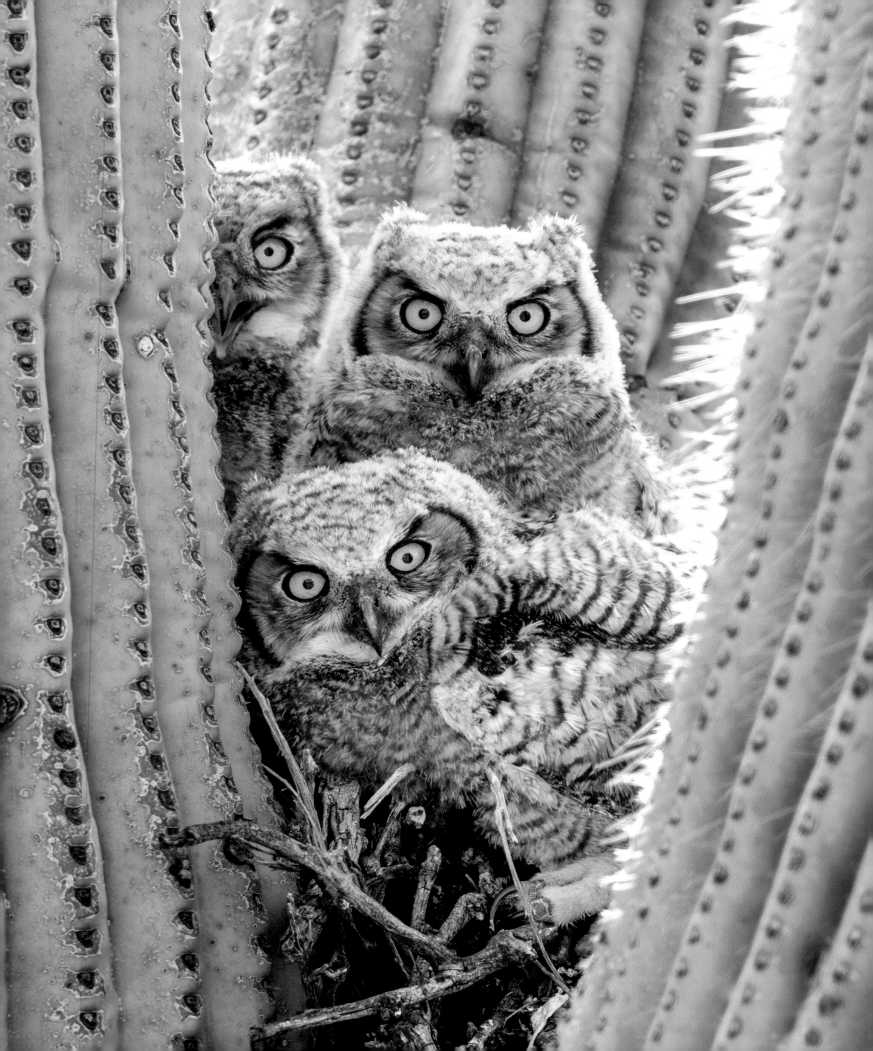

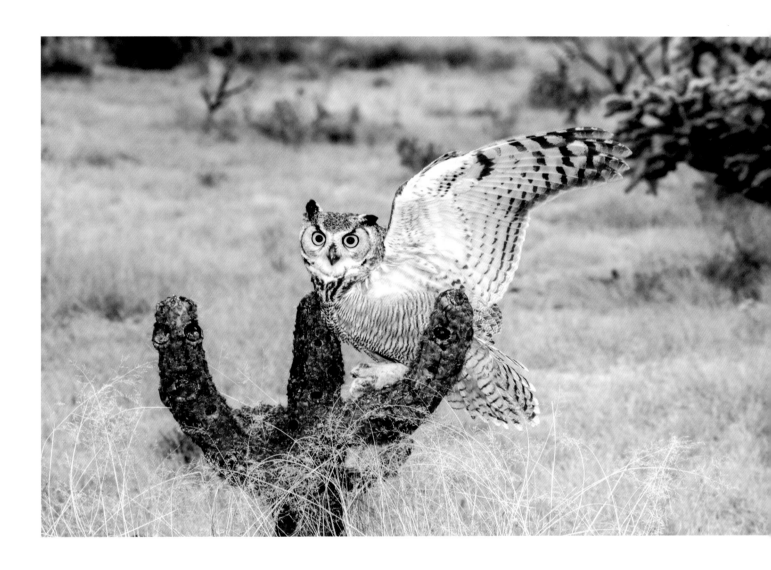

Above: An adult Great Horned Owl shows the long wings typical of *Bubo* owls.
Opposite: Three nestlings peer out from their spiny cactus citadel.

Right: A female Great Horned Owl at its nest in a tree cavity; intruders are repelled fiercely.

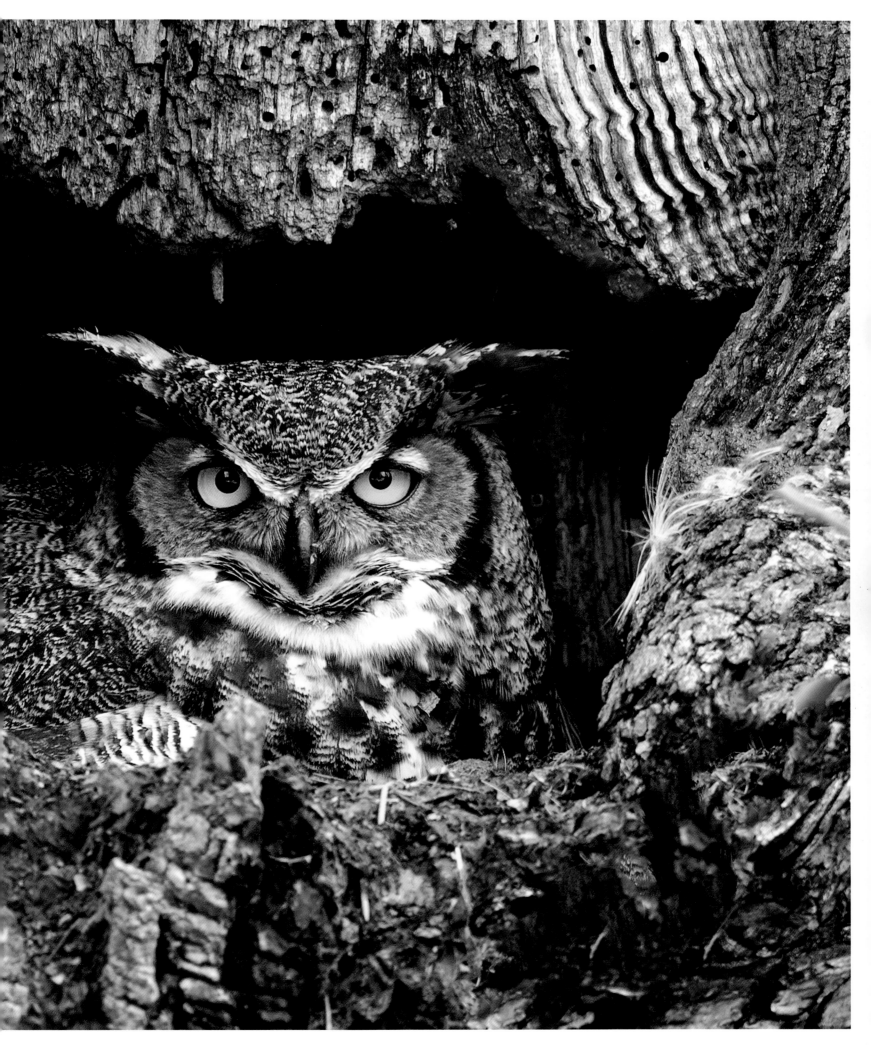

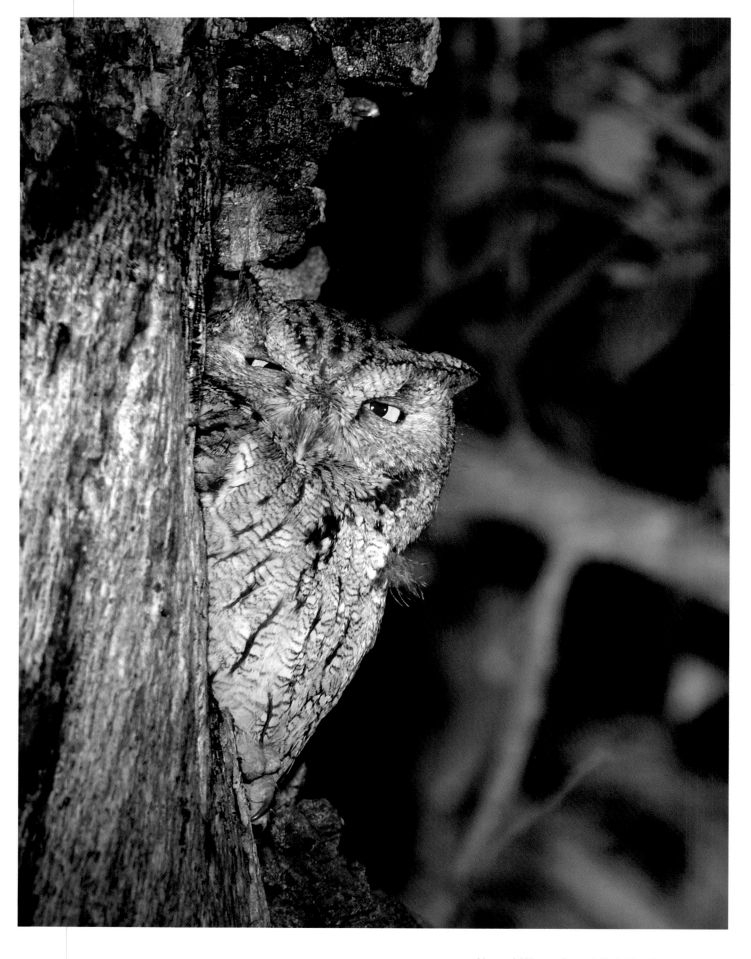

Above: A Western Screech Owl, like all screech owls, is camouflaged to resemble the trees in which it nests and roosts.

WESTERN SCREECH OWL

MEGASCOPS KENNICOTTII

APPEARANCE
Small; pale brown facial disk with dark edges and faint eyebrows over yellow eyes and a yellowish bill; crown and upper parts gray-brown and heavily streaked, with white scapular line on shoulders; under parts pale, with blackish streaks and irregular cross-barring; flight feathers and tail heavily barred; a rare brown color morph occurs in some northern areas.

SIZE
*length 8.7 in. (22 cm) ave
weight 3.1 – 7.8 oz (88 – 220 g)
wingspan 22 in. (55 cm)
females slightly larger than males*

DISTRIBUTION
Western North America, from Alaska in the far north, south to central Mexico and east to Western Texas.

STATUS
Least Concern

"SCREECH" IS NOT A PARTICULARLY APT NAME for this diminutive owl. It can certainly produce a variety of harsh noises, but the call for which it is best known is the male's distinctive territorial song: a series of whistled notes all uttered at the same pitch and accelerating with the rhythm of a bouncing ball. This repetitive refrain can be heard after dark up the length of western North America. It carries for more than a mile on still nights, providing a nocturnal sound track to landscapes as diverse as the humid northwest forests of towering Douglas firs and the stands of saguaro cactus on the edge of the Arizona desert. Rival males contest their territorial claims, each hoping for a female's answer.

This species is one of several very similar owls in the *Megascops* genus. It was once thought to be conspecific with the Eastern Screech Owl (*Megascops asio*), which occupies a corresponding ecological niche in the eastern half of the continent, but the two have completely different songs—voice is the most reliable way to separate species in this genus—and DNA studies have confirmed that they are indeed different species. In the few places where their ranges overlap, such as the Pecos River in Texas, they are not known to interbreed.

The *Megascops* screech owls comprise up to twenty-nine species and are the New World equivalent of the Old World scops owls (*Otus*). Some six to eight million years ago, the two groups diverged from a common ancestor, and it was only in the late twentieth century that taxonomists assigned each its own genus. Certainly, the Western Screech Owl looks very similar to the Common Scops Owl (P. 159) and other *Otus* species. It is roughly the same size, with a large round head, short tail, distinct ear tufts, and cryptic plumage that provides effective camouflage at its daytime roost. Taxonomists recognize nine subspecies, with the nominate race *M. k. kennicottii* found from Alaska to northern California. Across most of its range, this bird is a permanent resident; only at the northernmost limits do some undertake southbound winter migrations.

The diverse habitats favored by the Western Screech Owl comprise a mixture of woodland, with abundant nesting cavities and roost sites, and open country, in which it can hunt. Consequently, it tends to occur in highest densities at forest edges, clearings, and alongside rivers. Forest types vary from western hemlock, western red cedar, and Sitka spruce in the northwest, to deciduous woodland, pinyon pine, and cacti stands in the southwest. This species avoids dense forest, partly because here it runs a greater risk of encountering the Great Horned Owl (P. 48) and Barred Owl (P. 69), which both pose a significant threat. It has, however, shown an increasing capacity to adapt to gardens and suburban habitats, which serve well when prime wild habitat is lost elsewhere.

The Western Screech Owl is a nocturnal bird, seldom active by day. It roosts in tree cavities or in dense foliage near the tree trunk, where it freezes when disturbed in an attempt to blend into the bark. About half an hour after sunset, it sets out hunting, at which point it is often seen moving between trees. It flies directly—with glides interspersed between bursts of fast, soft wingbeats—and appears rather front-heavy, with its short tail and large head tucked in. This bird's standard hunting technique is to watch for prey from a high perch—often on a forest edge or beside wetlands—and then, having spotted a target, to swoop down and grab it, delivering the mortal blow with its sturdy little bill. Prey varies from deer mice (*Peromyscus*) and other small rodents to large insects and

small birds, depending on local abundance. This agile owl is also able to capture prey on the wing, including insects, bats, and flying squirrels. It has even been known to snatch small trout from a pool, scavenge from a roadkill possum, and attack domestic ducks that are at least twice as big as itself.

The Western Screech Owl generally mates for life, but an individual will take a new partner if it loses its mate. Adults remain near their breeding territory and may use the same nest site for many years. Courtship starts in late winter or early spring, when males sing their bouncing-ball refrain in order to reestablish territorial boundaries. Once mates have renewed contact, the male's call changes to a high double trill. Male and female duet as they approach one another through the woods. The male performs a dancing display along a branch, and the two birds nibble bills and preen one another as they renew their bonds and he shows her to a suitable nest site. They may also make discreet barking and chuckling calls, as well as a softer "coo-roo" in greeting. The nest site is a tree hole, usually one excavated by a woodpecker. It is generally located around 16 to 20 feet (5–6 m) off the ground in a large deciduous tree, such as an oak or sycamore, but sizable fir trees and junipers will also do, as will cacti in the southwest. One Arizona race of this species nests exclusively in saguaro cacti.

A female lays two to five eggs, with the average clutch size increasing further north and inland. Incubation lasts twenty-six days, and the chicks fledge after another thirty-five days. Meanwhile, the male provides food and defends the nest aggressively, attacking trespassers with angry bill snapping and raking of talons. The hatching is synchronized with the spring northbound bird migration, so the parents have a good supply of small exhausted songbirds with which to supplement the diet. The chicks continue to receive their parents' care for five to six weeks after fledging, before they disperse ready to establish their own breeding territory the following spring.

One interesting detail in this bird's nesting arrangements, and one that it shares with the Eastern Screech Owl, is the male's habit of collecting blind snakes and depositing them alive into the nest. These diminutive reptiles lurk among the debris at the bottom of the hole, where they feed on flies and parasites, and thus help keep the nest hole clean and healthy.

With an estimated population of 700,000 individuals, the Barred Owl is classed as Least Concern. It has suffered localized declines due to habitat loss, pesticides, and the westward spread of the Barred Owl, but in recent years the Western Screech Owl has offset this to some extent by moving into built-up areas. It takes readily to nest boxes, which helps considerably.

Right: Owls, including this species, have proportionally the largest eyes of any birds.

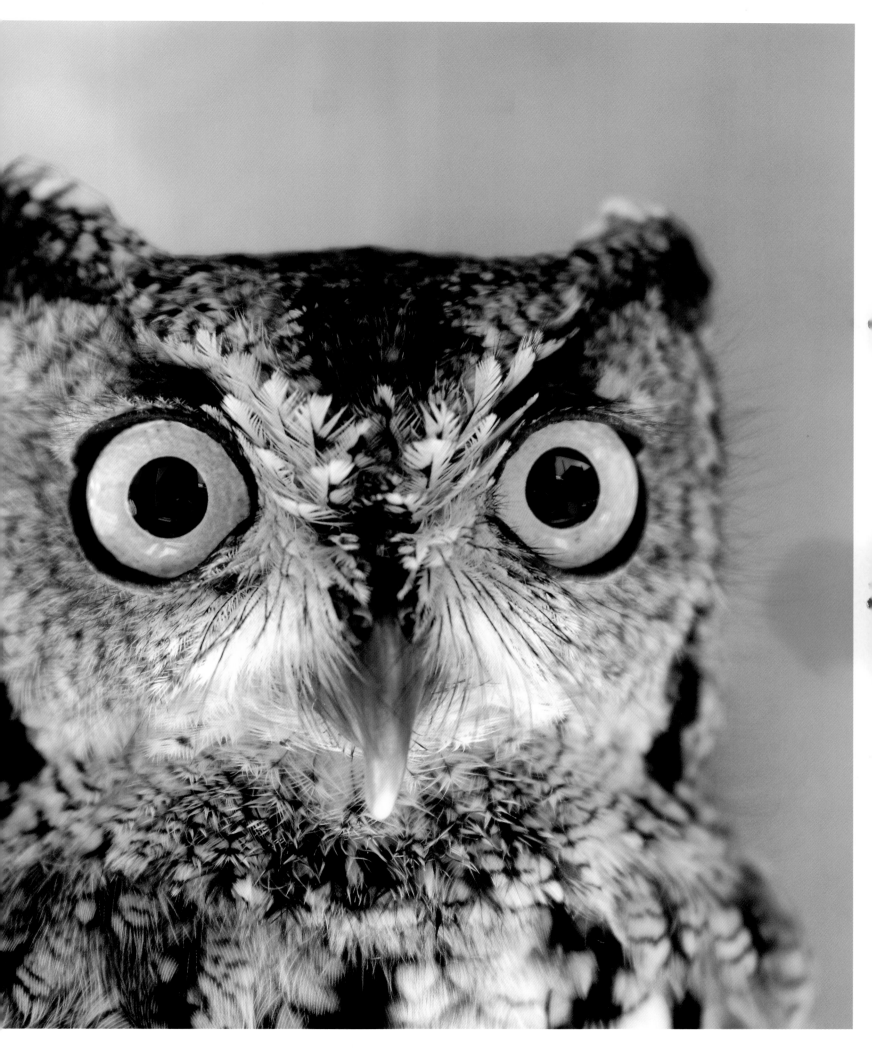

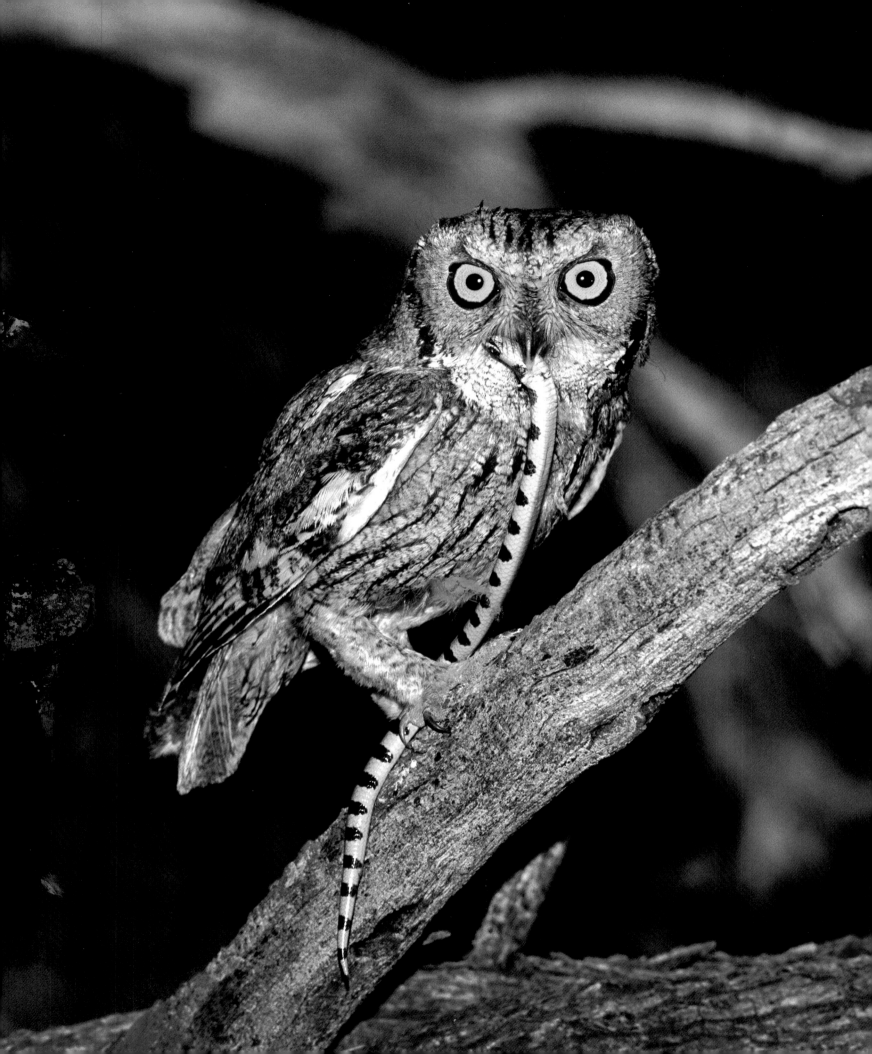

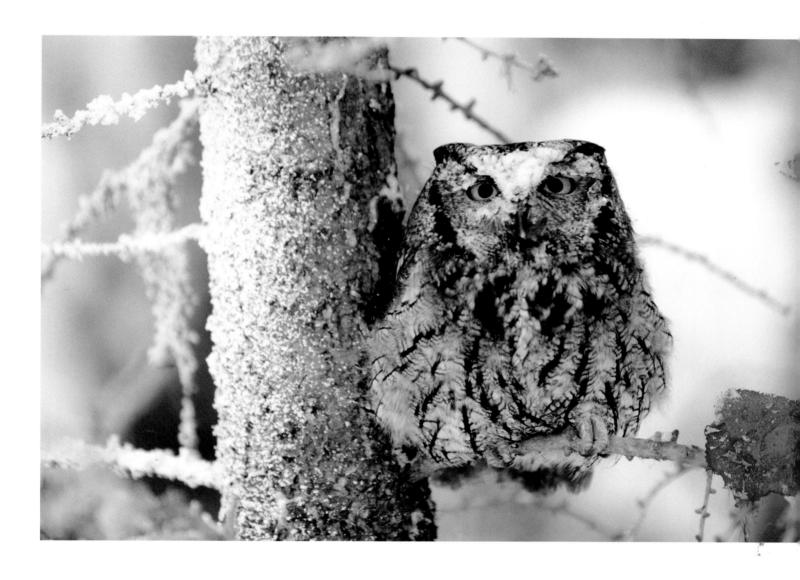

Above: A Western Screech Owl fluffs out its feathers for warmth.
Opposite: Snakes and other reptiles often fall prey to this species.

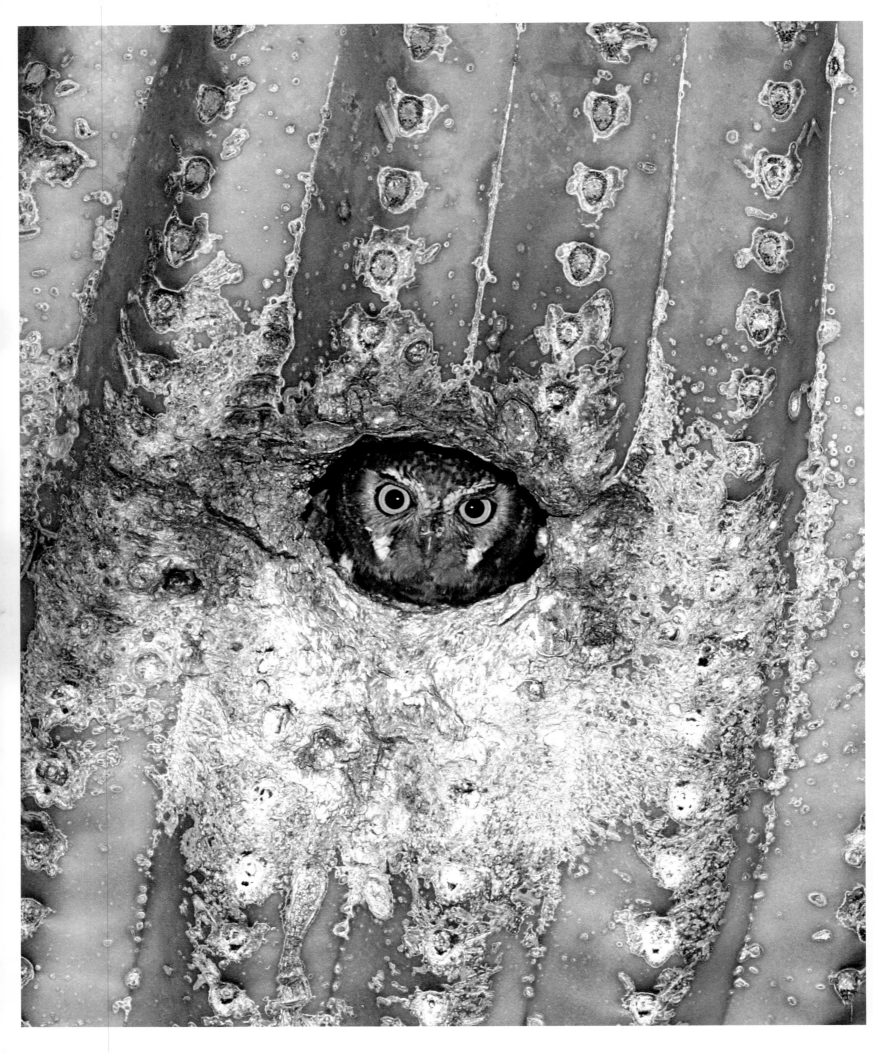

ELF OWL

MICRATHENE WHITNEYI

APPEARANCE	SIZE
Tiny, with round body and large round head with no ear tufts; faint facial disk, strong white eyebrows, and yellow eyes; upper parts brown, with pale blotches and scalloping that grades to barring on flight feathers, and strong white scapular line on shoulder; breast pale with soft, broad, rufous-brown streaks; in flight, shows short round wings.	*length 4.9–5.7 in. (12.5–14.5 cm)*
	weight 1.4 oz (40 g)
	wingspan 10.5 in. (27 cm)
	females larger than males
	DISTRIBUTION
	Southwestern United States, from Arizona, New Mexico, and southeast California south to northern and central Mexico; separate population in southern Baja California.
	STATUS
	Least Concern

THIS POCKET PREDATOR IS the world's smallest owl. No larger than a sparrow, it is lighter on average than any other owl species. However, what it lacks in size it more than makes up for in charisma. Its intense face, peering from a hole in its spiny cactus citadel, is one of the bird world's most distinctive.

This is an owl of arid terrain; it ranges across the semideserts and chaparral of the southwestern United States. This breeding population migrates south and east to winter in Mexico, where it finds a more abundant insect supply. A separate population in Baja is sedentary. In pure desert habitat, the Elf Owl is strongly associated with the saguaro cactus, a giant that towers up to 42 feet (13 m) and thrives across the uplands of northwest Mexico, where this owl is abundant. Elsewhere, it inhabits lightly wooded desert fringes and scrublands, from canyons up to mountain slopes. In winter, with no need for breeding trees or cacti, it often moves to more open ground.

The Elf Owl is nocturnal, roosting by day in holes or, on its winter quarters, among low ground vegetation. At dusk, it sets out to hunt, flying low in search of prey. The staple diet comprises large arthropods, ranging from crickets and beetles to spiders and scorpions. In flight, it appears tiny, its short round wings no wider than the span of some tropical butterflies. However, this owl is adept at capturing winged insects in the air, either sallying out from a perch flycatcher-fashion or hovering until the prey takes flight, then snatching it with deft talons. The Elf Owl lacks the sound-dampening feather adaptations of most owls, as the insects on which it subsists are not alerted by sound. Indeed, in flight it is one of the most audible of owls. It may occasionally also capture vertebrates, including small rodents, snakes, and reptiles. In general, this owl's diet reflects both location and season: in the midsummer rains, for example, the Elf Owl takes advantage of the mass emergence of beetles from their underground pupae.

Like many migratory birds, the Elf Owl seldom sustains a pair bond beyond one season. For migrants, courtship starts when the males return to their breeding grounds in late February. On moonlit nights, they deliver their squeaky chuckle of a song enthusiastically from exposed perches. Once a female arrives, the male moves into a potential nest hole to entice her closer. Soon the pair is duetting as she checks out all potential nest sites around the territory. At this stage, they spend much time preening one another and copulating.

Nest sites are invariably woodpecker holes. The female lays an average of three eggs and starts incubating from the second. Incubation lasts twenty-one to twenty-four days, after which the male provides food at a frantic rate—as often as one item per minute—while his mate broods the chicks. The young can catch their own insects immediately after they leave the nest. When nesting in saguaro cacti, this species has the highest breeding success rate (70 percent) for any North American owl, largely because the spines help to deter any would-be mammalian nest raider. It is not aggressive when defending its nest, however, preferring flight to fight. Females may even feign death if surprised inside the hole.

The Elf Owl has an estimated population of 190,000 and is classified as Least Concern. However, it is vulnerable to loss of food due to pesticide use, and also to competition for its nesting holes, especially from the introduced European starling (*Sturnus vulgaris*). It may live six years in the wild and up to ten in captivity.

Opposite: An Elf Owl peers from its nest hole in a saguaro cactus, a plant to which its fortunes are closely tied.

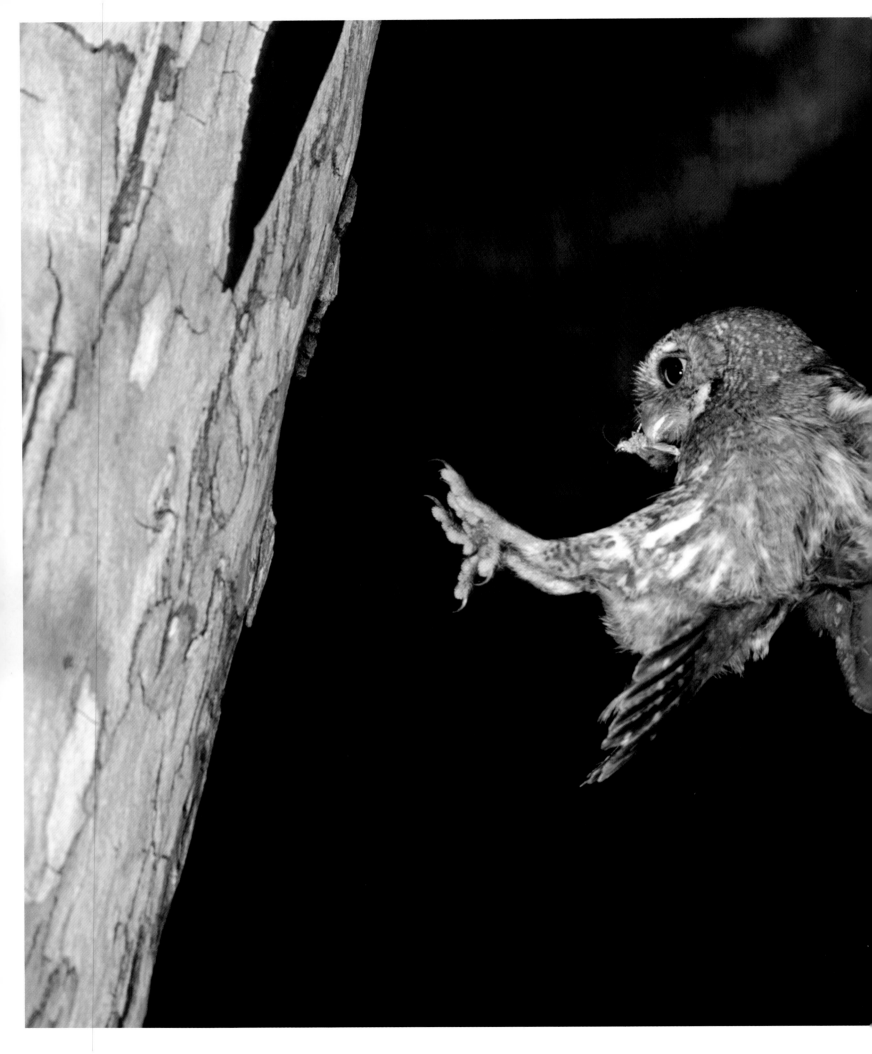

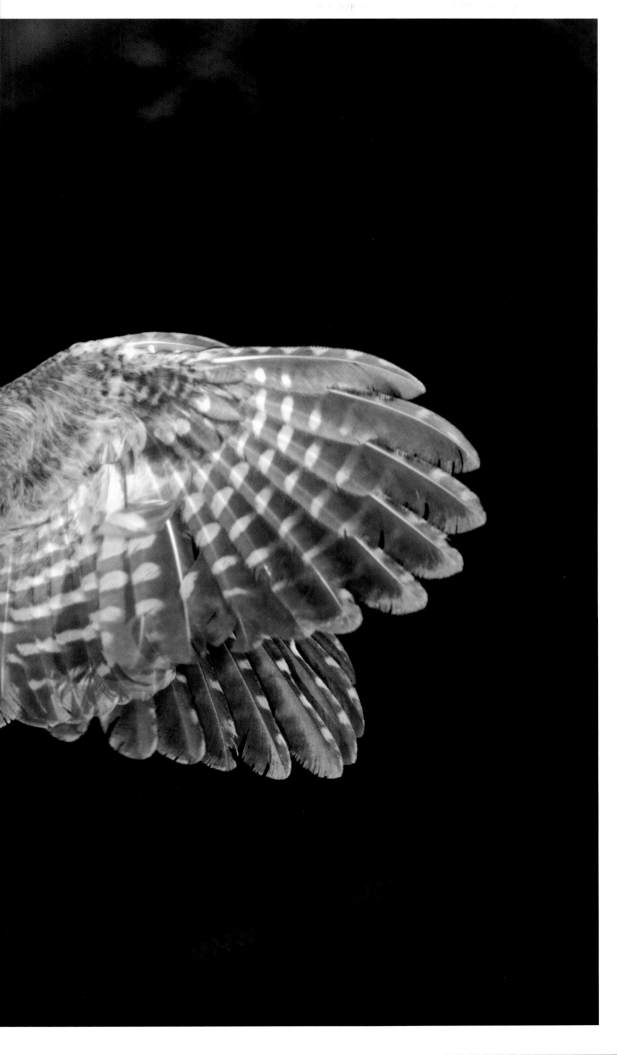

Left: An Elf Owl returns to the nest
with insect prey for its young.

NORTH AMERICA

SPOTTED OWL

STRIX OCCIDENTALIS

APPEARANCE
Robust, medium-size, with round head, no ear tufts, and relatively long tail; upper parts dark brown with pale spots; under parts graduate from brown and whitish barring on upper breast to heavy white spotting lower down; flight feathers and tail heavily barred; eyes dark brown/black in buff facial disk with dark rim.

SIZE
length 17 in. (43 cm)
weight 1.3 lb (600 g)

wingspan 45 in. (114 cm)
females larger than males

DISTRIBUTION
Pacific North America, from southwestern British Columbia south through western Washington and Oregon to southern California; also Rocky Mountains, from southern Utah and Colorado south through Arizona and northwestern Texas into central Mexico.

STATUS
Near Threatened

"My friends, it is time to consider the human factor in the Spotted Owl equation," said U.S. President George Bush, addressing lumber employees in Colville, Washington State, in 1992. And so, this threatened bird became a political football: symbolic of the struggle between loggers, who felt its conservation threatened their livelihoods, and environmentalists seeking to save the old-growth forests of the Pacific Northwest. The bird in question is, in fact, one of the more mild-mannered of its kind. Despite belonging to the same *Strix* genus as the notoriously feisty Tawny Owl (P. 120) and Ural Owl (P. 160), it is surprisingly tame and shows no appetite for defending its territory. Unfortunately, its territory is under serious threat as the forests continue to disappear.

The Spotted Owl resembles the slightly larger Barred Owl (P. 69), the two having diverged from a common ancestor some six to eight million years ago. Its plumage is a complex patterning of spots and bars, and the dark brown eyes sit in a buff facial disk with a dark rim. This owl inhabits mountains and humid coastal forest, and its intricate patterning provides camouflage against the dappling shadow in the Douglas fir forests of the northwest. Elsewhere, it frequents mature hardwood forests of oak, alder, and cottonwood. Whatever the forest type, it prefers a multilayered canopy and tends to choose steep-walled valleys, generally with water nearby.

This species roosts by day on a high branch against a tree trunk, and hunts from shortly after sunset to just before sunrise. Top of the menu are wood rats and flying squirrels, with pocket gophers, rabbits, and a variety of other small mammals also taken. It may also capture birds, sometimes in flight, as well as snakes, crickets, beetles, and moths. This owl has even been observed walking around a campsite picking up scraps. In good times, surplus prey is cached for later.

The Spotted Owl forms monogamous pairs that maintain a year-round bond. In early spring, the male advertises his territory with a mellow four-syllable hoot: "whoop, wu-hoo, hu." The female responds in kind, and the two call together in courtship. Among various other barks, grunts, and chattering calls, the female uses a piercing "coo-weep," reminiscent of a Tawny Owl, to contact her mate. Breeding depends upon prey abundance and does not happen every year. The pair generally chooses an old stick nest, typically that of a northern goshawk (*Accipiter gentilis*), but may also use mistletoe, broken treetops, and cavities in banks and rock faces. On average, the female lays a clutch of two to three eggs, and the chicks hatch at twenty-eight to thirty-two days.

In the wild, the Spotted Owl may live seventeen years. Juveniles suffer high mortality (up to 90 percent in some regions) and must dodge forest predators such as the Great Horned Owl (P. 48) and red-tailed hawk (*Buteo jamaicensis*). The species' greatest threat, however, comes from the loss of its habitat, and the attempt to save these forests has made the Spotted Owl a conservation icon. Furthermore, modern logging practices often benefit the larger and more aggressive Barred Owl, against which the Spotted Owl cannot compete. With a total population estimated at 15,000 birds, the species is classed as Near Threatened. It is declining across most of its range, with the Canadian population reduced to fewer than one hundred breeding pairs. "Shoot an owl, save a logger," was once a popular bumper sticker. Unless this heavy decline is reversed, there may soon be no owls left to shoot.

Opposite: Old-growth forests, festooned with mosses and lichens, are prime habitat for this threatened species.

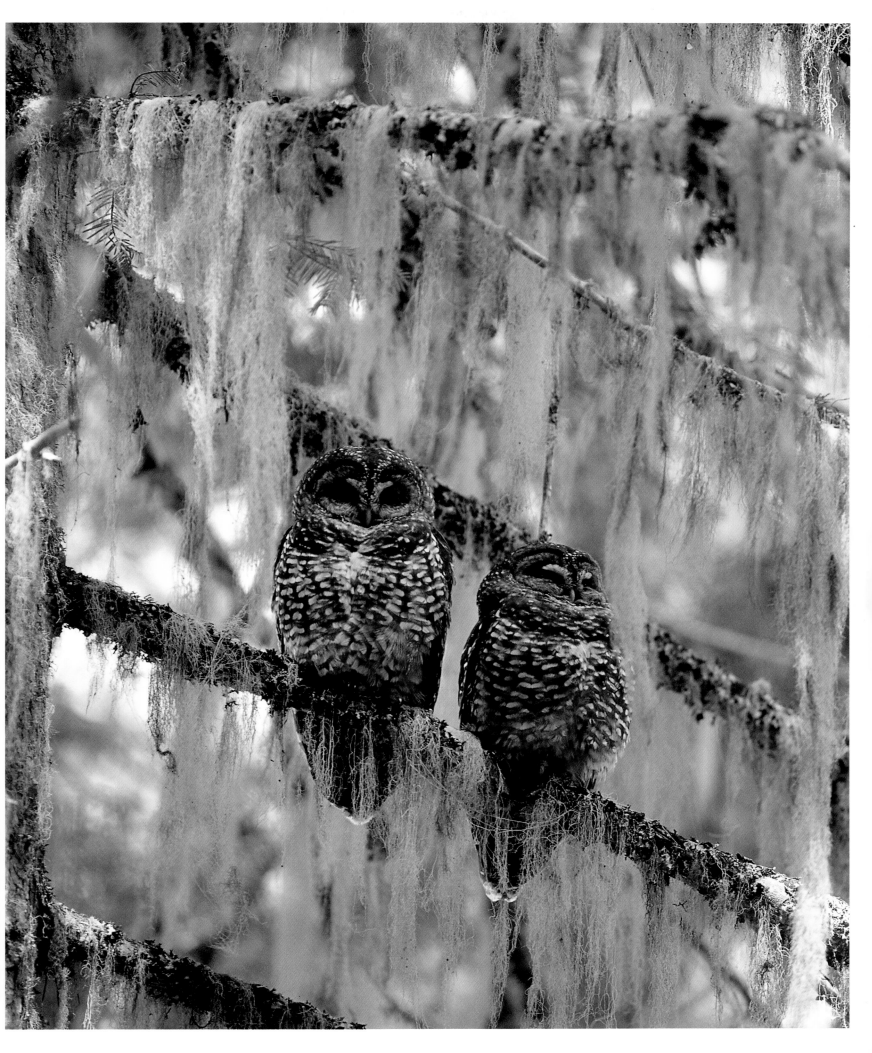

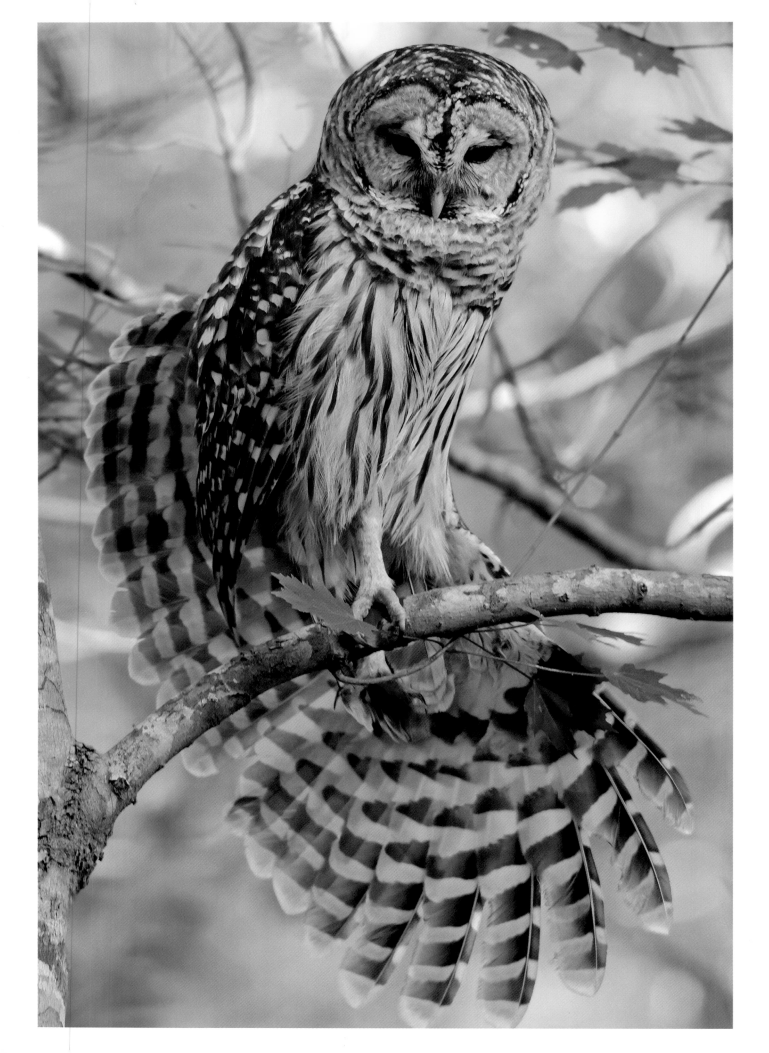

BARRED OWL

STRIX VARIA

APPEARANCE
Medium-large owl with wide, rounded head, dark eyes, yellow bill, and no ear tufts; pale gray-brown facial disk indented at top and bottom; plumage largely grayish-brown; upper parts barred with white and spotted on wing coverts; pale under parts densely barred on upper breast and more finely streaked below; flight feathers heavily barred.

SIZE
*length 19–22 in. (48–56 cm)
weight 1.1–2.3 lb (500–1,050 g)*

*wingspan 42–44 in. (107–111 cm)
females larger than males.*

DISTRIBUTION
Eastern North America, from southern Canada to Florida and south to southern Mexico; range expanding in northwestern United States; northerly populations make irregular southward migrations.

STATUS
Least Concern

IT IS NOT OFTEN THAT THE GOOD FORTUNES of one owl species spell misfortune for another. However, the advance of the Barred Owl in the northwestern United States—following a trail blazed by the loggers—is giving conservationists a headache, because it may be at the expense of the much rarer Spotted Owl (P. 66). The two species belong to the *Strix* genus, but the Barred Owl is larger and more aggressive. In the past, the Spotted Owl was secure in the large, untouched tracts of forest in the northwest, while the Barred Owl flourished further east. However, the logging and fragmentation of these northwestern forests have produced a forest structure better suited to the Barred Owl. The more common species has been quick to accept the invitation, ousting its cousin in the process.

Four subspecies of the Barred Owl are recognized, of which the nominate race, *S. v. varia,* is the largest and most northerly, occurring from southeast Alaska to North Carolina. This bird frequents moist, dark, mature forests, typically in wooded swamps or woodland fringing lakes. It thrives in large parks with old trees and will take to old-growth forest where this has been opened up by logging. It is a nocturnal species that hides away by day in dense foliage, usually close to a tree trunk. Here, it can escape the attentions of the irate songbirds that are often drawn to mob it. After dark, however, this owl

need fear no such persecution. Like most *Strix* species, it is largely a sit-and-wait hunter, watching and listening from its high perch, then swooping down to grab the prize. Prey comprises small rodents, notably meadow voles (*Microtus pennsylvanicus*), but it may take larger mammals, including possums and weasels. It hunts birds, such as jays and pigeons, by ambushing them in flight as they settle at their roost, while smaller owls, including the Eastern Screech Owl (*Megascops asio*) and Long-eared Owl (P. 146), also sometimes fall victim. Among other interesting observations, this species has been seen wading in shallows to capture fish, plucking baby alligators from swamps, and visiting campfires to capture large insects drawn to the light. At peak nesting, it may also hunt by day.

The Barred Owl is easily identified by its territorial call: a resonant "hoo, hoo, too-HOO; hoo hoo too-HOO, ooo" phrase. A male tends to repeat this call in bursts of eight and then fall silent, waiting for a female's reply. Once the two meet, the male pursues the female, giving a variety of calls and displays, swaying on a branch and sidling up to her with wings raised. This is a very vocal species, and the pair communicates throughout courtship with hoots, yelps, barks, and monkey-like shrieks, cementing their bond with feeding and mutual preening. Unpaired birds may call in fall, but an established pair does not get going until late winter. The pair usually selects an old stick nest from a hawk, crow, or squirrel but may also choose a natural cavity. The female lays two to four eggs and incubates them for twenty-eight to thirty-three days while the male provides food. The parents care for their chicks for four months, longer than most owls.

In captivity, the Barred Owl has been known to live thirty-two years. With an estimated population of 600,000, it is classed as Least Concern. Indeed, its recent range expansion in the northwest is a worry for conservationists, who fear the impact on the Western Screech Owl (P. 57) and rare Spotted Owl. In a contentious initiative of the U.S. Forest Service, considerable numbers of Barred Owls have already been culled.

Opposite: A Barred Owl stretches one wing to reveal the markings for which it is named.

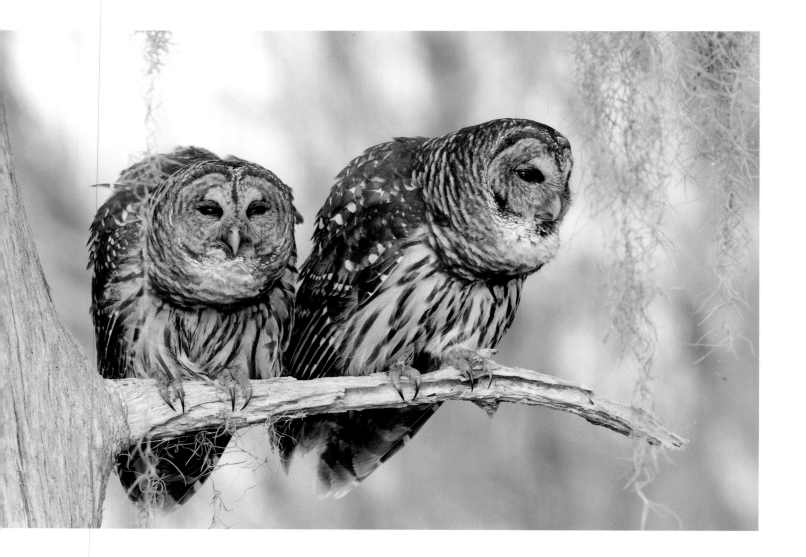

Above: A pair of Barred Owls inflate their throats as they call in duet.
Opposite: Prey for this species ranges from small rodents, as here, to mammals as large as opossums.

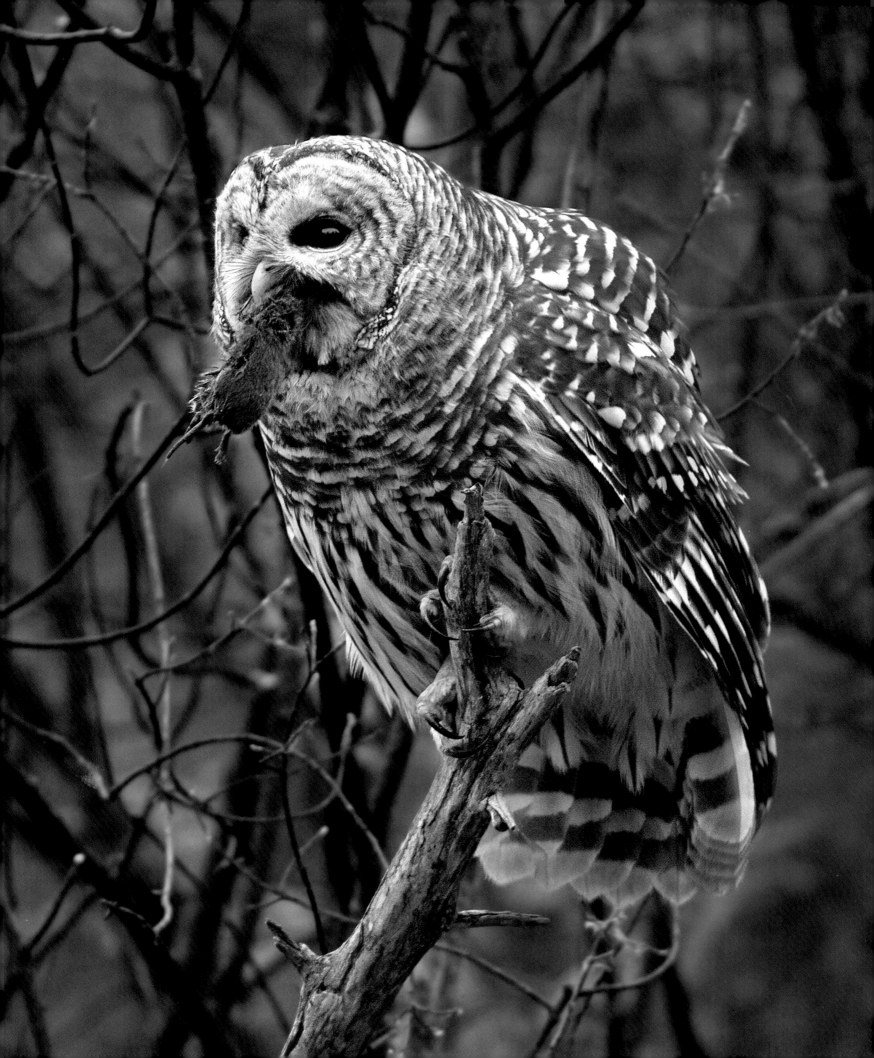

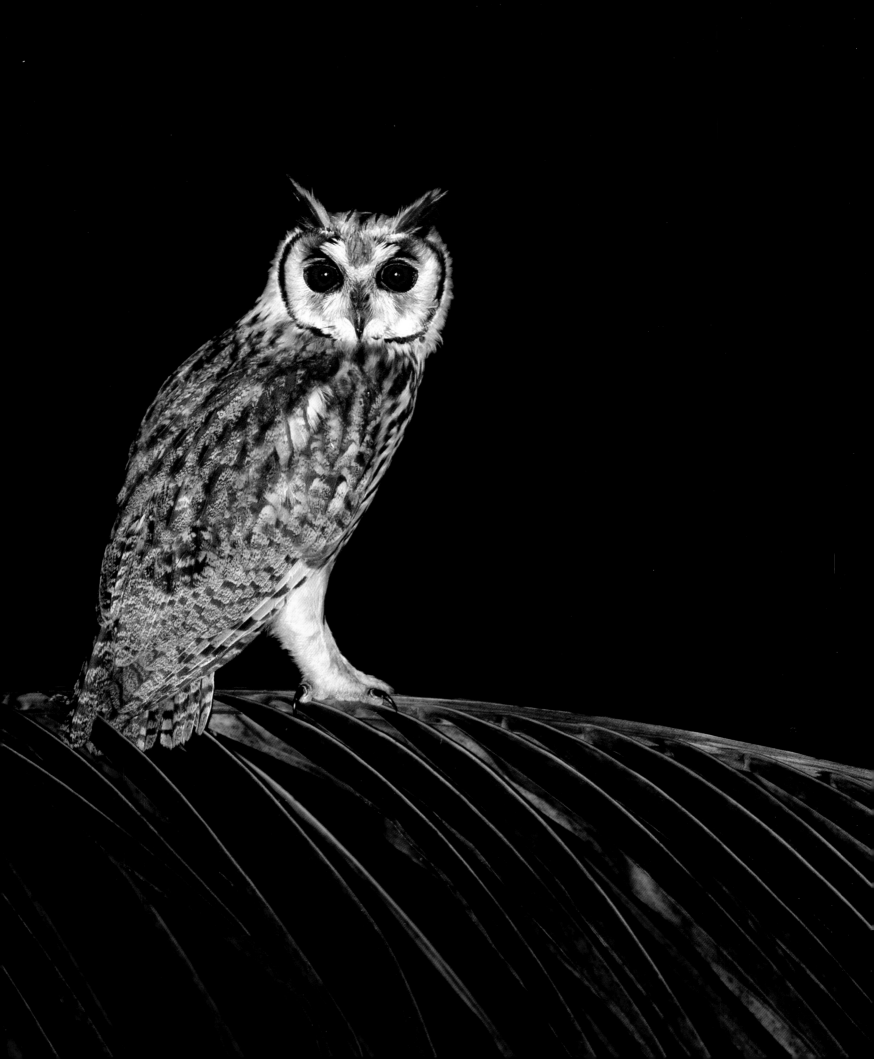

02 | CENTRAL & SOUTH AMERICA

For the ornithologist, the neotropics—that is to say, the combined continents of South and Central America—offer riches beyond those of any other continent. Although South America may be only two-thirds the size of North America, covering an area of some 6.9 million square miles (17.8 million sq km), it is home to around three times as many bird species: more than 3,200 in total. Indeed, the world's three most bird-rich countries, in terms of number of species, are Colombia, Peru, and Brazil, in that order.

This general avian profusion is hardly surprising, given that much of the region is carpeted with tropical rain forest, the world's most biodiverse habitat. It centers upon the Amazon Basin, the world's largest forest, but also extends north into Central America and down the Atlantic west coast of Brazil. Within this world of green, owls play their part in the grand avian assemblage, with some fifty-five species recorded in South America and twenty-nine (including some that overlap the two) in Central America.

Many neotropical owls are relatively little known, however, compared with their relatives in the northern hemisphere. This is precisely because they occur largely in dense, remote tropical forest that does not give up its secrets easily. It is, perhaps, for the same reason that they have not generally attracted the equivalent wealth of literature, folklore, and imagery as have owls in some other parts of the world.

The prolific biodiversity supported by tropical rain forest reflects the year-round supply of rain, warmth, and sunlight, which in turn fuels ceaseless plant growth, thus creating an inexhaustible food supply and a huge variety of ecological niches. From the stratified layers of a tree canopy to the aquatic carpet of a flooded swamp forest, the forest teems with invertebrates, reptiles, birds, and small mammals, all of which offer rich pickings for a variety of owls. This constancy of weather and food supply means that, like most other rain forest birds, the owls have no need to migrate or wander far in search of prey. In addition, the cat's cradle of the canopy, with its creepers, epiphytes, and rotten wood—riddled with the excavations of woodpeckers and other arboreal animals—leaves them spoilt for choice when it comes to places in which to roost and nest.

Typical rain forest owls include such charismatic species as the Spectacled Owl (P. 76), with its unmistakable facial markings, and the Crested Owl (P. 95), with its bizarre headgear. Others include a wide variety of pygmy owls, such as the Ferruginous Pygmy Owl (P. 85), which take up prominent perches in forest clearings and edges, often by day, and hunt with great agility for birds and other small vertebrates. Members of the wood owl (*Strix*) genus are also well represented, with species such as the Black-banded Owl (P. 93), which often finds a home in banana plantations and other cultivated areas in the forest, and the Mottled Owl (P. 82), which calls with a characteristic frog-like hooting.

The calls of rain forest owls, although many and various, are generally heard against a rich background chorus of insects, amphibians, and other nocturnal songsters. This may partly explain why these calls have acquired a little less cultural prominence than those of species in northern climes, where the voice of an owl in a forest after dark—especially during winter—often has the added impact of being the only voice.

Opposite: A Striped Owl perches on a palm frond, revealing the prominent ear tufts typical of the *Asio* genus.

South America has many other landscapes beside forest. Running down the western flank of the continent, spanning some 4,300 miles (7,000 km) from top to bottom, are the Andes. This enormous mountain chain, the world's longest, offers its own rich mosaic of habitats, from misty cloud forest to snow-capped peaks and high tundra-like *páramo*. Owl species that inhabit these higher elevations include the Andean Pygmy Owl (*Glaucidium jardinii*), the Buff-fronted Owl (*Aegolius harrisii*), and the endangered Long-whiskered Owlet (*Xenoglaux loweryi*), the last of which is a tiny species that hunts among the mosses, orchids, and epiphytes of the Peruvian cloud forest.

South America also harbors large areas of grassland, graduating from the tropical Cerrado savanna of Brazil to the more arid plains further south. These open habitats are well suited to owls of the *Asio* genus, which breed largely on the ground and hunt by quartering the grass on long wings for small prey below. Tropical grasslands are home to the handsome Striped Owl (P. 80), which resembles the Long-eared Owl (P. 146) of the northern hemisphere. Further south, the Short-eared Owl (P. 141), one of the world's most widely distributed species, makes its home alongside the rheas and guanacos of the pampas. This bird, perhaps greatest wanderer in the owl family, has even colonized the Galápagos Islands, some 620 miles (1,000 km) off the coast of Ecuador, where a number of scientists now believe it has evolved into a new species, the Galápagos Short-eared Owl (*Asio galapagoensis*).

Some owls even find a home at the tip of the continent in the cold wastes of Tierra del Fuego. These hardy species include the Rufous-legged Owl (*Strix rufipes*), which occasionally makes its way across to the Falkland Islands from Argentina, and the Magellanic Horned Owl (*Bubo magellanicus*), a southern relative of the very similar Great Horned Owl (P. 48), found across much of the Americas. The latter is a generalist, making itself at home in a variety of habitats, from pampas to farmland and the coastal dunes of Patagonia.

Sadly, the birds of the world's most bird-rich continent are far from secure. Vast swathes of tropical forest have been lost to logging, mining, and slash-and-burn agriculture, and today more than 300 species face extinction. Owls are no exception, and those species that continue to do well tend to be the ones that have adapted to cultivation and human settlement.

Above: A family of Tropical Screech Owls regard the photographer with collective curiosity.

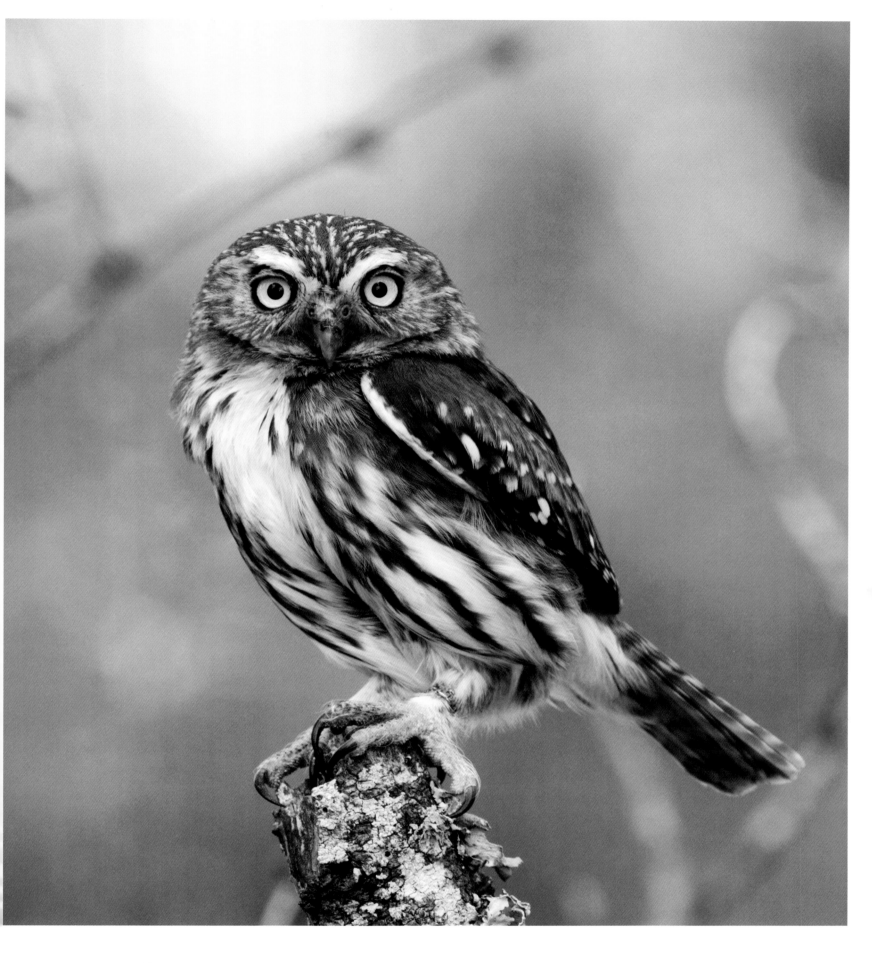

Above: The impressive talons of the Ferruginous Pygmy Owl
provide more power than its diminutive size might suggest.

SPECTACLED OWL

PULSATRIX PERSPICILLATA

APPEARANCE
Medium-large, with rounded head and no ear tufts; upper parts plain chocolate-brown to black; under parts pale yellowish to fawn, with broad brown breast band; black head with white throat band; black facial disk boldly marked with white eyebrows and lores that create spectacles effect around bright yellow eyes.

SIZE
length 16–20.6 in. (41–52.3 cm)
weight 1–2.76 lb (460–1,075 g)
wingspan 49–59 in. (125–150 cm)

DISTRIBUTION
From southern Mexico south through Central America and across the northern two-thirds of South America, south to northern Argentina.

STATUS
Least Concern

THE SCIENTIFIC SPECIES NAME OF THIS BIRD—*perspicillata*—translates as "sharp-sighted," which rather suggests that it has no need to wear spectacles. Nonetheless, there is no denying that the bold white markings around its large yellow eyes recall a pair of glasses perched on its sharply hooked bill.

The Spectacled Owl is the largest truly tropical owl of the Americas, and one of the most recognizable owls anywhere. It does not have the cryptic camouflage patterning common to most of the owls described in this book: the upper parts are a plain chocolate-brown to black, while the under parts, below the dark brown breast band, are pale yellowish to fawn. However, it is the bird's face that grabs the attention: bold white eyebrows and lores almost completely encircle the bright yellow eyes, as though the bird has pressed a pair of binoculars to its face with the eye-pieces covered in chalk. A broad white band runs across the throat and beneath the bill like a chinstrap: against the otherwise sooty black face and head, the effect is very striking.

The *Pulsatrix* genus is part of the Strigidae family of typical owls. It comprises four species, all confined to the neotropics and all with similar bold facial markings. The Spectacled Owl is the best known and most widespread. It ranges from southern Mexico, through Central America and across the northern two-thirds of South America, as far south as northern Argentina. Five subspecies are listed, of which

the Trinidad and Tobago race *P. p. trinitatis* is now thought to be extinct. A sixth race, native to a small area of southeastern Brazil, Uruguay, and Argentina, has been formally recognized through DNA analysis as a separate species: the Short-browed Owl (*P. pulsatrix*). Unfortunately, it is increasingly threatened by habitat destruction.

Throughout its range, the Spectacled Owl inhabits mature tropical and subtropical forests, typically lowland rain forest but also tropical dry forest, and generally near water. It is also found in areas of secondary growth and in plantations, groves, forest edges, and wooded savanna. Primarily a lowland bird, although sometimes ranging up to 5,570 feet (1,700 m), it is replaced at higher elevations in the Andes by the closely related Band-bellied Owl (*P. melanota*).

This owl is generally the largest and most dominant owl wherever it occurs. The larger Great Horned Owl (P. 48) seldom ventures into dense tropical forest, and in one playback study the Spectacled Owl showed no alarm response to the calls of other owls that share its range. It is a nocturnal species that does not usually become active until dusk. By day, it roosts in trees with dense foliage, avoiding the attention of jays and other songbirds that will whip up a frenzy of mobbing should they chance across it. Once darkness falls, it sets out on the nightly search for prey.

For the Spectacled Owl, hunting is largely a matter of sitting and waiting, then swooping down onto any prey that reveals itself below. Small mammals make up much of the diet, with different species preferred according to availability: one study in Oaxaca, Mexico, for example, revealed that local Spectacled Owls concentrated on the Peters's climbing rat (*Tylomys nudicaudus*) and a variety of mouse possums. However, the bird's powerful talons are quite capable of tackling larger mammalian prey, such as possums, skunks, agoutis, tamarins, and even, in one record, a 7.7-pound (3.5 kg) female three-toed sloth. Birds such as jays, motmots, and oropendolas may be snatched from their

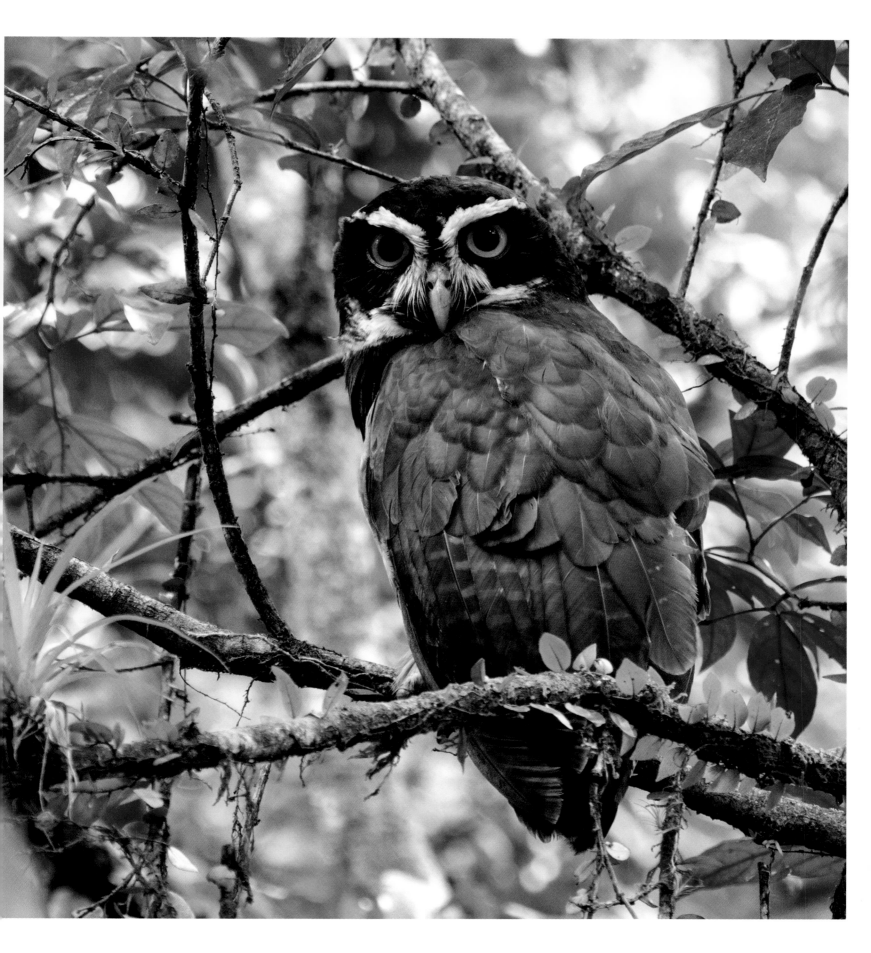

Above: Typical habitat for the Spectacled Owl is the
tangled mid-story of lowland tropical rain forest.

evening roost, while smaller fare, including frogs, caterpillars, spiders, crabs, and snails, can be swiftly plucked from the foliage or forest floor.

The Spectacled Owl forms long-term, monogamous pair bonds. Breeding takes place either during the dry season (November to May in Costa Rica, for example) or at the start of the wet season (June to July). As territorial and courtship activity intensifies, the forest resounds to the distinctive song of the male. His sequence of short dry hoots, which accelerate as they fade away, has more of the timbre and rhythm of a woodpecker's tapping than an owl's hoot; indeed, this species is known in Brazil as the "knocking owl." Each burst lasts some seven to nine seconds and resembles the sound of a hammer hitting a hollow tree. The song is usually given from the top third of a tall tree and is loudest on calm moonlit nights. The female will join in, and the pair perform duets. She also gives voice to a piercing hawk-like scream, of two syllables, which has been likened to a steam whistle.

Generally, the nest is in a natural hollow or the crutch of a large branch. The female lays one to two eggs, which she incubates for about five weeks. At around five to six weeks, the chicks leave the nest and clamber around the surrounding branches. They are covered in white down and have a very distinctive, dark, heart-shaped face. The parents continue to feed them once they have fledged, and the chicks will sometimes remain dependent on their parents for up to a year, which inhibits the ability of the adults to breed in the following year. Often only one chick survives, the weaker of the two succumbing to starvation or to the aggression of its sibling.

The Spectacled Owl is a popular species in zoos around the world, and it has been known to live for up to twenty-five years in captivity. There are no available figures for its global population, but its large range in the wild, estimated at some 4.9 million square miles (12.7 million sq km), means that its conservation status is classed as Least Concern. This is a versatile bird, and in certain regions—notably Costa Rica, Colombia, and the Brazilian Amazon—it can be locally common. However, it is vulnerable to habitat loss through deforestation, and there is already evidence that the cutting of new roads through previously virgin habitat is leading to more Spectacled Owls being killed by traffic. Based on a model of projected deforestation in the Amazon, BirdLife International has calculated that the Spectacled Owl stands to lose 17.5 to 20.3 percent of suitable habitat within its range over three generations (seventeen years), and therefore is likely to decline by at least 25 percent during this time. The loss of the Trinidad race has already shown that there is no room for complacency.

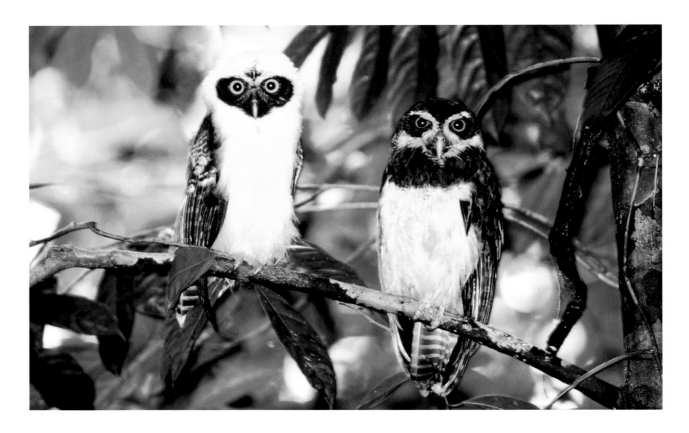

Above: The dark face and white plumage of a fledgling Spectacled Owl (left) are quite distinct from those of its parents.

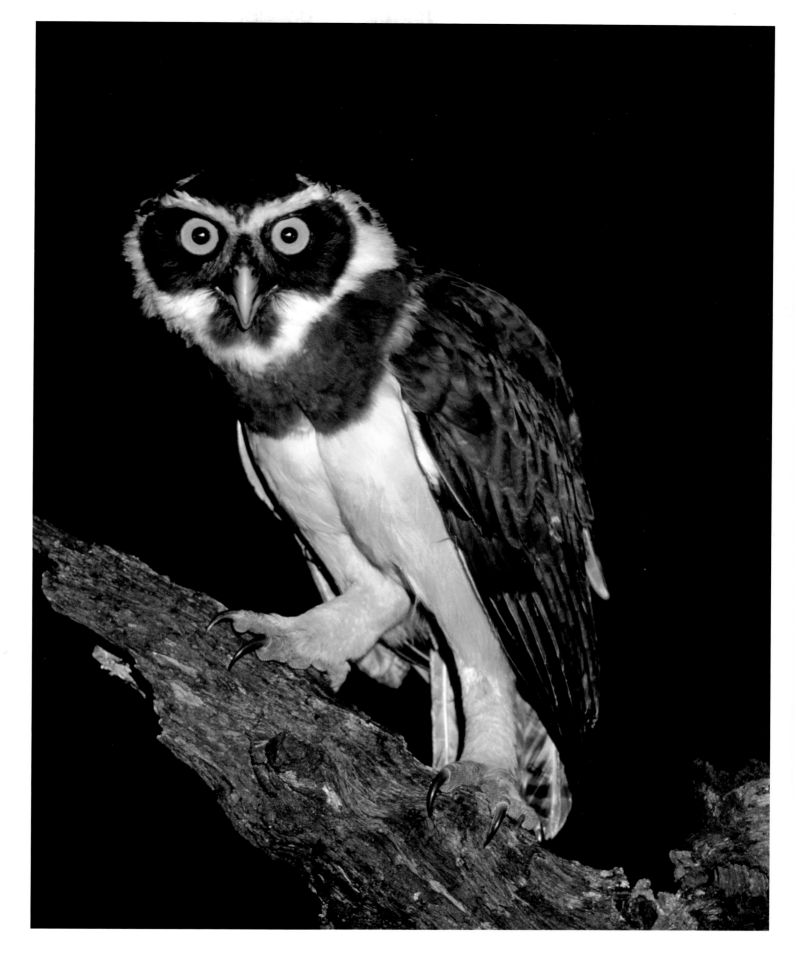

Above: With its powerful legs, a Spectacled Owl
can capture prey as large as a sloth.

STRIPED OWL

ASIO CLAMATOR

APPEARANCE
Medium-size, with slim build and long dark ear tufts; upper parts tawny-buff with dusky mottles, bars, and streaks; under parts pale with clear dark streaks; white throat and white scapular line; pale facial disk ringed with blackish ruff; brown eyes surmounted by strong white eyebrows; in flight, shows long wings, with dark carpal patch on pale underside.

SIZE
length 12–15 in. (30–38 cm)
weight 11.3–19.3 oz (320–546 g)

DISTRIBUTION
Central and South America, from southern Mexico to northern Argentina; absent from central Amazon Basin.

STATUS
Least Concern

THIS HANDSOME OWL is similar in size and general appearance to the Long-eared Owl (P. 146) of the northern hemisphere. They both sport impressively long ear tufts and share similarities of lifestyle. Taxonomists once placed the Striped Owl with the Jamaican Owl (P. 262) in the genus *Pseudoscops*. However, DNA research has led to the conclusion that it belongs—with its northern hemisphere cousin and six other species—to the *Asio* genus of "eared owls."

A close look reveals an owl that appears slightly more clean-cut in its markings than the Long-eared Owl, with more contrast and a little less of the cryptic complexity. The only regional species with which it might be confused is the closely related Stygian Owl (*A. stygius*), but this species is much darker. The Striped Owl occurs in a total of twenty-one countries. Four subspecies are listed, of which the nominate race, *A. a. clamator,* occurs from Colombia to central Brazil. Typical habitat comprises open or semi-open savanna and grasslands. It also frequents humid forest edges, riparian woodland, and marshes, and thrives on human-modified landscapes that offer suitable hunting conditions—from rice fields to airfields.

This owl is a largely nocturnal species that roosts by day in dense foliage, trusting to its camouflage to avoid detection. Favorite roosts are in small trees and shrubs, but it may also use thick tangles of ground vegetation. Like other *Asio* species, the Striped Owl may roost communally outside the breeding season, forming small groups of up to twelve. At dusk, it sets out in search of prey, quartering low over open ground and forest edges with long glides and rapid shallow wingbeats, before dropping onto prey below. Prey comprises mostly small mammals, but this owl may also target birds and will take small reptiles and large invertebrates where available. Its long claws and powerful talons indicate its adaptation to taking large prey, and this species has even been known to capture a white-eared opossum (*Didelphis albiventris*), which weighs almost as much as itself.

The Striped Owl is resident in its territory all year around. An increase in vocal activity gets the breeding season under way, the male calling with a series of well-spaced nasal hoots a little higher in pitch than those of the Long-eared Owl. There is often a burst of calling an hour before dawn. Females respond with a similar call at a higher pitch, and both sexes utter various other calls, including a high hawk-like whistle: "whee-yooo." The male may also cement his bond with the female in a wing-clapping display flight, and by presenting her with prey in ritualized courtship feeding. Like the Short-eared Owl (P. 141), this species makes a rudimentary nest on the ground, usually among long grass and dense bushes. The female lays two to four eggs, which she incubates for thirty to thirty-three days, starting with the second egg. The male provides food, first passing it to the female, who tears it up for her progeny, then later simply dropping it into the nest. By around thirty-five days, the youngsters are making their first feeble flights, and at forty-three days they can fly strongly.

In captivity, this bird may live for more than ten years. In the wild, its threats include insecticides, traffic, and predators, including larger owls and raptors. With a stable population and total range calculated as some 2.76 million square miles (7.16 million sq km), however, this owl is not a species of conservation concern. Indeed, it may benefit to some extent from the deforestation that threatens so many other species, as this opens up more of its favored savanna habitat.

Opposite: **The bold facial markings and ear tufts of a Striped Owl are typical of the *Asio* genus of eared owls.**

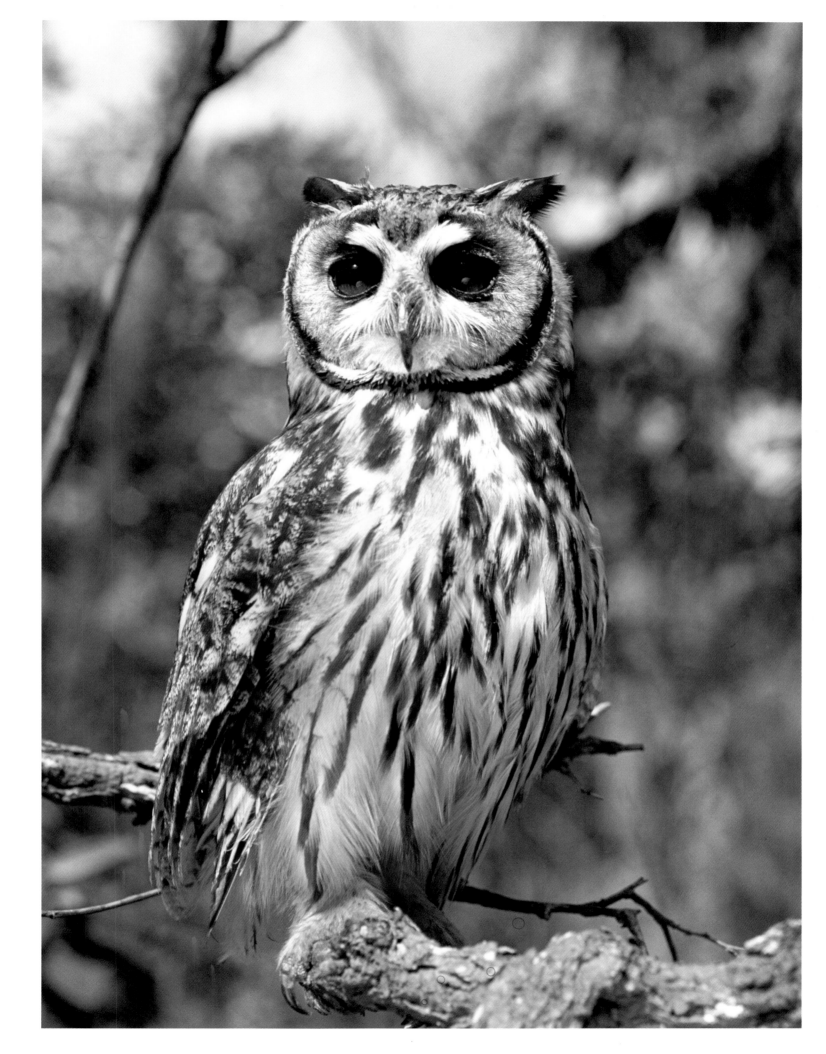

MOTTLED OWL

STRIX VIRGATA

APPEARANCE
Medium-size, with rounded head and no ear tufts; dark brown eyes and blue-gray bill; pale morph has brown facial disk, with white eyebrows and whiskers; dark brown above, with pale flecks and bars and a pale scapular line; whitish below, with brown streaks and dusky mottling on either side of breast; dark morph has similar markings in deeper tones, with darker yellow under parts and fainter eyebrows.

SIZE
length 12–15 in. (30–38 cm)
weight 8.2–10.8 oz (235–307 g)

DISTRIBUTION
Eastern Panama south across northern half of South America, from Venezuela in the north to northeast Argentina and southeast Brazil in the south; does not occur on the Pacific slope of the Andes south of Ecuador.

STATUS
Least Concern

A FROG-LIKE CROAKING in the South American rain forest is not always a frog. The series of short, guttural "gwho, gwho, gwho" hoots may sound to the untrained ear like the voice of an amphibian. However, a decent view of the singer, perched high on a forest branch, confirms it to be a bird. And this is only the start of its vocal repertoire.

The Mottled Owl is a medium-size species, but it has among the most pronounced sexual size dimorphism recorded of any owl, with the female being 25 to 30 percent heavier than the male. It belongs to the *Strix* genus of wood owls, along with the Tawny Owl (P. 120) and Barred Owl (P. 69) from the northern hemisphere. Originally classified within the *Ciccaba* genus, the Mottled Owl was transferred to *Strix* in 1999. In recent times, taxonomists have also split it from the similar but paler Mexican Wood Owl (*Strix squamulata*), which replaces it through much of Central America and Mexico. Four subspecies are listed, of which the nominate, *S. v. virgata*, is the northernmost, occurring in eastern Panama, Colombia, Ecuador, Venezuela, and Trinidad.

Certainly, this species is not unlike the Tawny Owl in its build and coloration. The plumage comes in both light and dark morphs, both of which have dark brown eyes and a blue-gray bill. The Mottled Owl is typically a bird of humid lowland forest, both primary and secondary. It also occurs in drier woodlands, thorny forest, and plantations, and is often at home close to villages and human habitation. Like all wood owls, this species is largely nocturnal and becomes active from dusk. By day, it roosts in dense foliage, often concealing itself among thickets or tangles of creepers around a trunk to avoid the unwelcome attention of any small birds that might give it a hard time. After dark, it moves silently through the canopy in search of prey. It is typically a sit-and-wait opportunist, swooping down from a perch onto small creatures among the branches or on the forest floor below. Prey comprises mostly mice and other small mammals, but it will also take reptiles, amphibians, small birds, and large arthropods. It may also hawk bats and winged insects in flight; around villages it is attracted to light in search of the insects drawn there.

Seldom wandering far from its breeding territory, the Mottled Owl is a sedentary species. Its frog-like call is best heard during the breeding season, when the male reestablishes his territory and his bonds with the female. She replies with a higher-pitched version of his song, whereupon the pair may duet in softer hoots. The female also utters a high "wheearrrh" whinny as a contact call, among harsher barking noises.

The breeding behavior of the Mottled Owl is relatively unknown. A pair generally chooses a nest site either in a natural tree hole or at the top of a broken palm, but may sometimes reappropriate the stick nest of another bird. The female lays an average clutch of two eggs, the season varying with geography: from February to April in Costa Rica, for example, and from September to November in northeast Argentina. As with most owls, the female incubates her clutch while the male brings the food.

The conservation status of the Mottled Owl is Least Concern. It has an estimated population of 500,000 to five million. However, little is known about this bird and, like many tropical forest species in South America, it may be vulnerable to habitat loss through deforestation.

Opposite: The Mottled Owl, like all wood owls, is a largely nocturnal hunter.

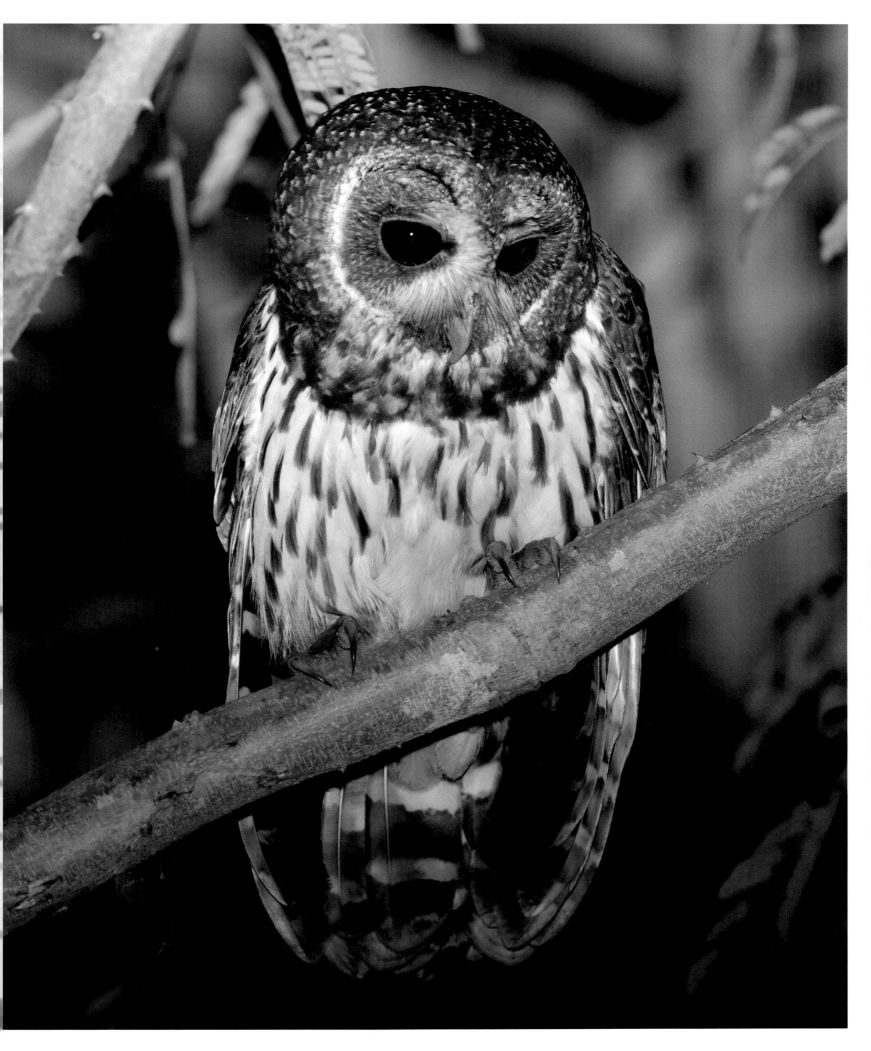

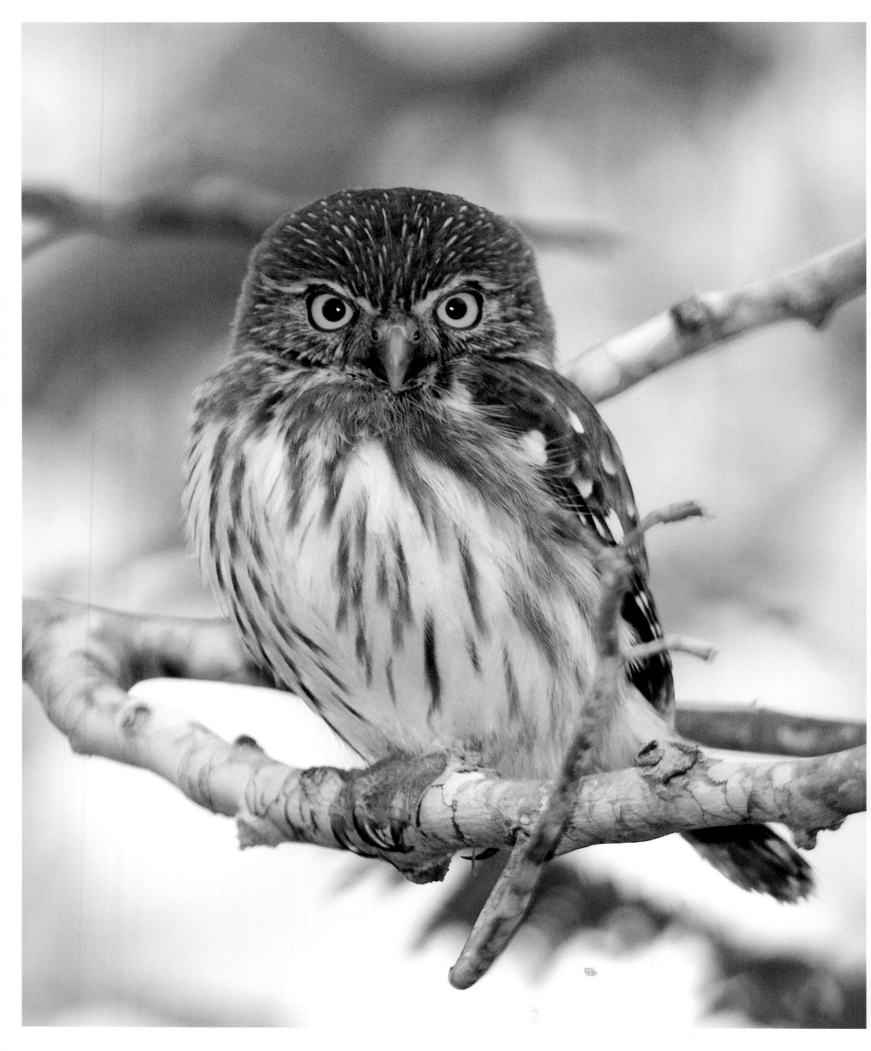

FERRUGINOUS PYGMY OWL

GLAUCIDIUM BRASILIANUM

APPEARANCE
Large round head and no ear tufts; red, gray, and brown morphs; upper parts (brown morph) earth-brown, irregularly spotted with white; upper tail coverts rufous; flight and tail feathers barred brown; under parts off-white with brown streaks and flanks densely mottled in brown; facial disk ocher-brown, with yellow eyes and strong white eyebrows.

SIZE
length 6.5–7 in. (16.5–18 cm)
weight 2.2–2.7 oz (62–76 g)
wingspan 14.5–16 in. (37–41 cm)

DISTRIBUTION
Northern half of South America, from Venezuela and Colombia to eastern Bolivia, Paraguay, eastern Brazil, Uruguay, and Argentina.

STATUS
Least Concern

AN ANTHROPOMORPHIC TAKE ON OWLS would characterize the pygmy owls of the genus *Glaucidium* as "feisty." And this diminutive species, just like the Eurasian Pygmy Owl (P. 134), more than deserves the description. Smaller than a starling, its piercing expression, bold behavior, and predatory prowess humble many much larger predators by comparison.

The Ferruginous Pygmy Owl is the best known among at least twenty very similar pygmy owl species found across the neotropics. The name "ferruginous" refers to the rufous tone that suffuses the bird's plumage, although this species comes in three different color morphs—red, gray, and brown—of which brown is the most widespread. A brown-morph Ferruginous Pygmy Owl has warm earth-brown upper parts, irregularly flecked and spotted with white on the crown, back, and mantle. The upper tail coverts are rufous, and the flight and tail feathers are barred with darker brown. Off-white under parts are marked with long, strong, brown streaks, and flanks are densely mottled in brown. The facial disk is ocher-brown and indistinctly defined, whereas the bright yellow eyes give a penetrating gaze from beneath strong white eyebrows. This challenging gaze comes from more than one face. When the owl turns its head, it reveals a second "occipital" face on the nape of its neck. This feature comprises black and white markings that are positioned to resemble two false eyes. It is a feature common to many owls in the *Glaucidium* genus, and functions in the same way as the eye markings on the wings of several species of moth and butterfly, which convince any predator creeping up from behind that it has been spotted.

This owl was once thought to range as far north as Arizona. However, recent research has reclassified the subspecies found in the southern United States as Ridgeway's Pygmy Owl (*G. ridgwayi*), on the basis of voice and DNA studies. Other similar species with which this owl could be confused within its South American range include Sick's Pygmy Owl (*G. sicki*), Pernambuco Pygmy Owl *G. mooreorum*), and Amazonian Pygmy Owl (*G. hardyi*), each of which is very similar in size and markings but has slightly different habitat preferences and its own distinct song. Research into the complex taxonomy of this group is ongoing.

The Ferruginous Pygmy Owl is much the most widespread of the group. It ranges across the northern half of South America east of the Andes, from Venezuela and Colombia across the Amazon Basin to eastern Bolivia, Paraguay, eastern Brazil, Uruguay, and northeastern and central Argentina—as far south as Buenos Aires province. Across this range, it prefers lowland evergreen or semi-deciduous forest, both primary and secondary, and with abundant suitable clearings. It is also found along forest edges, in riverine forest, across pasture land with groups of trees, and in large parks and gardens. It seldom ventures higher than 4,900 feet (1,500 m). Seven races are listed across this range, with the nominate race occurring from northeast Brazil to northern Uruguay.

Partially diurnal and conveniently drawing attention to its presence by calling at all times of the day, this bird is one of the world's easier owls to observe. It is most active at dusk and dawn, and may spend much of the day roosting in thick foliage to avoid the attention of smaller birds. However, it always seems to be alert, and often takes up a high, conspicuous perch in broad daylight from which to deliver its territorial song. When excited or alarmed, the Ferruginous Pygmy Owl cocks

Opposite: The Ferruginous Pygmy Owl, like other pygmy owls, is often active by day.

its tail and flicks it from side to side. If driven to move—perhaps tormented by a mobbing party—it disappears in a woodpecker-like undulating flight, with short bursts of rapid wingbeats between glides.

Like all pygmy owls, this species is a rapacious little hunter. It either drops down on its victims from a perch or dashes after them in fast agile flight. Prey ranges from large arthropods, such as grasshoppers, crickets, and scorpions, to small vertebrates, such as skinks, mice, and small birds. Powerful talons allow it to capture prey larger than itself, including birds up to the size of doves, and it dispatches vertebrates with a bite from its sharp bill just behind the head. Large insects are generally decapitated, with only the soft body parts eaten.

The male Ferruginous Pygmy Owl has a highly distinctive territorial song, which he delivers during the breeding season with monotonous regularity. It comprises a series of whistled bell-like notes, twenty or thirty, repeated at roughly three per second at the same pace and pitch, with a pause of a few seconds before starting again. Listeners with perfect pitch will realize that the note hovers somewhere between D and E flat. Those familiar with Africa's avifauna may liken it to the call of a tinkerbird (*Pogoniulus*). Either way, the call often provokes a mobbing party of small birds that arrive to drive the diminutive predator from their territory. This may prove useful to the canny birder who, by imitating the owl's call, can lure other birds out of the forest for a better look.

The male's song is particularly loud and clear on moonlit nights during the courtship season. In response, the female utters a higher-pitched and weaker version, which—when the pair get together in duet—turns to a high-pitched twitter. The male then leads the female to potential nest sites, using a cricket-like trilling call to advertise their potential, sometimes from inside the hole.

This species is monogamous and defends its territory all year. The nest is generally in an old woodpecker hole, drilled in a tree trunk, or sometimes a tall cactus. Alternatives include mud nests made by other birds, holes in mud banks and walls, and open tree termite nests. The female lays from three to five eggs in a small depression that she scratches out at the bottom of the hole. Her eggs are laid at two-day intervals, and she incubates the clutch for twenty-four to twenty-seven days, the male bringing food to sustain her. At four weeks, the chicks leave the nest and are able to fly a short distance. The parents continue to provide for them for another two to three weeks.

The Ferruginous Pygmy Owl can be locally common in the right habitat, and with a global range of some 5.5 million square miles (14.4 million sq km), its conservation status is Least Concern. Nonetheless, habitat destruction is thought to be causing a decline in some areas.

Above: A Ferruginous Pygmy Owl feeds a lizard to its fledgling.
Opposite: A Ferruginous Pygmy Owl perches in the open.

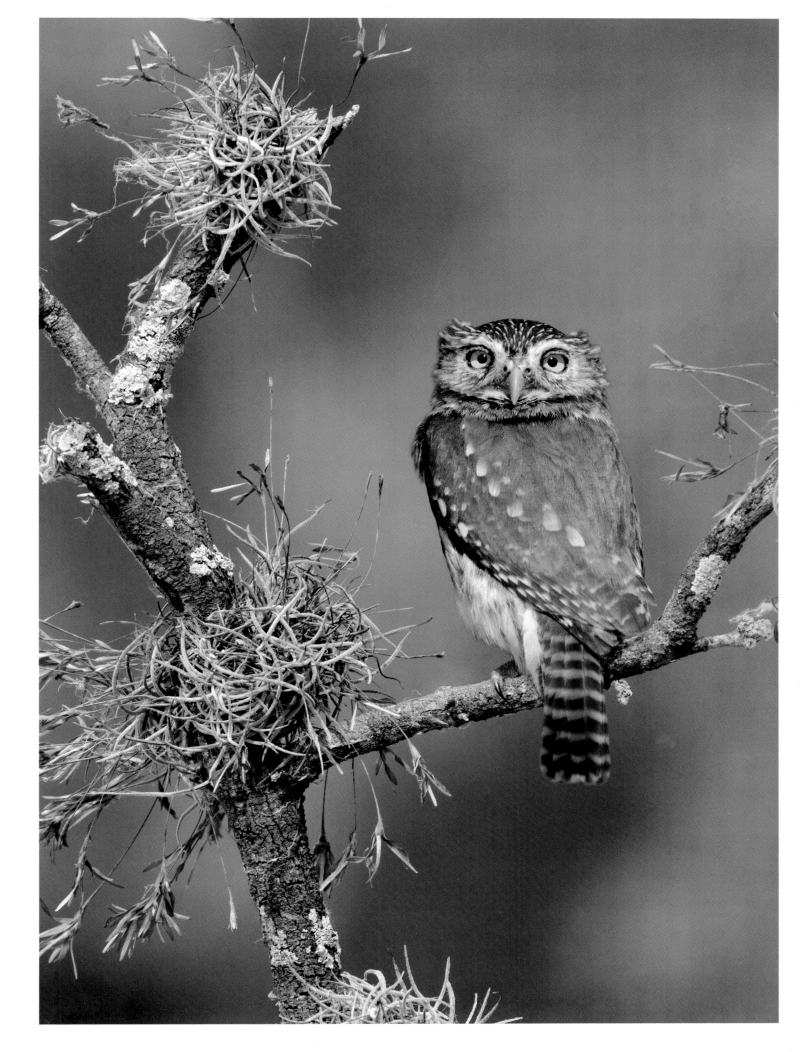

TROPICAL SCREECH OWL

MEGASCOPS CHOLIBA

APPEARANCE
Small (thrush-size), with large round head, short tail, and short ear tufts; gray-brown facial disk with dark edges, faint eyebrows, and yellow eyes; crown and upper parts gray-brown and heavily streaked and blotched, with white scapular line; under parts paler, with fine, dark, herringbone streaks; tail and flight feathers barred; occurs in gray-brown, brown, and rufous color morphs.

SIZE
length 8.3–9.1 in. (21–23 cm)
weight 3.4–5.6 oz (97–160 g)
wingspan 22 in. (55 cm)
females larger than males

DISTRIBUTION
From Costa Rica south across the northern two-thirds of South America, from Venezuela to northern Argentina, with the western limit in the Andes foothills.

STATUS
Least Concern

THIS BEAUTIFULLY CAMOUFLAGED OWL is a widespread Latin American cousin of North America's Eastern and Western Screech Owls (P. 57). It would certainly be hard to distinguish by sight were it to perch alongside one of them. Happily, given its distribution, this is unlikely to happen. Furthermore, like all screech owls, it has a signature call all its own.

Roughly the size of a thrush, the Tropical Screech Owl is slightly larger than the pygmy owls (*Glaucidium* species), with which it shares much of its range. It also sports the typical screech owl ear tufts, which it tends to hold erect by day as it perches immobile among the thick cover of its roost. Three color morphs occur—gray-brown, brown, and rufous—of which gray-brown is the most common and rufous the rarest. The overall effect of its plumage provides cryptic camouflage against the lichen-encrusted tree bark on which it perches.

This species is one of at least twenty-nine in the *Megascops* group. Confusion is possible with the Montane Forest Screech Owl (*M. hoyi*) and Black-capped Screech Owl (*M. atricapilla*), both of which have overlapping ranges, but these owls have slightly different patterning on the crown and under parts, as well as distinct calls. Little is known about its movements, but like other tropical *Megascops* species, this one is probably largely sedentary across its range. Nine subspecies are listed, of which the nominate race, *M. choliba*, occurs from southern Mato Grosso and São Paulo, Brazil, south to eastern Paraguay.

Typical habitat comprises open to semi-open landscapes, including wooded savanna, dry caatinga, secondary forest, and forest edges. The Tropical Screech Owl also takes readily to plantations, town parks, and farmland with stands of trees, but avoids treeless grassland and the densest forest. It is largely nocturnal, roosting by day in dense foliage. Come dusk, the Tropical Screech Owl sets out on its search for food. It may hunt from a perch, but also catches flying prey on the wing. Its diet can be roughly divided by biomass between two-thirds large invertebrates and one-third small vertebrates.

August and early September herald the breeding season for this species, which sees the male in a frenzy of calling. His distinctive territorial song is a brief trill that breaks up into more staccato hoots: "gurrrrrrrr ku-kuk." When battling a territorial rival, the final notes become more numerous. The female may join in, prompting the male to utter a second song—a long bubbling "bubububub"—given in and around the nest site as he entices her to take a look. The Tropical Screech Owl is a hole nester, typically in a woodpecker hole but also sometimes choosing a natural cavity in a tree, termite mound, or even rotten fence post. It may also take to nest boxes. The female lays from one to four eggs, occasionally up to six. She handles incubation, while the male brings food. Like other screech owls, this species is courageous in defense of its nest: if threatened inside the hole, a female will throw herself on her back over her nestlings and strike upward with her talons. Both parents swoop at intruders, including humans.

Little is known about the mortality of the Tropical Screech Owl, although its habit of hunting by roadside lights means that it sometimes falls victim to traffic. Pesticides in agricultural areas also have a damaging effect on its food supply. Nonetheless, this is one of the most abundant and widespread owls in South America, found over an estimated range of 5 million square miles (13.1 million sq km).

Opposite: Like all screech owls, this species is extremely well camouflaged at its daytime roost.

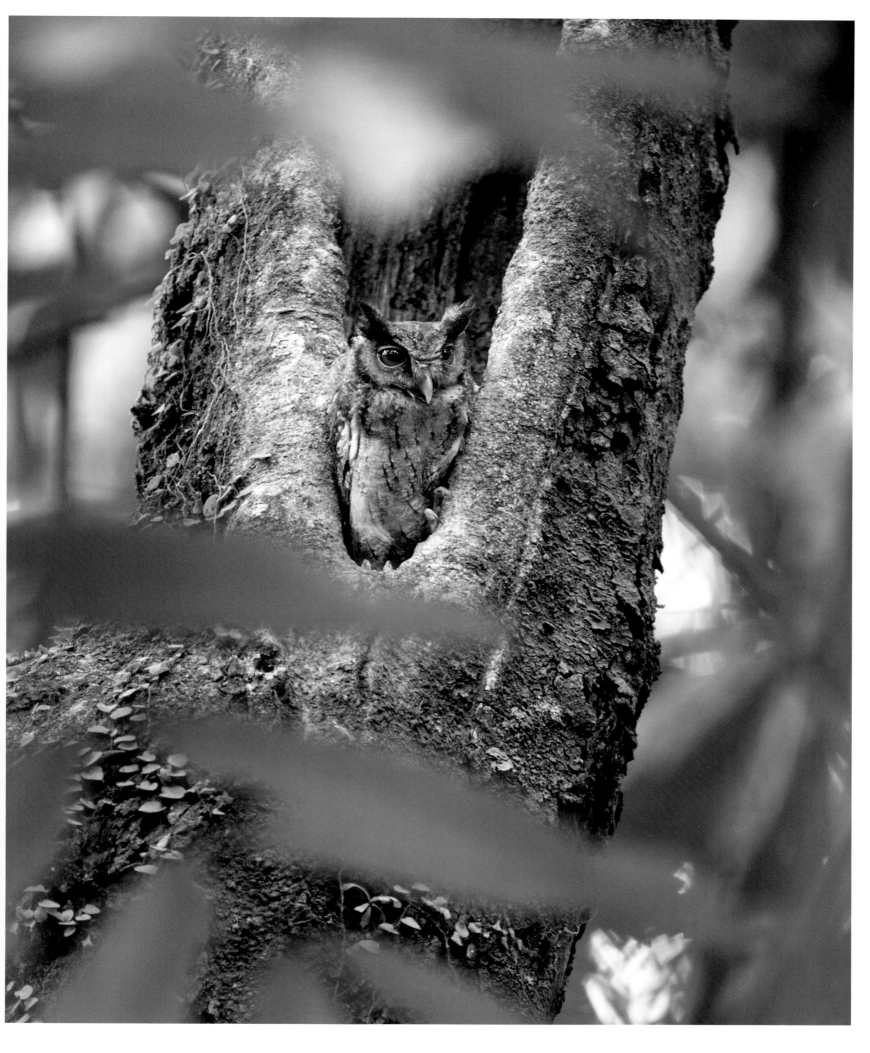

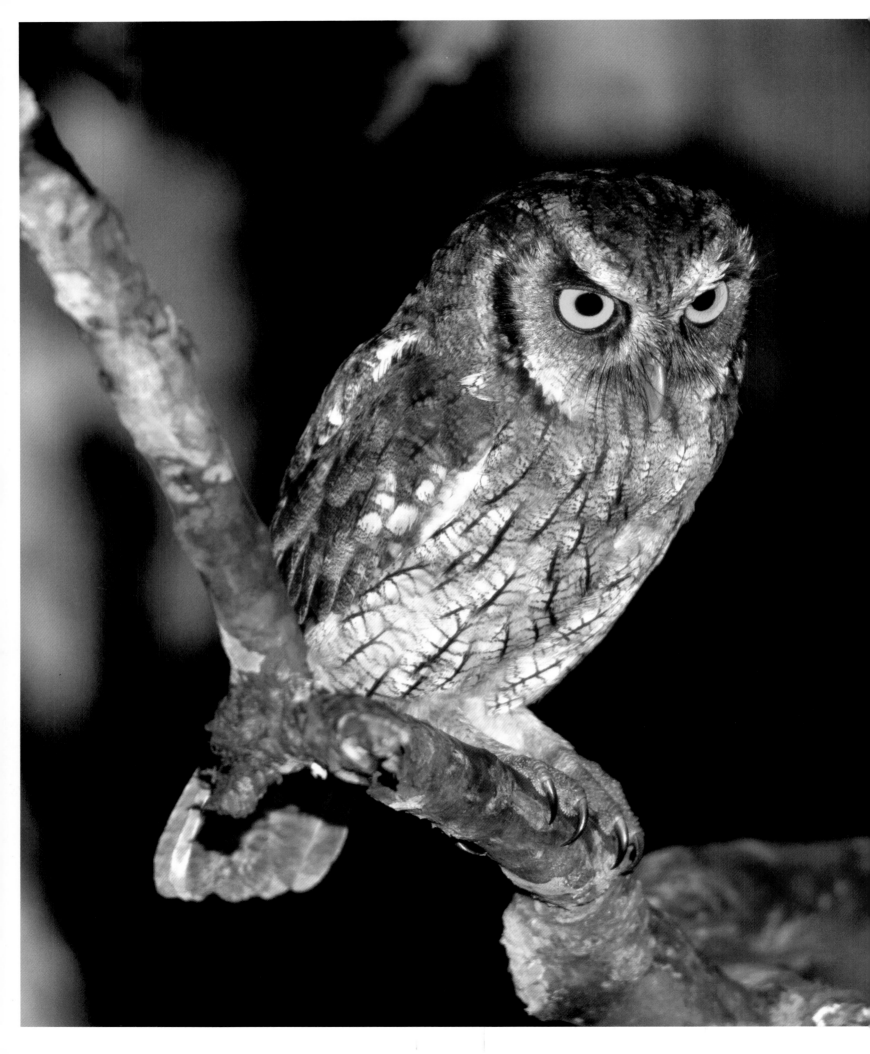

Left: The ear tufts of the Tropical Screech Owl are held flat while it is hunting.

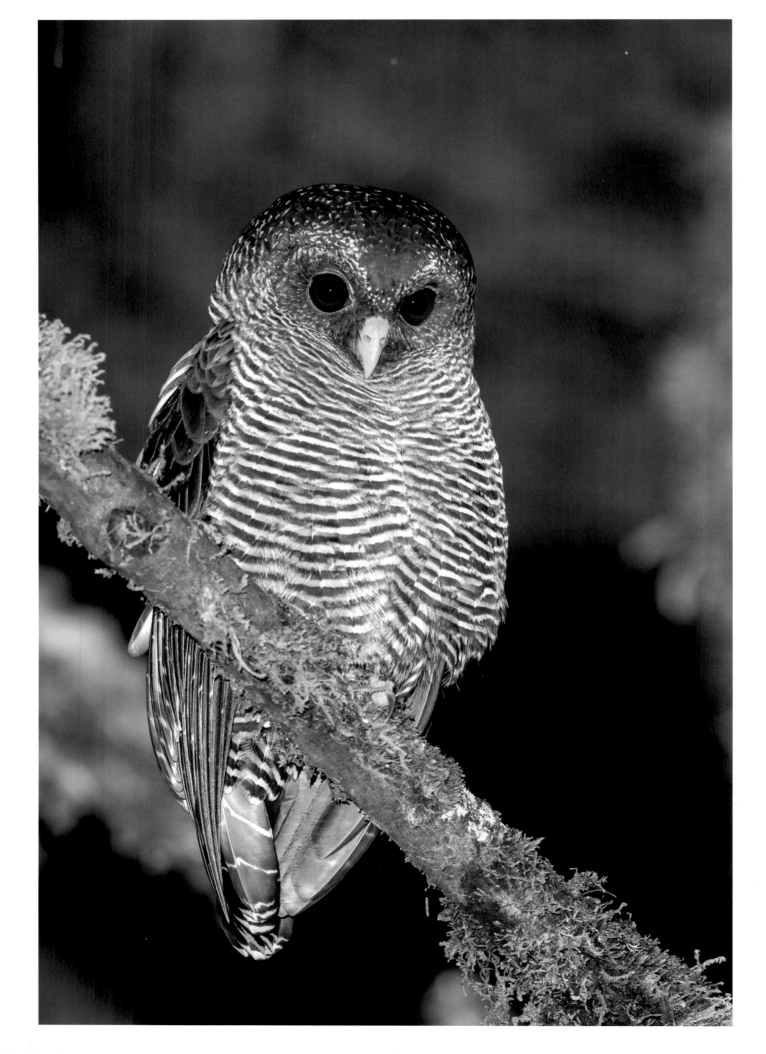

BLACK-BANDED OWL

STRIX HUHULA

APPEARANCE
Medium-size, with a stocky body, rounded head, and no ear tufts; sooty-black to dark brown, marked with fine white barring above and below; dark facial disk with dark brown eyes; bill and feet yellow-orange; black bib below chin; tail barred in white with white terminal band.

SIZE
length 14–16 in. (35.4–40.6 cm)
weight 1 lb (450 g)

DISTRIBUTION
One subspecies in northeast Brazil, Colombia, and Peru; one in Argentina, Paraguay and southeast Brazil.

STATUS
Least Concern

THIS MEDIUM-SIZE WOOD OWL is one of the more subtly beautiful species of its genus. In shape it resembles other *Strix* owls, but instead of the camouflage palette of bark-colored browns and buffs that is characteristic of its northern relatives, it sports sooty-black base plumage etched in fine white, wavy bands. The overall effect has the two-tone delicacy of a wood engraving, and it is set off by the yellow-orange bill and feet, which stand out boldly against the soft darkness. A closer view reveals that the barring is denser on the under parts and that the flight feathers are the blackest part of this owl. Dark brown eyes are set in a dark facial disk rimmed with a fine black-and-white stippling, and reveal pink eyelids when blinked. There is also a black bib below the chin, and the tail is barred in white.

The Black-banded Owl was first described to science in 1824 by German biologist Johann Baptist von Spix. It occurs across a large part of northern South America east of the Andes, from Colombia, Venezuela, and Ecuador across the Amazon Basin, and south to Bolivia, Paraguay, northern Argentina, and southeast Brazil. Throughout this range, it inhabits tropical and subtropical forest, including forest clearings and coffee and banana plantations. A close relative of the Black-and-White Owl (*S. nigrolineata*), with which it was once thought conspecific, the Black-banded Owl occurs in two subspecies. The nominate race, *S. huhula huhula*, is found in northeast Brazil, eastern Colombia, the Guianas, and Peru, whereas a more southerly race, *S. h. albomarginata*, lives in

northeast Argentina, eastern Paraguay, and southeast Brazil. Both are generally known from lowland forest. However, a bird documented in the high-altitude cloud forest of San Isidro, Ecuador, and known as the "San Isidro Mystery Owl," is now thought to represent either a new subspecies of the Black-banded Owl or perhaps a new species entirely—possibly a bridge between the Black-banded Owl and the Black-and-White Owl. Other closely related, sympatric species include the Mottled Owl (P. 82) and the Rusty-barred Owl (*S. hylophila*).

Like all wood owls, the Black-banded Owl is nocturnal. By day, it hides in a concealed roost, usually in dense foliage near the trunk of a tree. At dusk, it comes out to hunt, chiefly for large insects, but also for small mammals and other vertebrates. These evening activities are heralded by the bird's distinctive call. This consists of a rapid series of four to five guttural notes, rising both in volume and pitch, and followed by a separate explosive, down-slurred hoot—transcribed as "gu-gu-gu-gu-gu, hwuo." Sometimes a second weaker hoot follows the first, after a short break. The call is very similar to, although slightly longer than, that of the Black-and-White owl, which may explain why in Colombia the two species have been known to interbreed. The female has a similar but higher and more wailing call, and also a high-pitched "how-how-how."

Very little is known about this owl's breeding habits. It is thought to be a sedentary species, occupying its breeding territory all year around, and it is reasonable to infer that its lifestyle is similar to that of other tropical *Strix* owls. One nest studied in northeast Argentina had a single nestling in October to November 2010 and a single egg in September 2011. The nest chamber was in the main fork of a tree, and the species most likely uses predominantly natural tree holes and rotten stumps. With a range estimated by BirdLife International as some 2.84 million square miles (7.37 million sq km), this bird enjoys a conservation status of Least Concern. Nonetheless, as with many tropical forest species in South America, habitat loss through deforestation is an ever-present threat.

Opposite: The subtle two-tone plumage of the Black-banded Owl could almost be a wood engraving.

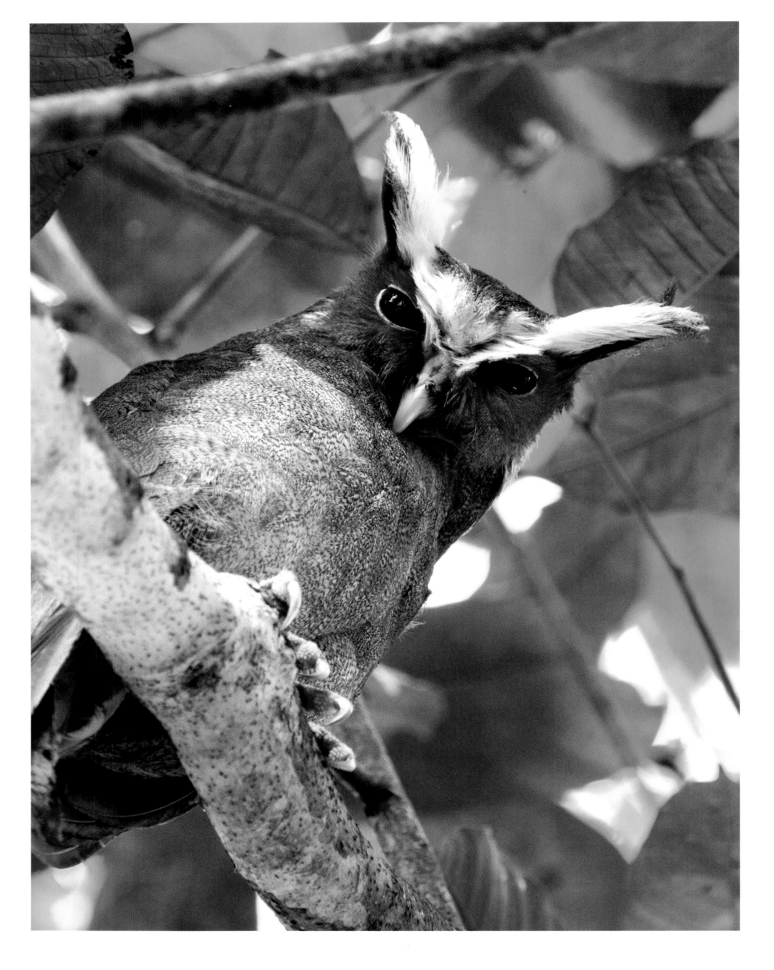

Above: The Crested Owl derives its name from impressive
ear tufts, among the longest of any owl worldwide.

CRESTED OWL

LOPHOSTRIX CRISTATA

APPEARANCE
Medium-size; large white ear tufts; upper parts dark chocolate-brown, lightly spotted with white; flight feathers barred; under parts pale buff with dark brown neck and upper breast; rufous morph has similar patterning on a pale rufous base.

SIZE
length 15–17 in. (38–43 cm)
weight 14.9–21.8 oz (425–620 g)

DISTRIBUTION
Three subspecies split across two discontinuous populations: South America east of the Andes, from Amazonian Colombia, Ecuador, Peru, Brazil, and Bolivia north to Guyana; and from western Colombia through Central America north to southern Mexico.

STATUS
Least Concern

THIS EXTRAORDINARY BIRD is easily described but poorly understood. Sporting a pair of comedy eyebrows that surely rank as the most striking plumage of any owl, it neither looks like any other American species nor is related to one. Unmistakable, but its secretive life in some of the world's deepest forests has revealed very little to the eyes of science.

The Crested Owl is a medium-size species, about the height of a Barn Owl (P. 127) if you discount the extravagant "crests" from which it gets its name. These are, in fact, two exceptionally large, drooping ear tufts, which extend seamlessly from the white supercilia, thereby creating the impression of "mad professor" eyebrows sprouting untamed from the head.

With such a unique identification feature, describing the rest of the bird seems superfluous. Nonetheless, this is a species of subtle and handsome plumage. Lacking the complex cryptic patterning of many owls, it comes in at least two color morphs: chocolate-brown and paler rufous-brown. The former has a uniform dark brown facial disk, which contrasts boldly with the white forehead, eyebrows, and ear tufts, the orange-brown eyes, and pale yellowish bill. The throat is a pale buff, while the under parts graduate from a dark chocolate neck and upper breast to a pale buff belly, with numerous fine vermiculations that are visible only at close proximity. With a dark brown collar across the upper breast, the rufous morph has the same basic patterning but on a pale rufous-brown

base color. The only other species that this owl resembles is the Maned Owl (*Jubula lettii*) of Equatorial Africa. The two were once thought to be related, but studies have since shown that any resemblance is purely a result of convergent evolution, and that the two monotypic species have come from different lineages on their respective continents.

Across most of its range, the Crested Owl is primarily an owl of lowland rain forest, preferring dense primary forest but also occurring in secondary forest. It is usually found close to water. In some areas, it also inhabits cloud forest and has been recorded at an altitude of 6,400 feet (1,950 m) in Honduras. It is a nocturnal species, roosting by day in riverine thickets or other dense vegetation, often in pairs. If disturbed, it stands slim and upright with ear tufts erect. At dusk, it sets out to hunt, typically swooping down on prey from a perch. It is thought to prey predominantly on large insects, such as caterpillars and beetles, but may also take small vertebrates.

This owl has a staccato, frog-like call lasting about one-and-a-half seconds, which accelerates from a stuttering rattle into a deep, guttural croak. It starts singing at dusk from a perch in the middle canopy and may continue all night. Intense vocal activity heralds breeding, which across most of this owl's range takes place from February to May, during the dry and early wet season. Its breeding habits are largely shrouded in mystery. However, the Crested Owl is known to be a cavity nester, generally choosing holes in mature trees. Juvenile birds have bold white markings on the face and upper parts until they acquire full adult plumage.

Little is known about the conservation status of this owl, described by Scott Weidensaul in the *Peterson Reference Guide to Owls of North America and the Caribbean* (2015) as "an enigma to science." It is locally common in parts of Costa Rica and Mexico, and with a population estimated at between 50,000 and 500,000 is classed as Least Concern. Much remains to be discovered about this bird's ecology, and like all tropical rain forest species it is vulnerable to deforestation.

Left: A fledgling Crested Owl, conspicuous in the gloom, awaits its parents on the buttress roots of a rain forest tree.

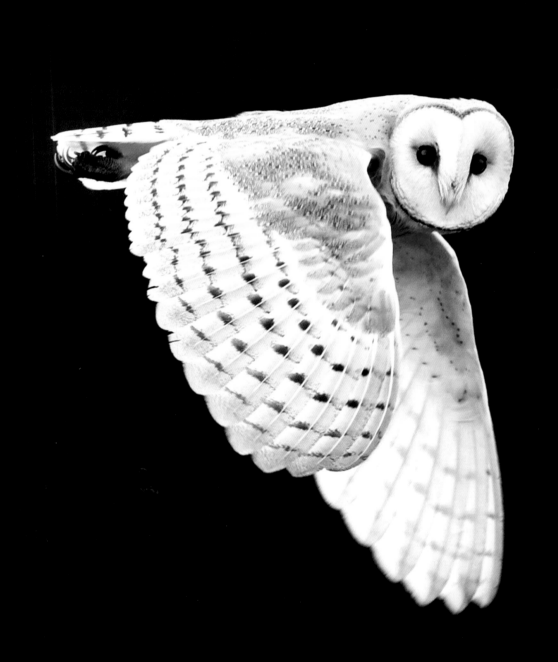

03 | EURASIA

EUROPE UNDOUBTEDLY HAS the world's most celebrated owls. Old Mr. Brown, from Beatrix Potter's *The Tale of Squirrel Nutkin*; the owl who goes to sea in a "beautiful pea-green boat" in Edward Lear's poem *The Owl and the Pussycat*; Hedwig from the *Harry Potter* series: all represent species found predominantly in Europe and, especially for children, have shaped the western idea of what an owl is. In reality, however, they make up only a small proportion of the owl family worldwide.

Eurasian owls are found in the temperate biogeographical realm known to scientists as the Palearctic ecozone. This encompasses the whole of Europe, from Lapland to the Mediterranean, and extends east across Asia, from the Arctic Ocean south to the Himalayas and the Yangtze River. It does not include tropical southern and Southeast Asia, which—although part of the same huge Asian landmass—constitutes a very different biogeographical region.

Some two to three million years ago, the Palearctic was largely covered in ice, with the vegetation zones forced further south. As the ice sheets retreated, forest gradually returned to carpet the land and eventually became the region's dominant biome. Today, dense boreal forest extends from northern Asia into northern and central Europe. It also extends west into North America, once connected by land to Eurasia and now sharing many of the same habitats, and indeed many of the same owl species. South of the boreal forest zone, a belt of temperate mixed and deciduous forest reaches across to the Atlantic shores, while further south still the Mediterranean biome is typified by cork oak woodland and low, dry scrub. Further east are the vast central Asian steppes, which extend a tongue of short-grass plains into Europe as far west as Hungary.

The more northerly latitudes of this region experience long, snow-bound winters, where life is sustainable for only the most specialized animals. It is, therefore, one of the least biodiverse parts of the world, with a relatively limited number of species by comparison with warmer regions. Indeed, although the region is the largest one by area covered in this book, it is home to fewer owls than any other. Its total of seventeen species—of which only thirteen occur in Europe—is less than 7 percent of the world's total.

Among this modest number, however, are some of the world's best-known owls, and some of the most beautiful and fascinating. Europe's rich scientific tradition and cultural heritage have ensured that many of these owls have, for better or for worse, received more attention than most species elsewhere. Indeed, much of what we know about owls in general has been drawn from the owls of Europe.

Traveling from north to south across the region, the highest latitudes are carpeted by Arctic tundra, ranging from eastern Siberia west to Lapland. The wildfowl, shorebirds, and other migrants that invade this region in summer disappear in winter, leaving it almost bird free. The only owl adapted to the treeless terrain of pure tundra is the Snowy Owl (P. 31), also found in North America, although even this Arctic specialist is forced south during the hardest winters in search of a supply of food.

Opposite: The Common Barn Owl is perhaps the best known and the most unmistakable of Europe's owls.

South of the tundra is a vast belt of boreal forest, known in Russia as the taiga, which comprises tracts of spruce, birch, and other hardy, northern trees. This zone is home to species such as the Great Grey Owl (P. 150) and Northern Hawk Owl (P. 108), which are specialists at capturing voles and other rodents even when the ground remains covered in snow. The dependence of these owls upon their rodent prey, which, in turn, is subject to wildly fluctuating breeding cycles determined by the weather, means that they are sometimes obliged to move when their food supply dwindles. Their populations can, therefore, vary significantly from year to year.

The temperate forests to the south of the taiga comprise largely mixed and deciduous woodland. This is the habitat that once carpeted most of Europe, but in many areas—notably the British Isles—it was long ago lost to agriculture and development. It is a rich habitat for a number of owls, such as the Tawny Owl (P. 120) and Long-eared Owl (P. 146), which find plentiful prey on the forest floor and among the clearings, and take advantage of nest sites drilled by woodpeckers or built by other forest birds such as hawks. In the very far east of the region, this habitat is also home to the huge Blakiston's Fish Owl (P. 167), which hunts the snowy riverbanks of Japan and eastern Russia. Further south still are the warm, scrubby hillsides of the Mediterranean, where winter does not wring so much from the land. Here, the Little Owl (P. 114) is a typical resident, adapting well to the rural farming landscape. The Common Scops Owl (P. 159) is the northernmost representative of the largely tropical *Otus* genus and confirms its heritage by migrating south every winter across the Sahara to the savannas of Africa's Sahel region.

These broader biomes are punctuated by other more localized landscapes. Grasslands and flat coastal plains offer perfect habitat for the Short-eared Owl (P. 141), which hunts by day, nests on the ground, and is one of the owl world's great wanderers—drawn into long seasonal movements when its vole supplies run low. Mountainous regions and rocky ravines provide hidden roosts and nest sites for the Eurasian Eagle Owl (P. 103), which is joint largest of all the world's owls and one of Europe's most formidable predators. In addition, traditional farmland across the region offers the rodent-rich rough pasture and deserted outbuildings beloved of the aptly named Barn Owl (P. 127).

The last of these points to an inescapable reality: Europe, perhaps more than anywhere else on Earth, bears a heavy human footprint, with all habitats modified to some extent by human activity. Lost over the centuries to agriculture and development, the great forests that once covered nearly 90 percent of the continent have been reduced to barely a quarter of that. In addition to the great tracts of farmland and urban areas, large areas of "forest" are, in reality, monocultural plantations that support only a very limited biodiversity. These changes have taken their toll on owls, along with much of the region's other wildlife. There is no turning back the clock. However, conservation today focuses on managing these habitats in a way that best protects and restores their biodiversity. Consequently, many owls are benefiting from conservation initiatives, such as the provision of nest boxes for Ural Owls (P. 160) in Sweden's forestry areas. Many of the owls described in this chapter are declining at a local or regional level, but all retain a strong foothold on the region as a whole.

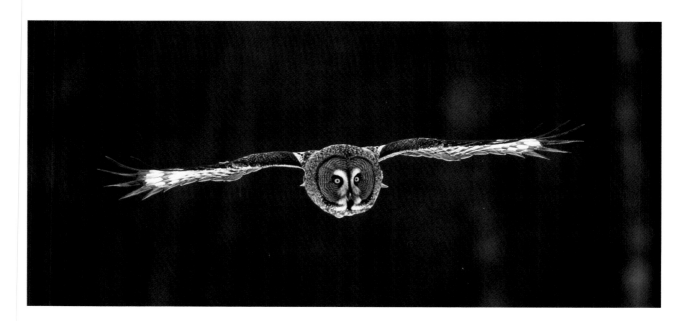

Above: A Great Grey Owl swoops upon prey in a silent glide from its treetop perch.

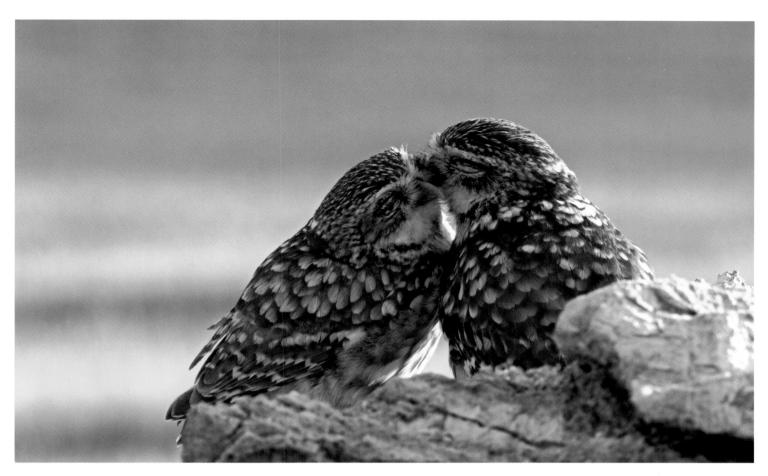

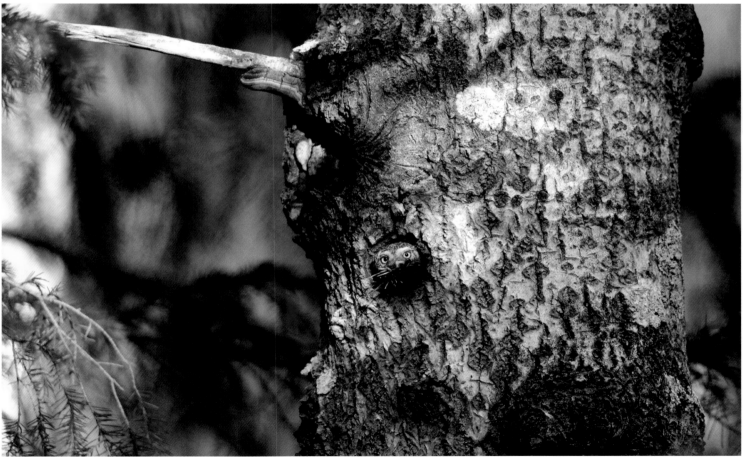

Top: Two Little Owls in Spain reinforce their bond through mutual preening.
Above: A Eurasian Pygmy Owl peeks from its nest hole in a Finnish forest.

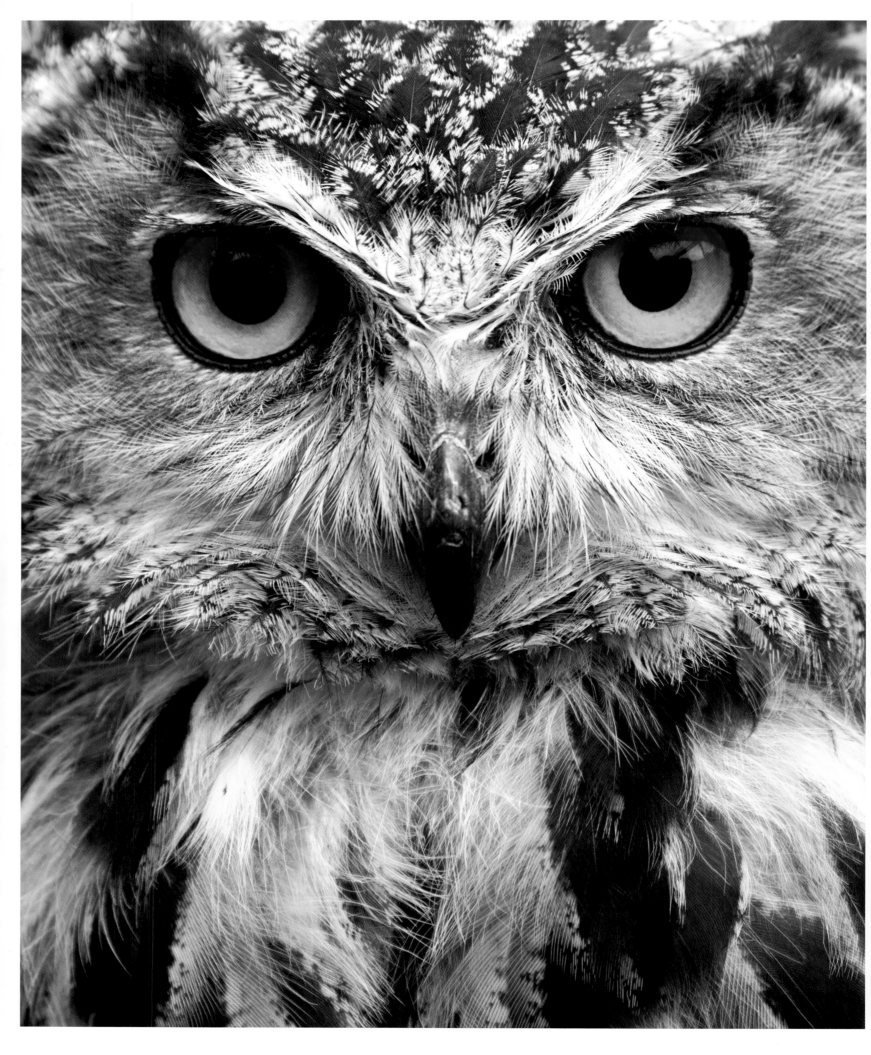

EURASIAN EAGLE OWL

BUBO BUBO

APPEARANCE

Very large and bulky cat-size body; relatively small head; short tail and prominent long ear tufts; tawny under parts streaked with bold black vertical marks; upper parts richly patterned with black, gray, and rufous-brown; penetrating orange eyes set in gray facial disk, strongly rimmed with black; white throat prominent while calling; long, rounded wings; female larger than male.

SIZE

length 22.8–29.5 in. (58–75 cm) weight 6.6–10.1 lb (3–4.6 kg) female up to 32 oz (1 kg) heavier wingspan up to 74 in. (188 cm)

DISTRIBUTION

Patchily distributed across Europe, from Portugal north to Scandinavia; extends east in broad band across central Asia, north to Siberia, south to the Middle East, and east to Japan.

STATUS

Least Concern

THIS FORMIDABLE OWL vies with Blakiston's Fish Owl (P. 167) for the title of the world's largest. The biggest individuals may be twice as heavy as the similar-length Great Grey Owl (P. 150). For power and ferocity, however, it has no rivals. The Eurasian Eagle Owl—often known as Eagle Owl—is one of the world's most powerful avian predators, capable of capturing prey as large as foxes and eagles. This awesome size and power, coupled with an imperious demeanor, has made this bird one of the best-known owls in Western culture. Its image is a staple of iconography and fiction, from its associations with the French nobility to J. K. Rowling's *Harry Potter* stories. In September 2007, a Eurasian Eagle Owl held up play during a European Championship soccer match at Helsinki National Stadium, swooping over the pitch and perching on both goal posts. Nicknamed Bubi, this individual was subsequently voted Helsinki citizen of the year in 2007, and today the Finnish team is known as *Huuhkajat* (Eagle Owls).

Throughout much of its range, size alone is enough to identify a Eurasian Eagle Owl. The distinctive silhouette combines a bulky, cat-size body with a relatively small head. In flight, this owl is equally impressive, interspersing short, soft wingbeats with long glides. It is one of the few owls that may occasionally use thermals to soar by day, invariably attracting a retinue of irate crows.

The Eurasian Eagle Owl belongs to the *Bubo* genus, which comprises some twenty to twenty-five species, according to taxonomy, and also includes the Great Horned Owl (P. 48) of the Americas. It is closely related to other *Bubo* species, such as the Indian Eagle Owl (*B. bengalensis*) and the Pharaoh Eagle Owl (*B. ascalaphus*). These two were once both thought to comprise smaller races of the same species, and may still breed with the Eurasian Eagle Owl.

Favored habit varies from woodland to semidesert, but always features an irregular topography, including rocky outcrops and patches of trees. This owl tends to avoid closed forests and can thrive around human habitation, at ski resorts in the Italian Alps, for example. Such a wide range and habitat tolerance have allowed great genetic diversity, amplified by the owl's largely sedentary nature, which means that populations become genetically isolated more easily. Today, scientists recognize twelve to thirteen regional subspecies. The nominate race, *B. bubo*, is found across Europe from the Pyrenees and into Russia. Other subspecies include the smaller and grayer *B. b. hispanus*, confined to the Iberian Peninsula, and also *B. b. omissus*, an ocher-colored desert race from Turkmenistan and Iran. Northerly races may sometimes disperse in in times of poor weather or a dearth of prey.

This owl perches at the top of the food chain wherever it occurs. Largely nocturnal, it hunts between dusk and dawn, and more by eye than ear. Armed with powerful talons and a strong bill, it will not hesitate to attack animals as large as or even larger than itself. Mammals make up around half the diet, typically rodents and rabbits but sometimes larger species, including marmots, martens, and foxes. There is even a record of a Eurasian Eagle Owl killing a young roe deer (*Capreolus capreolus*). Such catches are too heavy to carry so are fed upon in situ. Prey up to the size of rabbits is swallowed whole.

Birds also feature on the menu, generally snatched from their roost after dark. Typically, these are medium-size species, such as crows and pigeons, but larger birds, from

Opposite: The Eurasian Eagle Owl is the most powerful hunter among all owls.

cormorants to cranes, are also taken. This owl has a particular appetite for other birds of prey, a phenomenon known as intraguild predation. Every other European owl species may fall prey, as may diurnal raptors, with Common Buzzard (*Buteo buteo*) and Long-eared Owl (*Strix otus*) both frequent victims. More surprising victims include such powerful species as, in Turkey, Bonelli's Eagle (*Aquila fasciata*), while other unusual prey recorded includes hedgehogs—from which the owl peels the spiny skin—tortoises, trout, wild boar piglets, and even domestic cats.

The Eurasian Eagle Owl is highly territorial. Its deep hooting call is uttered mostly during the breeding season when a pair is renewing its bonds. The singer chooses a prominent topographical feature, such as a rock pinnacle, from which to broadcast the message, repeating the hoot at eight-second intervals. Male and female sometimes call in duet, the male standing upright and the female bowing down. While calling, an owl fluffs out its white throat, which serves as a visual warning to territorial rivals.

Pairs mate for life. Their nest is usually on a high rocky ledge, but in more open country it may be on a slope beneath a bank or among tree roots. The female lays one to four white eggs at three-day intervals. She incubates the clutch but also defends the nest, dive-bombing intruders, including humans and dogs. The chicks fledge at around seven weeks after hatching, but remain near the nest and receive parental care for another fifteen to eighteen weeks. Juveniles are paler than adults, with barring rather than streaking on their under parts. Eagle Owls may live more than twenty years in the wild. There are also some astonishing longevity records among captive birds, including one from Russia of sixty-eight years.

The Eurasian Eagle Owl is of Least Concern, with an estimated global population of 200,000 to 2.5 million. Despite recent upward trends in parts of Europe and a reintroduction program in Germany, the population as a whole is in decline. Today, human degradation of the bird's environment is the main threat, but collision with power lines also causes heavy losses, as do road traffic accidents. The bird's status in the United Kingdom offers an interesting footnote. A small but growing population, established in the late twentieth century, is thought largely to have descended from escaped falconers' birds. Scientists are unsure whether there has been any natural colonization (for example, by vagrant birds crossing the North Sea from Scandinavia), or indeed whether the Eurasian Eagle Owl was ever native to the British Isles. This raises a dilemma: the bird now threatens some rare British wildlife, including the endangered hen harrier (*Circus cyaneus*), and conservationists are unsure whether it should be encouraged, as a returning part of the native ecosystem, or resisted as an alien invader.

Right: A Eurasian Eagle Owl visits a graveyard at night in the Black Forest, Germany.

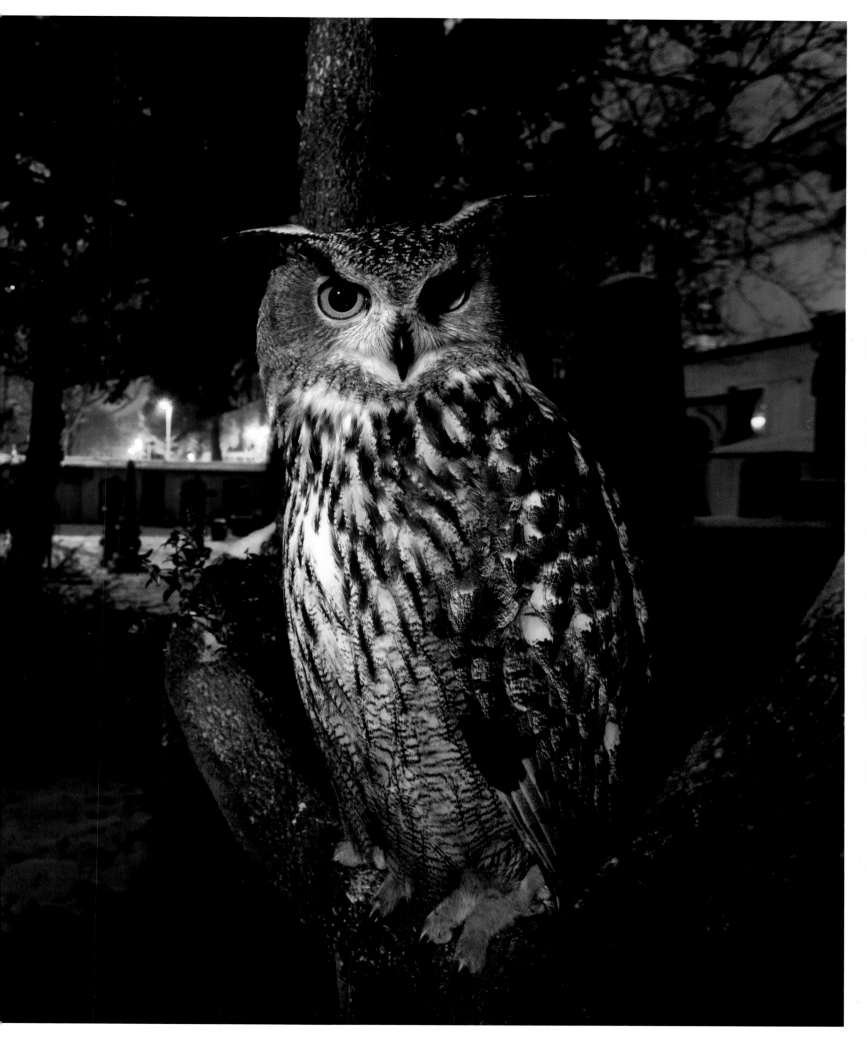

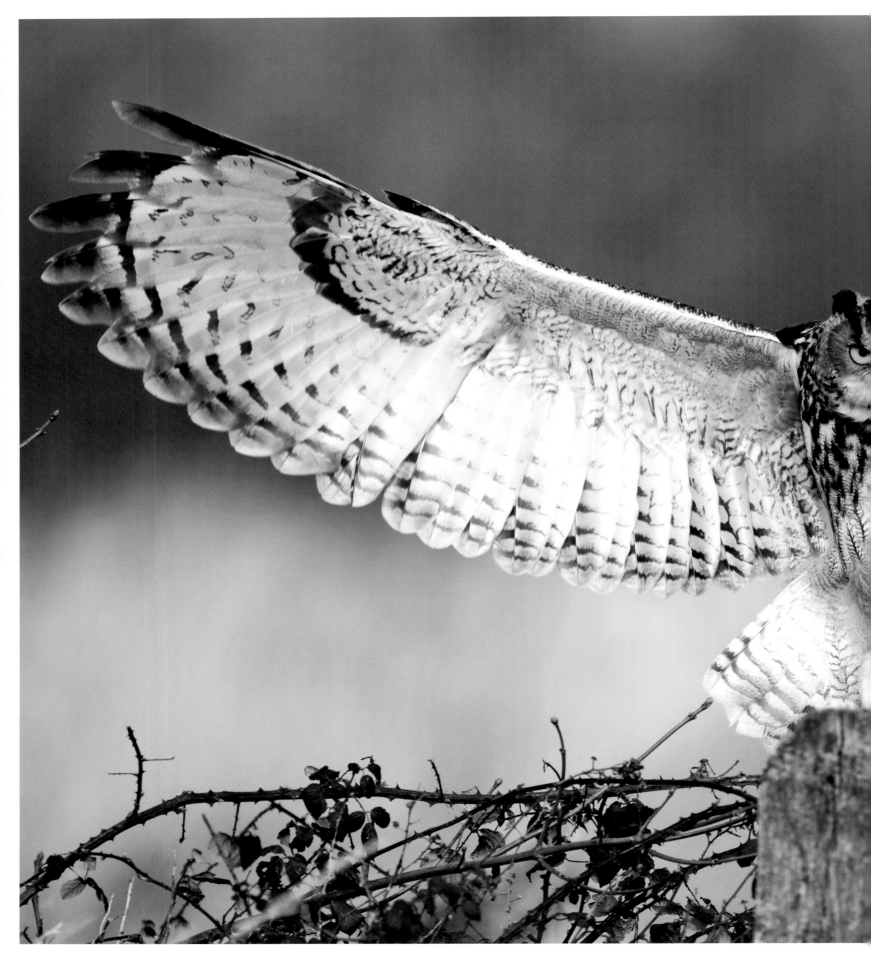

EURASIA

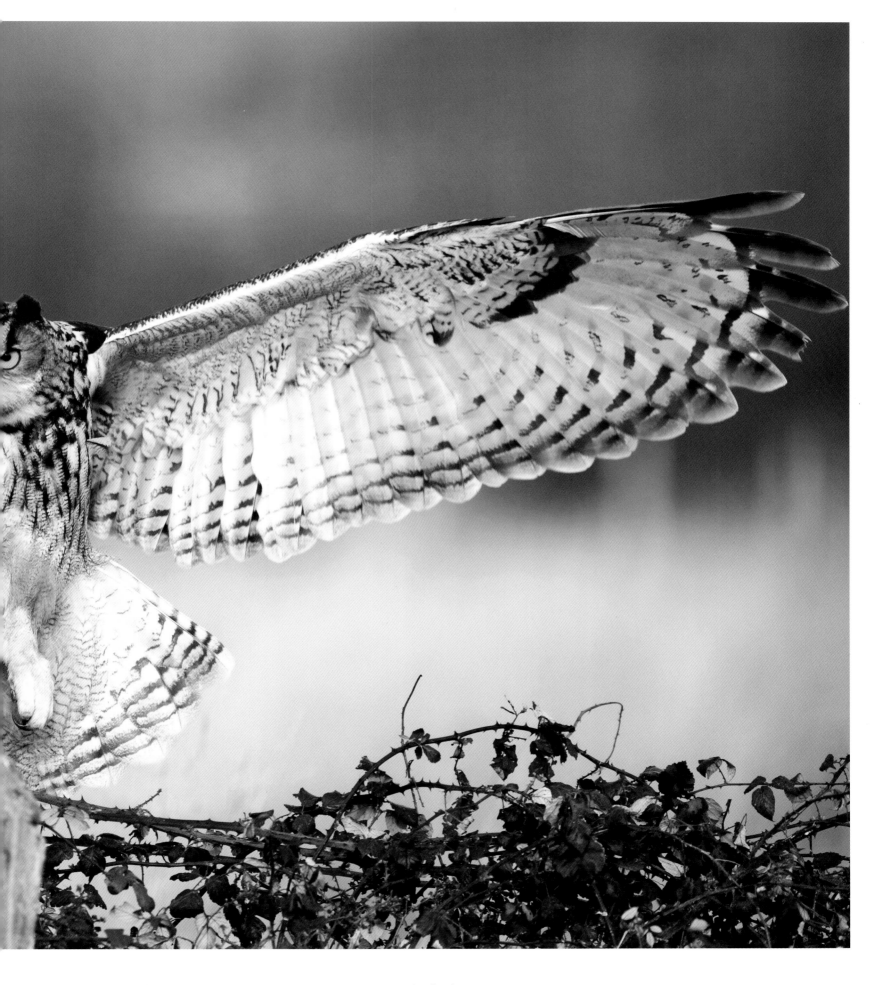

Above: The enormous wings of this species may span more than 6 feet (2 m).

NORTHERN HAWK OWL

SURNIA ULULA

APPEARANCE
Medium-size; square-headed silhouette; white-spotted crown, without ear tufts; long tail and (in flight) pointed wings convey hawk-like impression; prominently marked above in black, white, and gray, with bold white scapulars; pale below; pale face, with yellow eyes set in whitish facial disk bordered by broad black ruff.

SIZE
length 14–16 in. (36–41 cm)
weight 7.5–15.8 oz (212–450 g)
wingspan 28–31 in. (72–81 cm)

DISTRIBUTION
Holarctic region: northern Eurasia, from Scandinavia east to Kamchatka; Alaska, Canada, and northernmost United States; migrates south in winter, according to food supply.

STATUS
Least Concern

ONE GLIMPSE OF THIS MEDIUM-SIZE OWL explains the name. Sitting atop a tree in broad daylight, scanning for prey—or dashing between trees, with its long tail and pointed wings—it very much resembles a small hawk or falcon. As for the "Northern," this is a bird of high latitudes, inhabiting the boreal forest zone of northern Europe, Asia, and North America, where winter brings deep snow and the short, intense summer offers daylight around the clock.

The Northern Hawk Owl is the only species in the genus *Surnia*. It is unrelated to the *Ninox* species that also bear the name "hawk owl" and has a closer evolutionary affinity with pygmy owls. Taxonomists list three subspecies, of which the nominate race, *S. u. ulula*, occurs from Scandinavia to Kamchatka. The other two are found in northern China and North America. Like many northern predators, its distribution reflects the supply of voles and other small rodents. This fluctuates on a "boom and bust" cycle, typically of three to five years, which means that the owl may abandon areas when food is scarce or, conversely, arrive en masse when conditions improve. It also means that it may migrate large distances in winter, south to central Europe or the central United States.

This is a species of open coniferous and mixed forest—typically of pine and/or birch—and often on the edge of open terrain, such as marshy or recently felled areas. It needs isolated trees as hunting vantage points because hunting is by sight. Once the target is spotted, the owl swoops down to snatch up its prize. However, unlike some other northern owls, the Northern Hawk Owl cannot locate prey beneath the snow. It sometimes hovers kestrel-like above the ground, and may also use its hawk-like agility to capture small birds in flight. Birds, including species up to the size of willow grouse (*Lagopus lagopus*), are targeted more often during winter. Other occasional prey includes shrews, frogs, and large insects. In times of plenty, surplus food is cached in a tree cleft for later consumption.

A male Northern Hawk Owl starts advertising his territory from February. His excited bubbling trill, comprising some twelve to fourteen notes per second, is given at roughly ten-second intervals. He backs this up with a wing-clapping display flight, often circling potential nest sites. Once a female is won over, the pair cements its bond with duetting and mutual preening. However, pairs do not always maintain their territory or their pair bond from year to year.

Nests are generally in tree holes, often those excavated by large woodpeckers such as the black woodpecker (*Dryocopus martius*). Abandoned stick nests and nest boxes will also suffice. The female lays up to eight eggs in April, which hatch after twenty-eight to thirty days. At three weeks, the young leave the nest; they cannot fly at first and clamber around the branches where their downy mottled plumage blends in with the lichen-covered bark. The adults defend them fiercely, and by thirty-five days the youngsters can fly. This quick fledging period is typical of northern species, which must make the most of the short Arctic summer.

Although classified by the International Union for Conservation of Nature as Least Concern, with an estimated worldwide population of 130,000, this species appears to be declining in some areas and, in recent years, retreating north. This trend suggests that the Northern Hawk Owl, like many Arctic species, may be suffering the effects of climate change.

Opposite: The plumage of a Northern Hawk Owl perfectly replicates the tones and textures of tree bark.

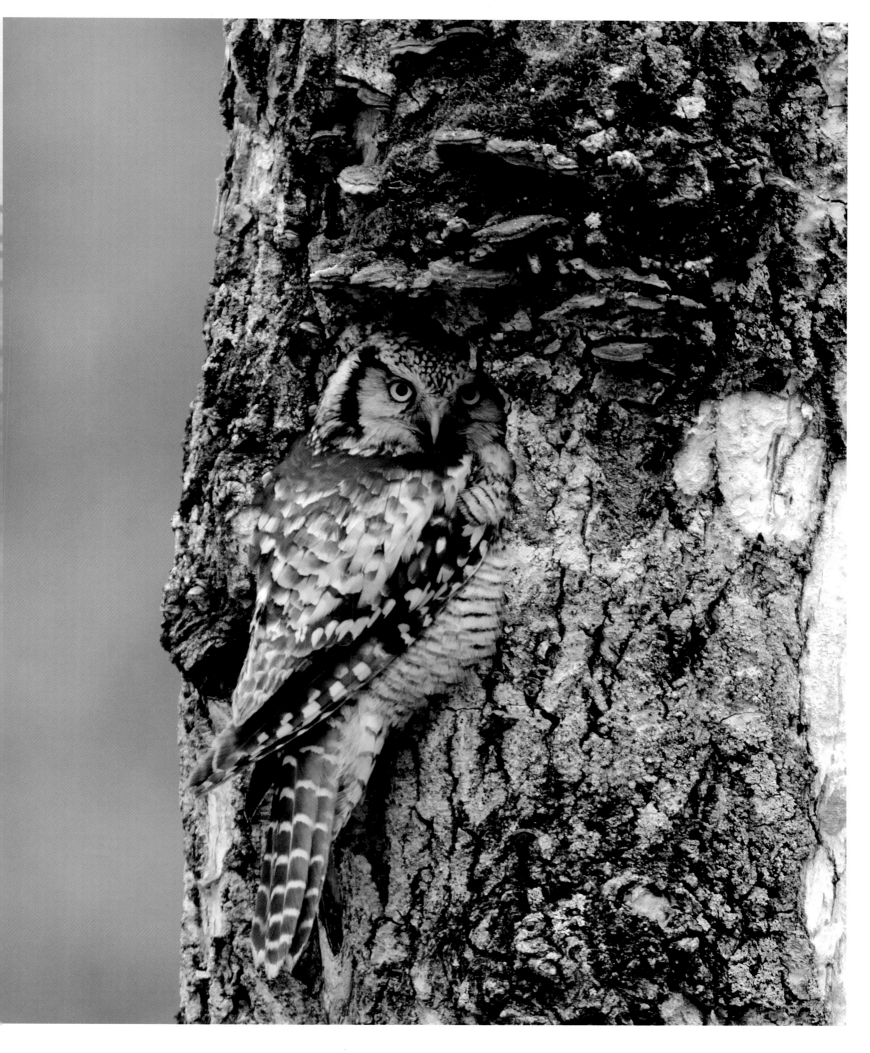

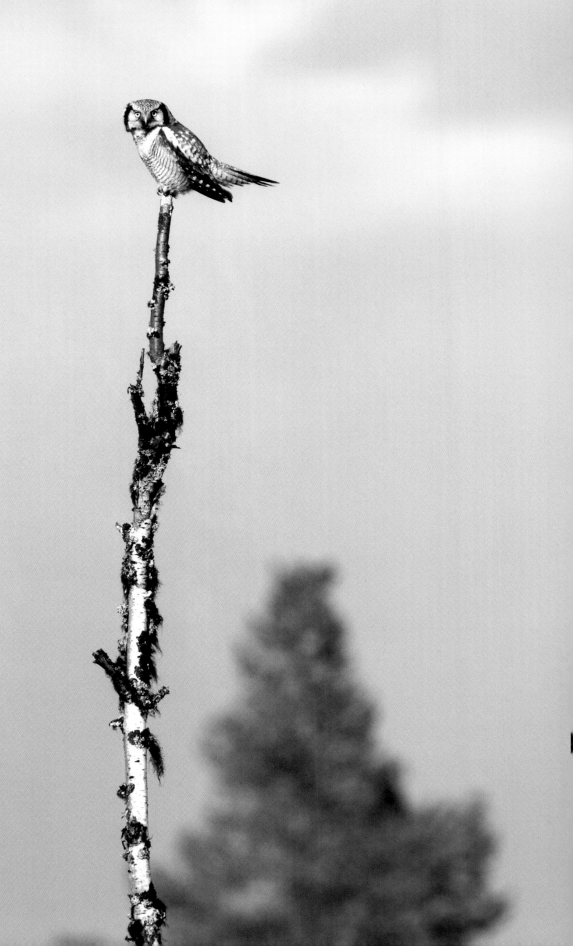

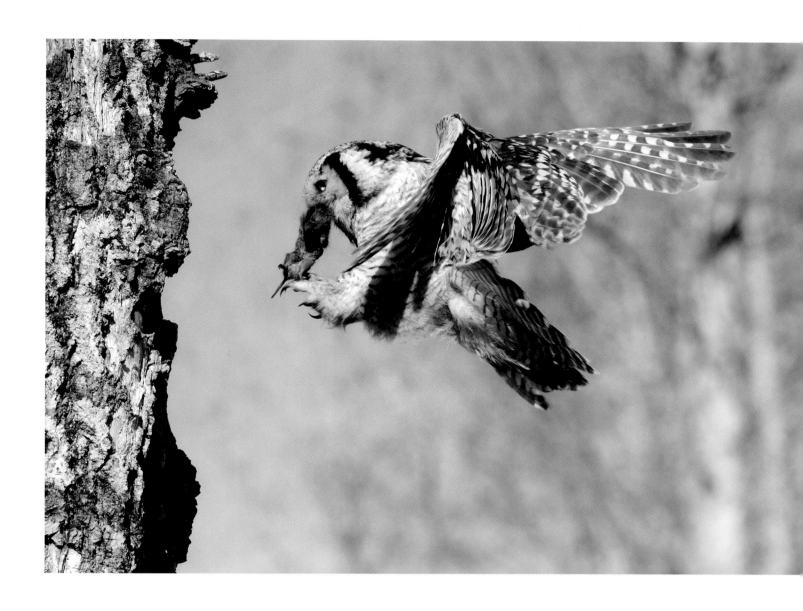

Above: Young in the nest require a constant supply of voles.
Opposite: This species typically perches on the top of tall, bare trees.
Overleaf: A Northern Hawk Owl clutches a vole, plucked from the snow.

EURASIA

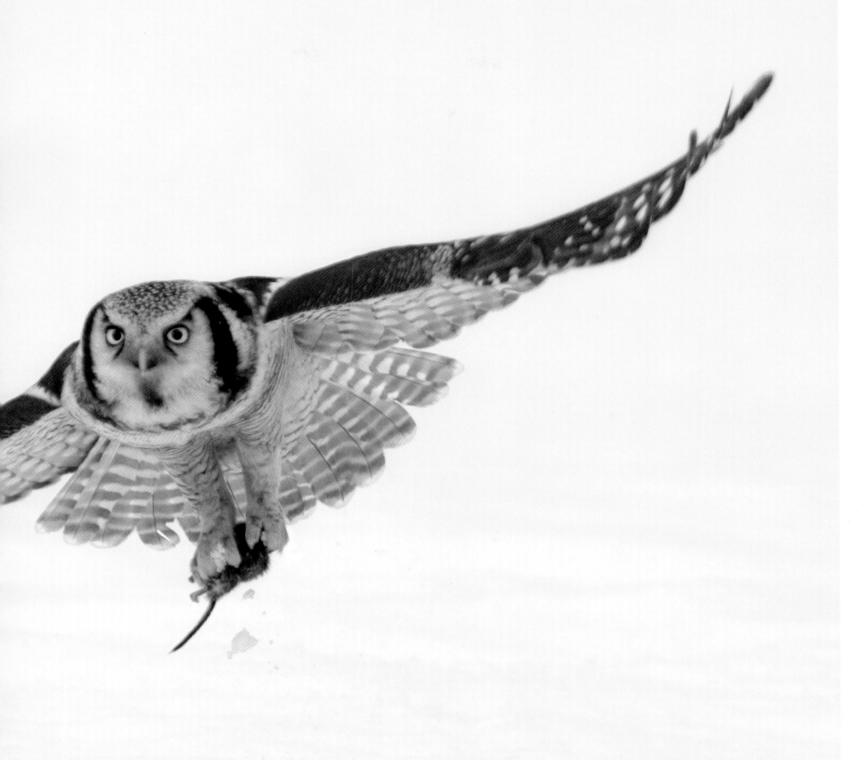

LITTLE OWL

ATHENE NOCTUA

APPEARANCE
Small, with flat head; no ear tufts; long legs; penetrating yellow eyes and white eyebrows give a disapproving stare; soft gray-brown above and below, heavily spotted in white; fine speckling on forehead and indistinct occipital collar on nape; wings long and barred in bounding flight; female larger than male; up to seven races recognized, varying in size and coloration.

SIZE
length 8.2–9 in. (21–23 cm)
weight 3.7–9 oz (105–260 g)
wingspan 21–23 in. (53–59 cm)

DISTRIBUTION
From Western Europe, as far north as Denmark and Latvia, east to eastern Russia; also North Africa, south to Mali and Niger; introduced to New Zealand and the United Kingdom.

STATUS
Least Concern

THIS SMALL, COMPACT OWL has long lived in close familiarity with humankind, its distinctive head-bobbing silhouette often popping up around derelict buildings. This may explain why the ancient Greeks saw the Little Owl as a sacred companion to Pallas Athene, goddess of wisdom and patron deity of Athens. Indeed, the owl's scientific name, *Athene noctua*, means "Athens of the night." In ancient Greek art, the bird was depicted perched on Athene's head, and it has long since appeared in this form on coins, crests, and other imagery.

In Europe, where this owl is the only member of the genus *Athene,* it is unlikely to be mistaken for any other. Thrush-size, it is stocky in shape, with a flat head, no ear tufts, and—when standing erect—surprisingly long legs. In its bounding flight, it appears long-winged and front-heavy, and reveals strong white barring on the wings. The European race is the nominate of seven subspecies, which include paler races in semidesert regions. Outside Europe, this species may be confused with the Lilith Owl (*A. lilith*) of Turkey and the Middle East, which is rather paler, and the Northern Little Owl (*A. plumipes*) of eastern China, which is smaller. Across its range, the Little Owl prefers open country, from rocky hillsides and semidesert to pastureland and open parkland. Suitable nest sites, such as old tree holes or nooks among boulders, are a prerequisite. It often frequents hedgerows or derelict buildings, where it typically sits by day on a low perch close by the nest site, and may take to gardens with fruit trees.

Like many small owls, this predator punches well above its weight. Its staple diet comprises large invertebrates, but it will also take small mammals up to the size of young rabbits, and birds as large as moorhens (*Gallinula chloropus*). Although often seen by day, it does most of its hunting at dusk. In its vigorous pursuit of prey, it has been seen to tumble backward when tugging an earthworm from the ground.

The Little Owl is sedentary throughout its range and forms long-lasting pair bonds. Partners are often seen sitting together, reinforcing their bond through mutual preening. Courtship starts in spring, when the male sings vigorously. The well-known call, given at dusk, is a high-pitched, almost cat-like "gooo-wek" hoot, with an upward inflection. When the bird is alarmed, it may rise to a faster, dog-like yapping.

The female lays her clutch of three to five eggs at two-day intervals and is responsible for incubation. The first egg hatches after twenty-two to twenty-five days, and the male provides for the female until the chicks are old enough to be left alone, at which point she will join him outside. Once able to fend for themselves, the young birds will disperse an average of 31 miles (50 km) in search of their own territory.

The Little Owl is classified as Least Concern, with an estimated population of five to fifteen million pairs. Although locally common, it is under threat in many regions from pesticides, which deplete its insect prey. It is also susceptible in northern parts of its range to severe winters. In the United Kingdom, where the species is not indigenous, it has a curious status. First kept as a pet during the 1700s, for its prowess as a cockroach killer, it was introduced to the Kent and Hampshire countryside in the 1880s and has since spread across England and into Scotland and Wales. Today, it appears to be in decline, but although its presence is not thought to cause ecological problems, its "exotic" status debars it from any specific conservation measures.

Opposite: Excellent eyesight helps a Little Owl to capture a wide variety of smaller prey.

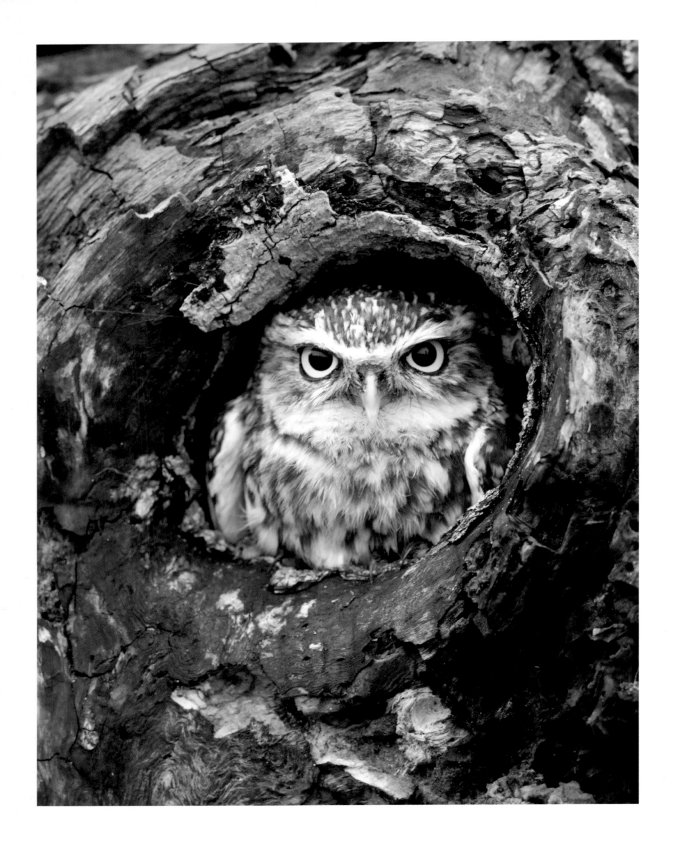

Above: A Little Owl peeks out of its nest burrow.
Opposite: The Little Owl was revered in ancient Greece as companion of the goddess Athene.
Overleaf: Little Owls are attended by their parents for several weeks after leaving the nest.

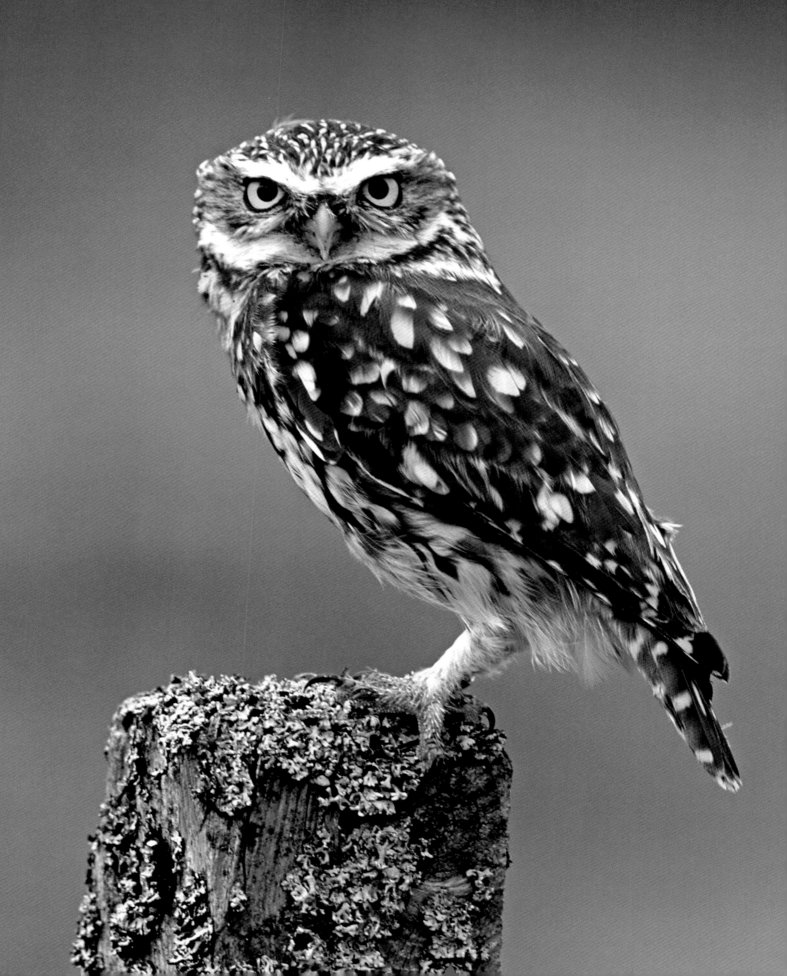

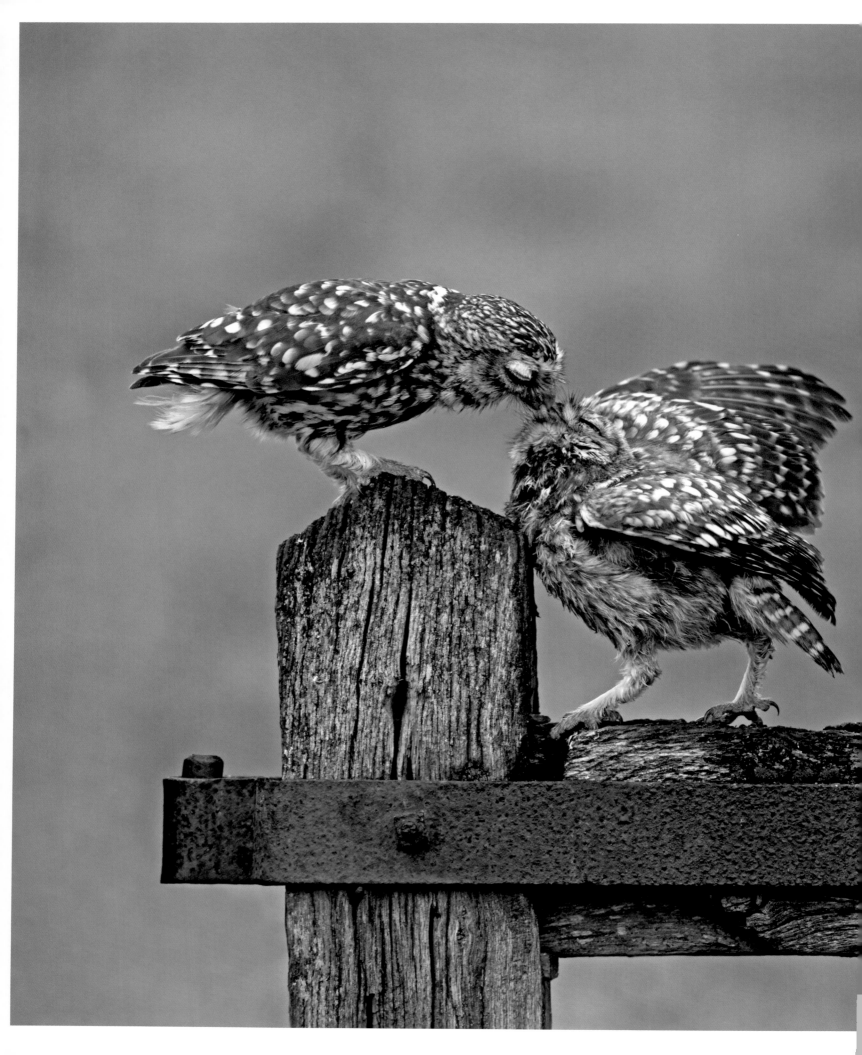

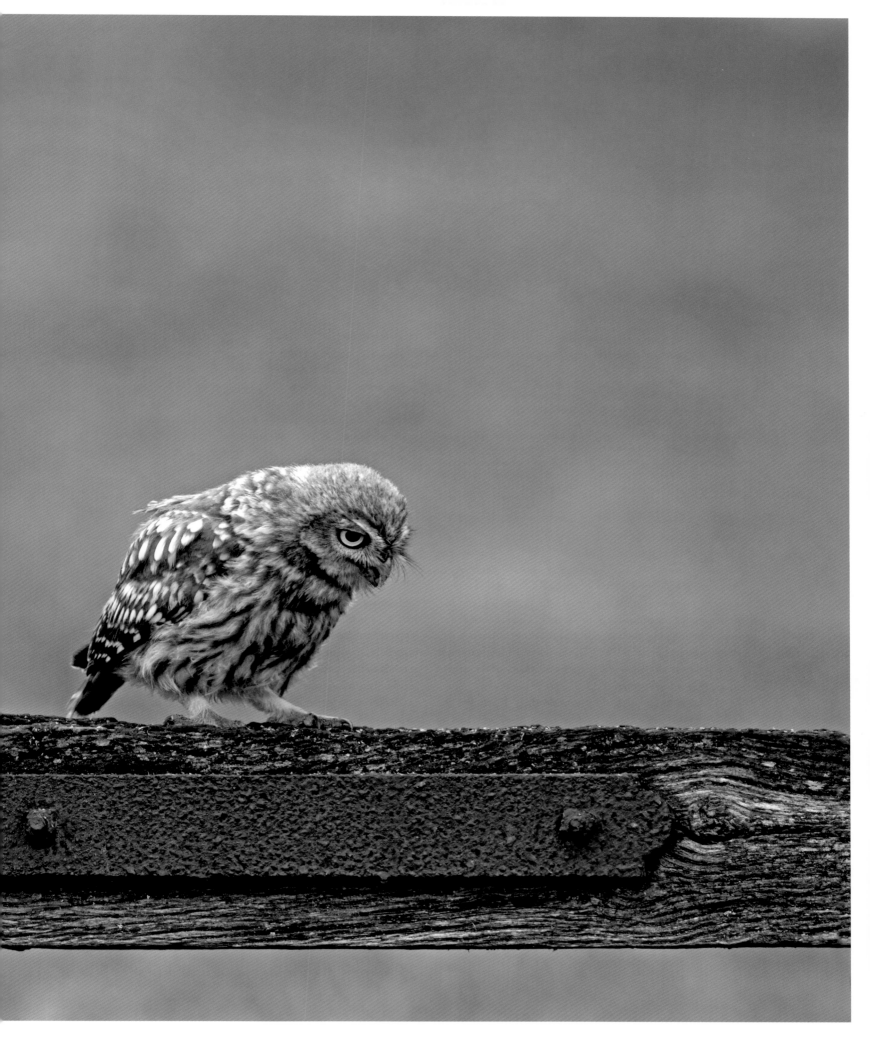

TAWNY OWL

STRIX ALUCO

APPEARANCE
Stocky, medium-size; rounded head without ear tufts; white eyebrows meet to form a bold white "V" on the crown; dark brown eyes sit in a buff facial disk; white cross between the eyes; occurs in three color morphs: brown, rufous, and gray; all morphs have heavy mottling and barring above and streaking below; bold white scapular line across shoulders; eyes dark brown to black.

SIZE
length 14–18 in. (36–46 cm)
weight 13.5–28 oz (385–800 g)
female up to 25% heavier than male
wingspan 31–41 in. (81–105 cm)

DISTRIBUTION
Eurasia, from the British Isles (but not Ireland) east to central Russia and western Siberia, north to southern Finland and south to North Africa, northwest India and Pakistan.

STATUS
Least Concern

THERE CAN BE NO BETTER-KNOWN BIRDCALL than the celebrated "tu-whit tu-whoo" of the Tawny Owl. The written phrase appeared as early as the sixteenth century, in Shakespeare's *Love's Labour's Lost*, and the sound itself has since become sound track short-hand for anything nocturnal, mysterious, or sinister. This is the owl hoot that schoolchildren imitate by cupping their hands and blowing through a gap between their thumbs. Indeed, in the popular imagination, it is the noise of all owls—no matter that many other species shriek, hiss, whistle, or croak.

"Tu-whit tu-whoo" is a little misleading. In reality, the bird's territorial call comprises a drawn-out "hoo," followed by a more tremulous, fading "hu, hu, hu, hu." It is given by both sexes, the male a little lower in pitch, and a pair sometimes calls together in duet. Although heard all year, the call is most noticeable in fall and early winter when the birds are setting up territories. The "whit" reflects the shrill, penetrating "ki-wick" given as a contact or alarm call by both sexes. Thus, two birds calling simultaneously, with the "hoo" and the "kiwick" heard together, explains the "tu-whit, tu-whoo" of popular folklore.

The Tawny Owl is found from the United Kingdom across Europe and east to central Russia and western Siberia. It occurs as far south as North Africa and Pakistan, and as far north as southern Finland. Curiously, it has always been absent from Ireland, banished by St. Patrick, so legend has it. However, the appearance of one storm-tossed individual in 2013 has led birdwatchers to hope that the species may yet colonize. Common it may be, but this owl is hard to see, hiding by day in a concealed roost, typically in its nesting cavity or dense foliage nearby. Once spotted, however, it is easily identified. Roughly pigeon-sized, it has a stocky body and large rounded head, and is the largest of the United Kingdom's breeding owl species.

The Tawny Owl is one of nineteen species in the *Strix* genus. It is closely related to the larger Ural Owl (P. 160), with which it is known to hybridize, and the smaller Hume's Owl (*S. butleri*) of the Middle East. Scientists recognize up to eleven subspecies. The nominate race, *S. a. aluco*, occurs in northern and central Europe, from Scandinavia to the Mediterranean and Black Sea. This is a sedentary species, seldom wandering more than 3 miles (5 km) from where it hatched and often roosting in the same tree for months on end. Typical habitat comprises deciduous and mixed forest, especially woodland patches beside rivers or clearings, and also extends to the parks and gardens of suburbia.

This rapacious predator is supremely adapted for hunting in darkness. It generally detects prey by sight or sound, swooping down from a perch to pluck it from the woodland floor. Superlative low-light vision and a detailed knowledge of its territory allow the bird to navigate through a wood in darkness, and its relatively short, broad wings are an adaptation for greater aerial agility among the branches. Occasionally, the Tawny Owl hunts by day, generally during peak breeding season when the chicks are demanding food around the clock, or in midwinter, when prey is hard to find.

A Tawny Owl's prey typically comprises rodents and small birds, but victims may range in size from moths and earthworms to mallard (*Anas platyrhynchos*), a bird twice its own weight. Other owls are often taken, notably the Long-eared Owl (P. 146), which shares the same habitat. This is a very

Opposite: The sleepy demeanor of this roosting Tawny Owl belies the bird's considerable aggression.

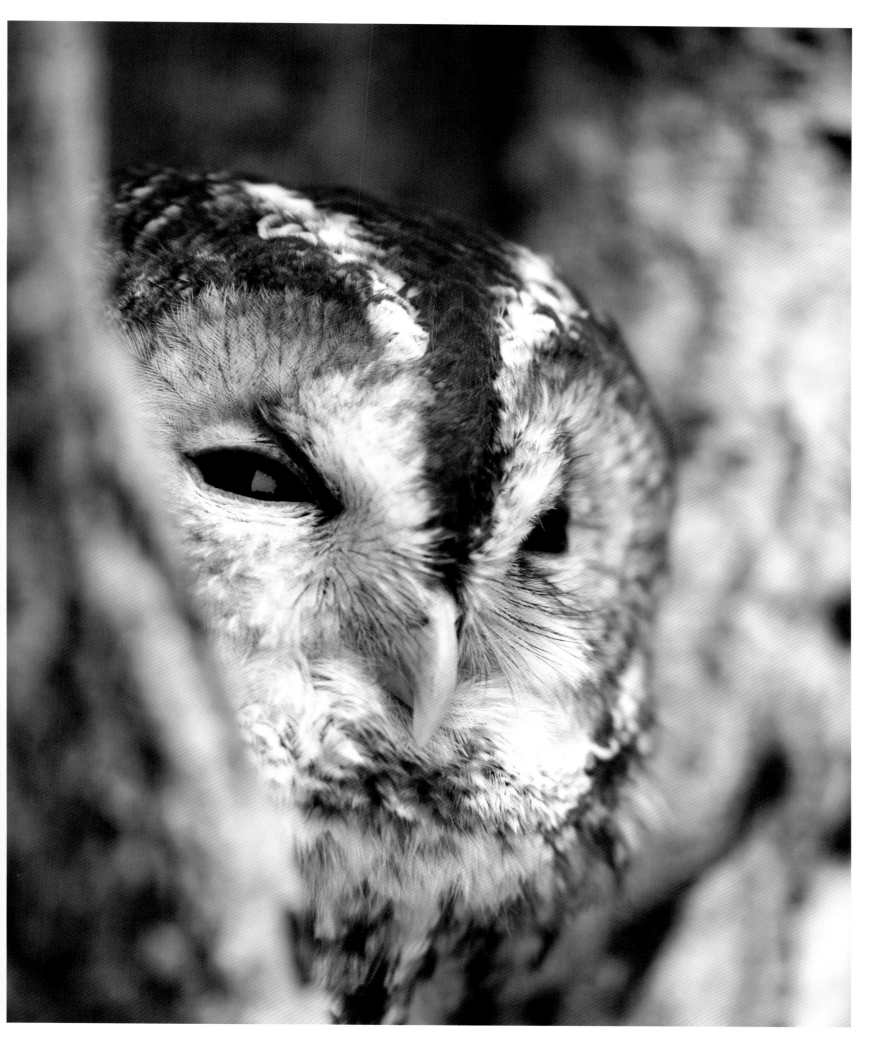

versatile predator: it has been known to hawk bats in flight, raid house martin (*Delichon urbicum*) colonies for fledglings, and even pluck goldfish from a pond. One unfortunate individual was found to have choked to death on a toad.

A pair of Tawny Owls remains together all year and may last many successive seasons. They will defend their territory aggressively against all intruders, which can make life difficult for youngsters trying to establish a place of their own. Preferred nest sites are in tree holes, often those excavated by black woodpeckers (*Dryocopus martius*). Where these are in short supply, a hollow stump or even a hole in the ground will serve just as well, and nest boxes are readily accepted.

The female lays from two to nine eggs (northerly clutches are usually larger) from late February. She starts incubating after the first egg, with the rest laid at two- to three-day intervals. Incubation lasts twenty-nine days. After hatching, the female broods the chicks for their first two weeks while the male brings food. The fluffy young leave the nest after a month and sit around nearby, sometimes tumbling to the forest floor, whereupon they use their growing wings and claws to clamber back up. Both parents continue to feed their young for another two months, while they grow. After fledging, the youngsters leave their parents' territory. Their first winter is a tough test of survival skills, and many do not make it through to spring.

With an estimated world population of two to six million, the Tawny Owl is classed as Least Concern. Although declining in parts of Western Europe, including the United Kingdom, it appears to be increasing elsewhere. Meanwhile, the bird remains ingrained in the continent's culture. In the United Kingdom, Brown Owl—the leader of a troop of girl guides—is a figurehead derived from this bird's image of and authority. This image is also celebrated in such fictional characters as Old Mr. Brown in Beatrix Potter's *The Tale of Squirrel Nutkin*, who presides like some tyrannical guru over an island and punishes the eponymous squirrel for his cheeky rhymes by tearing off his tail.

This ferocious side of the Tawny Owl is illustrated in the story of Eric Hosking. In 1938, in the Welsh retreat of Doldowlod, the famous British bird photographer was returning after dark to a tree hide from which he had been photographing Tawny Owls, when the female attacked him. "Out of the silent darkness a swift and heavy blow struck my face," he recalls. Hosking lost his left eye to the owl's talons. He held no grudge against the bird, however, and was out of hospital and photographing her soon afterward, wearing a fencing mask. Owls became Hosking's passion and are the subject of his most celebrated images. The title of his autobiography? *An Eye for a Bird*.

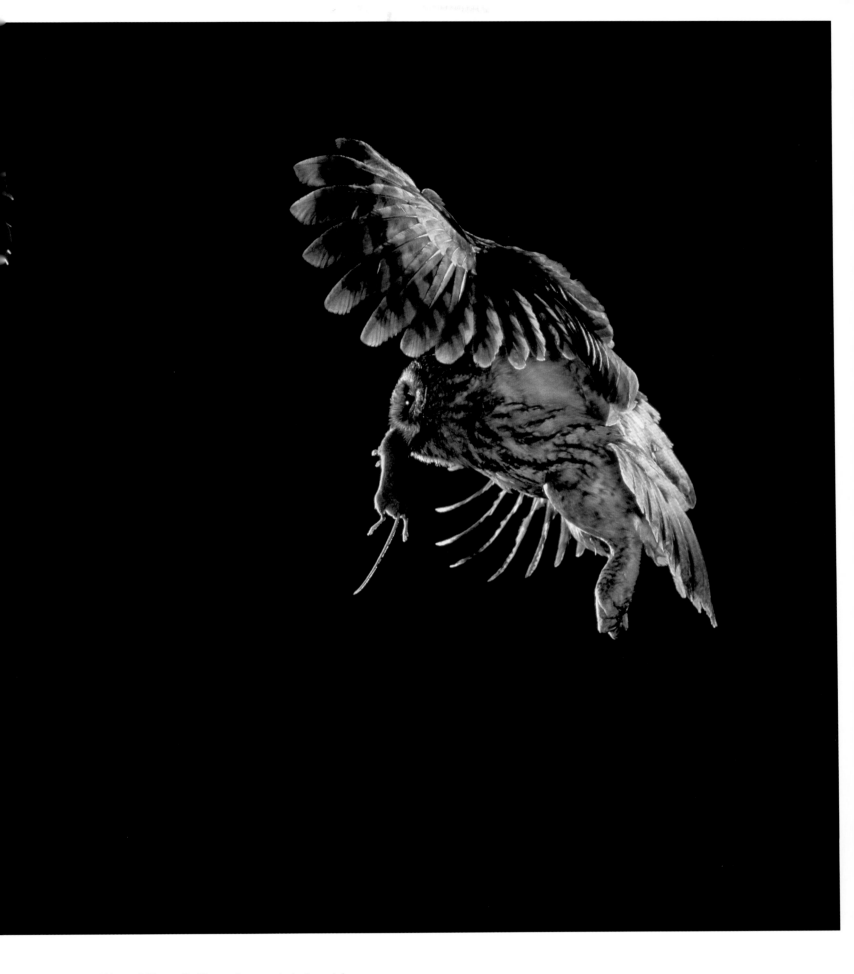

Above: A Tawny Owl hunts almost exclusively at night;
here it is returning to its nest hole with a mouse.

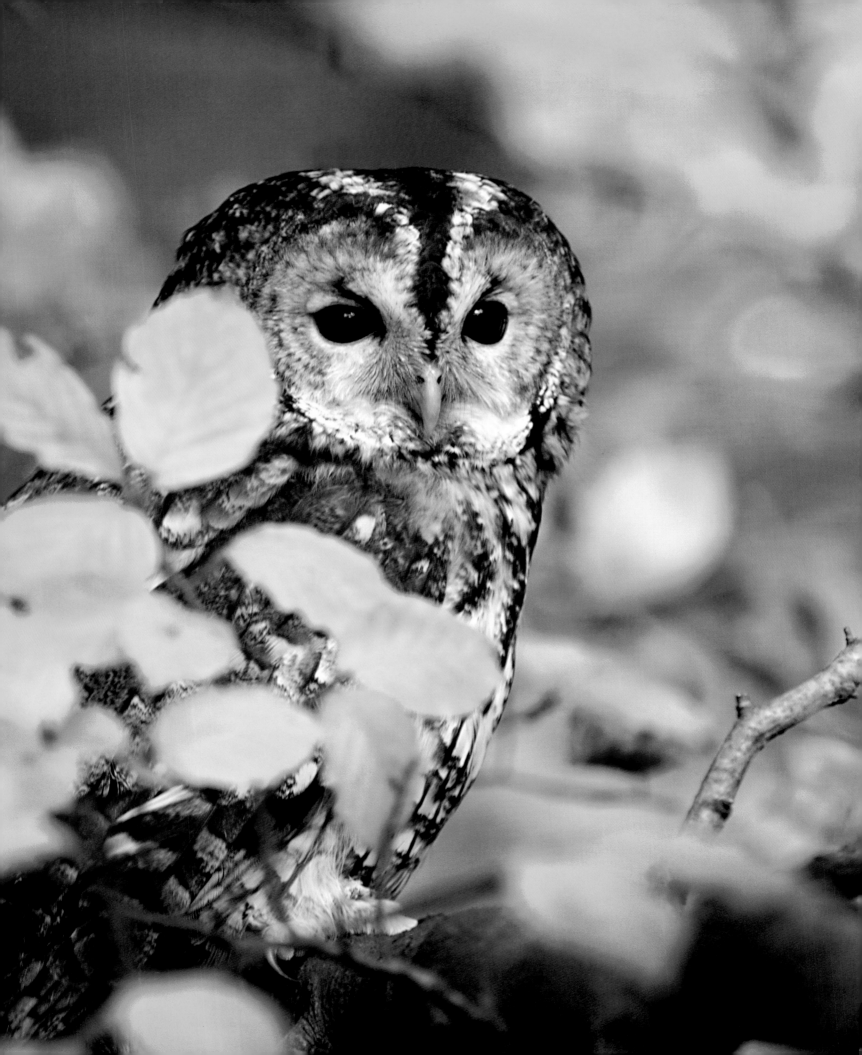

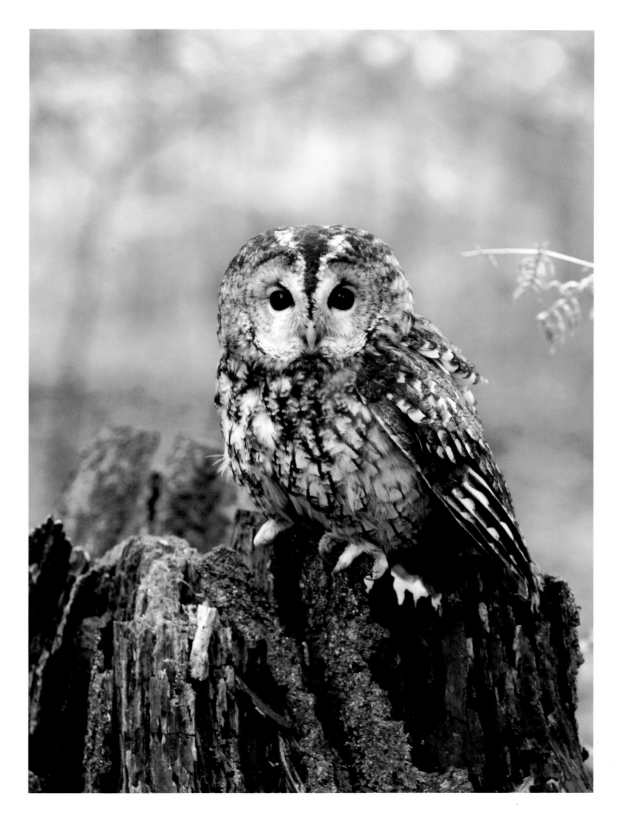

Above and opposite: Tawny Owls are largely birds of deciduous woodland;
they may sometimes be seen by day when disturbed from their roost.

EURASIA

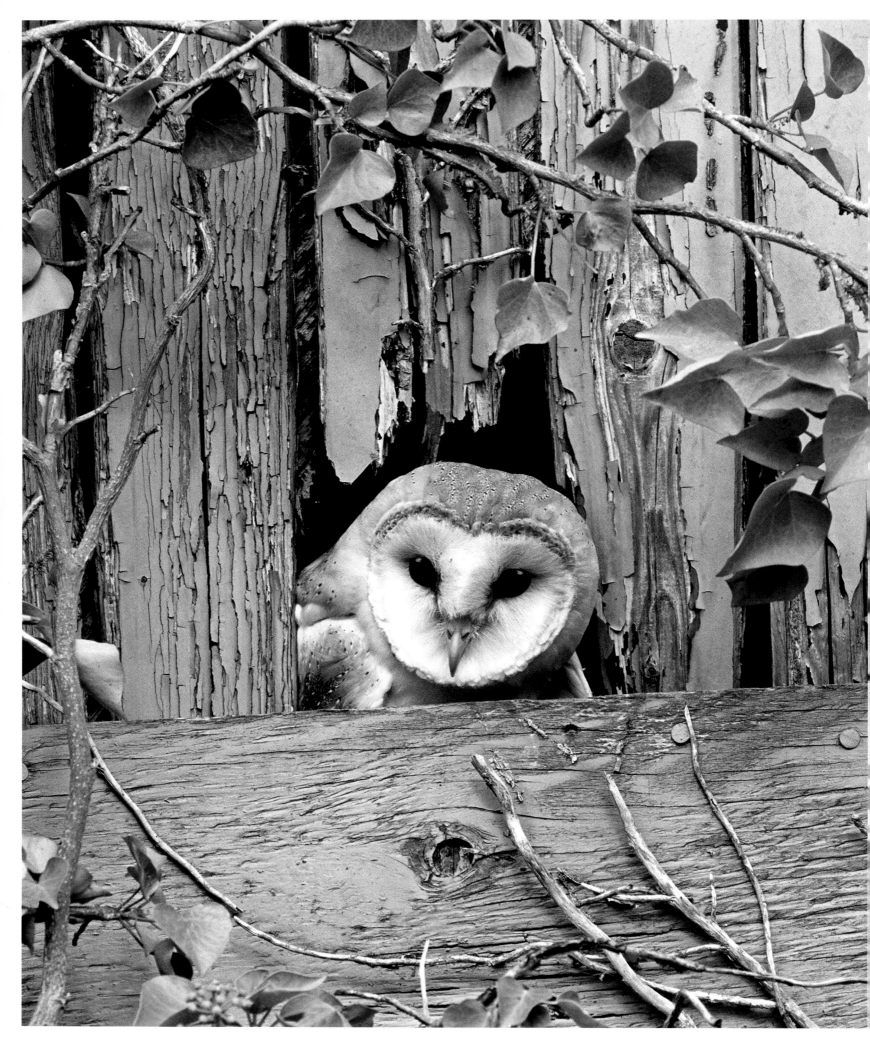

(COMMON) BARN OWL

TYTO ALBA

APPEARANCE

Pigeon-size, with slim, upright stance, long legs (for an owl), and disproportionately large head; long, rounded wings in flight; heart-shaped facial disk, which produces a mask-like appearance, complete with a ridge of raised feathers above the bill; under parts pure white to spotted buff; upper parts golden-fawn to dark brown, dusted with pale gray and a scattering of fine spots; plumage varies with race.

SIZE

length 13–15 in. (33–39 cm)
weight 10.5–14 oz (300–400 g)
wingspan 31–37 in. (80–95 cm)
females slightly larger; size varies with race

DISTRIBUTION

Found on all continents except Antarctica; absent from Asia north of the Himalayas, pure desert, polar regions, boreal forest, and most (but not all) oceanic islands.

STATUS

Least Concern

SCREECH OWL, GHOST OWL, DEMON OWL, death owl, hobgoblin owl: the sheer number of names acquired by this totemic bird attests to its deep cultural significance worldwide. Unfortunately, as the sinister connotations of these names suggest, the bird's role in popular folklore has not always been a positive one. Indeed, as late as the 1950s, rural folk in the United Kingdom would nail a spread-eagled Barn Owl to a door in an effort to ward off thunder and lightning.

An encounter with a wild Barn Owl can suggest just why it once provoked such superstition. Like most owls, it is a bird of darkness, operating at the mysterious limits of our visible world. A typical view, in the twilight, reveals what appears to be a pure white bird, appearing silently, as if from nowhere, and floating over the ground like an apparition. Imagine if this glimpse takes place near a churchyard or cemetery, both perfect hunting habitats, and is coupled with the bird's unearthly hissing screech. Small wonder, perhaps, that this owl is held responsible for numerous ghost stories across rural England.

In reality, the Barn Owl is simply a highly efficient predator of rodents that has found farmland a very productive hunting ground and so has rubbed up alongside rural communities. Indeed, so well has it adapted to this and other habitats, that the Barn Owl is not only the most widely distributed owl but also one of the most widespread of all birds. Found on all continents except Antarctica, it occurs pretty much everywhere that suitably open habitat allows, absent only from polar regions, deserts, the northern forests, and some oceanic islands.

Alba, the species name, means "white," and this bird's snow-white under parts are generally its most diagnostic feature, especially when caught in the beam of car headlights, when they appear almost to glow. Both the bird's size and plumage vary significantly among the ten or so subspecies that scientists recognize around the world. Consequently, while the nominate race, *T. a. alba*—found in the United Kingdom and much of Western Europe—has pure white under parts, the sub-Saharan African race, *T. a. affinis*, has freckled, buff under parts and the Andean race, *T. a. contempta*, is reddish-brown below and almost black above. Some races, such as *T. a. thomensis* of São Tomé, are entirely confined to small islands.

The Barn Owl in the New World has long been considered a subspecies of *T. alba*. Today, however, many scientists consider it to be a separate species—the American Barn Owl (*T. furcata*)—and, in order to clarify the distinction, refer to the Old World species as the Common Barn Owl. Although the two birds are very similar, the American bird is larger and equipped with more powerful talons than its Old World cousins. This species is further divided into six subspecies. The taxonomy, however, remains a matter of debate.

Behind the prolific spread of the Barn Owl worldwide is its extreme prowess as a hunter. Subsisting almost entirely on small rodents, this bird is supremely well adapted to capturing its elusive prey. It may hunt from a perch, but more often locates victims from the air, quartering its habitat with a low, floating flight and maneuvering with great agility to check out anything below. Powerful eyesight allows it to detect slight movements by the barest glimmer of light. Perhaps even more impressive is its hearing: ears positioned asymmetrically on a Barn Owl's head—one higher than the other—allow it to pinpoint sounds within horizontal and vertical planes, while

Opposite: Old farm buildings provide important refuges for Barn Owls in the U.K. and other areas.

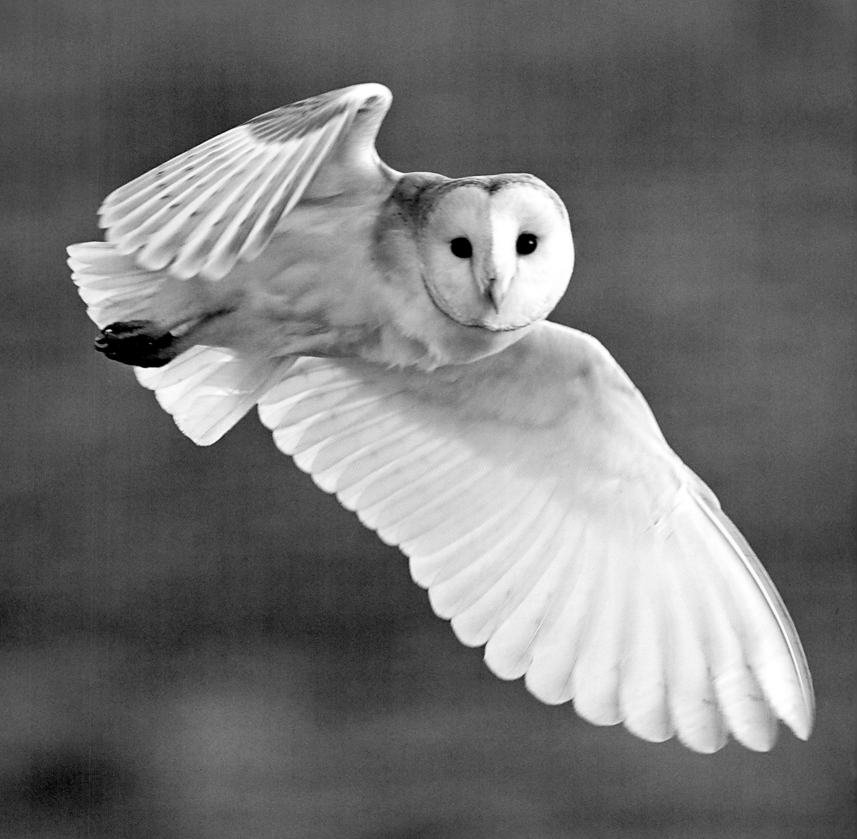

its facial disk acts like a satellite receiver, enabling it to locate the slightest rustle of a feeding rodent in pitch blackness and drop onto it with unerring accuracy. Prey is seized in needle-sharp talons, then, if small enough, swallowed whole.

This bird's appetite for rodents is impressive. Its victim of choice will depend on whatever species is most abundant in the region. An adult will consume on average at least one rodent a night, while a breeding pair and their chicks may consume more than 1,000 in a year. It is estimated that, pound for pound, the Barn Owl consumes more rodents than any other known predator. Nonetheless, it will adapt to other prey where conditions dictate; those in tropical grasslands take large insects while many island races turn to small birds.

The Barn Owl is non-territorial and has overlapping ranges of up to 20 square miles (52 sq km). A pair will choose a nest site in a hidden recess, such as a tree hole or, in farming country, an old farm building. The female typically lays four to seven eggs, with clutch and brood size directly related to food supply. In good rodent years, a pair may have two broods, or even three. Mortality is high, though: an average of 2.5 young will make it to fledging, more than half of which will not survive their first year. The average lifespan in the wild is less than four years, with accidents taking a heavy toll.

Although the Barn Owl is indisputably one of the world's most successful birds, it has suffered steep declines over much of its range. Across Western Europe it was once heavily persecuted, mainly due to a misconception among farmers and gamekeepers that it posed a threat to young chickens and pheasants. During the twentieth century, more serious threats arose in the form of chemical controls, such as DDT (dichlorodiphenyltrichloroethane), which poisoned the birds or affected their breeding success. Only relatively recently has the Barn Owl's great economic importance—it has been proven more effective than any poison in reducing rodent populations on farmland—been fully appreciated.

Today, farmers use nest boxes to encourage the Barn Owl, and countries such as Jordan and Israel have pioneered conservation schemes in which the raptors replace pesticides. Unfortunately, Europe's modern farming landscape, with its dearth of rodent-rich verges and traditional outhouses, no longer offers the Barn Owl the home it once did. On a global level, the species is listed as Least Concern, with a worldwide population—including the American Barn Owl—estimated at 4.9 million individuals. Today's U.K. population numbers fewer than 5,000 pairs, however, and across the European Union the species is listed as being of "European concern."

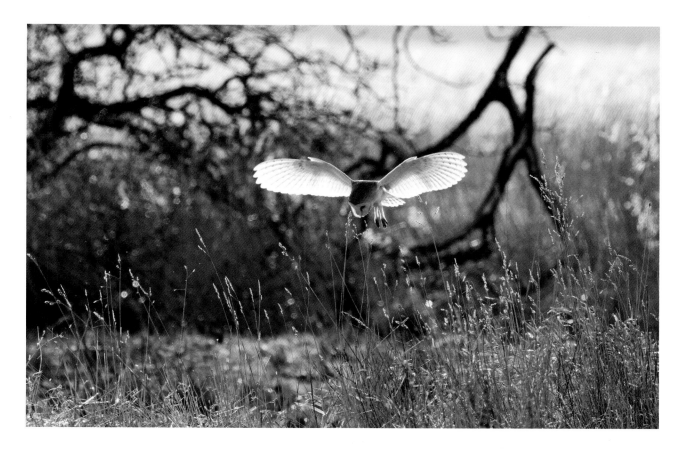

Above and opposite: The white underwings of a Barn Owl give the bird the spectral appearance that has been responsible for many ghost stories.

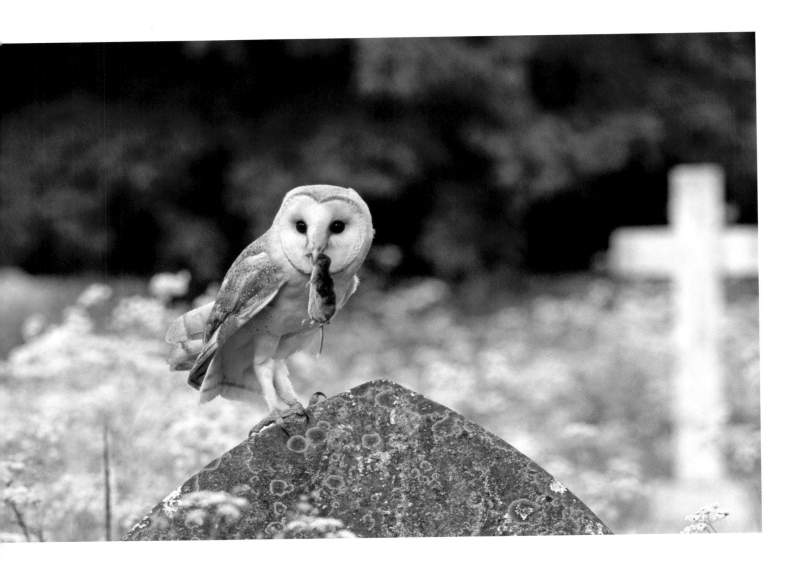

Above: A Barn Owl finds rich rodent pickings in a graveyard.
Opposite: A Barn Owl's acute hearing enables it to make pinpoint-accurate strikes on prey.
Overleaf: A Barn Owl perches beside the iconic Cley Towermill on the coast of Norfolk, U.K.

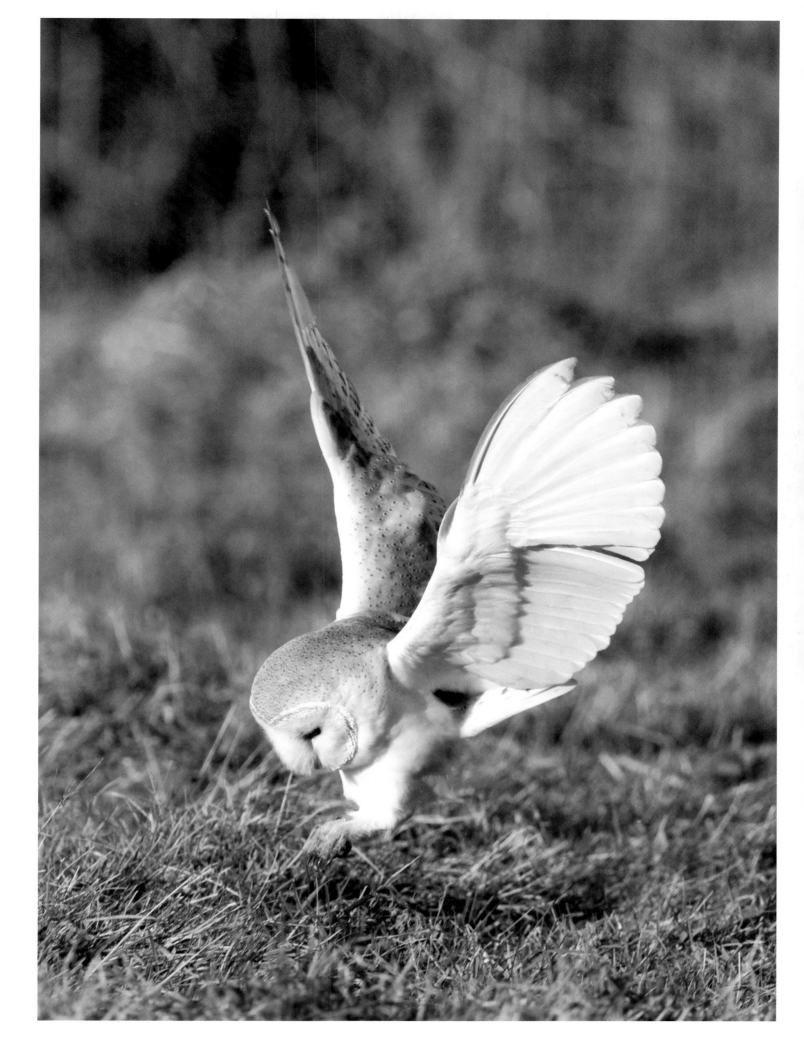

EURASIAN PYGMY OWL

GLAUCIDIUM PASSERINUM

APPEARANCE
Starling-size; dumpy body, with longish tail (for an owl) and large round head; small "pseudo ear tufts" that give the head a sharp-cornered appearance when erected in alarm; upper parts dark grayish-brown with fine spotting; under parts white with fine streaks; incomplete facial disk, with thin white eyebrows and bright yellow eyes; occipital collar on nape; female 15–20% heavier than male.

SIZE
*length 6–7.5 in. (15–19 cm)
weight 1.6–3.5 oz (47–100 g)
wingspan up to 33 in. (85 cm)*

DISTRIBUTION
Central and northern Europe, south to northern Greece; east in broad band across central Asia, through Kazakhstan, Mongolia, northern China, and southern Russia to Pacific coast.

STATUS
Least Concern

EUROPE'S TINIEST OWL is arguably its most terrifying, at least, that is, to many of the small creatures that share its forest home. No larger than a starling, this diminutive predator regularly captures birds larger than itself, and draws a frenzy of angry mobbing from others whenever they catch it in the open.

Like all *Glaucidium* pygmy owls, this species sports an occipital collar: markings that serve as false eyes to intimidate any predator approaching from behind. In its fast, bounding flight, the Eurasian Pygmy Owl shows heavily barred wings and a long tail. Its flight is surprisingly noisy for an owl: this is largely a diurnal owl, so it does not need to ambush prey in darkness and therefore lacks the sound-dampening modifications common to the plumage of many other owls.

The Eurasian Pygmy Owl is largely a bird of the northern boreal forests. Two subspecies are recognized: the nominate race is found in Europe; the other, *G. p. orientale*, which is slightly grayer and has bolder scapular spots, in eastern Russia and northern China. Its prime habitat is pine forest, up to an altitude of 11,800 feet (3,600 m), and it tends to choose territory with clearings and meadows, where hunting is easier. Although largely sedentary, birds in northern regions are subject to unpredictable southward winter movements, according to food supply. One banded bird was recovered at a distance of 186 miles (300 km) from its nest site.

This species is as characteristic in behavior as it is in appearance. It is active by day, especially in winter, and when hunting it often perches atop a tall pine tree, where it cocks and flicks its tail while scanning the area for prey. Its distinctive call—a single, short, whistled note—is repeated monotonously at two-second intervals. If the bird is excited, this can accelerate into a short trill. When not hunting or displaying, the Pygmy Owl finds a concealed roost in order to avoid not only predators, including larger owls, but also the retinue of angry songbirds. Most hunting takes place at dawn and dusk. Prey comprises an equal mix of small mammals and small birds. Indeed, the Pygmy Owl punches well above its weight, killing birds as large as the great spotted woodpecker (*Dendrocopos major*), and it may take large insects, reptiles, and even fish, depending upon what is locally available.

Pairs start to associate in late fall, but courtship does not begin until midwinter, when the male begins to call from a high exposed perch. The nest is typically in an old woodpecker cavity, often in a conifer, and nest boxes are readily used. An occupied nest is betrayed by a small pile of prey remains and other debris that the female ejects while cleaning up inside. A female lays between three and seven eggs and starts incubation only when the full clutch is laid. She incubates alone while the male brings food, often calling her from the nest to collect his offering. The young grow rapidly and leave the nest once ready to fly. They are independent by seven weeks and, if they survive the winter, will breed in the spring. Commonly, this species lives to six or seven years of age.

The Eurasian Pygmy Owl is classified as Least Concern, with an estimated world population of 300,000 to one million individuals. In northern areas, its numbers fluctuate with the vole supply, although less so than some northern owls. However, its biggest threat is deforestation, with populations fragmented by the loss or modification of their habitat. In Germany's Black Forest, where the population died out for this reason, it has since been successfully reintroduced.

Opposite and overleaf: The Eurasian Pygmy Owl is the smallest owl species in Eurasia but is a rapacious predator.

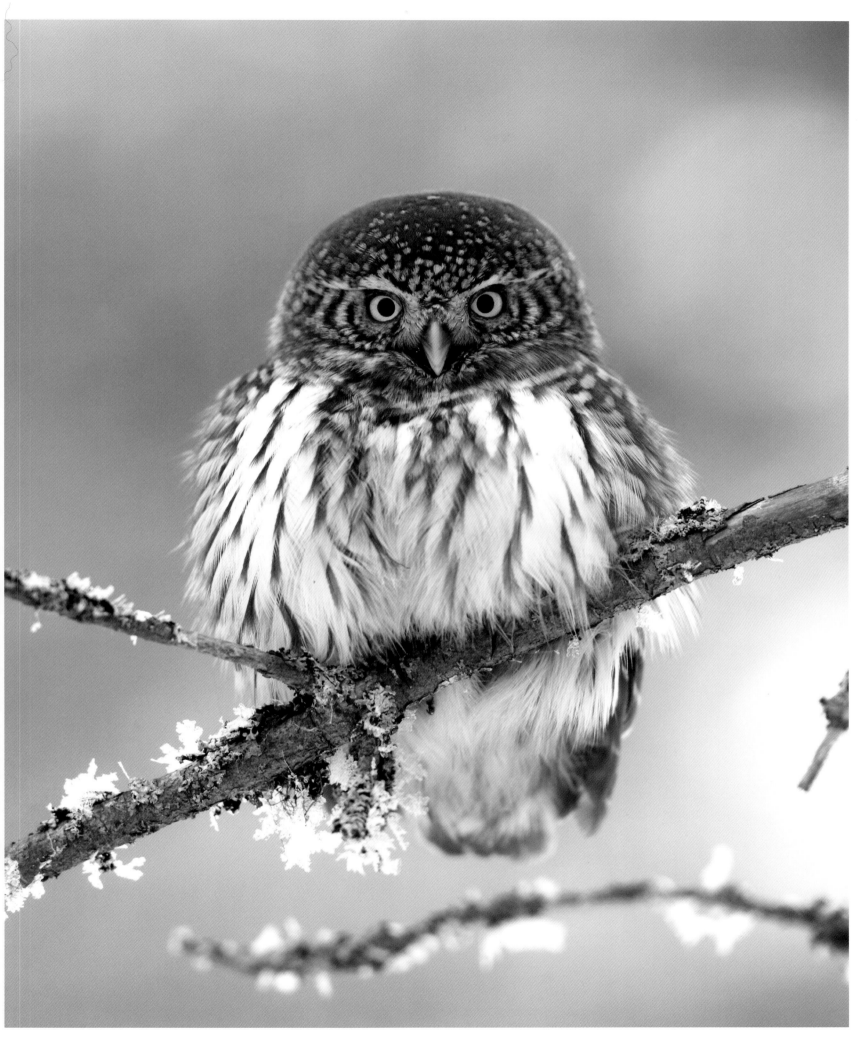

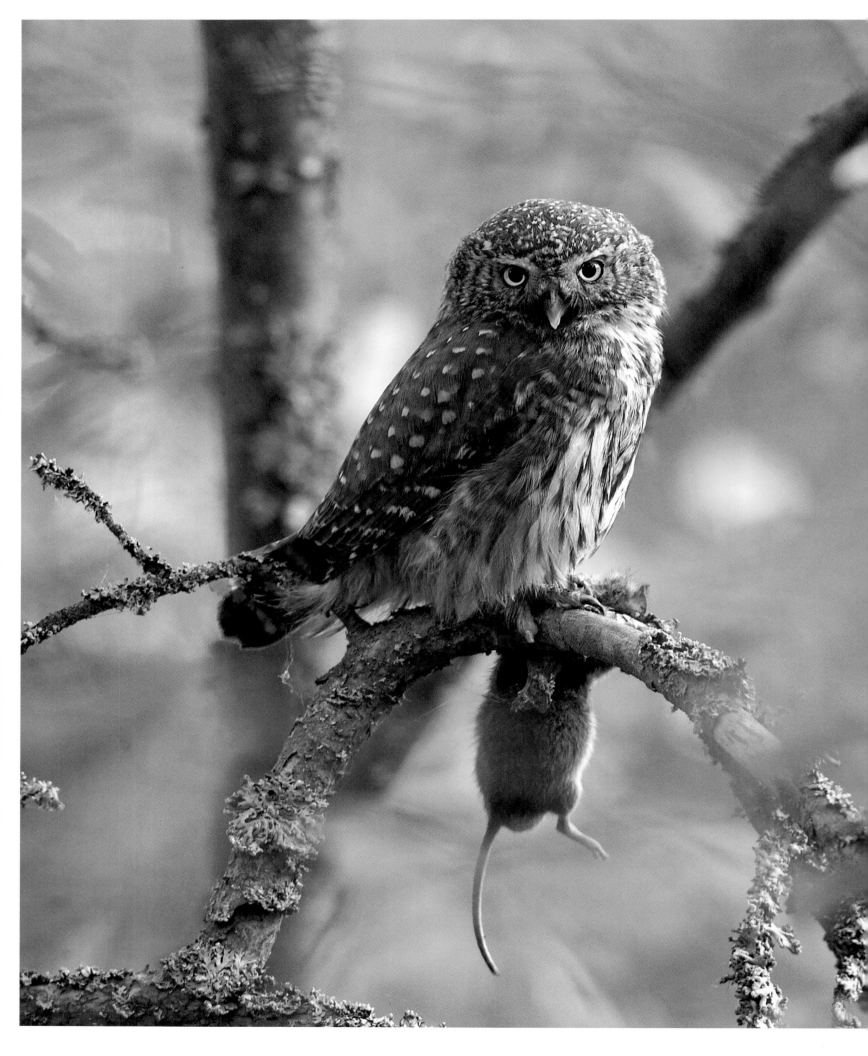

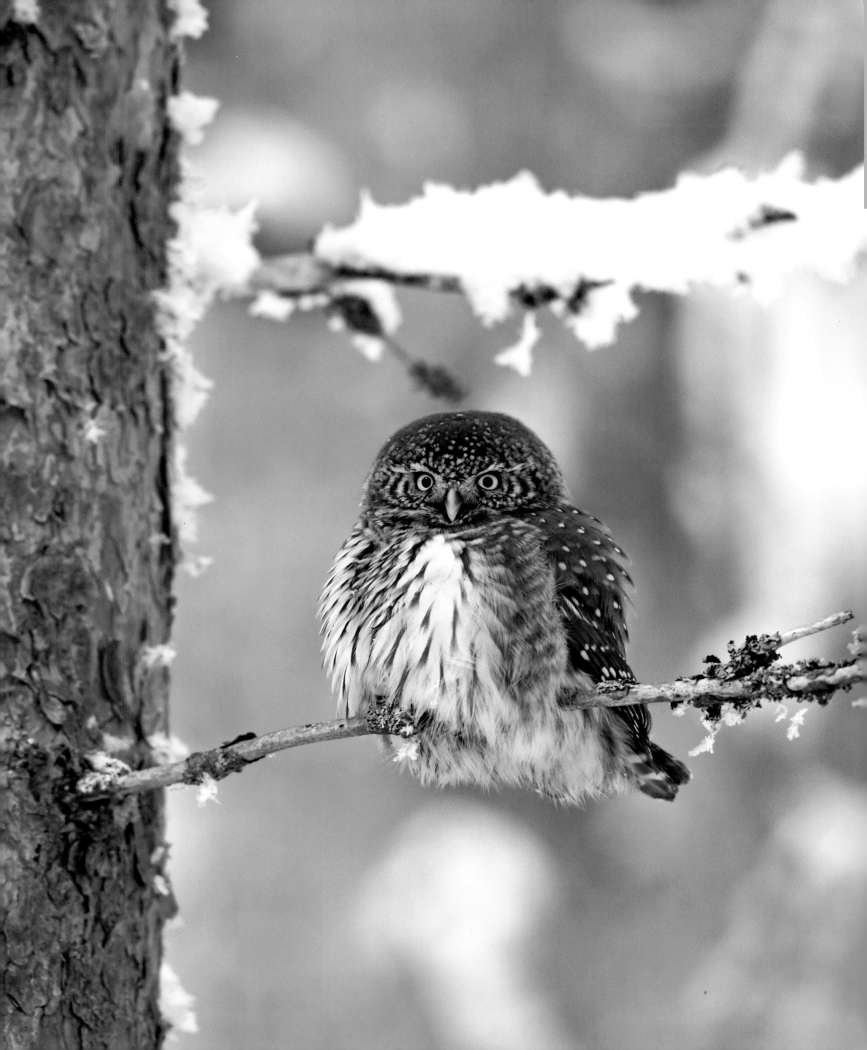

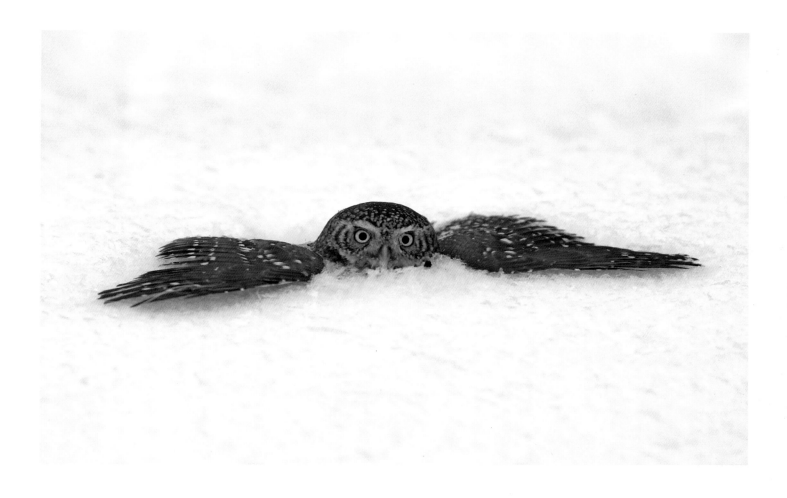

Opposite: A Eurasian Pygmy Owl watches for prey in the snowy forests of northern Finland.
Above: This species may plunge right through snow in pursuit of rodent prey beneath the crust.

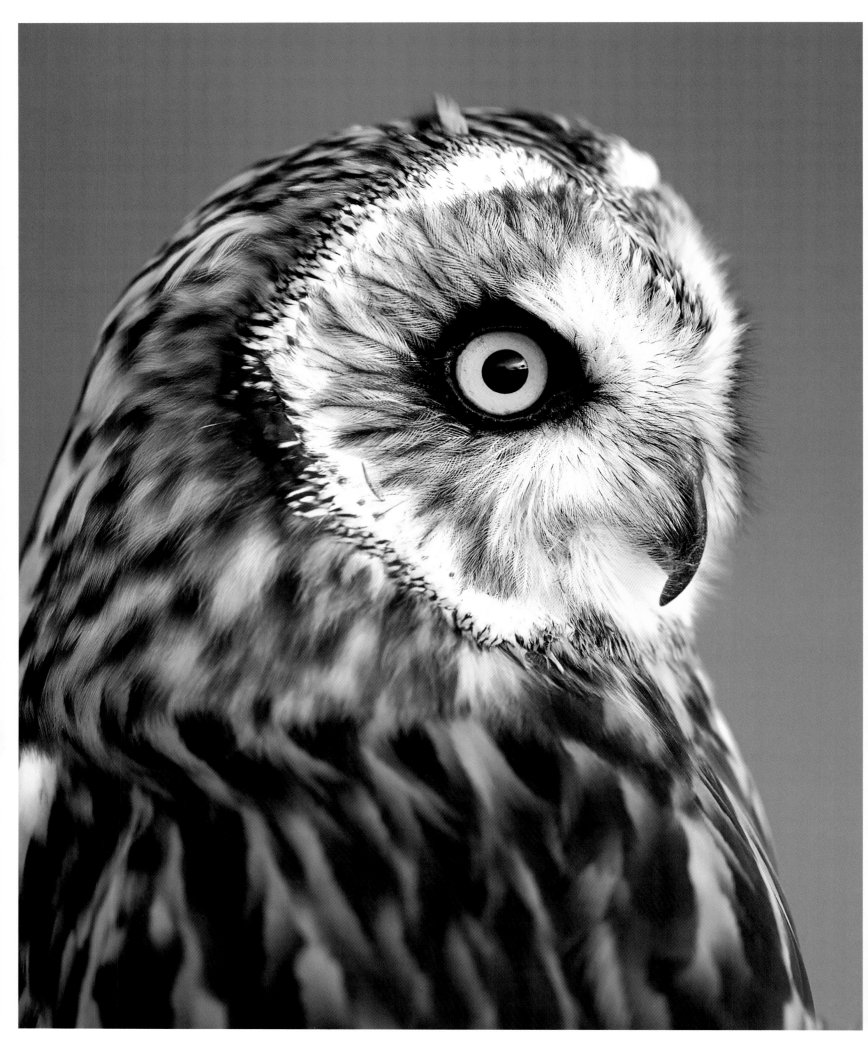

SHORT-EARED OWL

ASIO FLAMMEUS

APPEARANCE

Pigeon-size, with relatively small head and long wings for an owl; overall plumage sandy, yellowish-brown (varies by race); upper parts densely mottled in darker brown and black; streaked upper breast and white belly; bright yellow eyes, accentuated by dark outer rings; tiny ear tufts hardly visible; wings pale beneath, with dark carpal patch and broad white trailing edge.

SIZE

length 13 – 17 in. (34 – 43 cm)
weight 7.3 – 16.8 oz (206 – 475 g)
wingspan 33 – 43 in. (85 – 110 cm)
females slightly larger

DISTRIBUTION

All continents except Antarctica and Australia; central and northern Eurasia, from Iceland to northeastern Russia; in the Americas, across Canada and most of the United States.

STATUS

Least Concern

THIS STRIKING BIRD may not meet the popular image of an owl. It flies by day, for a start, and is largely silent. It also lives out in open country and grasslands, perching on posts, gliding over fields on long wings—like a harrier (*Circus*)—and even nesting on the ground, far from the nearest tree. Furthermore, some races migrate great distances over the sea.

Many of these qualities are, in fact, typical of open-country owls, which follow a more nomadic lifestyle in pursuit of their unpredictable food supply. And the Short-eared Owl is nothing if not a wanderer. With one of the largest ranges of any bird worldwide, its lifestyle is tied to the availability of voles, which make up its staple diet. In vole "explosion" years, when the rodents breed prolifically, it has the capacity to relocate to the most productive areas and to time its breeding to coincide with the period of greatest plenty. Northern populations migrate south: in Europe, heading to the Mediterranean and North Africa, as far south as the Sahel; in North America, down to Mexico and Central America; and in Russia, relocating to South Asia and the northern Philippines. In past times, before rodenticides reduced the number of voles, the United Kingdom saw periodic large gatherings of Short-eared Owls that arrived to take advantage of vole infestations.

Once known in Scotland as the "cataface," the Short-eared Owl is one of eight species in the *Asio* genus of "eared owls," named for their feathered ear tufts. These are not ears and have nothing to do with hearing, but enhance the birds' camouflage by breaking up their outline. The Short-eared Owl is perhaps not the best example of this genus, having tiny ear tufts that are only visible when the bird is threatened. More striking are its bright yellow eyes, which—accentuated by dark, mascara-like outer rings—explain its scientific species name *flammeus,* or "flame-like." This owl is most often seen in its distinctively buoyant flight, when it drifts low over the ground with floppy, almost moth-like wingbeats, sometimes gliding with wings held up in a shallow "V." The white belly and broad white trailing edge to the wings distinguish it from the closely related Long-eared Owl (P. 146), which appears quite similar in flight.

The Short-eared Owl is present on all continents except Antarctica and Australia. In the Americas, it is found across Canada and most of the United States and, discontinuously, into northwestern and southern South America. It has also colonized many oceanic island groups, notably the Caribbean, Hawaii, and the Galápagos. With such a wide range, it is not surprising that the taxonomy is complex. At least ten races are recognized, differing largely in coloration, of which the nominate race, *A. f. flammeus,* is found on both sides of the Atlantic. Most island races, with the exception of the migratory Falkland Island race *A. f. sanfordi,* are sedentary and many are in the process of speciation. Indeed, some authorities now recognize the Galápagos Short-eared Owl (*A. galapagoensis*) as a species in its own right.

Typical habitat includes prairie, savanna, meadows, tundra, and young plantations, as long as it offers good ground cover for nesting and roosting. Although a day-flying bird, the Short-eared Owl is most active during the early morning and late afternoon. Occasionally, in bad weather, it hunts from a perch, but generally it hunts in flight, quartering the ground and flying into headwinds so that it can hover and maneuver at low speeds. Once the prey is sighted,

Opposite: Dark rings around bright yellow eyes give the Short-eared Owl one of the most penetrating expressions of all birds.

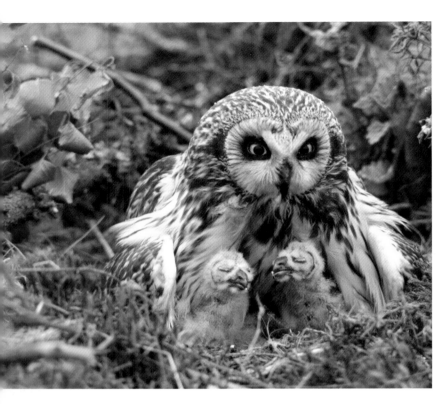
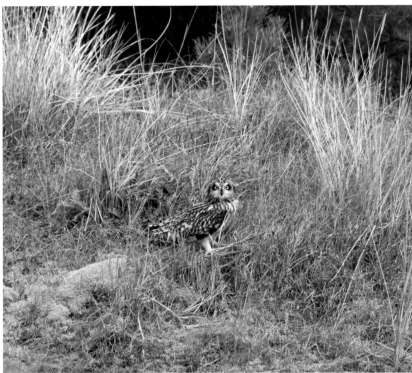

it swoops down feet-first and grabs it in its talons. In addition to voles, other prey includes larger mammals, up to the size of young rabbits and muskrats. Birds are sometimes on the menu, too, especially ground-dwelling species such as plovers (Charadriinae) and larks (Alaudidae), and particularly when the owls are hunting on wetlands near the coast. The Galápagos Short-eared Owl has learned how to capture storm petrels (Hydrobatidae); it hides behind rock outcrops and ambushes them on the ground. In areas of abundant food, the Short-eared Owl may gather in larger numbers. It is perfectly tolerant of others in the group because open-country owls are less territorial then forest owls. However, it faces fierce competition from other raptors that share the same habitat, notably the hen harrier (*Circus cyaneus*), from which it sometimes steals prey.

Breeding begins in March in the northern hemisphere and is heralded by the display flight of the male, who flies high above the ground with exaggerated slow wingbeats, sashaying from side to side and clapping his wings audibly. The call—given on the wing—is a series of deep pumping hoots. This bird also makes a scratchy bark and loud rising scream. The dramatic aerial performance is a prelude to mating, to which the female usually consents after a gift of food from her suitor. She makes the nest on the ground, most often in a hollow concealed by low vegetation. Unusually

for an owl, she attempts a little interior decor, lining the hollow with weeds, grass, or feathers. Ground nests are more vulnerable than tree holes, but they have the advantage of offering a wider range of sites, thereby enabling the owls to breed quickly should conditions dictate. Several pairs may nest close together, and males may be polygynous, mating with several females, although pairing up with only one.

The female lays an average of four to seven eggs, though clutches as large as sixteen have been recorded in bumper vole years. If prey remains plentiful, the pair may attempt a second brood. The eggs are laid one every other day and incubation starts immediately, which means that the resulting brood has a wide age range and the youngest often fail to survive. The offspring develop quickly, wandering out of the nest from as early as twelve days, and fledging at just over four weeks. During this period, the female will attempt to lure any inquisitive predators from the nest in a distraction display, feigning a damaged wing.

With a wide global range and an estimated population of two million individuals, this bird is classed as Least Concern. However, numbers have fallen steeply in some parts of its range, notably North America, and some races—the Hawaiian subspecies *A. f. sandwichensis*, for example—are endangered. The main threat in many areas is the loss of habitat (and therefore voles) to intensive agriculture.

Above left: Short-eared Owls raise their chicks on the ground.
Above right: The nest site is hidden in long grass.

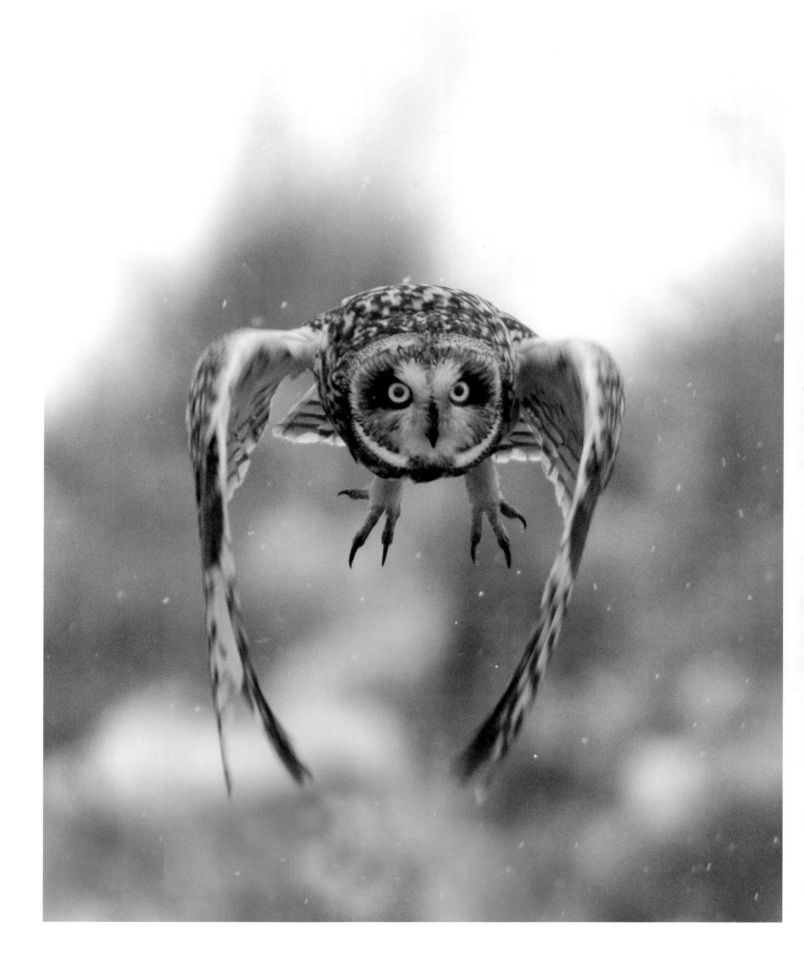

Above: With deep wingbeats and talons extended, a Short-eared Owl zeroes in on its target.

Right: Short-eared Owls hunt largely by daylight over open country and are not fazed by a blizzard.

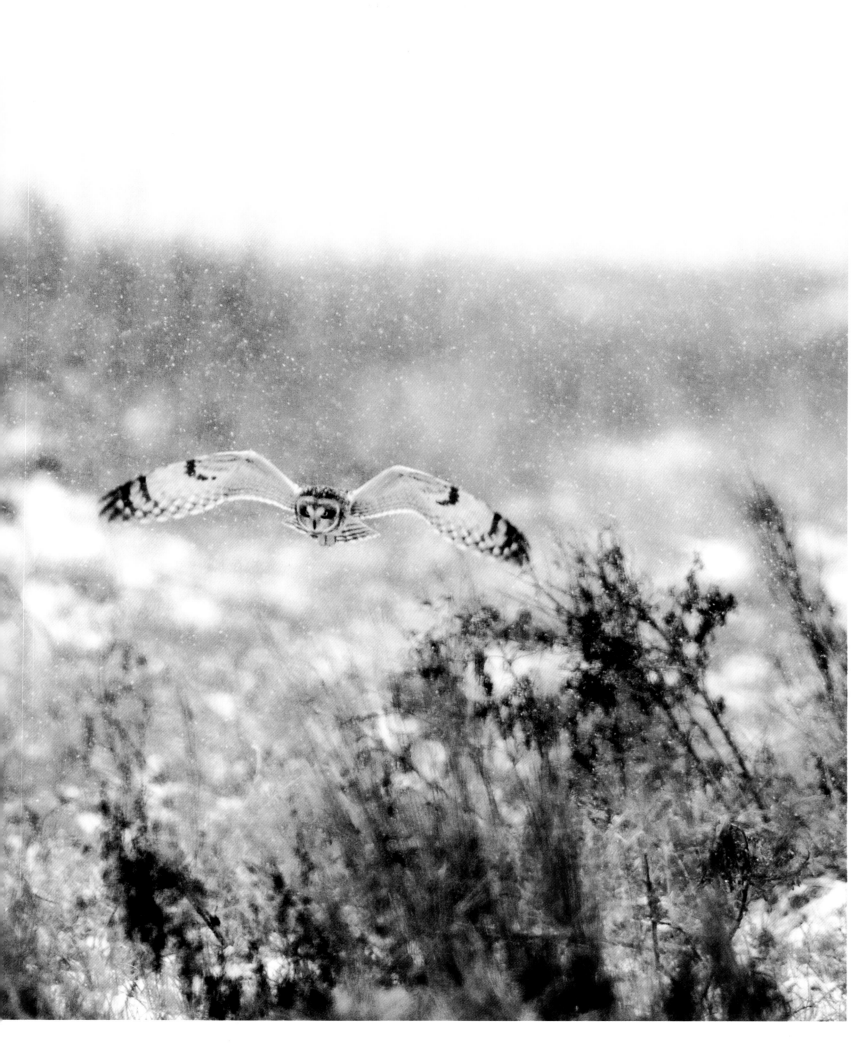

LONG-EARED OWL

ASIO OTUS

APPEARANCE

Slim owl; upper parts heavily spotted and barred; under parts thickly streaked with dark brown down to legs; buff facial disk with blackish rim, short white eyebrows, and orange to yellow eyes (according to race).

SIZE

length 13.7–15.7 in. (35–40 cm)
weight 7–15.3 oz (200–435 g)
wingspan 35–39 in. (90–100 cm)

DISTRIBUTION

Ranges widely across northern hemisphere: in North America, from south Canada to north Mexico; in Eurasia, from the United Kingdom and mainland Europe east to North Korea and western Himalayas; also North Africa, the Canary Islands, and the Azores.

STATUS

Least Concern

THIS ELEGANT, MEDIUM-SIZE OWL derives its name from its conspicuously long ear tufts, which it erects when trying to hide. These serve to break up the bird's telltale outline so that it disappears more convincingly among the tangle of foliage at its roost. Not that a Long-eared Owl needs much help with camouflage: its cryptically patterned plumage makes this species very hard to spot. If disturbed, it will compress its body into a slim, stick-like shape and stand erect on a branch, with nothing to give it away but its piercing eyes.

A good view in broad daylight reveals an owl that is roughly the same length and color as the Tawny Owl (P. 120), whose range it shares, but one-third or more lighter. Its plumage is warm grayish-brown above and gingery buff below. In flight, however, this bird is very different from a Tawny Owl. It has the longer wings of an open-country hunter, and glides considerable distances between short wingbeats. The ear tufts are seldom visible in flight, but a black comma-like carpal patch at the wrist is a good identification feature.

The Long-eared Owl is one of seven species in the *Asio* genus of "eared owls." Close relatives include the very similar Madagascar Long-eared Owl (*A. madagascariensis*) and the Abyssinian Owl (*A. abyssinicus*). Taxonomists recognize four subspecies, with the nominate race occurring in Eurasia and North Africa. Wherever it occurs, the Long-eared Owl likes a habitat mosaic of forest patches, in which it breeds and roosts, and open land, in which it hunts. Populations fluctuate with food supply. More northerly birds are migratory, heading south in winter in search of food. In some areas, notably Eastern Europe, large communal roosts form; sometimes more than one hundred birds gather among trees in a park. These may be the origin of the expression "Parliament of owls."

Generally, the Long-eared Owl is a secretive and largely nocturnal bird, hard to spot by day as it crouches motionless in thick foliage. At dusk, usually an hour before sunset, it comes out to hunt and may continue until dawn. Its staple diet is voles and other small rodents, but it will also take birds, bats, frogs, and insects. It generally hunts in a slow, low quartering flight over open ground, often following hedges and woodland edges, and dropping down on any prey that it spots. It uses a headwind in order to slow, hover, and turn with more ease.

The calling of the Long-eared Owl is a prelude to breeding. In resident birds, this may start from late fall; in migrants, it is early spring, as they return to their breeding grounds. The male's call—given mostly from dusk to midnight—is a soft, breathy "whoo," somewhere between a hoot and a pigeon's coo, and it is repeated every two to four seconds. The female answers with a harsher yelping. Circling his territory at treetop height, the male reinforces his message with a display flight, clapping his wings on the downstroke.

A pair may breed together for a few seasons. They generally use the old stick nest of another bird, such as a magpie, crow, or raptor. The female selects the nest and lays up to eight eggs over a week or more. Chicks clamor for food with piercing calls, often likened to the squeak of a rusty hinge. If surprised at the nest, a female will adopt a defensive posture, her wings half-raised and spread in order to double her apparent size.

The Long-eared Owl is listed as Least Concern, with an estimated population of some 1.5 to 5 million individuals across its broad range. Nonetheless, this secretive species is very hard to monitor, and there is evidence from parts of Europe of a gradual decline.

Opposite: Few owls are harder to detect than a Long-eared Owl at its roost.

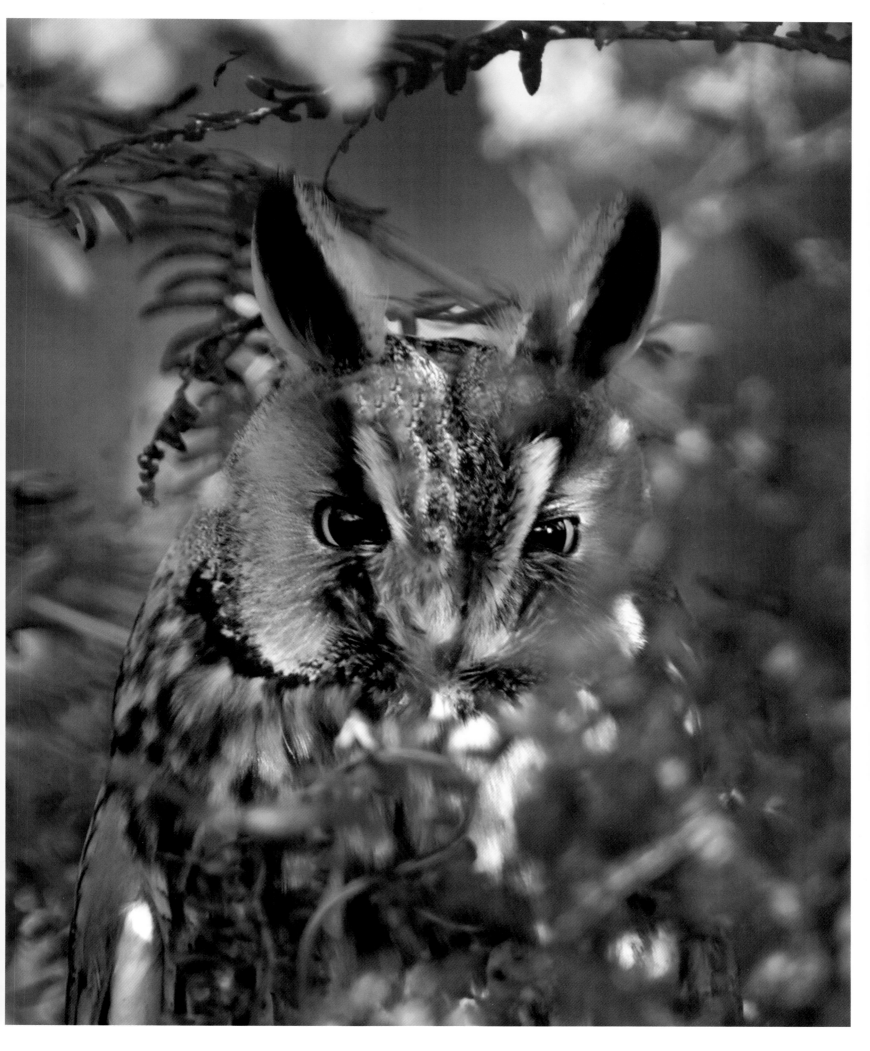

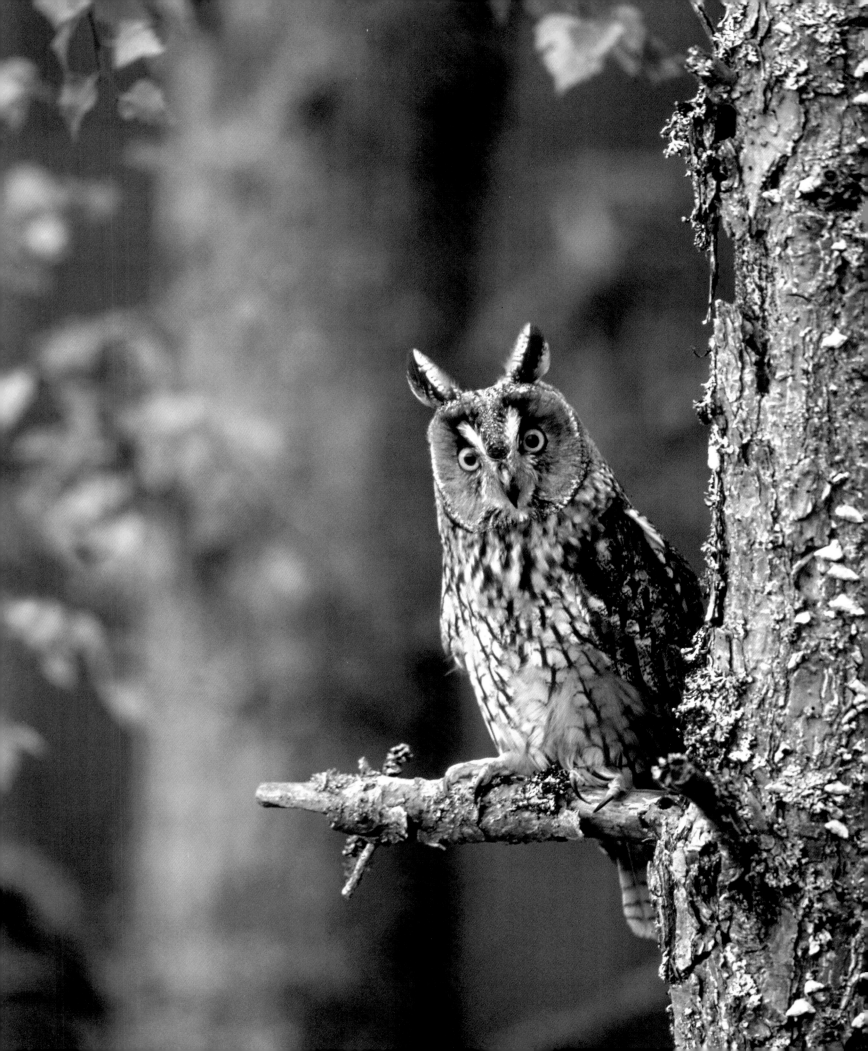

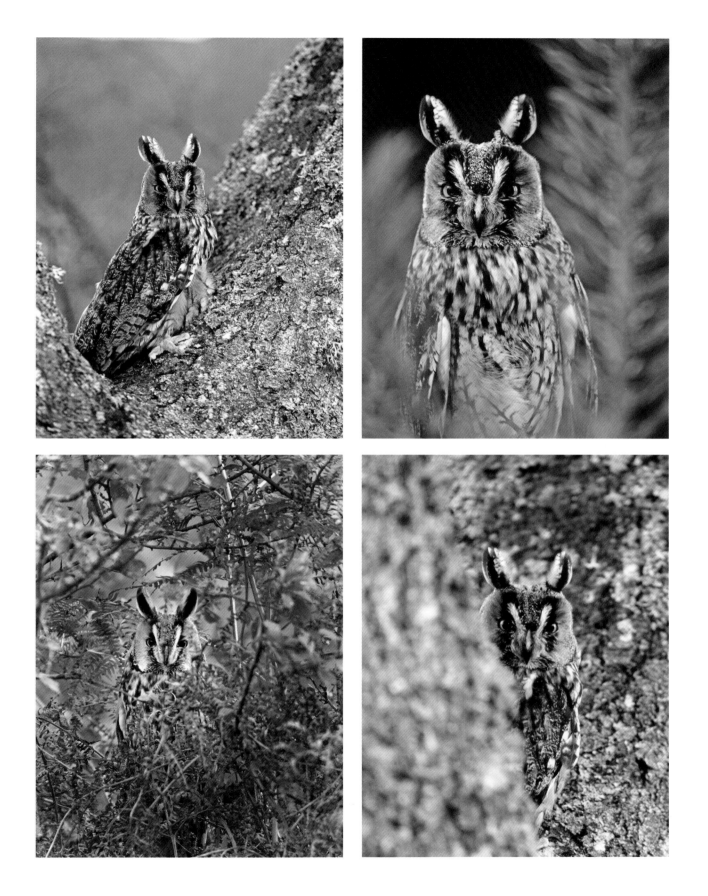

Opposite and above: The prominent ear tufts of a Long-eared Owl help to provide camouflage in a variety of forest habitats. They may also express mood, being erected when the bird is alert or alarmed.

EURASIA

GREAT GREY OWL

STRIX NEBULOSA

APPEARANCE
*Very large, with huge head
and long tail; smoky gray-brown
plumage, heavily mottled on
upper parts and streaked on
under parts; large facial disk,
with dark concentric rings
around small yellow eyes;
white eyebrows and small dark
"beard"; in flight, broad wings
heavily barred.*

SIZE
*length 24–33 in. (61–84 cm)
weight 1.28–4.19 lb (570–1,900 g)
wingspan up to 60 in. (152 cm)*

DISTRIBUTION
*Across the Holarctic belt of the
northern hemisphere, from northern
Eurasia and northeastern China; also
into northern North America.*

STATUS
Least Concern

THIS BIG BIRD OF THE NORTHERN FORESTS must surely be the original "wise old owl." If some owls appear ferocious or cross, then this one's expression suggests intense intellectual curiosity; you almost expect it to peer over a pair of bifocals. The impression of aged wisdom comes perhaps from the concentric rings and semicircular white eyebrows that surround the bird's small yellow eyes, and the small black goatee beard beneath the bill. Furthermore, the huge head—the largest of any owl—is the head of a boffin.

Wisdom, however, is only in our imaginations. In fact, the owl's huge round facial disk aids phenomenally acute hearing, which enables it to locate and capture by sound alone a vole creeping along its burrow some 23 inches (60 cm) beneath the snow. And all those feathers exaggerate the head's real size. Indeed, this entire owl—on average, the longest of all the world's owls—is not as large as it seems. Although measuring longer than the Eurasian Eagle Owl (P. 103), it weighs only half as much and is a far less powerful bird.

The Great Grey Owl ranges right across the Holarctic belt of the northern hemisphere, from northern Eurasia into northern North America. It is the largest of nineteen species in the *Strix* genus of typical owls and closely related to the Tawny Owl (P. 120), and Barred Owl (P. 69). There are two principal subspecies: the American race, *S. n. nebulosa,* is the nominate one and ranges from Alaska to Quebec and south to the northern states of the United States, including Wyoming

and Minnesota. The European race, *S. n. lapponica,* occurs across northern Eurasia, from Fennoscandia through Siberia to Sakhalin and northeastern China, ranging as far north as the north of Norway and as far south as Poland. Taxonomists have also recently recognized a third race, *S. n. yosemitensis,* which occurs as a small population in the Sierra Mountains of northern California.

The Great Grey Owl does not migrate, but, like other northern species that depend upon a staple diet of voles, it is often obliged to make local movements as this food supply fluctuates, generally heading south when food becomes scarce further north. The most northerly populations are most at the mercy of the weather, and radio tracking of individual owls has recorded movements of up to 400 miles (650 km) in three months. Occasionally "irruption" years occur, when large numbers of Great Grey Owls are forced to move en masse: the winter of 1980 to 1981 saw hundreds move from Russia to Finland and beyond; while the North American winter of 2004 to 2005 saw an unprecedented 5,000 owls recorded in Minnesota, thirteen times the previous state record.

The favored habitat of this species is boreal forest, notably of spruce, pine, and birch. Ideal forest habitat requires clearings and swampy areas in which to hunt, tree stumps on which to perch, and old, broad trees in which to nest and roost, which is why dense forestry plantations that lack these features are unsuitable. In winter, it often moves out of the forest onto farmland, where it is frequently seen around farmhouses.

The Great Grey Owl, also known as "spectral owl" and "bearded owl," is a crepuscular species, hunting mostly at dawn and dusk but also sometimes through the night. When inactive, it roosts in a concealed spot against the trunk of a large tree, adopting a tall, thin stance when alarmed. When hunting, it either takes up a high perch on which to wait, listen, and watch for prey, or flies low and silently over open areas searching the ground below. Its huge facial disks enable the bird to focus sound with great precision, and it can detect

**Opposite: A hollow tree stump makes a perfect nest site for the
Great Grey Owl.**

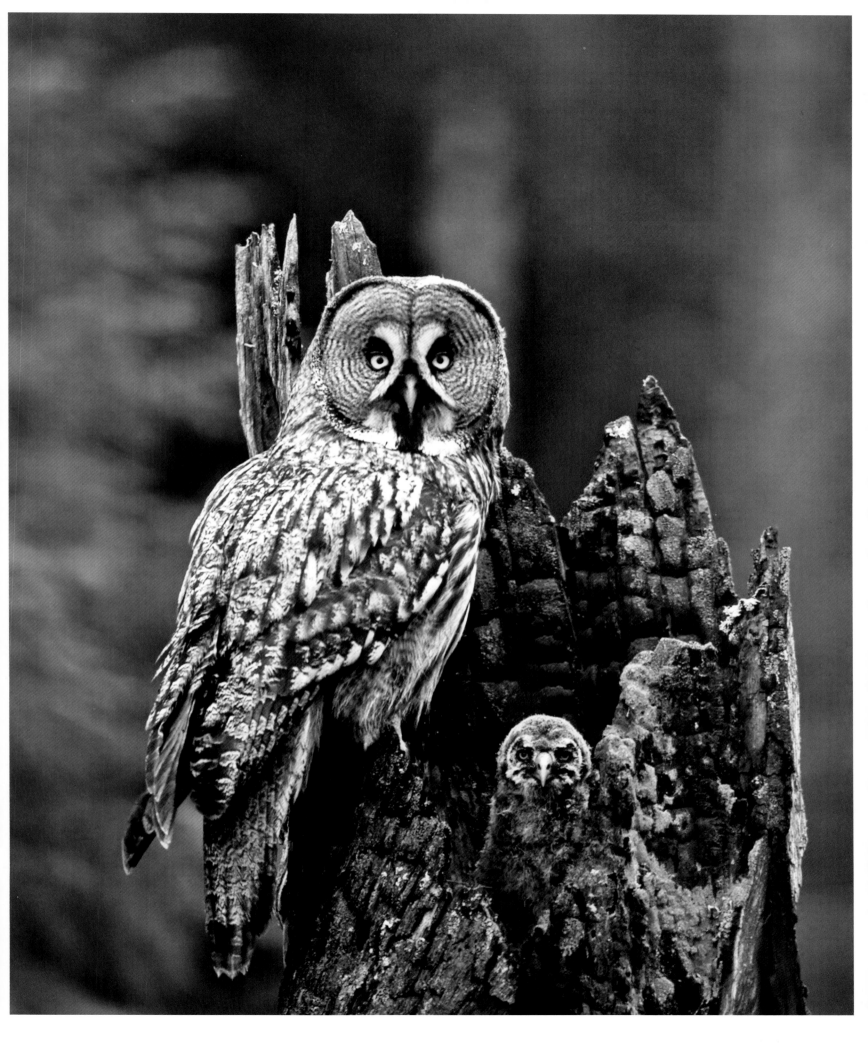

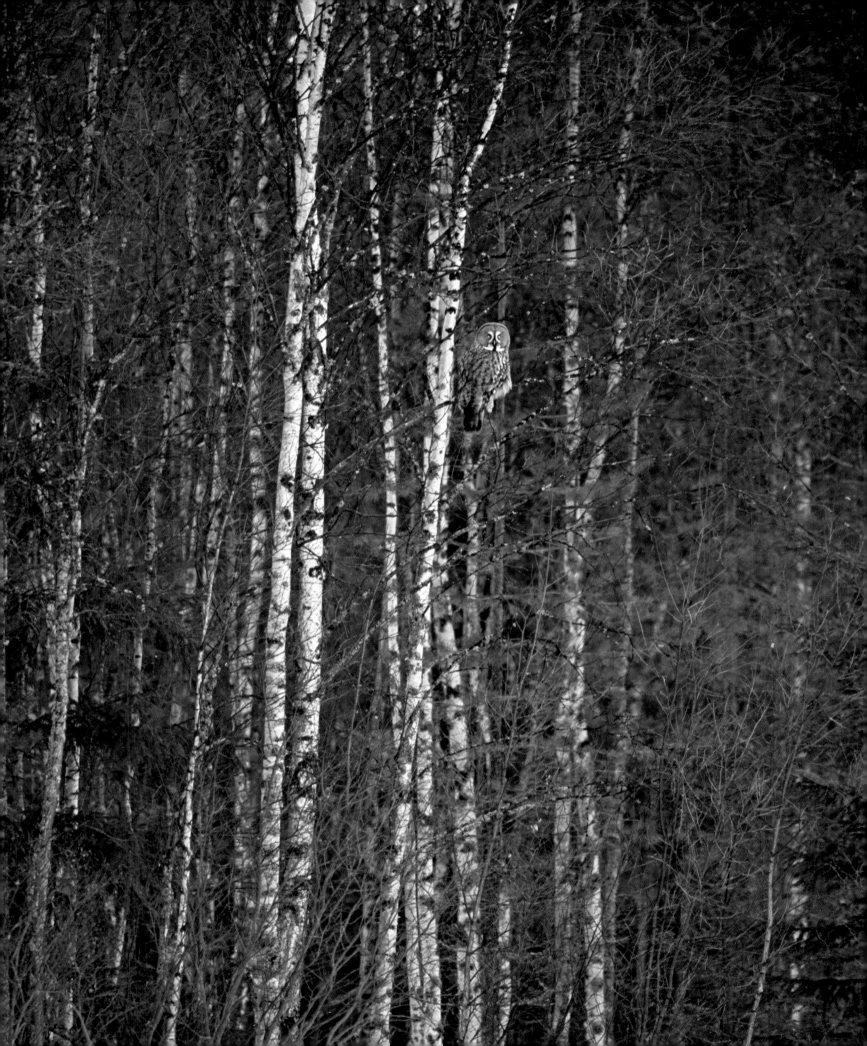

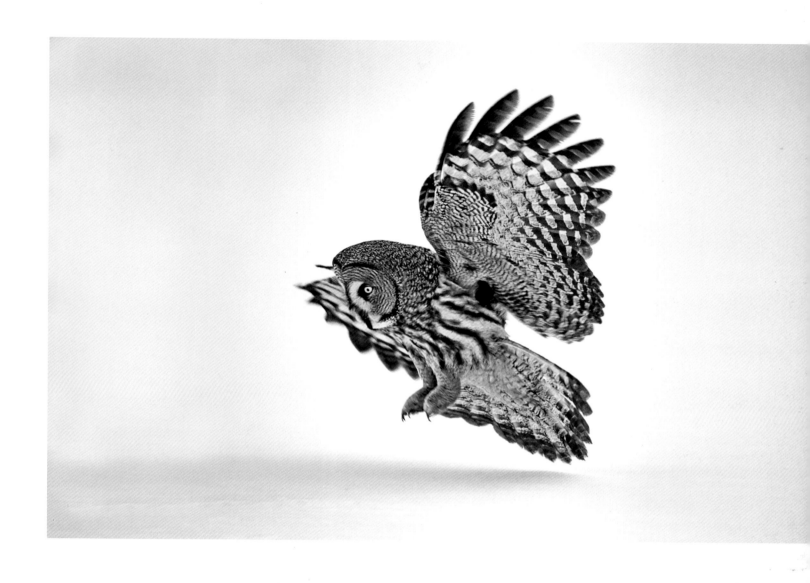

Opposite: The Great Grey Owl is the quintessential bird of Eurasia's northernmost forests.
Above: Extraordinary powers of hearing allow this species to capture rodents moving in their
invisible runs beneath the snow.

the slightest rustle of a rodent in grass or even under the snow. This owl is a master of the "snow plunge," in which—having located the movement of a vole—it will dive feet-first through the surface to grab its hidden victim. If it misses, it may remain on the ground for a while, sometimes continuing to search with its feet, but usually, by this point, without success. For such a large bird, its prey is relatively small, with up to 90 percent of its diet comprising voles, lemmings, and other small mammals. However, it has also been known to take larger mammals, up to the size of hares, weasels, and pocket gophers. It may also sometimes take birds, up to the size of grouse.

Like other nomadic owls, this species does not form strong pair bonds, although there are records of one pair continuing to share a site for up to five years. Whether with an existing partner or a new one, the male gets courtship under way with his call: a deep, rhythmic "ho" note that is repeated in bursts of six to eight seconds, with an average thirty-three-second interval before the next burst. The female replies in a harsher tone. Courtship is protracted, with much mutual preening and food gifts from male to female.

Nesting is from March to May. The pair generally chooses the old stick nest of another bird—typically a raptor, such as a northern goshawk (*Accipiter gentilis*)—but may also use a cavity in the broken top of a tree. Conservationists have found that the Great Grey Owl will readily take to artificial nests, even a dog basket placed high in the branches. The female lays three to six eggs (four on average), depending on the abundance of food. Incubation lasts some thirty days, and the female broods her young for two to three weeks, after which she moves off to roost nearby. Throughout this period, the male brings food and the female tears it up for her young until they are old enough to deal with it themselves. At three to four weeks, they leave the nest to sit out in the nearby branches. In one to two weeks, they are able to fly, although they will remain around the nest site, requiring their parents' care, for at least another two months. During their early days, the young are vulnerable to predators, including the Eurasian Eagle Owl and mammals such as the Eurasian lynx (*Lynx lynx*), but the female will defend the nest carefully and has even been seen to drive off an American black bear (*Ursus americanus*).

With an estimated worldwide population of 60,000 individuals—the American race being the more numerous—this owl is listed by the International Union for Conservation of Nature as Least Concern. However, its numbers fluctuate significantly with the boom-and-bust population cycle of voles. Threats include timber management, in which suitable nesting trees and deadwood perches are removed and forest gaps planted over. In lowland meadows and rough pasture, livestock grazing also reduces the cover needed by prey.

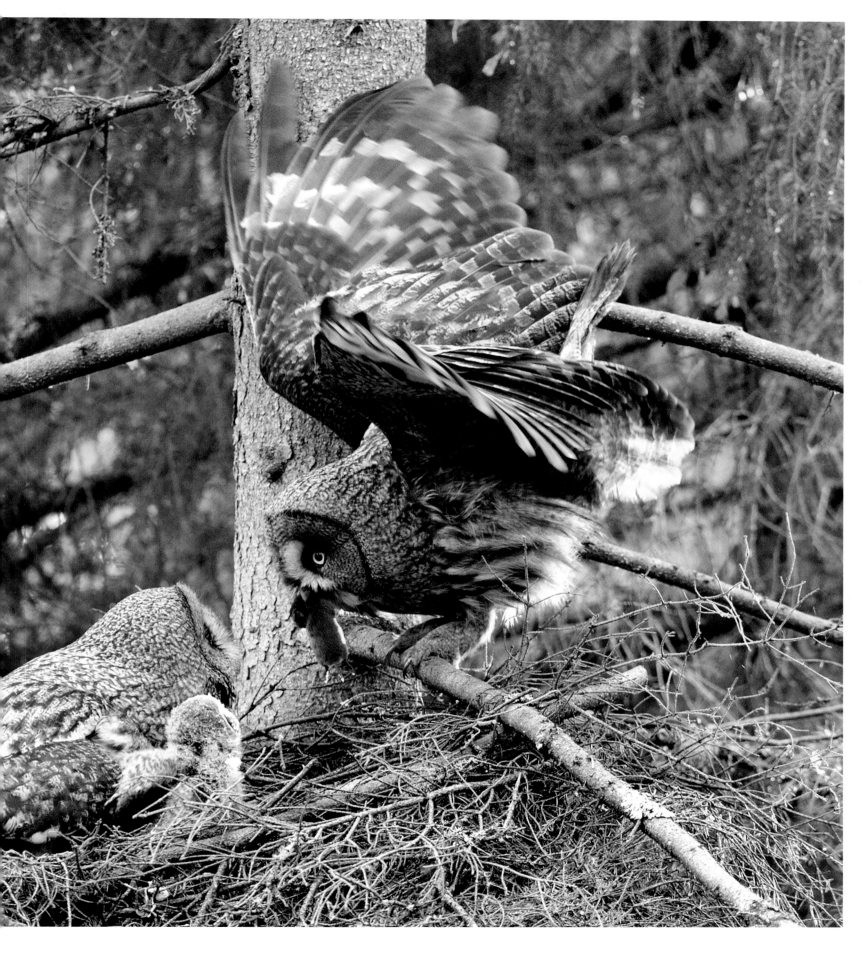

Above: A male Great Grey Owl delivers a vole to its mate, who will feed it to the pair's single chick.

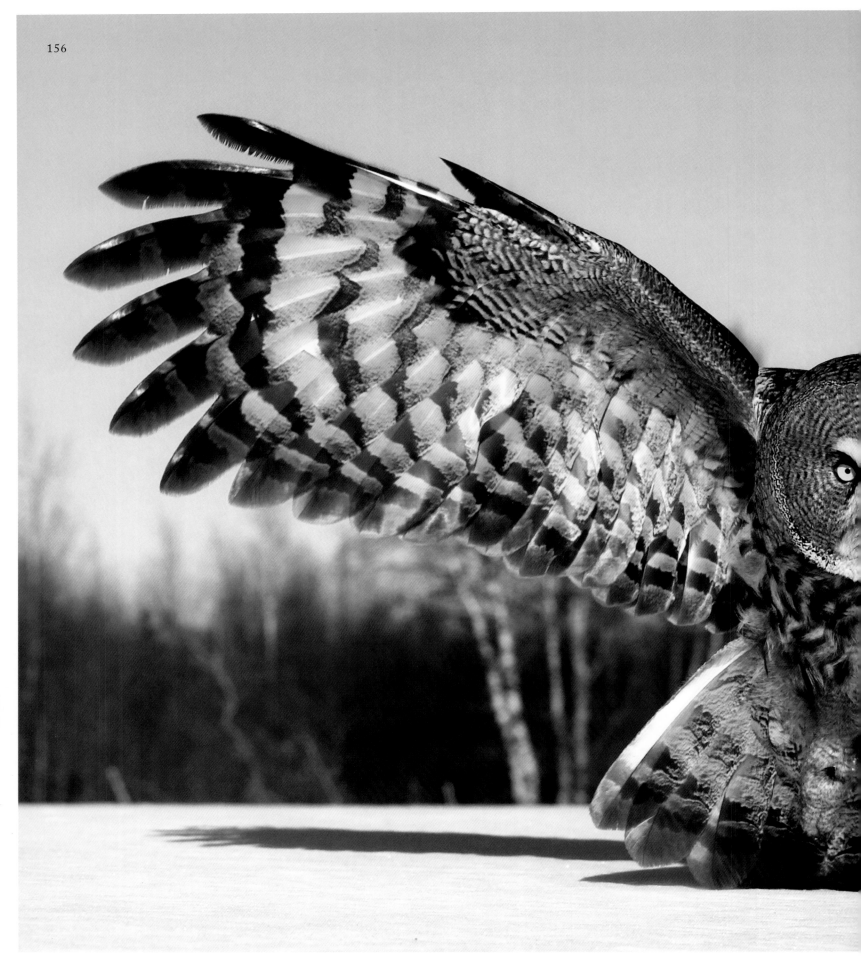

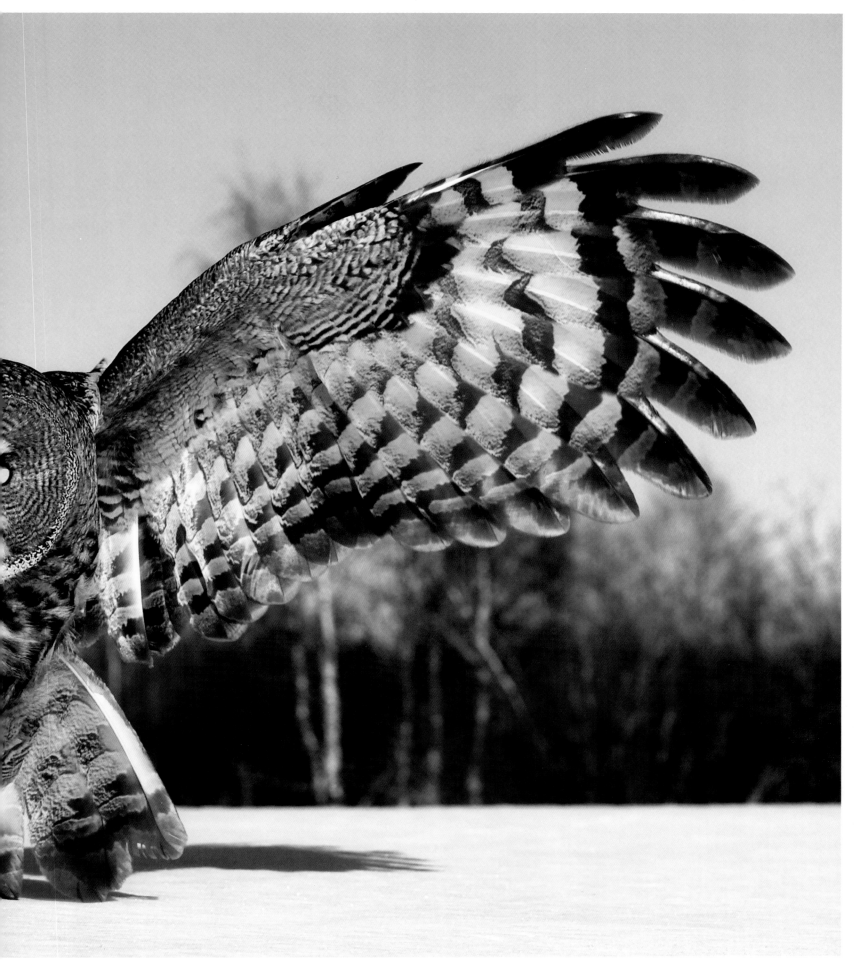

Above: The Great Grey Owl has the largest head and one of the largest wingspans of any owl.

COMMON (EURASIAN) SCOPS OWL

OTUS SCOPS

APPEARANCE
Small and slim, with large head, ear tufts, and short tail; piercing yellow eyes; gray, brown, black, and rusty-brown plumage, heavily patterned above and below with cryptic camouflage coloration in bars and streaks; under parts paler than the upper parts; a rare rufous morph also occurs; in flight, the wings appear longer and narrower than the broader wings of the similar-size Little Owl.

SIZE
length 7.5–8.3 in. (19–21 cm)
weight 2.3–4.8 oz (64–135 g)
wingspan up to 19–21 in. (47–54 cm)
females slightly larger

DISTRIBUTION
Breeds from southern Europe and western Asia, from the Mediterranean east to Western Mongolia; migrates south to winter in sub-Saharan Africa, in an east to west band between the Sahara and equatorial forest line.

STATUS
Least Concern

THIS DIMINUTIVE OWL provides a distinctive sound track to a Mediterranean summer's night. Its soft whistled note, repeated every few seconds, chimes metronomically over the buzzing of crickets and cicadas and continues relentlessly from dusk to midnight. To some it evokes the charm of an olive grove after dark; to others it is a harbinger of evil: Sicilian tradition holds that when a Common Scops Owl calls outside your house for three nights in a row there will be a death in the family.

Hearing a Common Scops Owl is easy; spotting one is a different matter. By day, this owl's cryptic camouflage allows it to blend into near-invisibility against the bark of a tree. In order to complete the deception, it flattens itself into a slim, upright stance, like a broken stump, and erects its ear tufts. Only by opening its piercing yellow eyes does it give itself away.

The Common Scops Owl is the only European member of the *Otus* genus, which is the largest owl genus and numbers more than fifty species. Most are very similar in size, plumage, and call. Studies suggest that this species is most closely related to the Pallid Scops Owl (*Otus brucei*) of the Middle East, although *Otus* taxonomy is constantly under review, with new island species still being discovered. At present, taxonomists recognize six subspecies, of which the nominate, *O. s. scops*, occurs from Western Europe to northern Turkey.

This is an owl of warm, dry, open, or semi-open country. It prefers areas with scattered trees or small woods, and takes well to cultivated areas, including olive groves, parks, and gardens. It may adopt suitable habitat on mountainsides, but avoids dense forest. Around settled areas, it can be quite tame, although seldom easy to see. Nocturnal in habits, the Common Scops Owl often uses the exact same daytime roost for weeks. It is generally a sit-and-wait hunter, watching from a perch before swooping down on prey. Its staple diet is large invertebrates, such as crickets, beetles, and cicadas, but it may take larger fare, including small mammals and birds. Small prey is caught with the bill, larger prey with the talons.

Courtship for returning migrants starts from late March, but resident birds may begin as early as February. Once a female has located a male by his call, she may join him in duet; the call then sometimes becomes bisyllabic as the two birds chime together. Once a female has inspected and approved the nest site, the pair will remain close by every evening. Successful males fall largely silent once breeding is under way, but an unpaired male will continue calling late into the summer, advertising his credentials for the following year.

Nest sites tend to be natural cavities in walls, rocks, or trees, sometimes also under roofs. The female lays one brood of three to four eggs from late April. These hatch after an average of twenty-five days, depending on the climate, and the male steps up his food delivery as the chicks grow. At thirty-three days they can fly, but their parents continue to feed them for another four to five weeks, after which they head out on their first southbound migration. By the time they return the next spring, they are ready to breed.

This widespread owl is classed as Least Concern, with an estimated population of 800,000 to 1.4 million individuals. It is decreasing in some regions, however, largely due to agricultural intensification and pesticides. Its recent decline in the French Camargue has been attributed to a local increase in Tawny Owls (P. 120), one of its most significant predators.

Opposite: Large insects, such as this bush cricket, make up much of the diet of the Common Scops Owl.

URAL OWL

STRIX URALENSIS

APPEARANCE
Medium-large; pale gray plumage, almost ghostly pale in some individuals; upper parts are streaked and barred, with pale scapular line; under parts are more finely streaked; dark eyes in plain facial disk, indented at top and bottom; in flight, appears powerful and long-tailed.

SIZE
length 20–24 in. (51–61 cm)
weight 1.10–2.87 lb (500–1,300 g)

wingspan 43–53 in. (110–134 cm)
females slightly larger and heavier

DISTRIBUTION
From eastern Scandinavia across north-central Russia to Sakhalin, Japan, and Eastern China; isolated populations in Eastern Europe, including in Poland, the Czech Republic, Slovakia, Slovenia, and the Balkans; recently reintroduced to Germany.

STATUS
Least Concern

"MILD" IS A TERM COMMONLY USED to describe the facial expression of this hefty owl. Certainly, its small, dark eyes and large, plain face lack the apparent ferocity conveyed by the blazing yellow eyes and knitted eyebrows of some other species. "Mild," however, is not what springs to mind for anybody who approaches too close during the breeding season. As a defender of its nest, there are few more ferocious birds than a female Ural Owl. Many are the tales of people struck, knocked down, and sometimes badly hurt by the bird's vicious swoops. Researchers climbing trees to band youngsters at the nest don protective clothing and a crash helmet.

This large owl belongs to the *Strix* genus of wood owls, and it is therefore closely related to the smaller Tawny Owl (P. 120)—so closely, in fact, that the two species sometimes hybridize. It is smaller in length than the Great Grey Owl (P. 150), but on average almost as heavy. At first glance, it resembles a large, pale gray Tawny Owl, the plumage almost ghostly pale in some individuals. The upper parts are streaked and barred, with a pale scapular line; the under parts are more finely streaked, and the plain facial disk is indented at top and bottom. In flight, this owl appears powerful, flying almost like a heavy-winged common buzzard (*Buteo buteo*), and its longer tail—proportionally more like that of a Great Grey Owl than a Tawny Owl—is more noticeable.

The Ural Owl is a species of the northern boreal forest. It ranges from eastern Scandinavia in a broad band east across north-central Russia to Sakhalin, Japan, and Eastern China. Several isolated populations also exist in Eastern Europe, including in Poland, the Czech Republic, Slovakia, Slovenia, and the Balkans. Recently, the species has been reintroduced to Germany. Taxonomists have identified up to nine races, including three in Japan. The nominate race, *S. uralensis*, occurs from east Siberia to the southern Ural Mountains.

This bird's preferred habitat is mature pine and mixed forest, with plentiful open glades and areas of bog. In the Carpathian Mountains, it also frequents mature beech forest. Generally a lowland species, it occurs at altitudes of up to 5,250 feet (1,600 m) toward the south of its range. It is not shy of human habitation, if the surrounding habitat is right, and will visit grain spillages on farmland in search of the rodents that these attract. Largely sedentary, residing all year around in its territory, it may sometimes be forced away in times of cold weather, with individuals recorded as having wandered 93 miles (150 km).

The Ural Owl is largely nocturnal, although it may be active during daylight when feeding its young. By day, it roosts high in a mature tree, generally concealed by foliage. When hunting, it either swoops from a perch or quarters the ground in a low flight, and—like the Great Grey Owl—its powerful hearing allows it to locate unseen rodents beneath the snow and plunge through the crust to grab them. Voles make up some 90 percent of this bird's diet, with their availability having a strong influence on breeding success. It will also take lemmings and other small mammals, as well as insects, frogs, carrion, and birds up to the size of grouse (Tetraoninae) and wood pigeon (*Columba palumbus*).

Pairs usually stay together for life and defend their large territory year-round. Unpaired males start their singing in the fall, provoking a frenzy of activity among rivals. The main courtship period for paired birds begins in January. The male's

Opposite: The Ural Owl's thick plumage provides fine insulation against a cold northern winter.

deep hooting call comprises one long opening note followed by a short stuttering of three or four more. Pairs may duet together. Both sexes also have a sharp "kee-vit" contact call, like that of a Tawny Owl, and an abrupt barking alarm call.

Once paired up, the male begins to show off possible nest sites, typically in a tree cavity or hollow but also sometimes in a raptor's old stick nest or even among roots on the ground. The female sits inside for up to a week before laying, the male providing her with food to build up her strength. She lays three to four eggs at two-day intervals, and in a good vole year may lay up to six. Incubation starts with the first egg, as with all *Strix* owls, and lasts twenty-eight to thirty-five days. The male hunts throughout this period, and both birds defend the nest fiercely. Some thirty-five days after hatching, the downy chicks, which are not as pale as those of a Tawny Owl, leave the nest and move into nearby branches. They make their first flight at about forty-five days, but continue to beg food for another month and do not reach independence for

two more. Although sexually mature in their first year, they generally do not breed until their second.

Research in Finland suggests that the Ural Owl's notorious aggression plays a vital part in its breeding success. Studies of the closely related Tawny Owl have shown that mammalian predators are responsible for more than half of fledgling deaths, capturing the youngsters as they move around at ground level. Ural Owl offspring are similarly vulnerable at this stage and thus their parents direct fierce attacks on potential mammalian predators, such as red foxes and pine martens. It is the most aggressive females that raise the most young to independence.

The Ural Owl is classed as Least Concern, with an estimated population of 500,000 to eight million individuals across its wide range. Its greatest threat is deforestation, or the loss of good nest sites through new forest management. However, it has taken readily to nest boxes in Finland and Sweden and can therefore adapt to areas of sustainable logging.

Above: An adult Ural Owl keeps guard near the nest.
Opposite: Frogs are one of the foods given to young Ural Owls.

Right: A Ural Owl on its nest, in the heart
of an ancient forest.

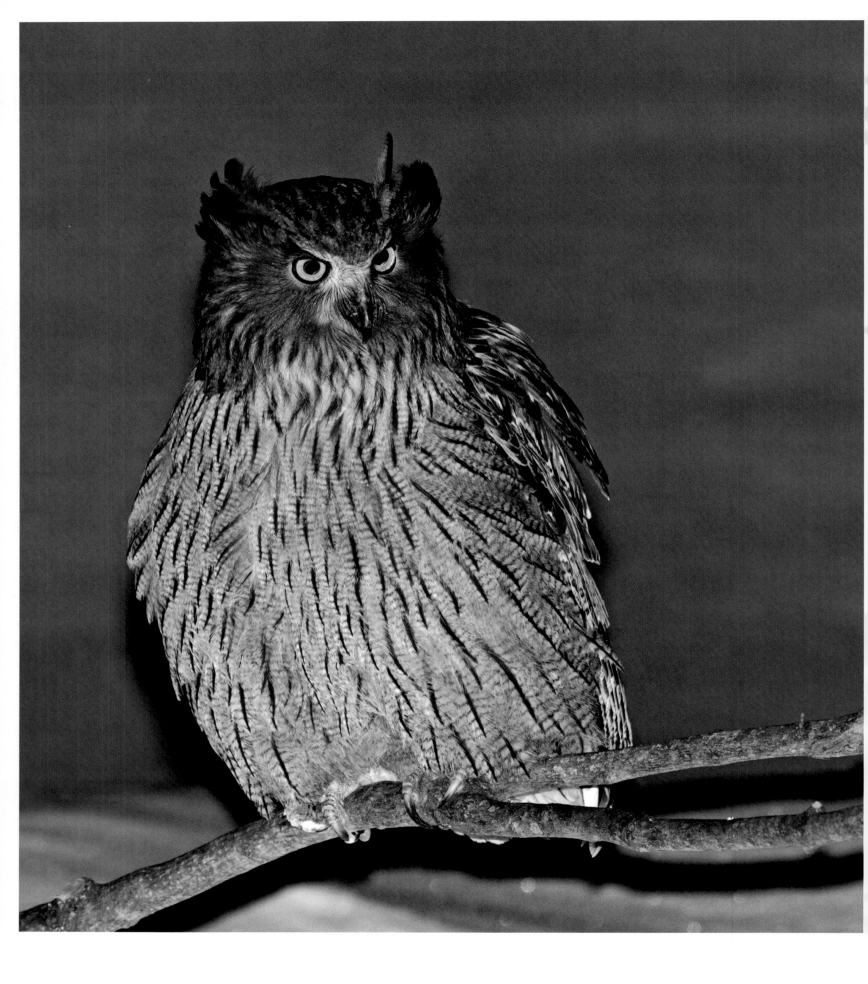

Above: By average weight, Blakiston's Fish Owl is the largest owl in the world.

BLAKISTON'S FISH OWL

BUBO BLAKISTONI (KETUPA BLAKISTONI)

APPEARANCE
Very large; tousled, sideways-projecting ear tufts; facial disk tawny, with indistinct rim and pale cross at center; eyes yellow and bill grayish; upper parts brown, with fine blackish-brown stripes; mantle paler and more rufous, with dark bars and streaks; under parts buffish-brown with dark vertical streaks; broad, long wings barred with buff; dark tail barred in cream-yellow; legs feathered down to feet.

SIZE
length 24–28 in. (60–72 cm)
weight 6.5–10.1 lb (2.95–4.6 kg)
wingspan 70–75 in. (178–190 cm)

DISTRIBUTION
Eastern Russia, from Amur and Ussuri river basins to Okhotsk Coast, Sakhalin, Lake Khanka, and south of Vladivostok; west Manchuria and Heilongjiang, China; Hokkaido Island, Japan, and Kuriles.

STATUS
Endangered

ANY FISHERMAN WILL TELL YOU that good things come to those who wait. And this huge owl—on average, the world's largest—follows this maxim with great dedication. Perched beside an icy stream in the cold night, feathers fluffed against the falling snow, it may sit for hours on end to get its reward.

The title of world's largest owl has two main contenders: this species and the Eurasian Eagle Owl (P. 103). Both boast the same highest recorded weight: a hefty, cat-size 10.1 pounds (4.6 kg). However, only one race of Eurasian Eagle Owl—the easternmost Russian subspecies, which shares the range of Blakiston's Fish Owl—grows this large, so the species' average weight falls below that of the fish owl.

In addition to its size, the first thing you will notice about Blakiston's Fish Owl is its drooping, tousled ear tufts, which project horizontally to create a silhouette that immediately distinguishes it from the Eagle Owl. Seen in good light, its plumage is also more tawny-yellow overall. Unusual in a fish-catching owl, the tarsi are feathered right down to the feet, and the feet themselves are enormous, with long talons and rough scales to help grasp slippery, struggling fish.

Blakiston's Fish Owl gets its name from English naturalist Thomas Blakiston, who collected the original specimen on Hokkaido Island in Japan in 1883. It is also known as Blakiston's Eagle Owl, which is arguably more correct, because

this species is very closely related to eagle owls—whose genus *Bubo* it shares—and is thought by some scientists to represent an evolutionary link between fish owls and eagle owls. In fact, all four Asian fish owl species are now grouped along with eagle owls in *Bubo*, having formerly made up their own genus *Ketupa*. Scientists today divide Blakiston's Fish Owl into two subspecies: the nominate race *B. b. blakistoni* is found in Japan; the slightly larger race *B. b. doerriesi* inhabits the Russian mainland and differs by its call.

Throughout its range, Blakiston's Fish Owl needs dense forest near flowing waterways, typically on wide river plains. The forest types vary from coniferous (including dense fir and spruce forest on the Kuriles) to mixed and broad-leaved, but whatever the forest, it must have cavernous old-growth trees for breeding. The waterways—rivers, streams, or river mouths—should remain at least partially ice-free through the winter, even when snow covers the ground, in order to make fishing possible all year around.

Largely nocturnal, Blakiston's Fish Owl usually starts hunting as darkness falls, although it may also hunt by day while rearing young. Its typical strategy is to sit by a suitable patch of water and wait, on an overhanging branch or rock, or simply on the ground. Indeed, this species spends much of its time on the ground, trampling out regular trails along riverbanks. It will wait hours for fish to appear, but also may enter the water and wade through the shallows in search of prey. Once its extraordinary eyesight has detected prey, it pounces with a quick flap of the wings and grips the prize in vice-like talons. Occasionally, it dives down in flight, sea eagle-style, to snatch fish from the surface.

Prey comprises mostly fish, as the bird's name suggests, including pike, catfish, burbot, trout, and salmon. It may take fish of a considerable size—reputedly up to twice its own weight—and has been seen to cling with one foot to a branch while hauling in its catch with the other. Other aquatic prey on the menu includes crayfish, freshwater crabs, and frogs:

168

in Russia, notably Dybowski's frog (*Rana dybowskii*), which the owl may feed to its young in large quantities. In winter, particularly during a big freeze, Blakiston's Fish Owl may turn to terrestrial prey, taking mammals, such as hares and martens, and birds such as hazel grouse (*Tetrastes bonasia*) and waterfowl. It will also take carrion, which is apparent from the number of Blakiston's Fish Owls that fall victim in Russia to fur trappers' snares baited with raw meat.

This species does not necessarily breed every year, but responds to food supply and weather conditions. Courtship occurs from January to February and is announced by the male stepping up his territorial calling. In Japan, the call is a short, deep, double hoot, which draws an instantaneous but slightly weaker response from the female, creating a "boo-boo uoo" sound. The Russian race follows a similar pattern but with a quadruple hoot. Pairs may pursue these duets at length.

A nest is chosen in a large tree hollow, and the female lays from one to three eggs as early as mid March, when snow still carpets the ground. She incubates the eggs alone, while the male provides the food, and the chicks hatch at about thirty-five days. Within thirty-five to forty days of hatching, the young leave the nest, and by fifty days they can fly. They continue to depend on their parents for some months, and will remain in their natal territory into their second year.

Today, this magnificent owl is one of the world's rarest birds. In the wild, it faces few natural threats. The two large sea eagles that share its habitat, Steller's sea eagle (*Haliaeetus pelagicus*) and the white-tailed eagle (*H. albicilla*), seem to cause few problems, and Blakiston's Fish Owl seldom comes into conflict with larger mammalian predators, although records exist of individuals killed by the Eurasian lynx (*Lynx lynx*) and Asiatic black bear (*Ursus tibetanus*). The real dangers are from humans. These include direct persecution, accidental entrapment in salmon nets or fur traps, and, in Japan, collision with motor vehicles and power lines. Most serious is the loss of precious riverine forest to development and dam construction. BirdLife International estimates a total population of between 1,000 and 2,499 individuals, with some 100 to 150 of these found in Japan. The species is listed as Endangered.

Conservationists have seen some encouraging successes in Japan, however, where the owls have taken readily to nest boxes provided to replace lost natural nesting trees. Despite the continued loss of chicks to traffic and other accidents, the species' decline has been arrested for now. The success of this scheme owes much to Blakiston's Fish Owl's almost sacred status on Hokkaido Island, where it is traditionally revered by the local Ainu people as Kotan koru Kamuy: "The God that Protects the Village."

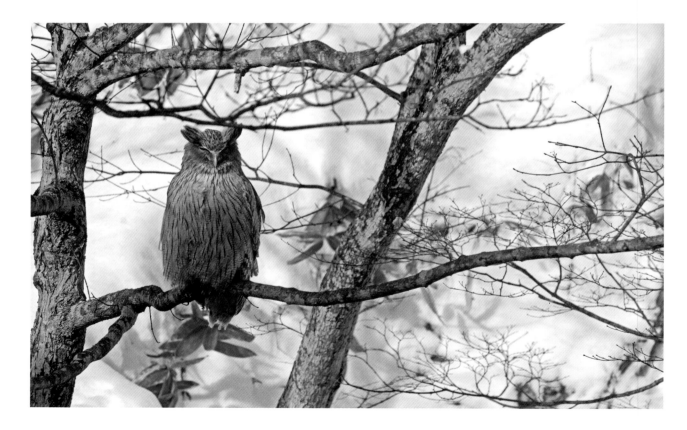

Above: Blakiston's Fish Owl at its daytime roost.

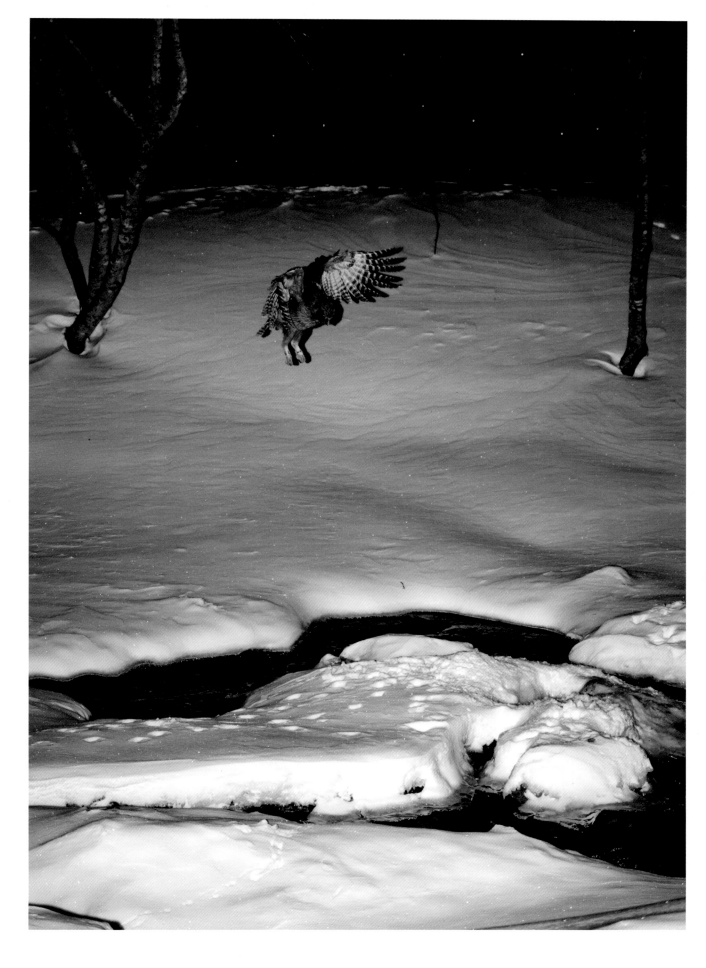

Above: A telltale ripple in the water brings the owl swooping
from its perch in search of prey.

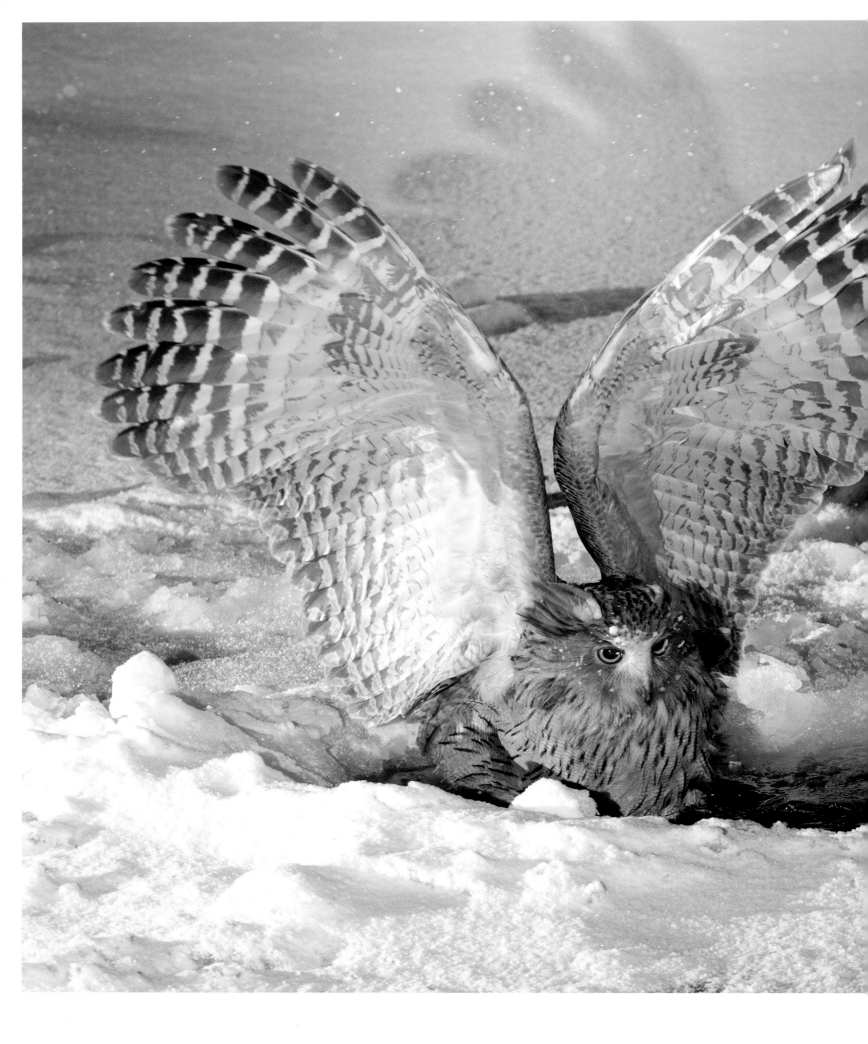

Left: Areas of running water in otherwise frozen terrain offer this species vital fishing holes during winter.

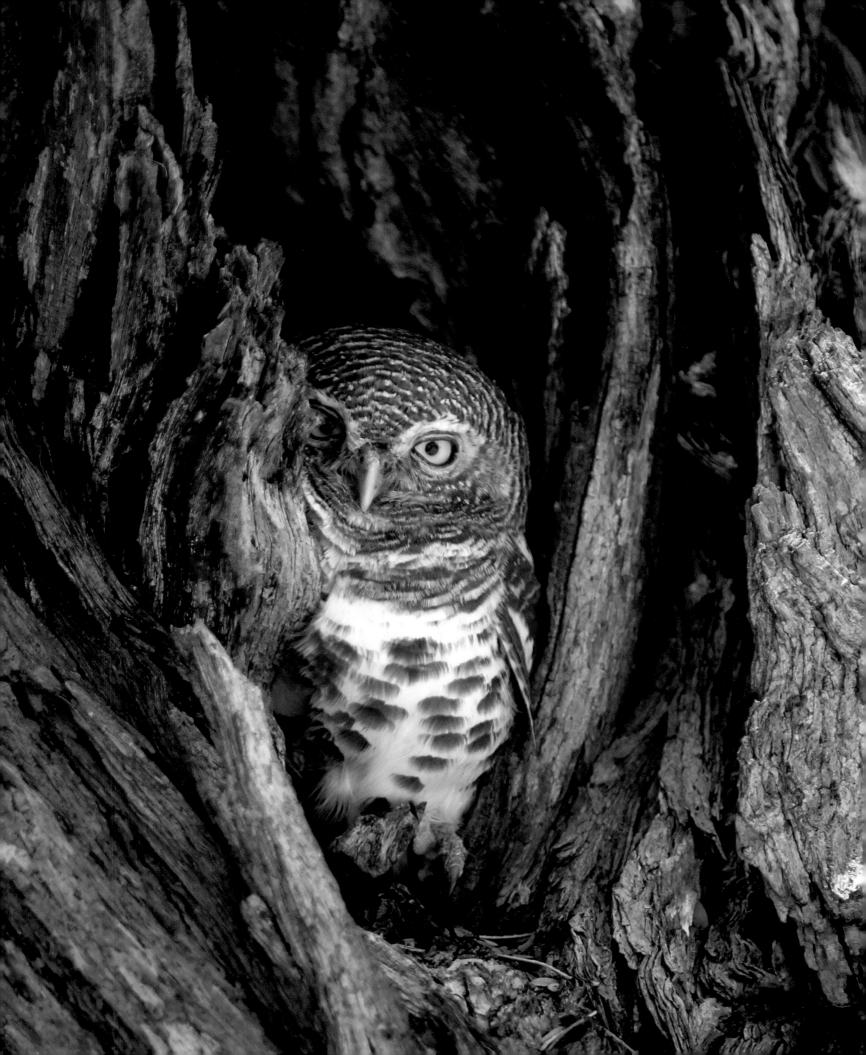

04 | AFRICA

Out of Africa always something new — *"Ex Africa, semper aliquid novi"* — wrote Roman author and philosopher Pliny the Elder. This thought must have seemed fitting during a Wildlife Conservation Society survey of the Itombwe Forest in the eastern Democratic Republic of the Congo in May 1996, when researchers captured in their mist nets a small chestnut owl that they could not identify. It was not a new species, in fact, but a Congo Bay Owl (*Tyto prigoginei*), a species that had been previously recorded only once, in 1951, and long since presumed extinct.

It is hardly surprising that in an area as vast as the Congo, an owl should have slipped beneath the radar. For all its recent development, Africa still has many such wilderness regions. It is the world's second-largest continent, covering an area of approximately 11.6 million square miles (30.2 million sq km). Its landscapes fall into three principal regions: in the north, the immense Sahara Desert and the fringing arid lands of the Sahel; in the center, the great equatorial forests of the Congo basin; and across the east and south, a patchwork of savanna habitats, which include such celebrated wildlife havens as Tanzania's Serengeti and Botswana's Okavango Delta. A closer look reveals a slightly more complex picture: among the continent's fifteen recognized biomes are unique landscapes such as the Afromontane highlands in Ethiopia, with their alpine influences, and the fynbos in South Africa, with its distinctly Mediterranean flavor.

All of this is good news for birds, with some 2,400 species found across the continent, among which more than half are endemic and countless millions arrive as migrants from Eurasia. This total includes at least forty-nine species of owl, with ten different genera represented and a considerable variety of size and form.

The tropical rain forest of West and central Africa may be the continent's most biodiverse habitat, but its owls are relatively little known and consequently are not often photographed. Among them are seldom seen species such as the Akun Eagle Owl (*Bubo leucostictus*) and the bizarre-looking Maned Owl (*Jubula lettii*), once thought to be related to the Crested Owl of the neotropics (P. 95) but now placed in its own genus. Less densely forested areas elsewhere on the continent are also home to the better known, though shy and secretive, African Wood Owl (*Strix woodfordii*), which in its habits and appearance is not unlike the closely related Eurasian Tawny Owl (P. 120).

A rather more familiar habitat is the woodland savanna of East and central Africa, known to hardened safari-goers as "the bush." This is one of the most predator-rich biomes on the planet, especially within national parks and other protected areas, with owls obliged to share the predatory pickings with everything from eagles to big cats and pythons. By night, they compete against the likes of mongooses, genets, and bush babies. However, the birds more than hold their own. Indeed, the massive Verreaux's Eagle Owl (P. 176) is one of the fiercest nighttime predators in Africa, bringing a swift end to everything from hedgehogs and guineafowl to sleeping monkeys and hyraxes. Other well-known owls from this habitat include the diminutive African Scops Owl (P. 208), whose soft mechanical chirrup resounds through the night like an error message from a computer keyboard. The Pearl-spotted Owlet (P. 201) is no larger but much easier to find,

Opposite: An African Barred Owlet keeps watch from its nest hole in a mopane tree.

because it is often active by day, its piercing whistled call inciting furious mobbing from other small birds in the vicinity.

In more open grasslands, the Marsh Owl (P. 194) and African Grass Owl (P. 193)—unrelated, but sharing a similar ground-nesting lifestyle—hunt over open ground like harriers. In addition, where the grassland and savanna give way to more arid country, owls continue to find a suitable home as long as there are enough scattered trees to provide roosting and breeding cover. Scan the shady canopy of a camelthorn (*Vachellia erioloba*) in the Kalahari, and you will often find roosting a distinctive Southern White-faced Owl (*Ptilopsis granti*) or even a large Verreaux's Eagle Owl. In true desert terrain, there are few species of owl, or for that matter of any other bird. However, specialists such as the striking Pharaoh Eagle Owl (*Bubo ascalaphus*) still thrive in the central Sahara, while the Common Scops Owl (P. 159), which breeds in Europe, passes over this harsh landscape twice a year on its annual migration.

Other biomes cut across the key landscapes of forest, savanna, and desert, each with its own specialist owls. Rocky and mountainous areas are home to the localized Cape Eagle Owl (P. 204), which in East Africa has been recorded above the snow line at altitudes of up to 13,750 feet (4,200 m). Wetlands harbor three species of fishing owl, of which Pel's Fishing Owl (P. 187) is the largest and best known, roosting in large trees beside lakes or slow-flowing rivers and emerging after dark to pluck fish from the surface waters, fish eagle-style. In recent times, a number of new endemic scops owls—*Otus*

species—have been identified on Africa's offshore islands, such as São Tomé, Pemba, and the Comores. For more about island owls, see Chapter Six.

Unfortunately, the role of owls in African culture has been an overwhelmingly negative one: the birds are associated with witchcraft and evil spirits in many regions and suffer persecution as a result. In the Swahili culture of East Africa, for example, owls are traditionally thought to bring illness to children. Consequently, people in many rural communities fix spikes on the roofs of their huts in an attempt to discourage owls from landing there at night. Nonetheless, owls can survive quite well alongside people in many regions, with the versatile Spotted Eagle Owl (P. 183) a common inhabitant of city outskirts and suburban areas across many parts of East and southern Africa.

Despite the vastness of Africa's wilderness, its birds—including its owls—are under threat. As the continent struggles with development issues, such as poverty, disease, conflict, and food security, it is not surprising that bird conservation does not always take priority. Conservationists are today working with local communities, giving local people a better understanding of their natural heritage, while encouraging poverty reduction schemes—ecotourism, for example—that help to alleviate pressure on protected areas. Meanwhile, a number of ambitious initiatives aim to protect and restore all Africa's biodiversity, including its owls. These include the creation of trans-frontier or "peace" parks, which establish conservation corridors across nations.

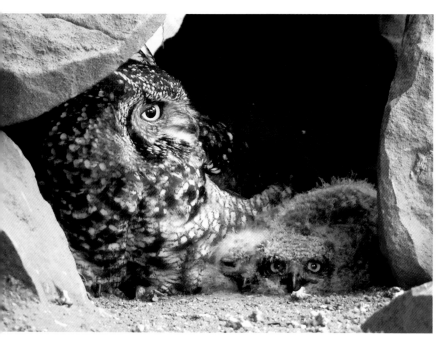

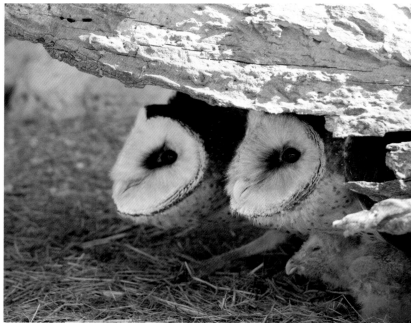

Above: Spotted Eagle Owls (left) will occasionally nest on the ground.
African Grass Owls (right) habitually do so.

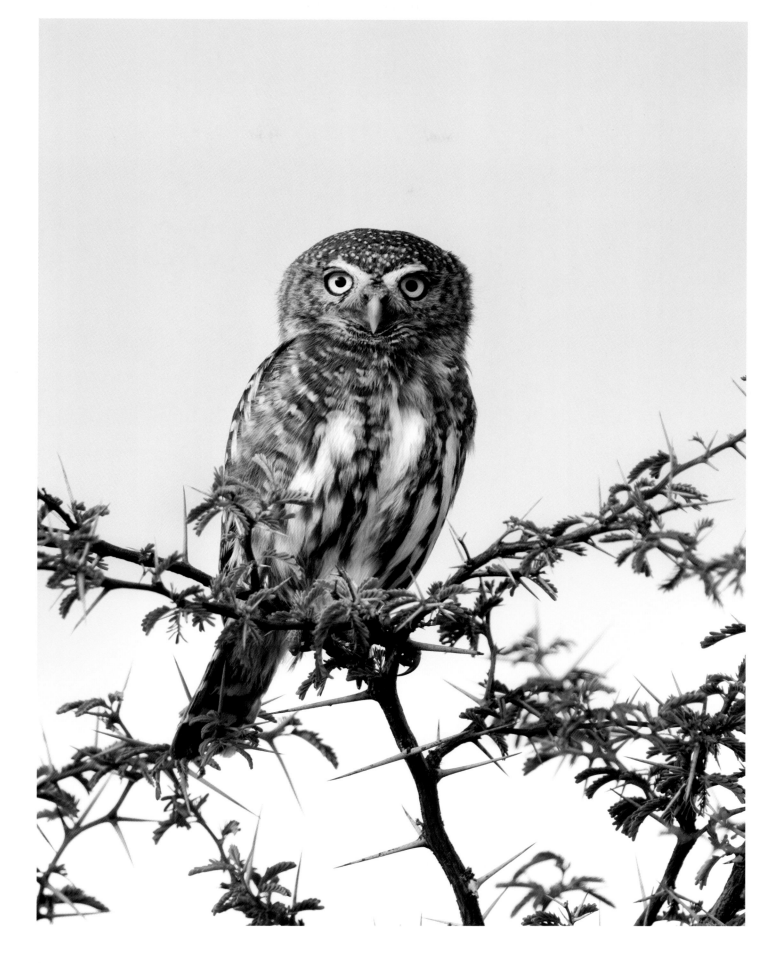

Above: A Pearl-spotted Owlet scans for prey from
the uppermost branch of an acacia.

VERREAUX'S EAGLE OWL

BUBO LACTEUS

APPEARANCE
*Very large, with small ear tufts;
plain-looking, without the more
elaborate cryptic markings of other
eagle owls; upper parts brown, with
bold white scapular spots; under parts
pale gray and finely barred; whitish
facial disk with black borders, like
brackets; eyes dark brown with
striking pink eyelids; wings long and
broad; barred tail and flight feathers.*

SIZE
*length 24–26 in. (60–66 cm)
weight 3.5–6.94 lb (1.6–3.1 kg)
wingspan 55 in. (140 cm) ave*

DISTRIBUTION
*Sub-Saharan Africa, north to Sudan;
absent from dense tropical forest and
true desert; isolated population in
South Africa's Cape.*

STATUS
Least Concern

THE LARGEST OWL IN SUB-SAHARAN AFRICA may not quite set the world record for size: in weight, it falls into fourth place behind the Eurasian Eagle Owl (P. 103), Blakiston's Fish Owl (P. 167), and Buffy Fish Owl (P. 222). Nonetheless, it is a very large and powerful bird; on a continent bristling with fearsome nocturnal predators, it is up there with the most impressive.

Verreaux's Eagle Owl was named by Jules Pierre Verreaux, a nineteenth-century French botanist and ornithologist who in 1825 helped found the South African Museum in Cape Town. Alternative names include Giant Eagle Owl and Milky Eagle Owl. Whatever this bird is called, however, it is unlikely to be mistaken for any other owl within its range; its only rival for size is the slightly smaller Pel's Fishing Owl (P. 187), which both looks and behaves very differently. Furthermore, in its powerful flight, on long, broad wings, the tail and flight feathers of Verreaux's Eagle Owl appear heavily barred.

This species ranges across much of sub-Saharan Africa, and the highest populations occur in East and southern Africa. Wherever it occurs, though, it tends to favor dry bush and savanna terrain, often frequenting ribbons of riverine forest, with open country nearby. It also thrives in arid, semidesert terrain, as long as this offers enough scattered trees and patches of cover for roosting and nesting.

Verreaux's Eagle Owl is a mostly nocturnal species that roosts by day in large trees, typically acacias and others with shady horizontal branches. Breeding pairs roost side by side, often preening one another when they wake up, and grown offspring may roost nearby. This species is a regular bather, soaking its feathers in a heavy rain shower or shallow water, often by day. It is at sunset, however, that it sets out for the evening's hunt, moving away from the roost site to suitable perches elsewhere, from which it swoops down upon any prey that it can spot below.

This owl is termed an avian apex predator: in other words, it is top of the tree among feathered hunters, lording it over a wide range of prey species and with very little to fear for itself. It specializes in capturing medium-size mammals, including nocturnal species such as genets, springhares, mongooses, and bush babies, as well as hyraxes, young monkeys, and other diurnal creatures, which it ambushes at dusk as they head for their night's shelter. Verreaux's Eagle Owl also takes a wide range of birds, from small fare—weavers and waxbills, for example—which it captures at their roost by flying swiftly and silently through the branches, to larger species such as ducks and guineafowl. Indeed, very few birds are off-limits: vultures, cranes, bustards, secretary bird (*Sagittarius serpentarius*), bateleur eagle (*Terathopius ecaudatus*), and even other owls have all been recorded on the menu of this rapacious predator.

Other food includes reptiles and large arthropods. A Verreaux's Eagle Owl will wade into shallow water in order to capture fish, and it is one of the very few African predators that, like the Eurasian Eagle Owl, knows how to tackle hedgehogs by peeling off the spiny skin in order to get at the soft interior. Most prey is carried away to be torn apart at a perch. However, food that is too heavy to carry—a bustard or, in one record, a warthog (*Phacochoerus africanus*) piglet, for example—is left where it falls. The owl returns later, often with its mate, to feed upon the catch in situ.

The territorial song of this eagle owl is not as haunting as some; it is a deep, muttering, pig-like grunt on a slightly hesitant rhythm that reputedly carries for miles on a still night.

Opposite: A Verreaux's Eagle Owl at its daytime roost among the distinctive branches of a fever tree.

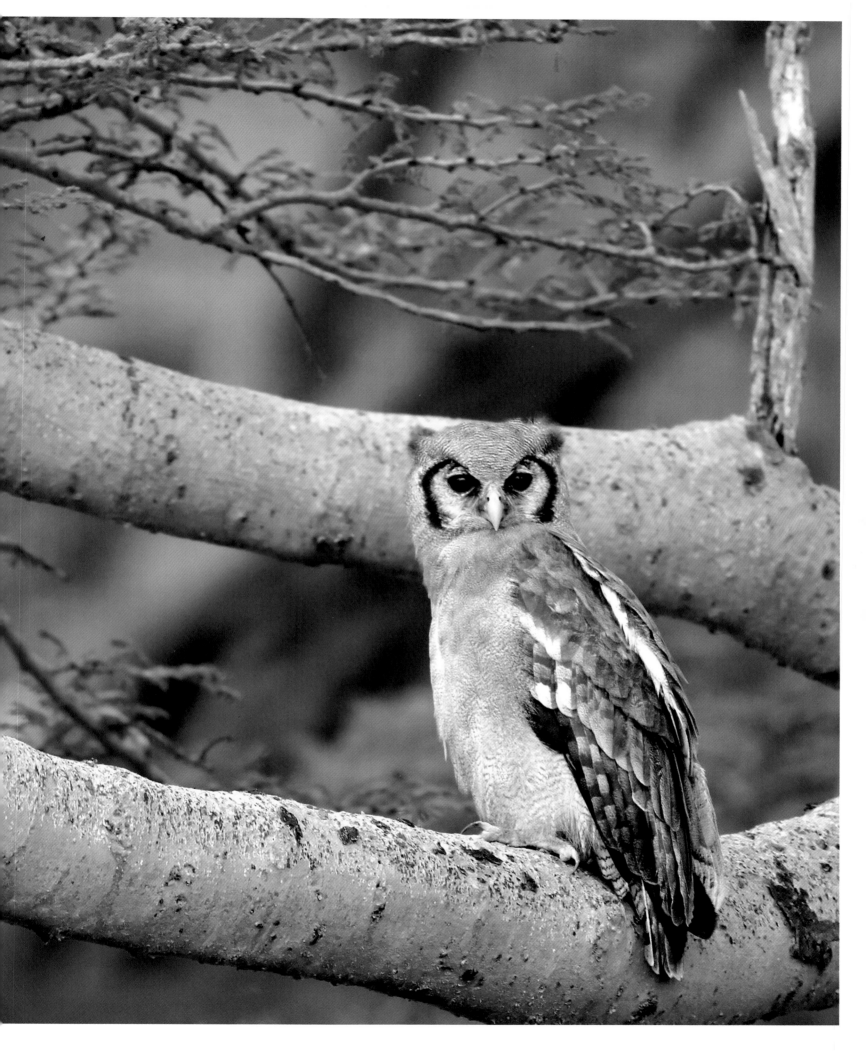

It has been written as "gwok, gwonk, gwok-wok-wok gwok-gwok, gwonk." During the breeding season, the male steps up his calling, and the female responds with a similar but higher-pitched call. The two may call together, with a more stuttering grunting duet, and reinforce their bonds through a courtship display in which they perch side by side and the male bobs up and down, flicking his wings. Both sexes also make high alarm screams and whistles.

Pairs are monogamous and may stick together for many years, although with breeding rates dependent upon food supply, they may not breed every year. Each defends a territory of some 27 square miles (70 sq km), with a study of one river valley showing that pairs were spaced out on average some 6 to 13.5 miles (9.5–22 km) apart. Nests are usually in, or on, the large platform nest of another bird, such as a vulture or secretary bird, with the huge communal nests of the sociable weaver (*Philetairus socius*) being a particular favorite in the Kalahari. Alternatively, Verreaux's Eagle Owl may use a natural tree cavity or a dense tangle of creepers.

The female lays two eggs, with an interval between them of up to seven days. She incubates her clutch for thirty-three to thirty-nine days and, after hatching, she broods the nestlings for another twenty days or so. In hard times, the second chick often dies. All being well, both youngsters leave the nest after sixty-two to sixty-three days and can fly well within another two weeks. They do not start catching their own prey for about five months, however, and remain heavily dependent on their parents' help. Sexual maturity comes at three to four years. Survival rates in the wild are not available, but this species has been known to survive in captivity for thirty years.

Verreaux's Eagle Owl has few natural enemies, although larger predators may occasionally ambush it on the ground: footage from a remote camera at a waterhole shows an owl captured at night by a jackal. Its avian competition might come from large diurnal raptors, such as the martial eagle (*Polemaetus bellicosus*), but although these two species share the same habitat they hunt at different hours so seldom clash. People are more of a threat. In some areas, the bird suffers direct persecution, either as an alleged (although generally unlikely) predator of livestock or because of a superstitious belief that it has evil powers. Otherwise, it is vulnerable to pesticide poisoning—particularly through ingesting poison in the bodies of rats and other rodents—and to the destruction and fragmentation of its habitat. A slow reproductive rate means that localized populations are slow to recover from such setbacks. However, the species remains widespread—with an estimated total range of 3.7 million square miles (9.8 million sq km)—and its conservation status is Least Concern.

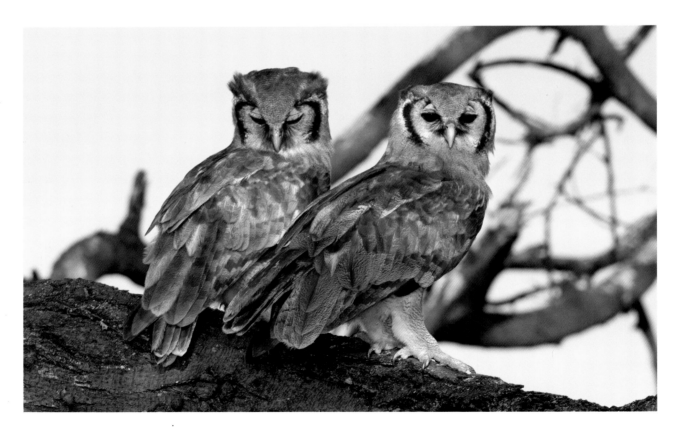

Above: Verreaux's Eagle Owls often roost close together.

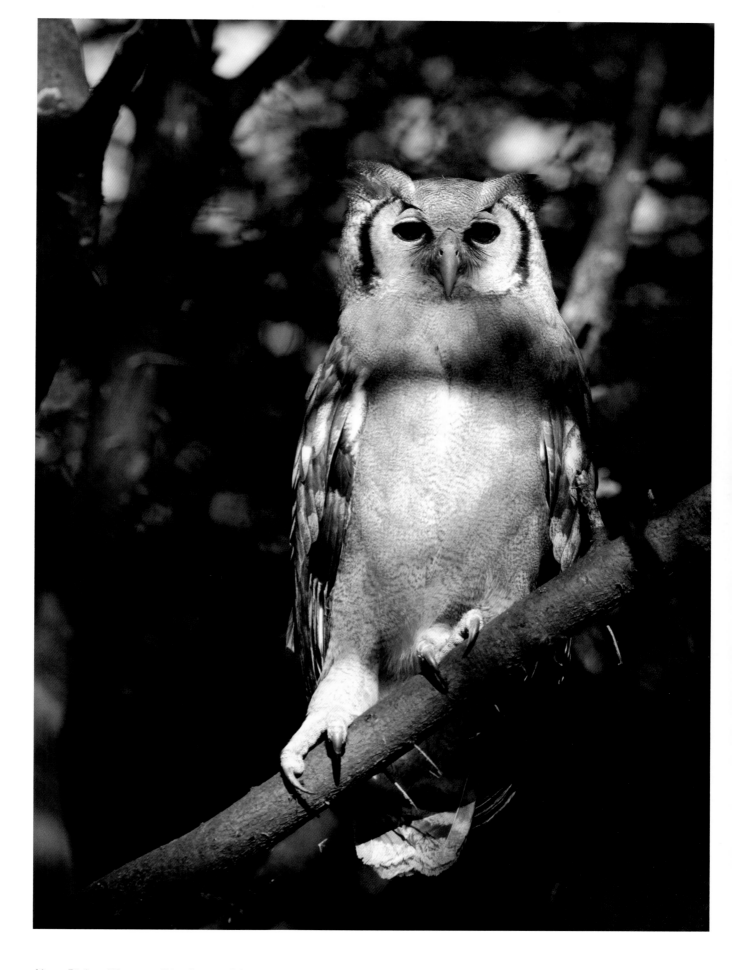

Above: Pink eyelids are a striking feature of this species.
Overleaf: An old hamerkop nest provides a nest site for a pair of Verreaux's Eagle Owls.

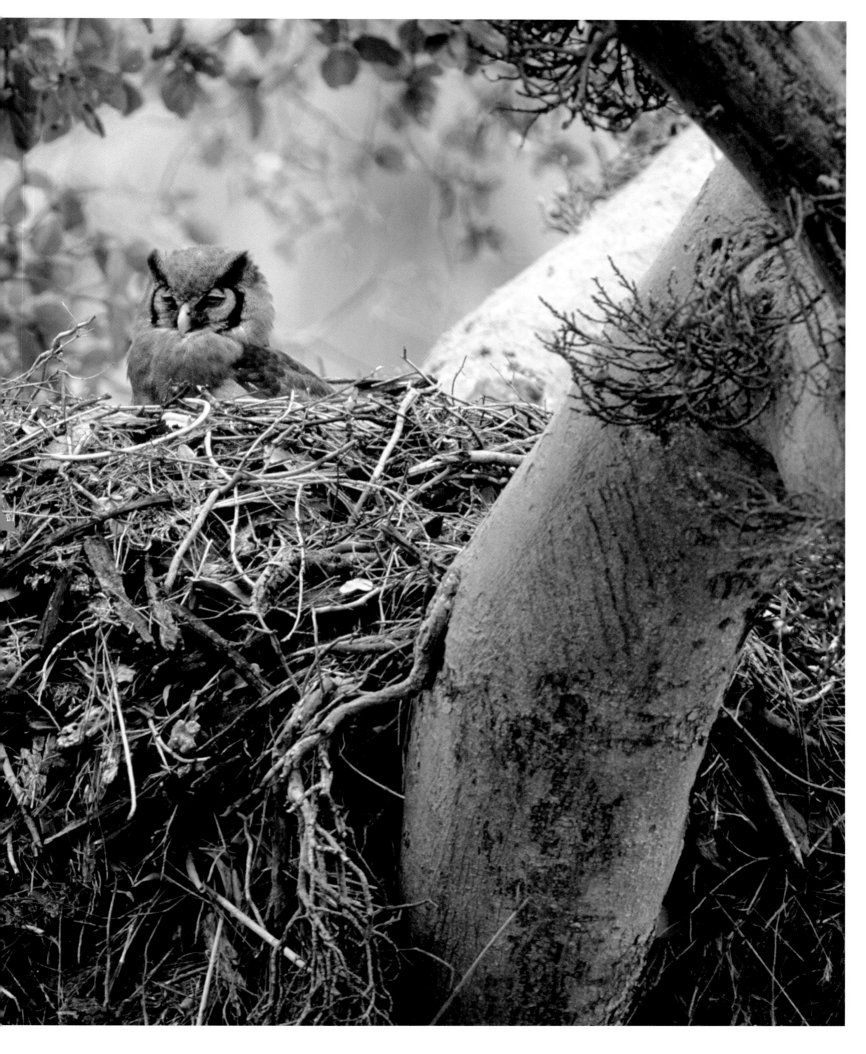

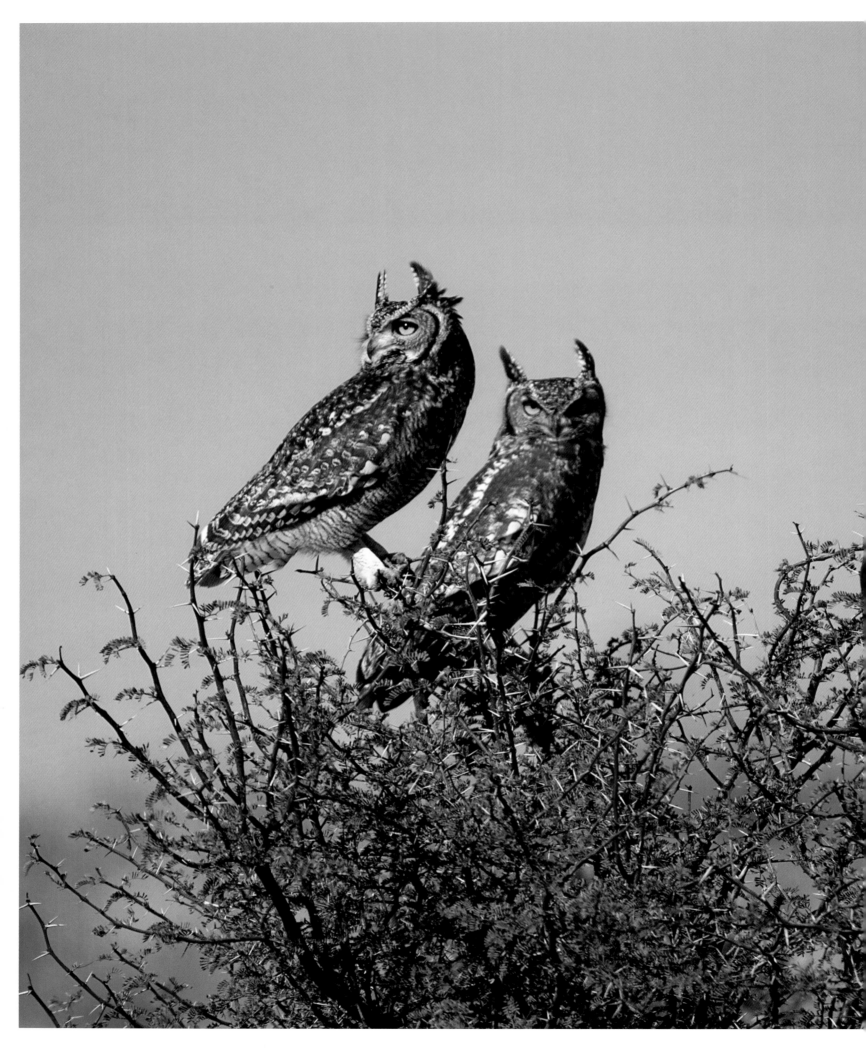

SPOTTED EAGLE OWL

BUBO AFRICANUS

APPEARANCE	SIZE
Medium-large, with prominent ear-tufts; upper parts brown, heavily patterned in white and cream with broken scapular line; under parts paler, finely barred with heavier blotching on breast; eyes yellow; male lighter than female.	*length 16–18 in. (42–45 cm)* *weight 1.1–1.9 lb (480–850 g)* *wingspan 39–44 in. (100–113 cm)* **DISTRIBUTION** *Widespread in Africa south of equatorial rain forest line; separate population found around the southern Arabian Peninsula.* **STATUS** *Least Concern*

THIS HANDSOME, BUZZARD-SIZE OWL is among the most common species in Africa, its familiar two-note hoot heard after dark across the southern half of the continent, from Cape Town to the Serengeti. It is similar, at first glance, to the Great Horned Owl (P. 48) of North America, but the fierce yellow-eyed glare and bristling ear tufts belie the fact that this is one of the smaller *Bubo* species.

The habitat preferences of the Spotted Eagle Owl, also known as the African Eagle Owl, range from semidesert to open woodlands, as long as the terrain offers enough shrubs, trees, rocks, and general cover in which to nest and roost. It has been recorded at altitudes of up to 6,900 feet (2,100 m) and is absent only from the densest forest and deepest deserts. It takes readily to suburban areas and will breed in parks and large gardens. Taxonomists list three subspecies: the nominate *B. b. africanus* occurs from Uganda to the Cape; the other two are found in coastal Kenya and the Arabian Peninsula, respectively. The Vermiculated Eagle Owl (*B. cinerascens*), formerly classified as an equatorial subspecies of the Spotted Eagle Owl, is now recognized as a species in its own right.

Generally, the Spotted Eagle Owl is nocturnal but it may be active before sunset. It roosts by day in trees, rock crevices, cave entrances, cliff ledges, and even on the ground, between rocks or in dense vegetation. In a tree, it tends to perch upright with ears fully erect. Paired birds often roost close together and can be seen preening one another during the day.

Hunting begins at sunset. Large arthropods, such as beetles, moths, and grasshoppers, make up at least half of this owl's diet, and the versatile predator will sometimes feed around streetlights in search of these. It will also take small mammals, reptiles, frogs, and birds. As with most *Bubo* owls, its standard hunting technique is to glide silently down onto prey from a perch. However, it will also snatch winged prey in flight and has been seen feeding on carrion.

The territorial song of the male Spotted Eagle Owl is a mellow two-syllable hoot, "hoo-HOOO," the first short one followed by a slightly longer one at a lower pitch. During courtship, the female responds with a triple hoot, "hoo-hoo, HOOO," at a higher pitch, and the two may call so close together that the combined sound resembles that of a single bird. This species also makes a barking "hokok-kok-kok-kok" during courtship and a wailing "keeow" when alarmed.

Pairs mate for life, stepping up their duetting as breeding gets under way. Typically, the nest site is a shallow scrape on the ground between rocks or a sheltered nook on a cliff ledge, but a hollow tree, the stick nest of another bird, and even a hole in the wall of a building may also be used. The female lays two to four eggs, at intervals of one to three days. She starts incubation from the first and continues for thirty to thirty-two days until they have all hatched. The chicks open their eyes at seven days, and by four to six weeks they are leaving the nest to explore. Both parents defend their brood aggressively, dive-bombing intruders. By seven weeks, the youngsters can fly but their parents will continue to care for them for another month or more.

This owl is among the most common in Africa so it inevitably faces a wide variety of threats. Natural enemies include Verreaux's Eagle Owl (P. 176), but human threats are more serious. These include pesticides, bush fires, barbed wire fences, vehicle strikes, and deliberate persecution among communities where a superstitious fear of owls still prevails. Nonetheless, its conservation status remains Least Concern.

Opposite: Two Spotted Eagle Owls, disturbed from their daytime roost, search for a new refuge.

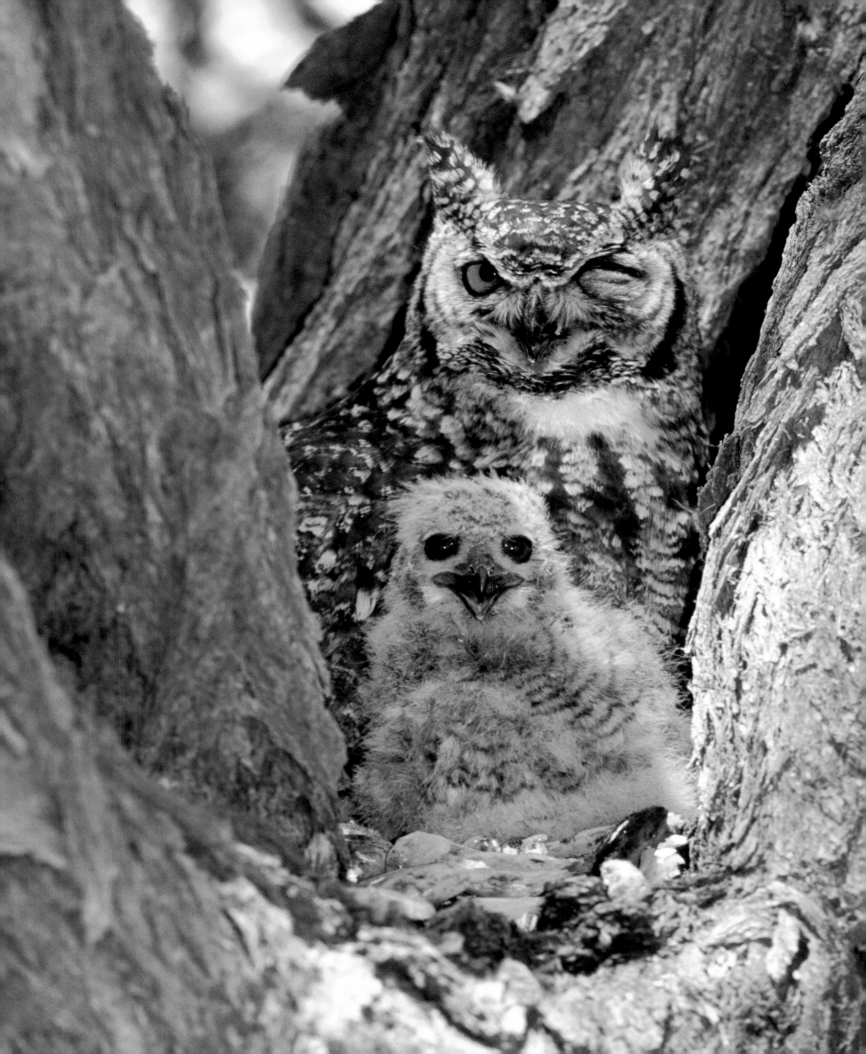

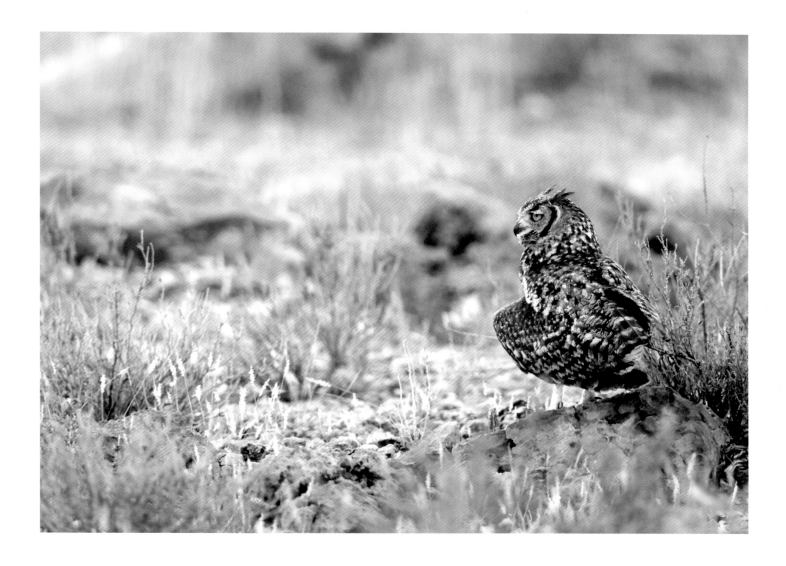

Above: Dusk falls in the Kalahari as a Spotted Eagle Owl sets out in search of prey.
Opposite: A Spotted Eagle Owl nestling enjoys parental protection at its nest in a tree hollow.

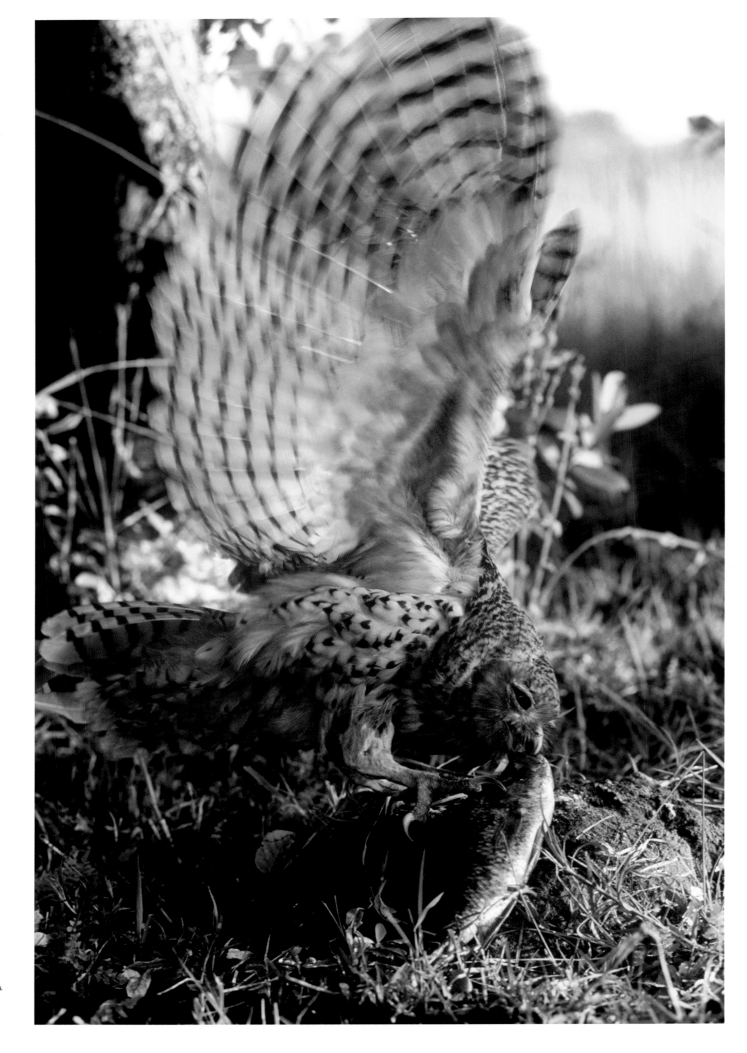

PEL'S FISHING OWL

BUBO PELI (SCOTOPELIA PELI)

APPEARANCE
Cat-size; rounded, shaggy-looking head with no visible ear tufts; large dark eyes in a pale face; lacks any defined facial disk; rich ginger-rufous plumage unlike that of any other owl.

SIZE
length 20–25 in. (51–63 cm)
weight 4.4–5.2 lb (2–2.35 kg)
wingspan 60 in. (153 cm)

DISTRIBUTION
Discontinuous range across sub-Saharan Africa, occurring in thirty countries; important populations in Senegambia region of West Africa; central Congo basin, scattered areas of East Africa and southern central Africa.

STATUS
Least Concern

FOR AFRICAN SAFARI-GOERS, this very large and rather odd-looking owl has acquired "must-see" status. By no means especially rare, it is nonetheless an impressive and elusive bird, and represents a sought-after sighting and top birding tick in some of the continent's best-known wildlife regions, including Botswana's Okavango Delta and Zambia's Luangwa Valley.

Pel's Fishing Owl was named for Hendrik Severinus Pel, the Dutch governor of Ghana from 1840 to 1850. Formerly classified within the *Scotopelia* genus of African fishing owls, along with two related species, it was the world's heaviest owl outside the *Bubo* genus. DNA research has since led most authorities to reclassify all three *Scotopelia* owls within *Bubo*, along with eagle owls and Asian fish owls. Whatever the taxonomy, this very big bird ranks on average as the world's fifth-largest owl by weight, and seventh by length.

On size alone—as when seen in silhouette after dark—the only species for which you might mistake Pel's Fishing Owl is the sympatric Verreaux's Eagle Owl (P. 176). Africa's two other fishing owl species are both a little smaller and have much more restricted distributions in West and Equatorial Africa. The Rufous Fishing Owl (*B. ussheri*) is more rufous and plainly marked, whereas the Vermiculated Fishing Owl (*B. bouvieri*) is browner, and more streaked below.

Pel's Fishing Owl depends for its survival upon catching fish and is supremely well adapted to the task. In contrast with other *Bubo* owls, it has very little feathering on the toes and tarsi. This prevents its plumage becoming waterlogged when it reaches below the surface. The undersides of its toes are coated with spiky scales called spicules to better grip its slippery prey, like the toes of the osprey (*Pandion haliaetus*) and sea eagles (*Haliaeetus* species), which feed in the same way. Its long, hooked claws also have a very sharp inner edge. Furthermore, because this owl hunts by sight, it has dispensed with the sound-channeling facial disks of many owls; because fish cannot hear it coming, it also has no need for the soft, sound-dampening feather adaptations common to the plumage of most owls.

Naturally, the habitat of Pel's Fishing Owl always includes water in some form. The bird generally frequents forest alongside lakes and large, slow-moving rivers, as well as swamps, estuaries, and forested islands. Its chief requirements are water that is both well stocked with fish and slow and clear enough to see and catch them, with large old trees close by in which to roost and breed. It is a resident species, showing no seasonal movement. By day, pairs roost together, typically on the large branch of a big tree, such as a sycamore fig (*Ficus sycomorus*), with a dense canopy. They are wary of disturbance, and often first seen when taking off and flying away to another roost. Dusk signals the start of the night's activity, when the owls move from their roost to stumps and branches that are either in or extend over the water, thereby allowing them a good vantage point from which to spot their prey. A fish generally gives itself away with ripples, whereupon the owl swoops down with talons extended to pluck its prize from the surface. At the moment of impact, it tends to close its eyes, and—unlike the osprey and fish eagles—does not plunge far beneath the water's surface, aiming to stay as dry as possible.

Prey comprises a variety of largely surface-feeding fish. There are no particular species preferences; the catch depends upon what is locally available. Most are in the 3.5 to 7.1-ounce (100–200 g) range, but monsters weighing up to 4.4 pounds (2 kg) may sometimes be landed. This owl is more strictly

Opposite: Pel's Fishing Owl feeds almost entirely on fish.

piscivorous than the fish owls of Asia, although it may vary its diet with frogs, crabs, mussels, and large insects. Even baby Nile crocodiles (*Crocodylus niloticus*) may fall victim.

In Pel's country, the bird gives itself away with its deep, booming hoot: a single note that reputedly carries for up to 2 miles (3 km) and is repeated every ten to twenty seconds. The male is noisiest at the start of the breeding season, and may follow the hoot with a higher-pitched "huhuhu." The female replies with a higher-pitched call. While singing, this bird inflates not only its throat, but also its entire breast with the frog-like effort at amplifying its call. Females and young at the nest also make a high wailing call as they await a food delivery.

Pel's Fishing Owl is both monogamous and territorial, claiming territory along a stretch of river or lake that it defends throughout the year. Its entire life history occurs within striking distance of the water. Breeding takes place during the dry season, when water levels are lower and the water is cleaner, which makes it easier to fish. The nest is usually in a natural hollow in an old shady tree close to the water, often at the junction of thick branches and the trunk. The female lays one to two eggs, usually as the water levels are starting to fall so that the brood grows up when prey is most concentrated and accessible. There is usually a five-day interval between the two eggs hatching, and often the second chick does not survive. During this period, both parents use distraction displays—screeching, as if injured—to protect the young, and may attack other predators, including the African fish eagle (*Haliaeetus vocifer*), if they get too close. The chicks fledge at around seventy days but remain dependent upon their parents for another six to nine months, not acquiring full adult plumage until at least ten months. This slow maturation process means that Pel's Fishing Owl has a slow reproductive rate, generally breeding only once every two years.

The International Union for Conservation of Nature lists Pel's Fishing Owl as Least Concern. It has a wide range, and in areas of abundant prey can be locally common. Its only serious predatory threat comes from Verreaux's Eagle Owl and, occasionally, the African fish eagle, which may also pirate its catches. However, this is a species of great environmental sensitivity, highly vulnerable to a decline in the quality of rivers and wetland habitats through such anthropogenic threats as damming, silting, pollution, overfishing, and irrigation schemes. Where populations are reduced, the loss of breeding trees through flooding and storms—and even elephant damage—can take a further toll. In Swaziland, for example, the species became extinct in 1984 after cyclone Domoina destroyed many mature sycamore fig trees along the country's lowland rivers and thus robbed the bird of its one breeding habitat in the country.

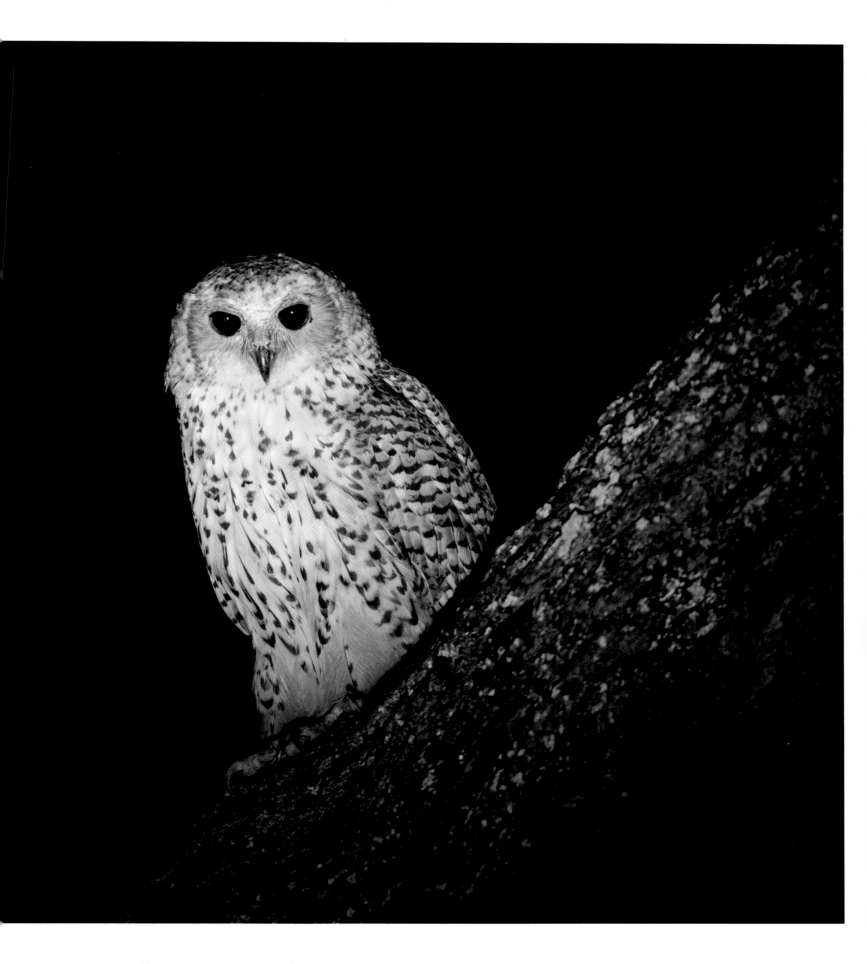

Above: The inky-black eyes and unmarked face of this species give it a presence unlike that of any other African owl.
Overleaf: Pel's Fishing Owl roosts high in the canopy by day.

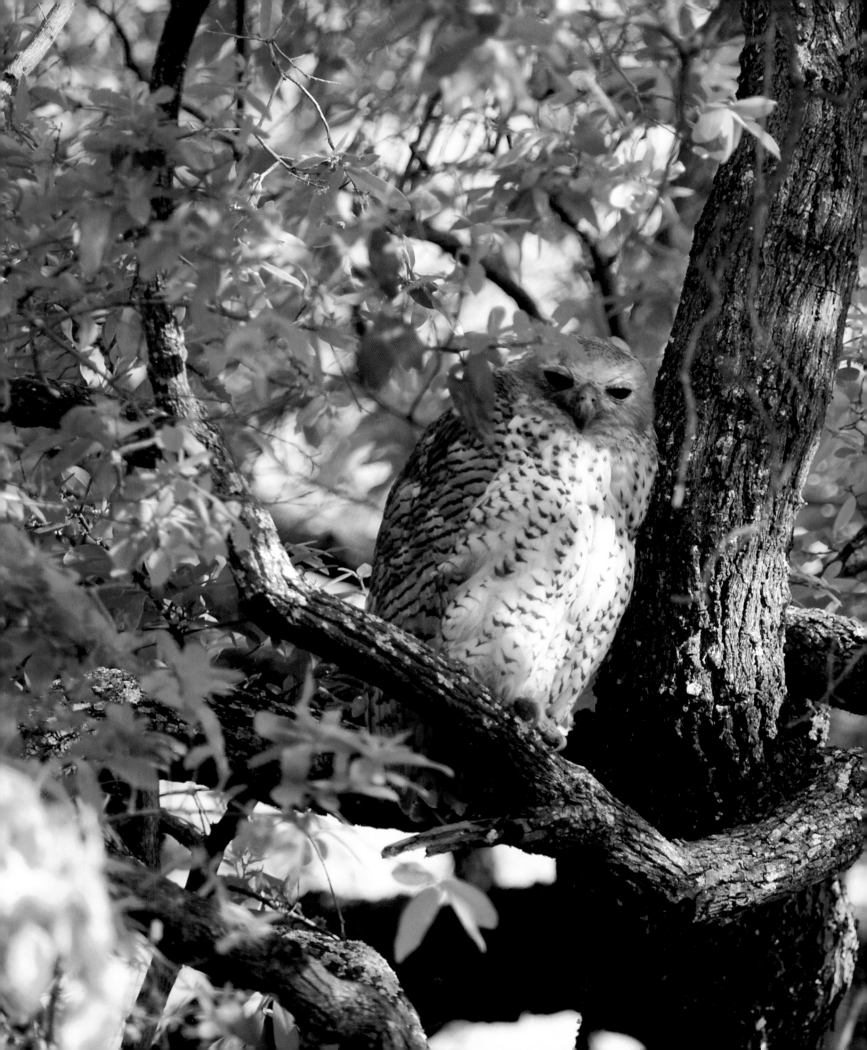

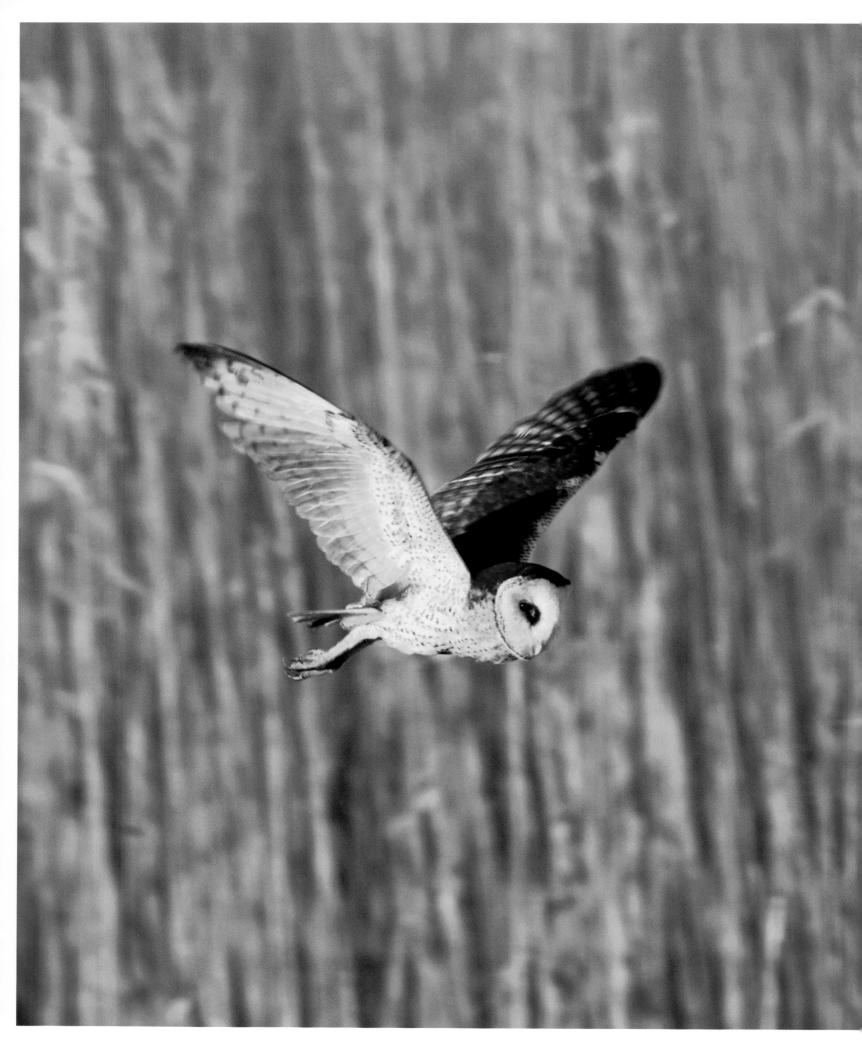

AFRICAN GRASS OWL

TYTO CAPENSIS

APPEARANCE
Similar to but larger and darker than the Barn Owl; upper parts sooty olive-brown, flecked in cream; under parts tawny to whitish-yellow, lightly spotted with dark brown; large round head with no ear tufts; well-defined facial disk, rounder than Barn Owl's; eyes dark and bill pale pink; wings long, with barred flight feathers; long white legs dangle beyond end of short tail; sexes similar.

SIZE
length 15–16.5 in. (38–42 cm)
weight 12.5–18.3 oz (355–520 g)

DISTRIBUTION
Patchily distributed across sub-Saharan Africa; occurs from Mozambique across the southern Congo to northern Angola; also north to Kenya and south to South Africa; isolated populations in Cameroon and Ethiopia.

STATUS
Least Concern

THIS ELEGANT, MEDIUM-SIZE OWL sits alongside the Barn Owl (P. 127) in the Tytonidae family of owls. At first glance, it resembles a larger Barn Owl in its general shape and coloration. In addition, its hunting behavior—quartering open ground in a floating flight and dropping down to seize unsuspecting rodents in its long legs—is very similar. However, a closer look shows that the African Grass Owl is not only larger than the Barn Owl but also quite different in plumage.

The African Grass Owl, also known as the Common Grass Owl, was once thought conspecific with the Eastern Grass Owl (*Tyto longimembris*) of southern Asia and Australasia. However, the ranges of the two species are separated by many thousands of miles, and the latter has a browner back with more yellowish markings. In Africa, it is more likely to be confused with the Marsh Owl (P. 194) than any other *Tyto* species, as both share the same habitat and behave in similar ways. It is a monotypic species, with no geographical variations.

This owl's habitat preference is reflected in its name: wherever it ranges, it requires grass in which to nest and hunt. Typical habitats range from moist grassland to dry savanna, up to an altitude of 10,500 feet (3,200 m) in Kenya's Aberdare Range and the Ethiopian Highlands. Its key requirement is plentiful long, dense grass. Although largely resident, it may move when this habitat changes: for example, after extensive droughts or bush fires.

A largely nocturnal species, the African Grass Owl rarely flies during daylight, except at times of prey shortage. By day, it roosts on the ground in tall, tangled grass, trampling its own runways and creating interconnected tunnels that may be several meters long. The roost or nest is on a domed grass platform at the end of one such tunnel, and pairs—even small parties—often roost fairly close together. At sunset, the owl starts its nightly hunt, quartering the ground in buoyant, floating flight, twisting its head from side to side as it watches and listens for prey in the grass below. It may occasionally hunt from a perch. The bulk of its diet comprises rodents and shrews, but it may also capture small birds, bats, and insects.

Breeding occurs at any time from December to August, but generally happens between February and April. The male becomes more vocal at this time, his territorial call being a trembling, hissing scream of one to two seconds that resembles a weaker version of that of a Barn Owl. During hunting flights, this species also makes an insect-like clicking call, which is thought to assist communication between individuals.

The nest is a shallow, grass-lined hollow at the end of one of the owl's grass tunnels. The female lays two to four eggs, normally at two-day intervals, and takes care of incubation while her mate supplies the food. Incubation lasts thirty-two to forty-two days. After the eggs hatch, the female continues for about ten days to feed the young with food brought by the male, then leaves the nest to help him with the hunting. At four weeks, she no longer roosts at the nest. By five weeks, the young are growing restless and wandering outside, and at seven weeks they make their first attempts at flying. They remain with their parents for another three weeks, before striking out for independence.

The African Grass Owl has a range of some 930,000 square miles (2.4 million sq km) and is classified as Least Concern. Nonetheless, it is declining in some areas due to the loss of its grasslands. In South Africa, it is listed as Vulnerable, with an estimated population of 1,000 to 5,000 birds.

Opposite: African Grass Owls quarter open ground on long wings in search of prey in the long grass below.

MARSH OWL

ASIO CAPENSIS

APPEARANCE
Medium-size; barely visible ear tufts; pale buff, well-defined facial disk with dark markings around eyes; eyes dark brown; upper parts are plain brown, with conspicuous buff patch at base of primaries; under parts are pale, plain buff to white; prominent dark carpal patch at the wrist of pale underwing; tail and flight feathers strongly barred in dark brown and buff.

SIZE
length 12.5–15 in. (32–38 cm)
weight 7.9–17 oz (225–485 g)
wingspan 32–39 in. (82–100 cm)

DISTRIBUTION
Locally common in a broad band across southern and central Africa north to Ethiopia and south to South Africa; isolated populations in West Africa, Morocco, and Madagascar.

STATUS
Least Concern

THIS LONG-WINGED, MEDIUM-SIZE OWL is Africa's equivalent of the Short-eared Owl (P. 141), which occupies a similar niche across much of Eurasia and North America. Roughly the same size and shape as its cousin, although more plainly marked, it is also an open-country bird that nests and roosts on the ground and hunts at dusk on long wings, quartering the ground for rodents and other small prey below.

Along with the Short-eared Owl, the Marsh Owl is one of eight species that make up the *Asio* genus of "eared owls." Its ear tufts are tiny, however, and only visible at close quarters when erected in alarm or display. The pale buff, well-defined facial disk sports dark clown-like markings around the eyes, like those of a Short-eared Owl, but the eyes are dark brown, rather than bright yellow like its northern cousin's.

This species has a patchy distribution that extends from the top to the bottom of the continent and east to the island of Madagascar. However, the range features large gaps— mainly regions of tropical forest and desert—where the habitat is unsuitable. It is locally common in twenty countries south of the Sahara, with the bulk of the population found in a broad band that stretches across southern and central Africa north to Ethiopia and south to South Africa's Cape, hence the name *capensis*. Isolated populations occur in the Senegambia region of West Africa and also in northwest Morocco. Three subspecies are listed: the nominate *A. c. capensis* is the one

found across Africa south of the Sahara; *A. c. tingitanus* is the Moroccan race, distinguished by its darker upper parts and more rufous under parts; and *A.c. hova* is the Madagascar race, which is larger and more distinctly barred than the other two. The taxonomy of this species, however, remains a work in progress.

The Marsh Owl is not particularly associated with marshes, but it does require open country without too much cover, and its habitats range from coastal plains to inland savanna and farmland. It will also make use of cleared drainage strips in more wooded savanna but is not found in forested, rocky, or arid regions. Although toward the north of its range it may overlap in habitat with wintering Short-eared Owls that have migrated south from Europe, confusion is more likely with the African Grass Owl (P. 193). This bird belongs to a different genus (*Tyto*) but has similar coloration—although is darker above and more spotted below—and hunts in a similar way over the same habitat.

A largely sedentary owl, in some parts of its range the Marsh Owl may wander further afield according to fluctuations in food supply. Birds from Morocco have been recorded in southern Spain and Portugal and even in the Canary Islands. Outside the breeding season, small numbers may converge on good feeding grounds and at these times they may form communal roosts comprising dozens of birds. Social behavior of this kind, unusual among owls, allows birds to follow one another to food and also creates an increase in their combined vigilance against predators.

By day, the Marsh Owl roosts in a grassy hollow on the ground, but it is not strictly nocturnal, often emerging to hunt in the early morning or late afternoon, and sometimes remaining active on cloudy days. Like the Short-eared Owl, it hunts in a slow, agile flight, swerving and hovering as it looks and listens for prey on the ground below before dropping down when a target is located. Prey comprises mostly small rodents, such as multimammate mice (*Mastomys* species),

Opposite: A Marsh Owl perches on a road, taking advantage of vehicle headlights to look for rodents.

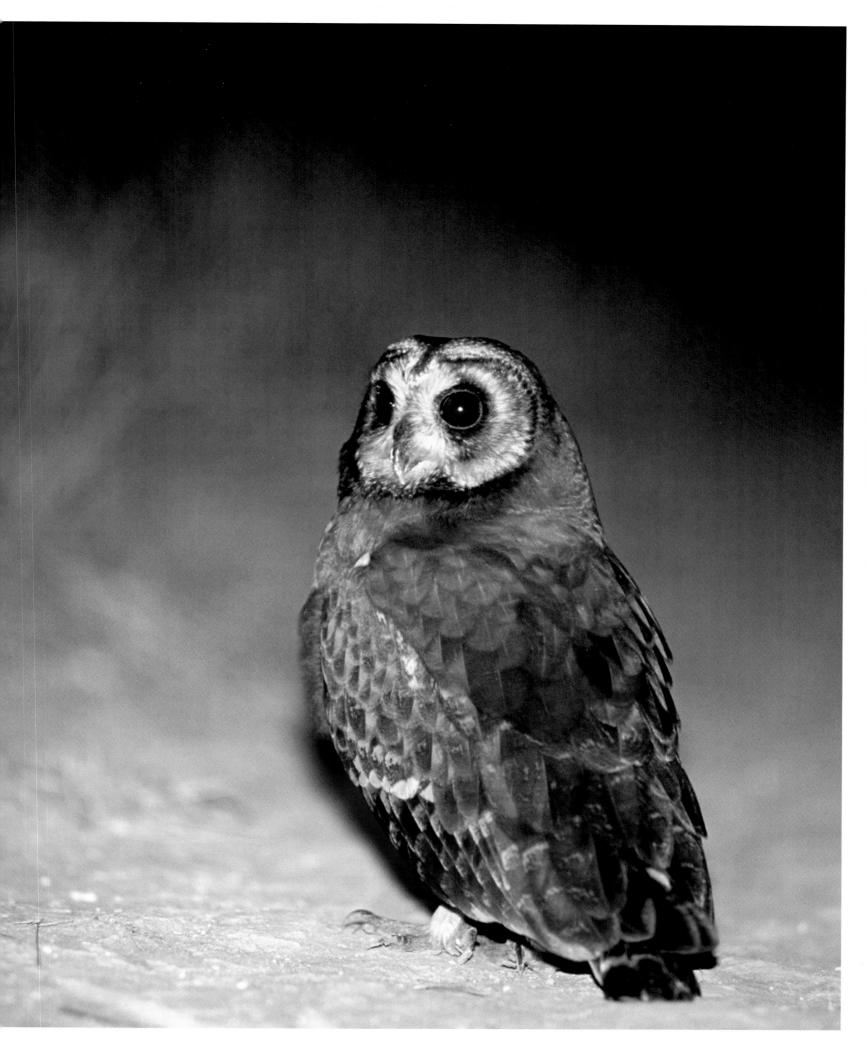

which in one study made up more than 80 percent of items brought to the nest. However, it may also include frogs, lizards, insects, bats, and small birds—the latter often taken in flight. This species may gather with other raptors to exploit seasonal bounty, notably the huge emergences of winged termites that herald the rainy season in some tropical regions.

The Marsh Owl's voice is not a thing of beauty. The male calls with a creaking, grating "kerrr," repeated at variable intervals. In order to push home the message during the courtship season, he also performs wing-clapping, aerial display flights, which may culminate in both sexes pursuing one another acrobatically around the sky. Pairs are monogamous and territorial, and nests with eggs have been found in every month except January, thus showing this species' capacity to breed opportunistically when conditions allow. Generally, the nest is a trampled patch or mound at the end of a tunnel or runway of grass, and it is lined with a few token dry leaves. The female lays from two to six eggs (an average of three) on this nesting "pad." She incubates the clutch, while the male brings food, which he continues to supply after the youngsters have hatched. He responds to the begging calls of the female, and when she and her brood are replete he piles up any surplus offerings at the entrance to the tunnel. The chicks open their eyes at seven days, and the female continues brooding and guarding them for about three weeks. She will aggressively drive away raptors and other predators that approach too close, or may employ an impressive distraction display— flying away from the nest and then crashing to the ground as though injured—in order to divert the interloper's attention from her brood.

At three weeks, the youngsters are strong and energetic enough to leave the nest and start wandering around in the nearby vegetation. At this point they scatter, which means that should a predator come across the nest, it will not necessarily be able to locate all the young. When the parents arrive with food, however, the youngsters will make begging noises and dance about in the grass to attract their attention. At thirty to thirty-five days, they embark on their first flights, and by ten weeks they have full adult plumage and can hunt adequately for themselves.

The Marsh Owl is listed as Least Concern. It has an extensive range and remains common in many areas. However, its nomadic habits make populations hard to monitor, and it is known to be uncommon and declining in certain areas, including Morocco, where the population is now estimated at only 40 to 150 pairs. Like all grassland species, it is vulnerable to bush fires, drought, and other climatic factors that may have an impact upon its habitat and prey supply. It is also a common casualty of road traffic.

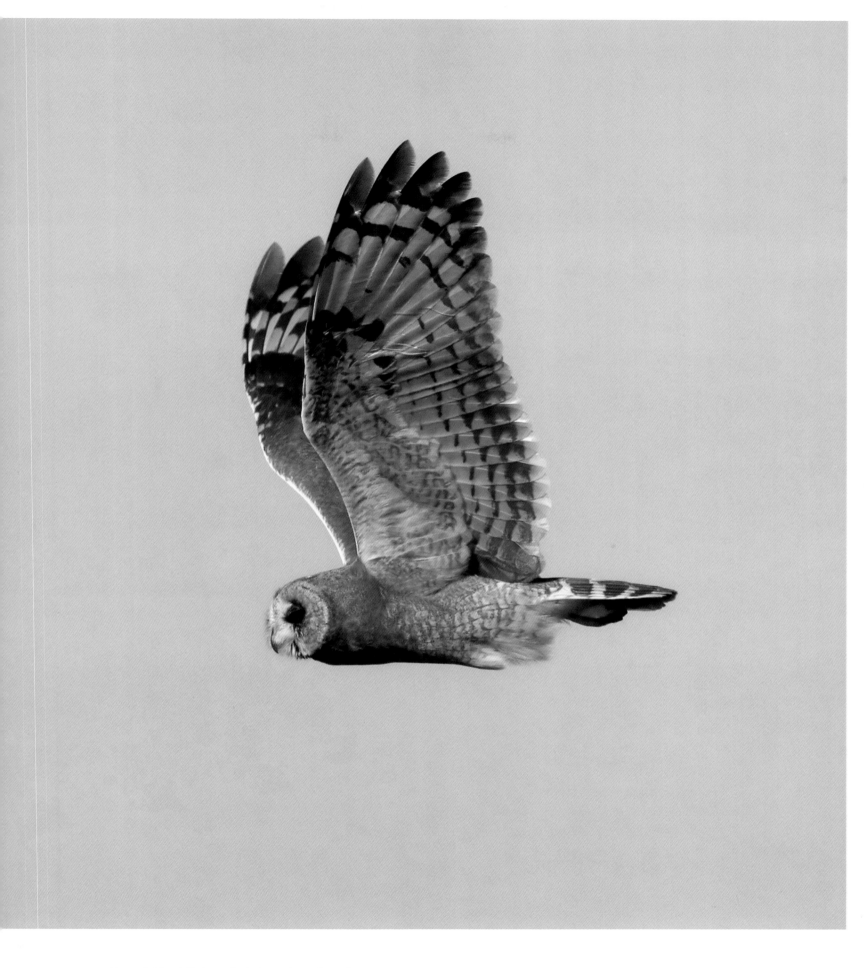

Above: A Marsh Owl reveals the long wings of a predator
that does most of its hunting in flight.

Right: The Marsh Owl hunts by daylight in open country, much like its northern relative, the Short-eared Owl.

AFRICA

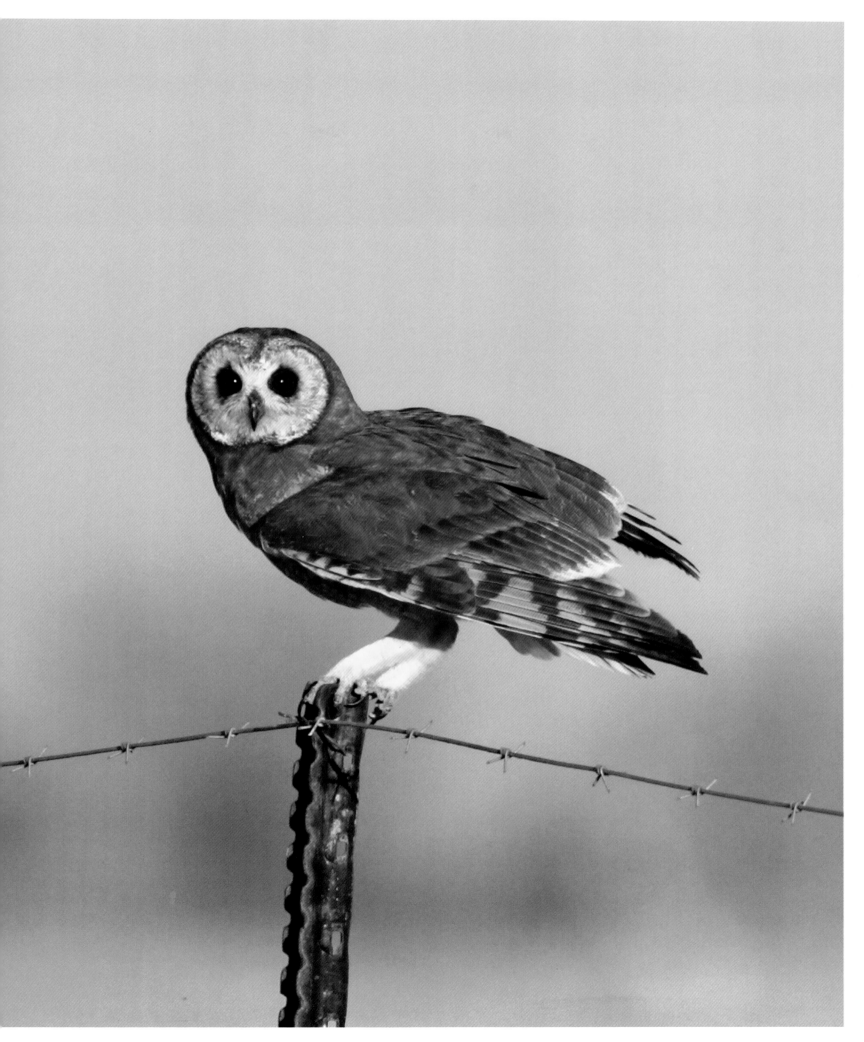

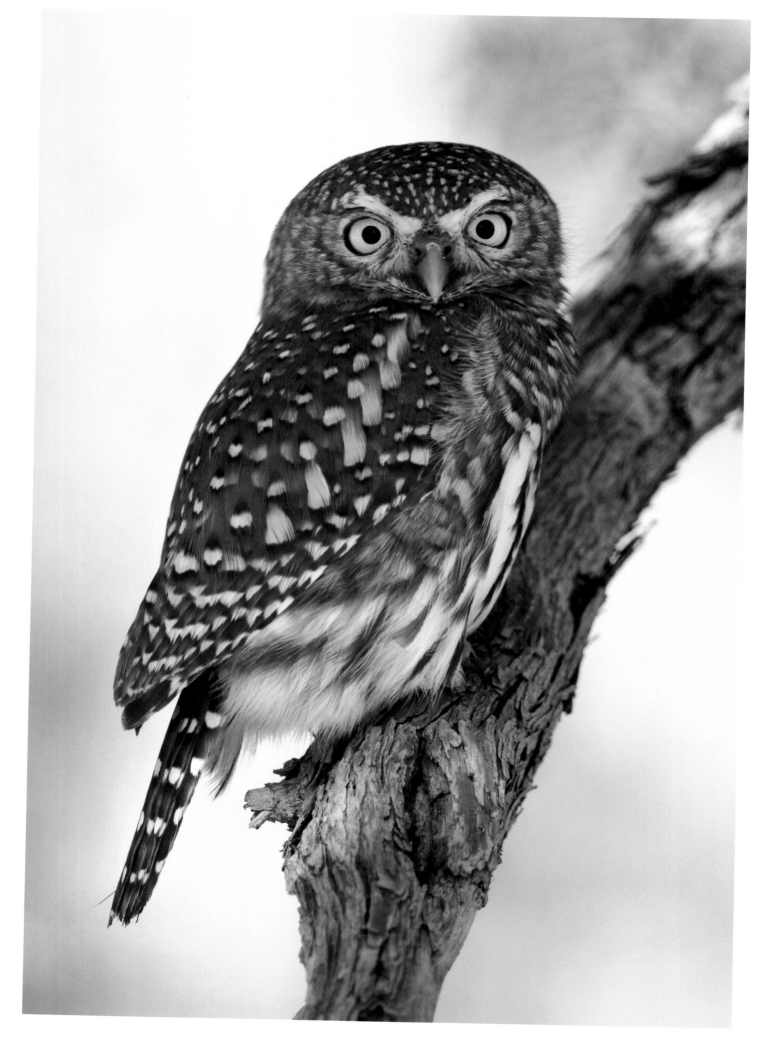

PEARL-SPOTTED OWLET

GLAUCIDIUM PERLATUM

APPEARANCE

Very small, with rounded head and no ear tufts; facial disk gray-brown, with yellow eyes and bold white eyebrows; upper parts chestnut-brown, with strong white scapular line and pearly white spots; under parts white, strongly streaked in dusky-brown with rufous-brown mottling on upper breast and flanks; occipital face on nape in dark brown and white; in flight, shows long tail and barred flight feathers.

SIZE

length 6.5–7.5 in. (17–20 cm)
weight 1.2–5.1 oz (36–147 g)
wingspan 15.5 in. (40 cm)

DISTRIBUTION

Across sub-Saharan Africa, south of east–west line from southern Mauritania to Ethiopia down to northern Cape Province of South Africa; absent from montane and tropical forest, and true desert.

STATUS

Least Concern

DAY OR NIGHT, THE PIERCING SONG of this diminutive owl is one of the most distinctive sounds of the African bush. It comprises a sequence of clear whistled notes, rising slightly in pitch and volume like a kettle coming to the boil. After a brief hiatus, a series of descending, slower, and even louder down-slurred whistles are heard. The call whips up other small birds into a fury of indignation as they flock to the offender and attempt to hound it from their territory. This provocative effect that the owl has upon its neighbors is a boon for the canny birder, who—by imitating the call of the hated predator—not only can attract the owl closer for a better view, but also may lure a good selection of other birds.

The Pearl-spotted Owlet is one of six African species in the *Glaucidium* genus of pygmy owls, all known as "owlets," and it is similar to the Eurasian Pygmy Owl (P. 134). Its typical habitat comprises open short-grass savanna with scattered trees and thorny shrubs. It also thrives in dry semi-open woodland and semi-open riverine forest bordering savanna. The Pearl-spotted Owlet is most active at dusk and dawn, but may be seen at any time of day and will continue to hunt and call on moonlit nights. It sings from an exposed perch, often atop a tree or bush, and seems heedless of the unwelcome attention that this often attracts from other species. Generally, it is a sit-and-wait hunter, swooping down from a perch onto its prey, which varies from large arthropods, such as beetles, grasshoppers, spiders, and millipedes, to small vertebrates, including lizards, rodents, and birds. Like all pygmy owls, this species is a rapacious hunter that uses powerful talons to tackle prey as large or even larger than itself, including birds up to the size of the laughing dove (*Spilopelia senegalensis*).

Singing intensifies during the courtship period, at which point the male's far-carrying signature song may draw a similar, slightly higher-pitched reply from his mate. Breeding is generally from August to November, with pairs duetting in order to claim their territory. Each pair will defend only the immediate surroundings of its nest site, which means that one pair will tolerate a neighboring pair at a distance of no more than 820 feet (250 m).

This species usually nests in the old unoccupied tree hole of a woodpecker or barbet, up to 33 feet (10 m) above the ground. The male advertises a potential site by singing near the entrance, and a pair will reuse a good site from one year to the next, competing fiercely with other hole-nesting birds and sometimes destroying their nests in the process. After three or four weeks of courtship, the female lays her brood of two to four eggs at two-day intervals. She is responsible for incubation, which lasts for twenty-nine days, with the male delivering food to her inside the nest hole. Occasionally, the male assumes temporary incubation responsibilities if his mate leaves the nest for a while. The young are fed by both parents, day and night, and leave the nest at around thirty-one days. At first, they fly only short distances and hide near the nest, to be fed by their parents, but after a short while they explore further afield to find their independence. They reach sexual maturity in less than one year.

The Pearl-spotted Owlet is a widespread and common species that occupies an estimated range of some 4.5 million square miles (11.9 million sq km) across Africa. Being largely a bird of open woodland, it is not as vulnerable to habitat loss as those species dependent upon grassland or forest.

Opposite: The Pearl-spotted Owlet boasts exquisite markings.
Overleaf: A Pearl-spotted Owlet perched in the open by day.

CAPE EAGLE OWL

BUBO CAPENSIS

APPEARANCE
Medium-large, with prominent ear tufts; orange-yellow to orange eyes set in tawny facial disk with strong black rim; crown and upper parts dark brown, with whitish, black, and tawny spots and mottling; broken scapular line; under parts pale tawny-brown, grading to whitish belly, heavily barred and blotched in darker brown and black; flight and tail feathers heavily barred; prominent white throat when calling.

SIZE
length 18–24 in. (46–61 cm)
weight 2–3 lb (900–1,380 g)
wingspan 47–49 in. (120–125 cm)

DISTRIBUTION
Scattered range across eastern and southern Africa, from Eritrea and Ethiopia, south through Kenya, Tanzania, Zimbabwe, Malawi, and Mozambique to southern Namibia and South Africa's Cape.

STATUS
Least Concern

THIS HANDSOME OWL STANDS roughly halfway in size between the larger Verreaux's Eagle Owl (P. 176) and the smaller Spotted Eagle Owl (P. 183), whose ranges it overlaps in some regions. Although quite widespread, it is generally less common and more elusive than either of its better-known relatives. A sighting is, therefore, always a red-letter day for the birder.

The Cape Eagle Owl is a typical mid-range *Bubo* eagle owl, roughly the size and shape of the Great Horned Owl (P. 48), with similar prominent ear tufts. Taxonomists recognize three subspecies: *B. c. capensis* is the nominate, occurring in the southern half of southern Africa; *B. c. dilloni* is the northernmost, occurring in Ethiopia and Eritrea; and *B. c. mackinderi* ranges from southern Kenya to the northern half of southern Africa. The last of these—the most tawny-orange in color—was formerly considered a separate species by some authorities and was known as Mackinder's Eagle Owl, but DNA studies have since confirmed that it is simply a geographical variant of the same species. Whatever the race, this owl is best distinguished from the smaller Spotted Eagle Owl—with which confusion is most likely—by its blotchier under parts and more rufous coloration overall. It also has larger, more powerful feet and, of course, a different call.

Throughout its range, the Cape Eagle Owl favors hilly and rocky regions, with gorges and wooded gullies. It may also hunt in adjacent savanna, but is absent from the dense forest and arid regions. It sometimes finds a home in developed areas, including both Johannesburg and Pretoria, which offer roosting sites above the city streets and an abundant supply of feral pigeons as prey.

This is a largely nocturnal owl. By day, it roosts between rocks, in crevices, or on shaded rock ledges. It may also use leafy trees and, like other *Bubo* species, sometimes hunkers down under a bush. Pairs often roost together, especially before the breeding season. Hunting starts from sunset, with the owl taking up a prominent perch from which to swoop onto its victims, often dispatching them with a bite to the head. Prey comprises largely mammals, ranging in size from small rodents and shrews to hares, but also includes birds up to the size of hamerkop (*Scopus umbretta*), as well as reptiles, frogs, crabs, scorpions, and large insects.

A male Cape Eagle Owl has a distinct two-syllable territorial song, consisting of one deep hoot, followed by a faint, short second note, "booo-hu." It repeats this every few seconds, usually from an exposed perch, and waits for the higher-pitched response of a female. The pair sometimes duet, and the male amplifies his courtship performance with a rhythmic "cu-coo-cu" note, while inflating his white throat and bowing up and down to his mate. The female also begs food with a drawn-out, wheezing "chrrreeh," and both sexes utter a barking "wack wack" alarm call. Breeding takes place annually or, sometimes, in alternate years. The nest is generally a shallow scrape, either on a sheltered rock ledge, cave entrance, between rocks, or under a bush. Stick nests of other large birds are also sometimes used.

The Cape Eagle Owl is classified as Least Concern. Although locally common in a few regions, such as Kenya's Mau Plateau, it generally occurs at low densities. Adult birds face few natural threats, but road traffic, power lines, and barbed wire all take their toll, while pesticides, fires, and overgrazing can all deplete the habitat of the prey they require.

Opposite: The Cape Eagle Owl is a bird of rocky terrain.
Overleaf: A Cape Eagle Owl at its nest in a tree fork.

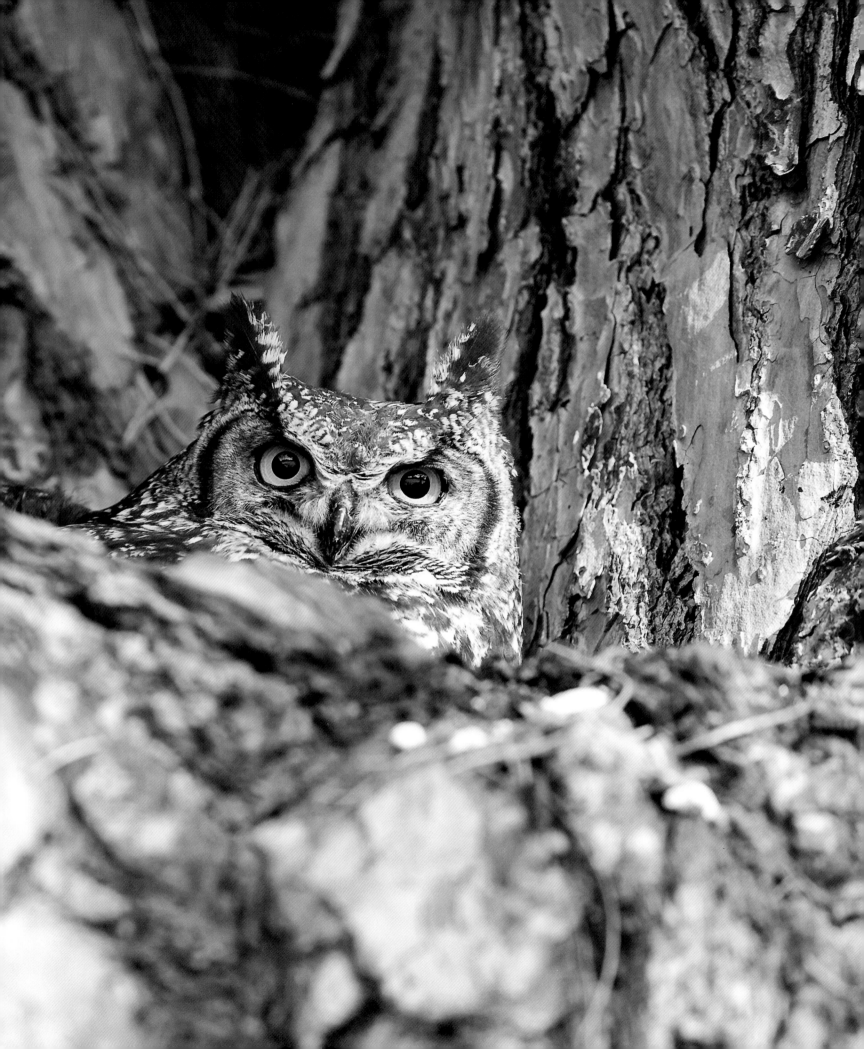

AFRICAN SCOPS OWL

OTUS SENEGALENSIS

APPEARANCE
Extremely small, slim profile; broad upright ear tufts; yellow eyes; crown and forehead have broad shaft-streaks, over gray to brownish upper parts; under parts a little paler.

SIZE
length 6.2–7.4 in. (16–19 cm)
weight 1.5–3.5 oz (45–100 g)
wingspan 15.5–17.5 in. (40–45 cm)

DISTRIBUTION
Africa south of the Sahara; from southern Mauritania to southern Sudan in the north, and south to South Africa's Cape; absent from dense equatorial forest zone of Congo basin; also occurs on Annobón island, off coast of Gabon.

STATUS
Least Concern

To some, the quintessential sound of the African bush after dark may be the roar of the lion or the whoop of a hyena. However, there is nothing that more evokes a night around the campfire than the brief cricket-like "prrrp" of this small owl. Sounding more like an insect or frog than a bird, it is a ubiquitous—and at time almost metronomic—part of the nocturnal sound track.

Finding the singer, however, is another matter entirely. Like all scops owls in the *Otus* genus, this tiny species—smaller on average even than the Pearl-spotted Owlet (P. 201)—is endowed with richly cryptic coloration that makes it extremely difficult to detect against the patterned background of its daytime tree roost. Once spotted, however, it is very approachable, trusting to its camouflage to escape detection even at very close quarters. The species occurs in both gray and brown morphs, with color and pattern varying between individuals. In either morph, the overall effect is of a plumage that in both color and texture resembles tree bark.

The African Scops Owl occurs across much of the continent south of the Sahara. Throughout its range, it favors semi-open habitats, including savanna with scattered trees and thorny shrubs, as well as open woodland. It may also inhabit parks, large gardens, and forest clearings, but seldom ranges above 6,560 feet (2,000 m) elevation. Three subspecies are recognized, with the nominate, *O. s. senegalensis*, occurring across most of sub-Saharan Africa.

A nocturnal bird, the African Scops Owl roosts during the daytime in dense foliage or in a hole, or against a branch or tree trunk, where its camouflage renders it almost invisible. Pairs may roost close together, and sometimes loose colonies form. After dark, it hunts from a perch for prey on the ground below. Its diet comprises predominantly large insects and other arthropods, including grasshoppers, beetles, moths, crickets, spiders, and scorpions, but it may also extend to small vertebrates, including rodents, frogs, geckos, and small birds. Flying insects may be hawked on the wing. The catch is usually taken to a favorite perch where it is killed, torn into pieces, and consumed.

At the start of the breeding season, the soft mechanical trill of a territorial male African Scops Owl is repeated endlessly throughout the night, with intervals of five to eight seconds between each call. This is a monogamous species, and during courtship male and female are often heard duetting. The male calls the female to potential nest sites by singing from the entrance of a tree hole, usually one made by a woodpecker or barbet. Once his mate has approved a site, she lays two to three eggs directly on the floor of the hole. Incubation is her job alone and starts with the second egg, continuing for about twenty-four days while the male—who roosts nearby—supplies her with food.

Three days after hatching, the chicks open their eyes, and they are fed by the female until they are eighteen days old. The female then leaves the nest to help the male with hunting. At about three to four weeks, the young leave the nest. They soon begin to catch prey themselves, but the female continues to feed them until they are sixty days old, by which time they have acquired virtually their full adult plumage. The youngsters reach sexual maturity at eight months.

In the wild, the African Scops Owl faces numerous predators. However, with an estimated pan-African range of some 5.2 million square miles (13.5 million sq km), and dense populations in many areas, the species is listed as Least Concern.

Opposite: The cryptic camouflage of the African Scops Owl allows it to blend in perfectly with the fissured bark of an acacia tree.

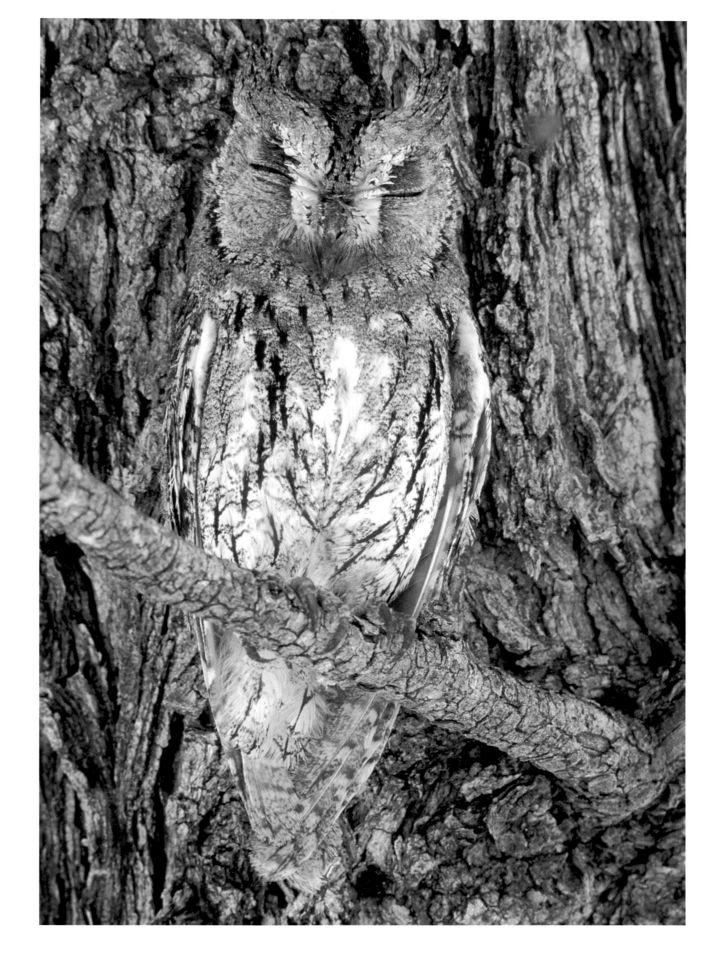

Overleaf: An African Scops Owl takes up a strategic perch in an acacia to scan for prey.

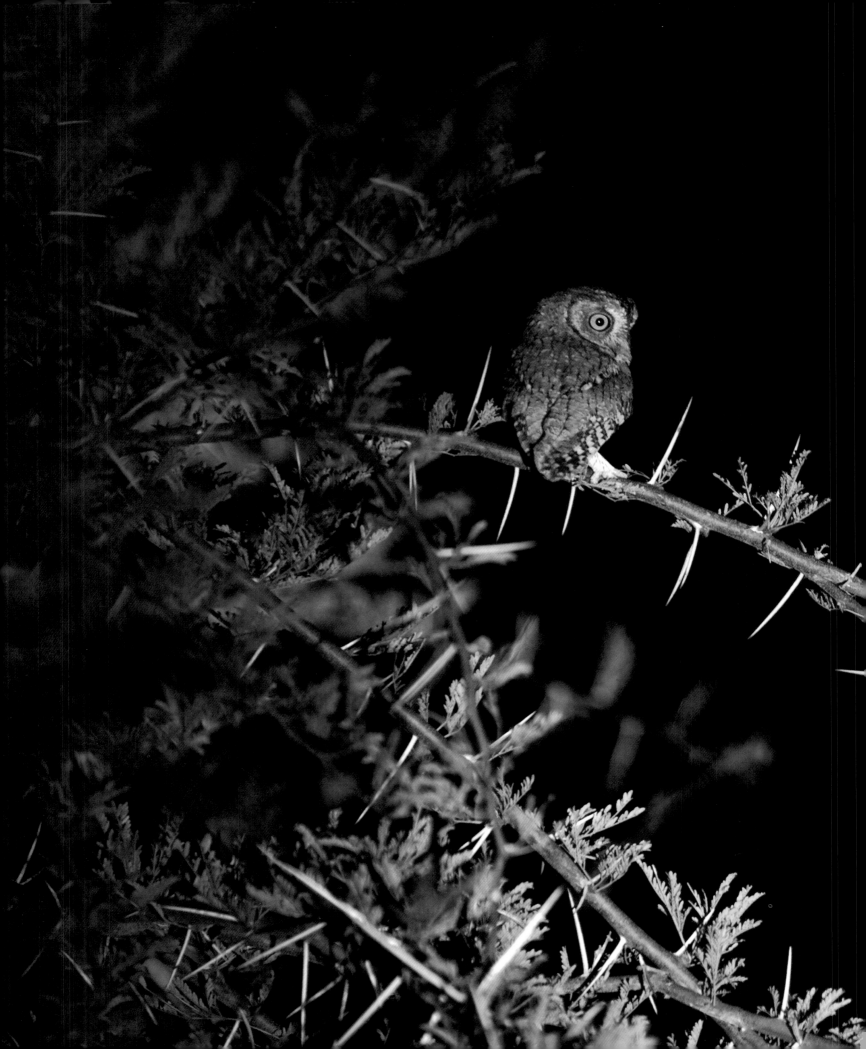

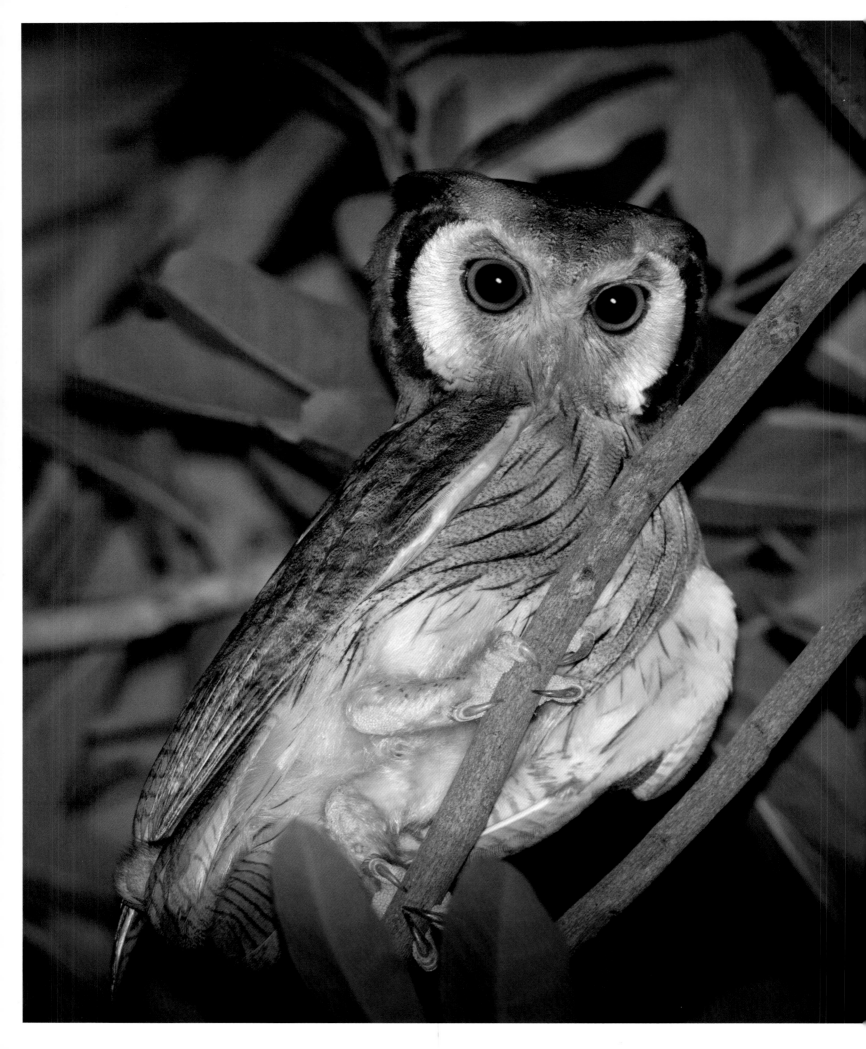

NORTHERN WHITE-FACED OWL

PTILOPSIS LEUCOTIS

APPEARANCE
Small with long ear tufts; black-rimmed white face; light and dark color morphs; light morph pale grayish-brown; upper parts marked with fine vertical dark streaks and bold white scapular line; under parts slightly paler; tail and flight feathers strongly barred; wings appear broad and rounded in flight; dark morph is similarly marked.

SIZE
*length 9.5–10 in. (24–25 cm)
weight 7 oz (200 g) ave
wingspan 19.5 in. (50 cm)*

DISTRIBUTION
Africa south of the Sahara and north of equatorial rain forest from Senegambia east to Sudan, Somalia, north Uganda, and Kenya.

STATUS
Least Concern

THIS DAPPER OWL LIVES UP TO ITS NAME, with a bright white facial disk—intensified by bracket-like black borders—that stands out boldly from the soft gray background plumage. Add the burning amber eyes and long, tousled ear tufts and you have one of the more intense expressions among African owls.

This species was once thought conspecific with the very similar Southern White-faced Owl (*Ptilopsis granti*), and the two birds were lumped together as the White-faced Scops Owl and placed in the *Otus* genus. They have since been assigned their own genus, *Ptilopsis*, and split into two species, as a result of DNA research and on the basis of their different calls. The Southern White-faced Owl occurs in the southern part of the continent, as far south as South Africa, with the two overlapping only in central Kenya. The Northern White-faced Owl occurs in a broad band across north-central Africa, between the Sahara to the north and the equatorial forests further south. Typical habitat is dry savanna and acacia thorn scrub. It is absent from deserts and dense tropical rain forest.

This owl is nocturnal, roosting by day against a tree trunk or among dense and often thorny foliage. It trusts to its camouflage plumage to avoid detection and if approached will, like many scops and screech owls, compress both its head and body into a tall, thin, stick-like shape—with its ear tufts erect and eyes closed to slits—to further enhance the deception. If its disguise is rumbled, it may face the predator and fan out its wings to appear larger and more intimidating.

Paired birds often roost close together, and outside the breeding season individuals may gather at a communal roost.

At dusk, this owl sets out to hunt, finding a prominent perch from which to scan for prey on the ground below. Much of its diet comprises large invertebrates, such as moths, crickets, beetles, scorpions, and spiders, but it also takes small vertebrates, including reptiles, birds, and mammals such as rodents and shrews; indeed, it captures a higher proportion of these than do *Otus* scops owls. Prey is generally swallowed whole, and the resulting pellets accumulate on the ground below a favorite roost site.

The male Northern White-faced Owl stakes his territorial claims with a mellow two-syllable call—an almost dove-like "po-prooh"—which he repeats at intervals of four to eight seconds. Calls may be heard at any time of the night, but are most frequent at dusk or just before dawn—and especially during the courtship season, when the male sings from potential nest sites and the female answers with a weaker and higher-pitched voice. As the pair duet, the male approaches the female and bobs his head up and down.

Generally, a nest is a natural hole or crevice in an old tree, some 6 to 26 feet (2–8 m) above the ground, but the old stick nests of other birds are sometimes also used. A successful site may serve a pair for several years. The female lays one to four eggs at intervals of about two days. She incubates alone, starting with the first egg, and continues until they hatch at thirty days. The male brings food and continues to do so as the chicks grow. At twenty-seven days, the young may leave the nest and clamber into nearby branches. By thirty to thirty-two days, they can fly, but they continue to receive food and protection from their parents for another two weeks.

This species is listed as Least Concern. Its breeding range covers some 3.2 million square miles (8.3 million sq km), and it can be locally common in suitable habitats. Dangers are likely to include fires and pesticides, which can both threaten the owl's food supply.

Opposite: The bold white facial disk gives this species a distinctive expression.

AFRICAN BARRED OWL

GLAUCIDIUM CAPENSE

APPEARANCE
Very small; head large and rounded without ear tufts; yellow eyes and white eyebrows set in poorly defined facial disk; forehead, crown, and nape finely barred in white; upper parts dark cinnamon-brown, finely barred with buff; bold white scapular line; throat and upper breast grayish-brown and densely barred in white; lower breast and belly boldly spotted with dark brown; gray-brown tail barred with pale buff.

SIZE
length 7.5–8.5 in. (20–22 cm)
weight 2.8–4.9 oz (81–139 g)
wingspan 15.5–17.5 in. (40–45 cm)
females heavier than males.

DISTRIBUTION
East and central southern Africa, from southern Somalia in the north to the Eastern Cape in the south and extending west to Angola; also on Mafia Island off the Tanzania coast.

STATUS
Least Concern

A PERSISTENT WHISTLE REPEATED on a single note announces this charismatic denizen of the African bush. Similar to that of its close relative the Pearl-spotted Owlet (P. 201), it is a call that can drive other small birds into a fury. And with good reason: this rapacious little predator puts many of its smaller winged neighbors on the menu. Furthermore, like all *Glaucidium* pygmy owls, the bright yellow eyes and knitted white eyebrows of the African Barred Owl create a fierce facial expression.

This is the only small owl in its range whose plumage is predominantly barred. It is fractionally larger than the Pearl-spotted Owlet, but with a slightly shorter tail. The African Barred Owl occurs in East and central southern Africa, from southern Somalia in the north to the Eastern Cape in the south and extending west to Angola. There is also a separate population on Mafia Island. Its distribution follows the broad band of open and semi-open woodland habitat that characterizes much of this region, and it may be found in acacia woodland, riverine forest, and deciduous woodland with large trees, such as mopane woodland. However, the African Barred Owl seldom occurs at elevations above 3,900 feet (1,200 m), and it is absent from forest and arid regions. Three subspecies are listed, of which the nominate, *G. c. capense*, found in South Africa's Eastern Cape, is the most poorly known. The taxonomy of this species is the subject of ongoing research.

Partly diurnal, the African Barred Owl may be heard calling at any hour of day and night, although its vocal activity peaks at dusk and dawn. Its roost is often a natural tree hole. If disturbed, it flies away low with whirring wingbeats, before swooping up to settle on the next perch. Most hunting takes place from dusk, when the owl takes up a strategic perch from which to pounce upon prey. Food comprises a variety of small mammals and birds, as well as frogs, reptiles, and large invertebrates, such as beetles, moths, caterpillars, and scorpions.

An increase in vocal activity heralds the start of the breeding season. The male's distinctive whistled call comprises a series of about six to ten slightly down-slurred notes, all at one pitch and equally spaced at the rate of about one per second: "peeu-peeu-peeu-peeu-peeu-peeu-peeu." This phrase is repeated at fifteen- to twenty-second intervals, and the female joins in with her own similar but slightly higher-pitched version. When they are excited, the two will also call together with a series of short purring notes.

Little detail is known about the breeding habits of the African Barred Owl. Its nest is generally in a tree hole, either a natural cavity or one excavated by a woodpecker or barbet, and typically from 19 to 32 feet (6–10 m) above the ground. The female lays two to three eggs; in southern Africa, this takes place from September to November. The incubation period is not known, but after the eggs hatch, both parents feed the young, restricting their visits to dusk in order to avoid revealing the nest's location during daylight hours. At thirty to thirty-three days, the nestlings leave the nest. The adults continue to care for them for a few more weeks before they strike out alone. At seven months, they have the voice of an adult, and by the next breeding season they have reached sexual maturity and are ready to breed.

The conservation status of this elusive owl is little known. With a total breeding area of some 1.5 million square miles (3.95 million sq km), it is not thought to be threatened and is listed as Least Concern.

Opposite: The African Barred Owlet is among the most rapacious of small owls.

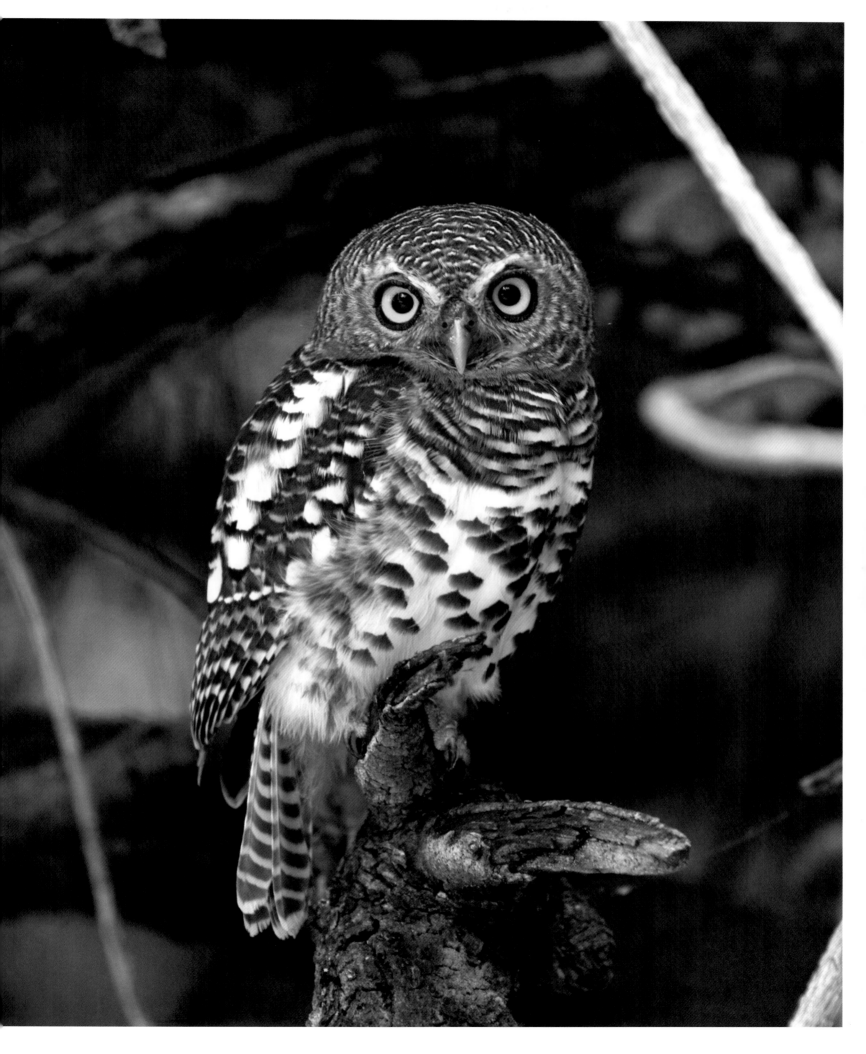

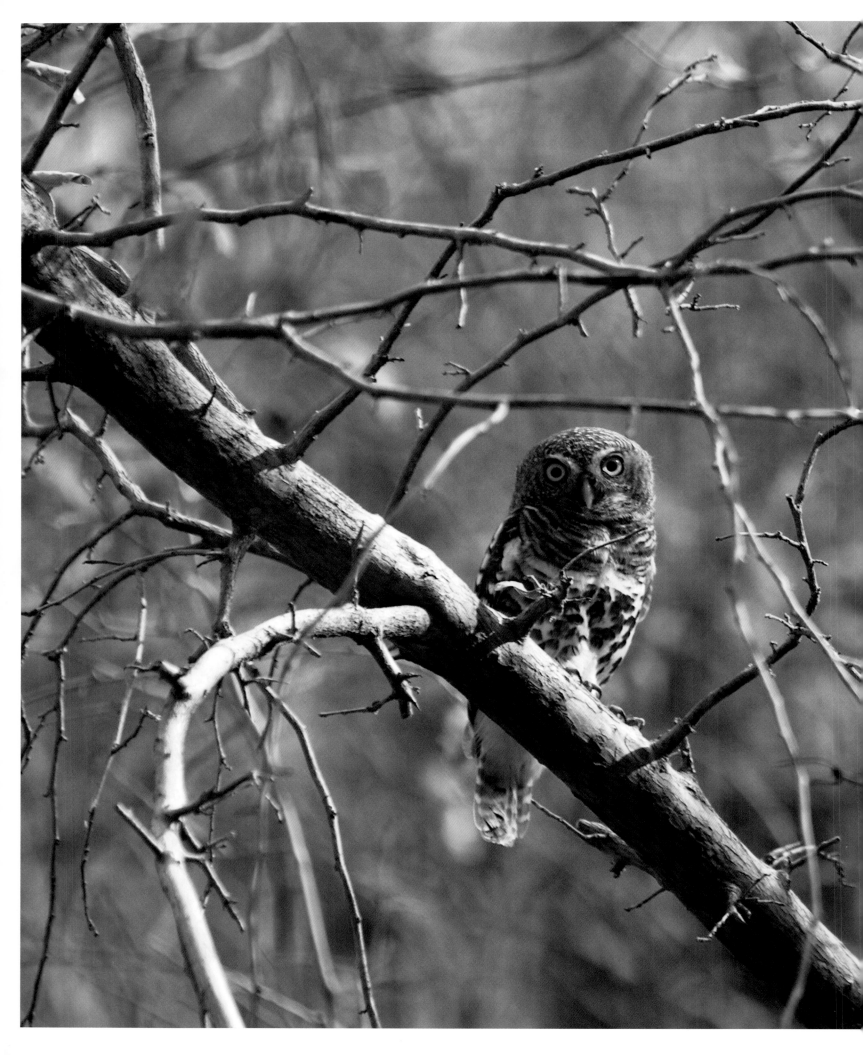

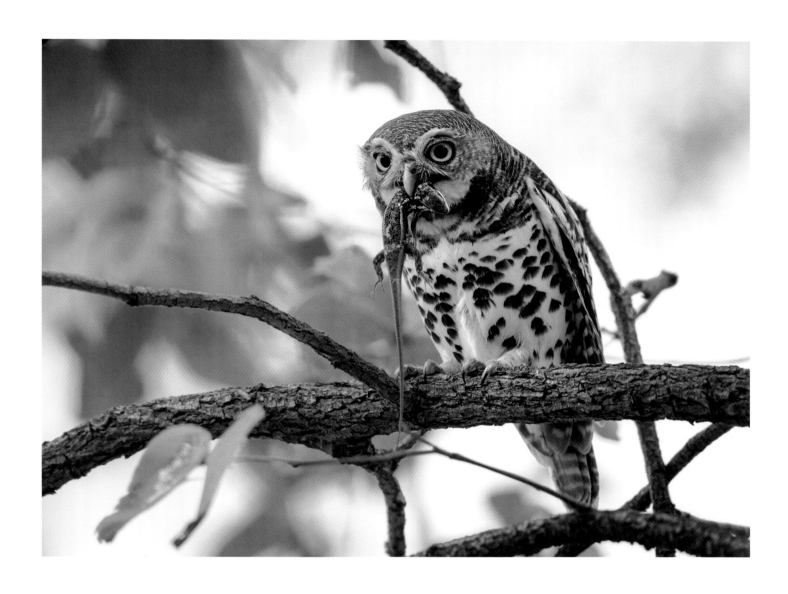

Above: Lizards are among a wide variety of prey for this species.
Opposite: The African Barred Owlet is sometimes active by day.

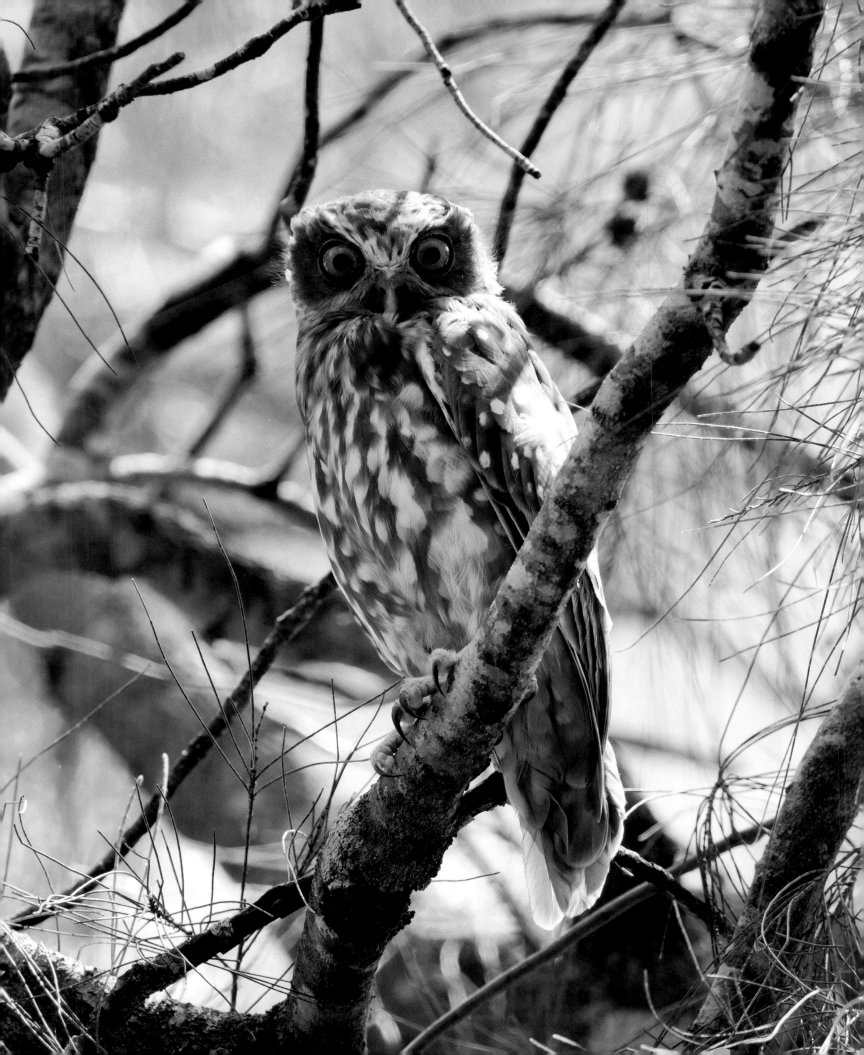

05 | SOUTHERN ASIA & AUSTRALASIA

THE OWLS REPRESENTED IN THIS CHAPTER embrace a wide variety of mostly tropical species, which range from India east across Southeast Asia and down through the islands of Indonesia to Australia and its satellite islands (with the exception of New Zealand). Its collected landscapes run from dense tropical rain forest to arid outback, and they include numerous biodiversity hot spots, which teem with owls and many other forms of wildlife.

In biogeographical terms, this chapter spans the Indo-Malayan (formerly "Oriental") realm of Southeast Asia and the Australasian realm. Although the two may appear contiguous on a map, there is an imaginary line—known as the Wallace Line—that divides one realm from the other. Where this passes between the Indonesian islands of Bali and Lombok, the two regions are only 22 miles (35 km) apart, but they are nonetheless separated by a deep-water trench that has, over millions of years and numerous fluctuations in sea level, proved an insuperable barrier to many life forms that might otherwise have colonized from one side to the other. To the west of the line, the fauna and flora are part of the Indo-Malayan realm, with its Asian affinities; to the east they form part of the Australasian realm.

The Wallace Line is named after British naturalist Alfred Russel Wallace, a contemporary of Charles Darwin and an early evolutionary theorist, who noticed the division between the two biogeographical realms during his travels in the nineteenth century. Although the line is very clearly reflected in the distribution of numerous terrestrial animals—there

are marsupials on the Australasian side, for example, but none on the Indo-Malayan side—naturally it has proved less of a barrier to birds, many of which have been able to cross the "border" by flying the relatively short distances between islands. Consequently, the affinities of many owls transcend the divisions of the Wallace Line.

The Indo-Malayan realm of Southeast Asia extends from India in the west, south of the Himalayas, through Peninsular Malaysia to Indonesia in the east, as far as the Wallace Line. This tropical and subtropical region is dominated by forest and wetlands, from the monsoon forests of India to the Mekong Delta of southern Vietnam and the cloud forests of Borneo. Biodiversity is second only to the neotropics, and this area accounts for nearly three-quarters of all Asia's bird species, including the great majority of its 110 species of owl.

The most powerful and impressive owls of the region are the fish owls and eagle owls that make up the *Bubo* genus. The Buffy Fish Owl (P. 222) is one of four species of fish owl, all of which inhabit lowland rivers, lakes, and swamp forest and are specially adapted to capture their slippery prey from the dark waterways. The Barred Eagle Owl (P. 235) is the smallest but, with its drooping ear tufts, perhaps the most distinctive of the region's five eagle owl species. It occurs right down to the island of Java.

At the other end of the scale are diminutive owls such as the Jungle Owlet (P. 231), one of several similar *Taenioglaux* and *Glaucidium* species, which makes its presence felt across India's woodlands with its loud daytime call and rapacious

Opposite: A Southern Boobook at its daytime roost in a casuarina tree. This species is widespread across Australia.

pursuit of small birds. Others of a similar size include the unrelated Spotted Owlet (P. 66), a common inhabitant of rural villages in India, which sits alongside the Eurasian Little Owl (P. 114) in the *Athene* genus, and the Indian Scops Owl (P. 227), which, like all scops owls, is much more easily heard than seen. Indeed, the region is home to at least thirty-two species of the *Otus* genus, the majority confined to small islands on the Indonesia or Philippines archipelagos.

East of the Wallace Line, the continent of Australasia comprises Australia, New Guinea, New Zealand, and various Pacific island groups. Australia once formed part of the ancient supercontinent Gondwana, which began to break up approximately 150 million years ago. Today's flora and fauna have their roots in this Gondwana past, which explains the abundance of marsupials and other unique forms that have continued to evolve in isolation. Nowadays, much of the interior comprises desert and arid woodland. Rain forest, which once carpeted the whole of Australia, is reduced to a fringe in the far northeast, although it still supports the country's greatest biodiversity.

This single biogeographic realm is home to some 1,600 species of bird, including many that are unique to the region. Indeed, Australia has the highest proportion of endemic birds of any country on Earth, with around 45 percent of species found nowhere else. Most groups, however, have their evolutionary origins in the Indo-Malayan realm, their ancestors having passed down through the islands of what is now Indonesia. This applies to the owls, too.

Most owls in Australasia belong to the *Ninox* genus of hawk owls, unrelated to the Northern Hawk Owl (P. 108) of the northern hemisphere. These range from the large Rufous Owl (P. 240), which captures sugar gliders, flying foxes, and other rain forest creatures of the tropical north, to the widespread Barking Owl (P. 246), whose distinctive canine call explains its name. They also include smaller boobook species, such as the Southern Boobook (P. 243), whose complex taxonomy remains a subject of ongoing research. Unrelated to these hawk owls are several *Tyto* species of the barn owl group. Among these, the Greater Sooty Owl (P. 245) resembles its paler relatives in flight and form, but is distinguished by its darker plumage and habit of hunting in forest.

The birds of Southeast Asia are under pressure, with unchecked human population growth and development, and rampant environmental destruction, in particular the felling of Indonesia's rain forests for palm oil plantations. Direct exploitation, both for the caged bird trade and the pot, also takes a heavy toll, and this is one of the few parts of the world in which wild owls are hunted and traded for food in significant numbers. Australasia is much less populous, but the human impact on its bird life has nonetheless been profound, notably through the introduction of invasive non-native flora and fauna, from rabbits to cane toads, which has driven many species to the brink of extinction, by direct predation, competition, or habitat destruction. Although none of the country's owls is endangered, many are locally threatened and their conservation is a priority at state level.

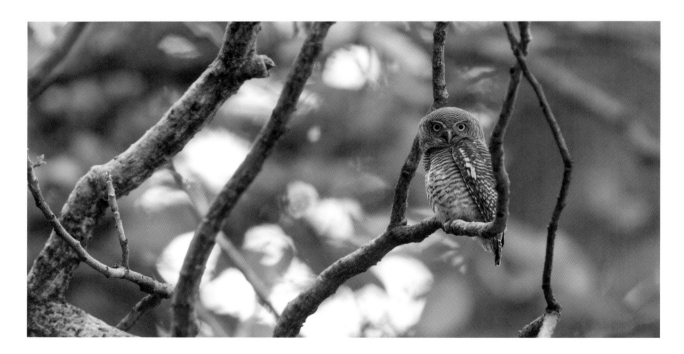

Above: A Jungle Owlet on the lookout for prey in an Indian forest.

Above: The Spotted Owlet is a conspicuous resident of
farmland and rural villages across much of southern Asia.

BUFFY FISH OWL

BUBO KETUPU (KETUPA KETUPU)

APPEARANCE
Medium-large; tousled, sideways-facing ear tufts; plumage yellowish-brown; upper parts darker brown, heavily marked and spotted across back, mantle, and wing coverts in buff, pale rufous, and whitish; flight feathers and tail dark brown, banded in white and rufous; forehead and eyebrows white; eyes yellow and black-rimmed; under parts rufous-brown, marked with fine vertical dark brown shaft streaks.

SIZE
length 15–19 in. (38–48 cm)
weight 2.2–4.6 lb (1–2.1 kg)
females much larger than males

DISTRIBUTION
Tropical Southeast Asia; South Myanmar, Thailand, Malay Peninsula, and Indonesia—from Sumatra to east Borneo, Java, and Bali.

STATUS
Least Concern

IN THE QUIET FOREST POOLS and waterways of Southeast Asia, a fish approaches the surface at its peril. On the bank or in the dark foliage above, this all-seeing owl notices the slightest moonlit ripple and, with unerring precision, swoops down to snatch its prey in wickedly sharp talons.

This species, also known as the Malay Fish Owl, is the smallest of four Asian fish owls, only half the weight of Blakiston's Fish Owl (P. 167). It is a large bird, nonetheless, and shares the tousled, sideways-facing ear tufts of its three relatives. A closer look also reveals the adaptations to a fishing lifestyle that all four birds have in common: the tarsi are long and unfeathered, in order to avoid bedraggled feathers when reaching for prey; the toes are lined with rough scales that improve their grip on slippery fish; the facial disk is less clearly defined than in other owls, as the bird hunts by sight rather than sound; and, because its prey cannot hear it coming, this species's flight feathers lack the hair-like fringes that in most other owls dampen the sound of flapping wings.

The four fish owls once made up the genus *Ketupa*, but have since been reclassified within *Bubo*, alongside the eagle owls. Across its range, the Buffy Fish Owl is a bird of tropical forest, chiefly in the lowlands but occasionally up to an altitude of 5,250 feet (1,600 m). Always near water, typical habitats include the wooded banks of lakes and mangroves, and this species is also often found in forests close to human habitation, including near fishponds and rice paddies. By day, it roosts in densely foliated trees near the nest site. After dark, it sets out to hunt, finding a suitable perch near or overhanging the water's edge, from which it can spy and swoop down on prey, generally aiming to submerge as little of its body as possible.

The bulk of this species' prey is fish. However, it will also wade into shallow water to snatch crabs, frogs, and aquatic insects, and may take larger terrestrial vertebrates. One study in Java suggested a very broad diet, with red junglefowl (*Gallus gallus*), goldfish, water snakes, fruit bats, centipedes, and black rats all recorded. This bird is also not averse to carrion and has been observed feeding on the carcass of a crocodile. Like other fish owls, it does not produce firm pellets but ejects bones and other indigestible prey remains in pieces.

At the onset of the breeding season, a pair of Buffy Fish Owls may duet for several minutes, the male making a rattling "kutook, kutook, kutook, kutook, kutook, kutook," to which the female responds in a higher voice. Both birds also make a more musical "to-whee to-whee" and a high, hawk-like scream. Little is known about their breeding habits. The nest is often made in a bird's nest fern or in the fork of a thick mossy bough, screened with epiphytes, but tree holes, caves, and old raptor nests are also used. Usually, the female appears to lay only one egg, mainly from February to April in most regions. Incubation lasts twenty-eight to twenty-nine days. The single chick—generally only one survives even if more eggs are laid—fledges at around six weeks.

In the wild, little is known about the mortality of the Buffy Fish Owl, although the species has lived for more than thirty years in captivity. Its conservation status is Least Concern, with a substantial population spread over a wide range. In some regions, it appears to have benefited from an increase in commercial fishponds, which provide a ready-made food supply, although by the same token this may bring retribution from the fishpond owners.

Opposite: Like all fish owls, this species often perches in low vegetation overhanging water, from where it can watch for prey.

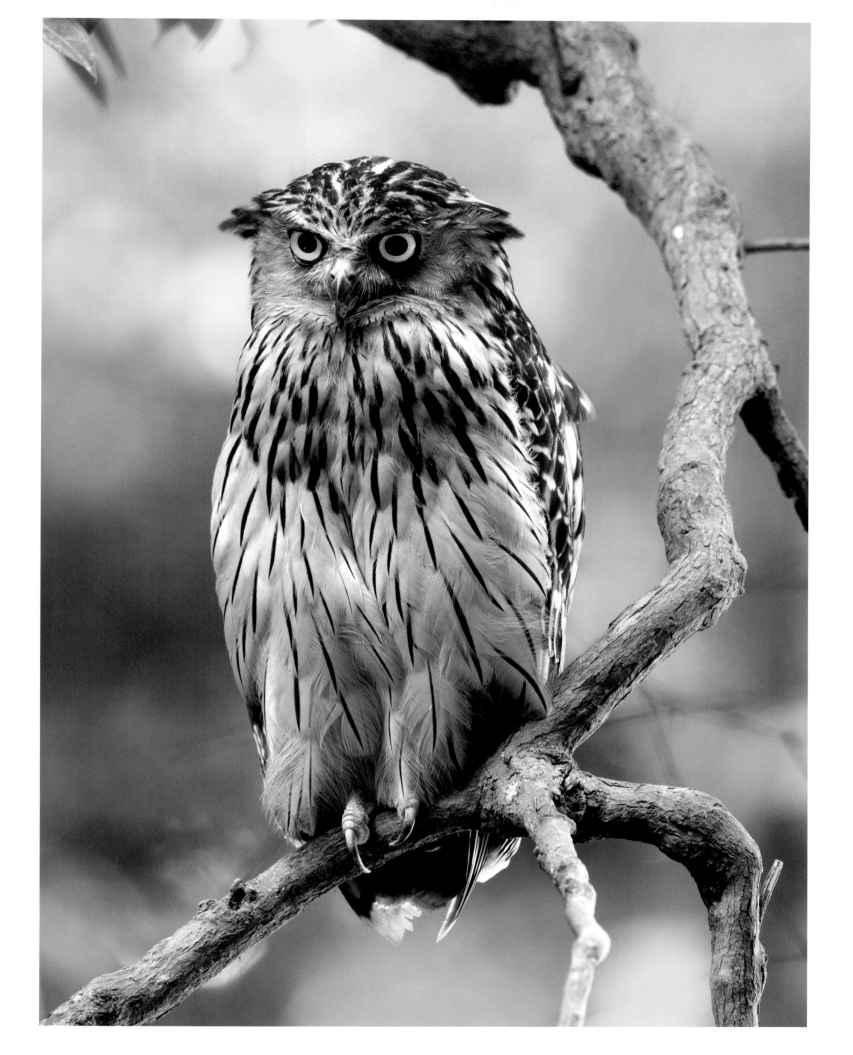

Right: A Buffy Fish Owl at its daytime roost among the ruins of Ranthambore, in Rajasthan, northwest India.

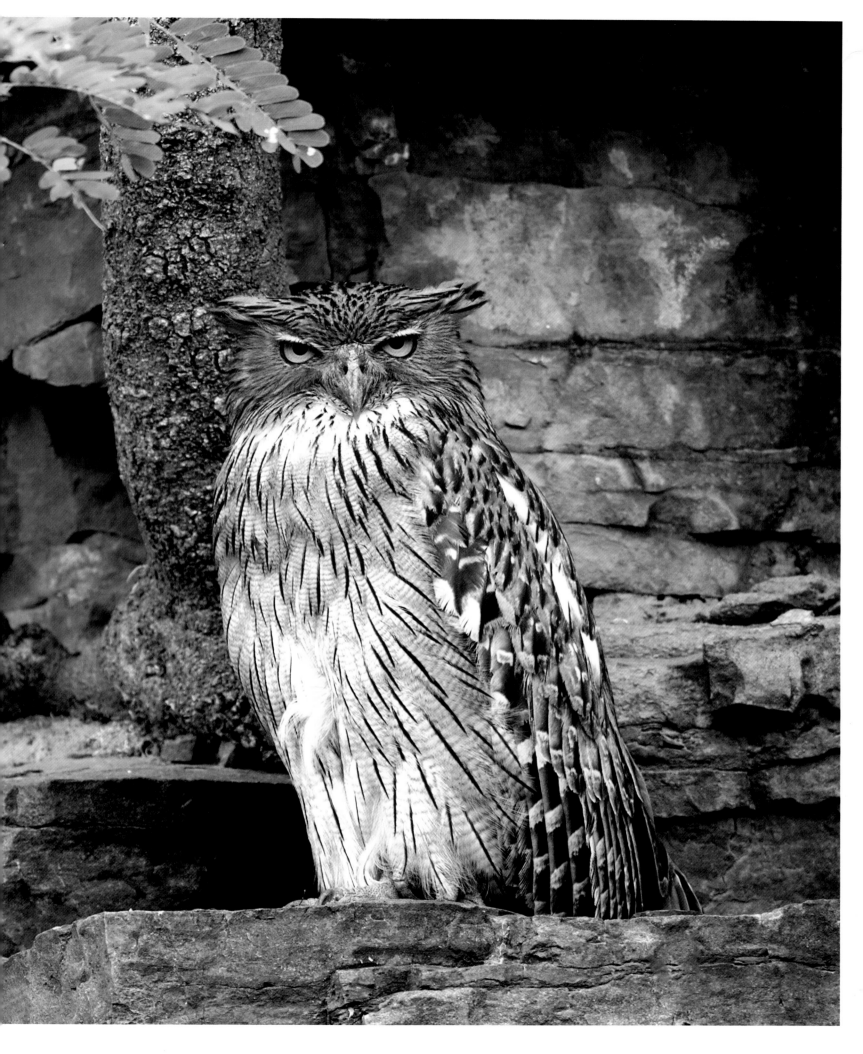

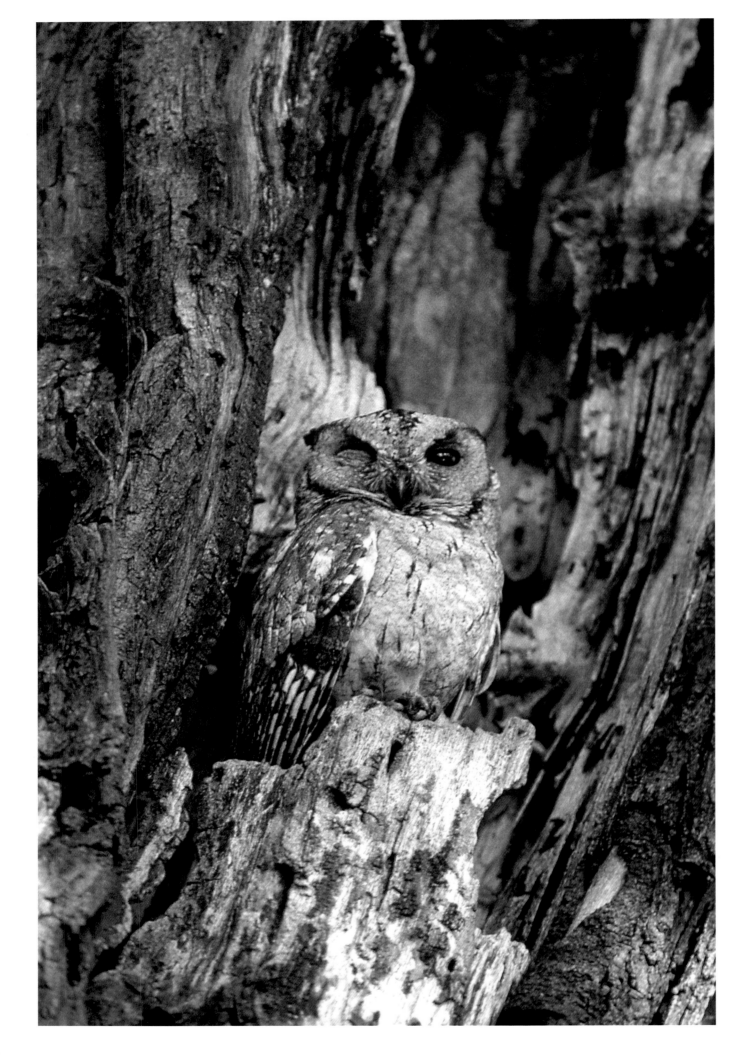

INDIAN SCOPS OWL

OTUS BAKKAMOENA

APPEARANCE
Small, with prominent pointed ear tufts and cryptic camouflage plumage; facial disk grayish-brown, outlined with a blackish prominent rim; eyes dark brown to hazel-brown; eyebrows and forehead paler gray and crown blackish; upper parts grayish-brown, with long black streaks; flight and tail feathers subtly barred; under parts pale ocher-buff; gray-brown and rufous color morphs occur.

SIZE
length 7.8–8.5 in. (20–22 cm)
weight 4.4–5.3 oz (125–152 g)
wingspan 24–26 in. (61–66 cm)
females slightly larger than males

DISTRIBUTION
Indian subcontinent, from southern Pakistan across Kashmir and the southern Himalayas to central Nepal, east to western Bengal, and south through India to Sri Lanka.

STATUS
Least Concern

A COMMOTION OF SMALL WINGS OVERHEAD has you peering up into the foliage. However, you can see nothing there, only the gnarled bark of the tree trunk and splintered stump of a broken branch. Closer scrutiny, though, reveals just what the birds are so upset about. The fissured, lichen-encrusted bark is actually the subtle camouflage outfit of an Indian Scops Owl, which freezes on the branch, hoping to bluff out its tormentors.

Like all members of the *Otus* genus, this small owl uses cryptic markings to escape detection by day, its complex patterning of bars, streaks, and vermiculations in a palette of browns, grays, and ochers almost exactly replicating that of the surfaces against which it perches. The deception is enhanced by two large pointed ear tufts, which protrude like the broken ends of a branch. Up close, more detail is visible. A distinct ruff around the throat, known as the nuchal collar, is prominent when the bird is calling and extends more faintly around the nape. The upper parts otherwise are grayish-brown, with darker and paler markings and long black streaks, but no clear scapular line.

This species is one of the largest of the *Otus* genus of scops owls, although slightly smaller than the migratory Collared Scops Owl (*O. lettia*), which occurs further east and with which it was once thought conspecific. The Indian Scops Owl is more or less restricted to the Indian subcontinent, found from southern Pakistan across Kashmir and the southern Himalayas to central Nepal, east to western Bengal, and south across India to Sri Lanka. Four subspecies are listed, of which the nominate race, *O. b. bakkamoena*, is the southernmost, occurring in south India and Sri Lanka. Across its range, the Indian Scops Owl inhabits forest and secondary woodland, including desert areas, where the vegetation is suitable, ranging from the lowlands to elevations of 7,600 feet (2,400 m) in the Himalayan foothills. It will also find a home among densely foliaged trees in gardens, mango orchards, and other cultivated areas around villages.

Largely nocturnal, this species roosts by day in thickly vegetated trees, often against the trunk, or at the entrance to its nest hole. It is seldom seen during the daytime, unless discovered by a mobbing party of small birds that gives the game away. After dark, it emerges to hunt, usually taking up an elevated perch from which to scan for and pounce upon prey below. Its diet comprises largely insects, such as beetles and grasshoppers, but it will also occasionally take small vertebrates, including lizards, mice, and small birds.

The territorial song of a male Indian Scops Owl is a repeated series of frog-like, questioning "what?" notes, regularly spaced around pauses of ten to twenty seconds. Both sexes also produce a series of slowly repeated bubbling or chattering calls, which start softly and rise to a harsher tone "ackackackack." Although widespread, this owl is very secretive and little is known about its breeding biology. Pairs generally nest in tree cavities at a moderate height, and females lay three to four eggs. It is reasonable to assume that their life cycle, including incubation, hatching, and fledging, is similar to that of other closely related scops owl species, such as the Common Scops Owl (P. 159).

The conservation status of the Indian Scops Owl is not clear, but the species is locally common in many areas, and with an estimated total range covering 1.1 million square miles (2.9 million sq km) it is not thought to be under threat.

Opposite: An Indian Scops Owl opens one eye, disrupting its otherwise perfect camouflage.

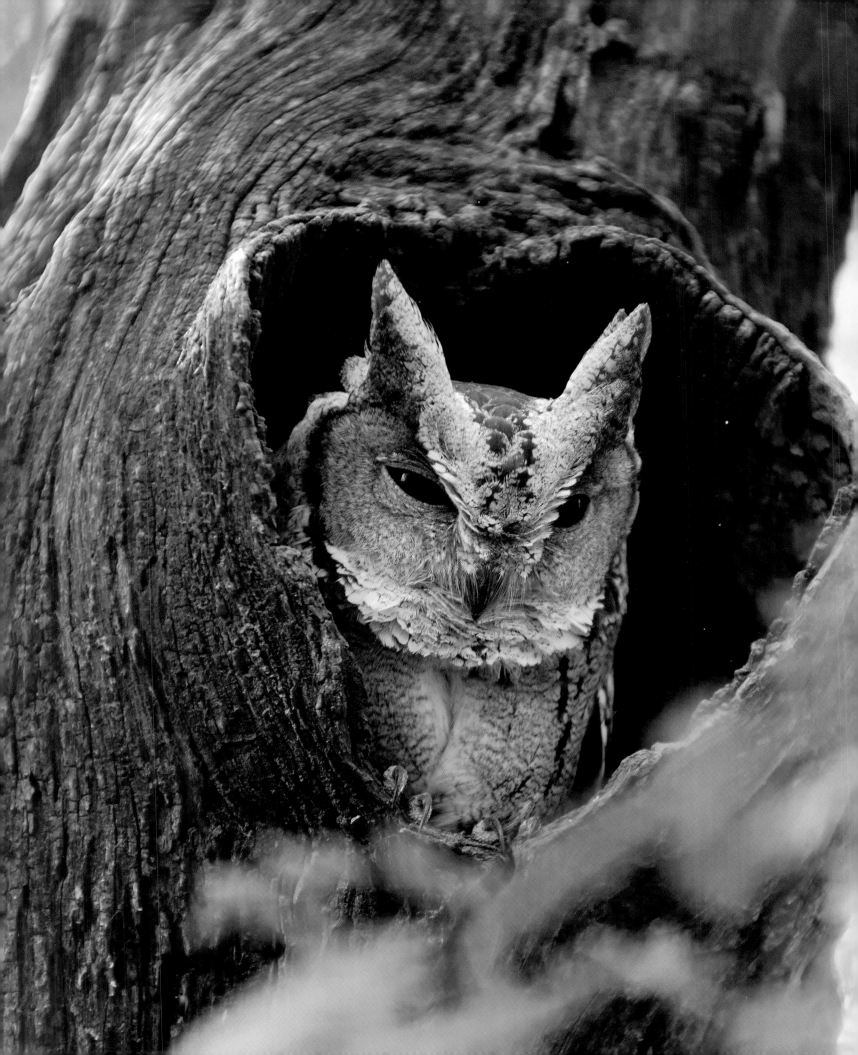

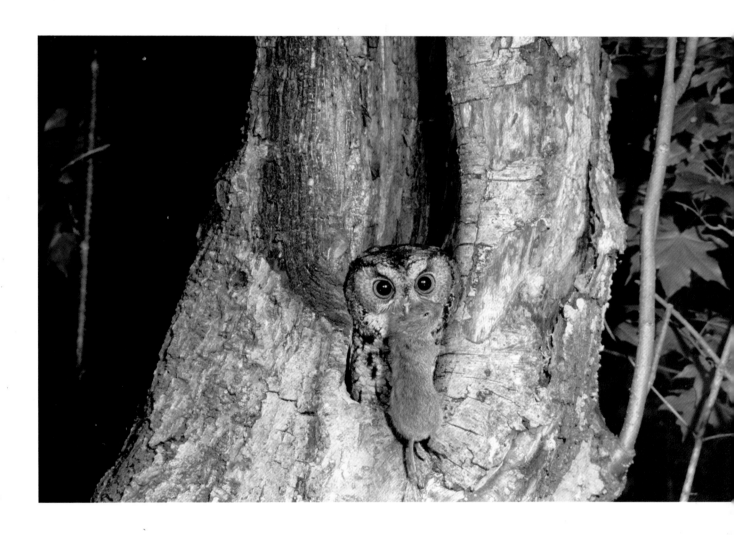

Above: Rodents figure prominently in the diet of the Indian Scops Owl.
Opposite: Like all scops owls, this species can raise or lower its ear tufts as required.

SOUTHERN ASIA & AUSTRALASIA

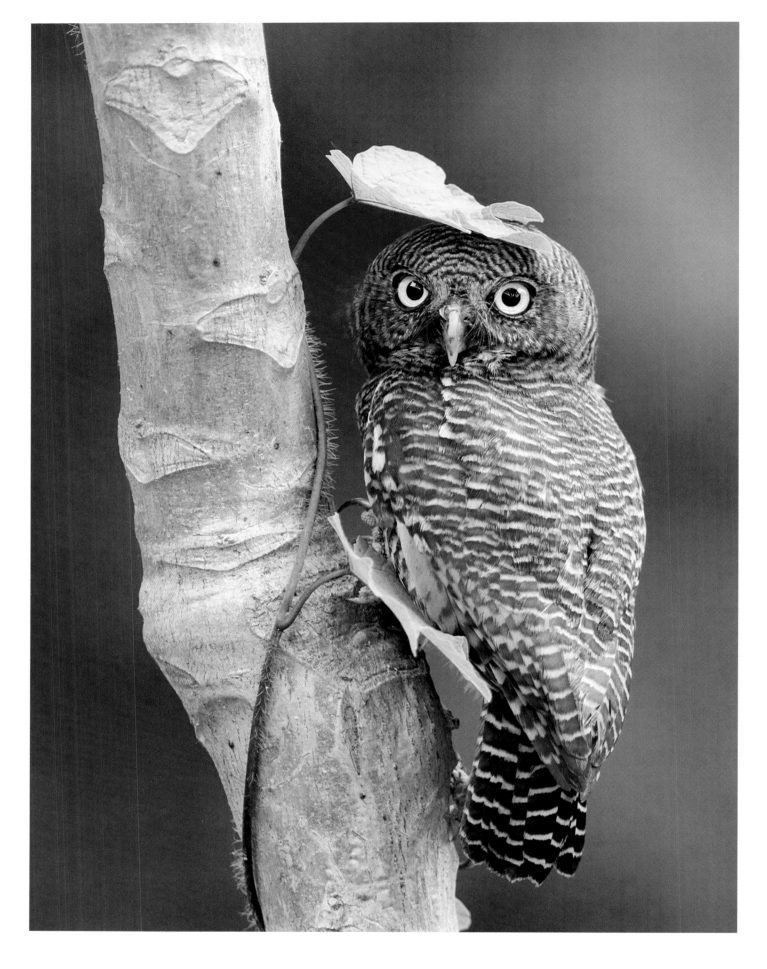

Above: The Jungle Owlet is active by day.
Overleaf: A Jungle Owlet on the lookout for prey.

JUNGLE OWLET

TAENIOGLAUX RADIATUM

APPEARANCE
*Very small, with round, earless head;
facial disk barely defined; brown face
ringed with fine concentric dark bars;
short white eyebrows; eyes
lemon-yellow and black-rimmed;
brown upper parts; head and nape
barred in brown, ocher, and white;
under parts white, tinged rufous on
upper breast and flanks; throat and
upper breast white; gray morph has
same markings in grayer tones.*

SIZE
*length 7.8 in. (20 cm)
weight 3.1–4 oz (88–114 g)*

DISTRIBUTION
*India and neighboring countries to
the east: from west Himachal and
Bhutan in the Himalayas, south
through peninsular India to Sri
Lanka; east to Assam, Arunachal,
Bangladesh, and Myanmar.*

STATUS
Least Concern

THE STUMPY PROFILE AND WHIRRING FLIGHT of this diminutive owl are a common sight in forested regions of the Indian subcontinent, and its repetitive call is as familiar by day as it is by night. Seen up close, the bird's rich plumage is as stripy and barred as that of the tiger whose jungles it shares.

The Jungle Owlet, also known as the Barred Jungle Owl, is even smaller than the Spotted Owlet (P. 66), with a rounder, earless head. Many taxonomists today place the species together with the other Asian owlets in the genus *Taenioglaux*, as distinct from the *Glaucidium* pygmy owls, where they were all formerly placed and to which they are certainly closely related. Whether *Taenioglaux* or *Glaucidium*, the Jungle Owlet comes in two distinct subspecies: the nominate *G. r. radiatum* occurs across the entirety of its range, apart from the Western Ghats of central India, where it is replaced by the race *G. r. malabaricum*. The latter is distinguished by its shorter tail and browner head, and it is considered by some authorities to be a possible full new species. Other sympatric species with which the Jungle Owlet may be confused include the Chestnut-backed Owlet (*T. castanonota*), confined to the Sri Lanka wet zone, and the Collared Pygmy Owl (*G. brodiei*), which is smaller, with an occipital face. The Asian Barred Owlet (*T. cuculoides*) is larger, with broader barring.

The Jungle Owlet occurs from sea level up to 6,500 feet (2,000 m) in the Himalayan foothills, and it frequents a variety of forest habitats, from submontane moist deciduous forest to dry forest, scrub forest, and secondary jungle with bamboos. It is particularly fond of steep hillsides. Essentially a crepuscular species, this owl is most active just before dusk and just before sunrise, but it also moves about on moonlit nights and can be active during daylight, especially when the weather is overcast. It roosts for much of the day on a leafy branch or in a tree hollow, but may emerge to sunbathe in the early morning or late afternoon—often on bare treetops or wires—and may even rouse itself for a little daylight hunting, typically for small birds such as leaf warblers (*Phylloscopus* species). If spotted at its roost, the Jungle Owlet freezes like a dead stump, but drongos, treepies, and other birds that see through this deception will mob it mercilessly.

This species feeds mostly on invertebrates, including grasshoppers, locusts, cicadas, and other large insects, swooping upon them from a high perch. It also takes small vertebrates, such as lizards, mice, and small birds—sometimes capturing the last of these in flight. The male's distinctive song is a sequence of three to ten short, trilled whistles, all repeated at the same pitch at a rate of one-and-a-half to two-and-a-half notes per second, rising in volume then fading away: "prrr-prrrr-prrr-prrr." A bold white patch on the throat and upper breast is puffed out like a snowball when the bird is calling. At the onset of the breeding season, he may continue his refrain relentlessly, especially on moonlit nights.

There is little detailed information about the species' breeding biology. Nesting takes place from March to May. A pair chooses a nest site in a natural tree hollow or in the abandoned nest hole of a woodpecker or barbet, usually some 10 to 26 feet (3–8 m) above the ground. Typically, the female lays three or four eggs.

Locally common in many regions, the Jungle Owlet has an estimated range of 800,000 square miles (2.19 million sq km). According to the International Union for Conservation of Nature, its conservation status is listed as Least Concern.

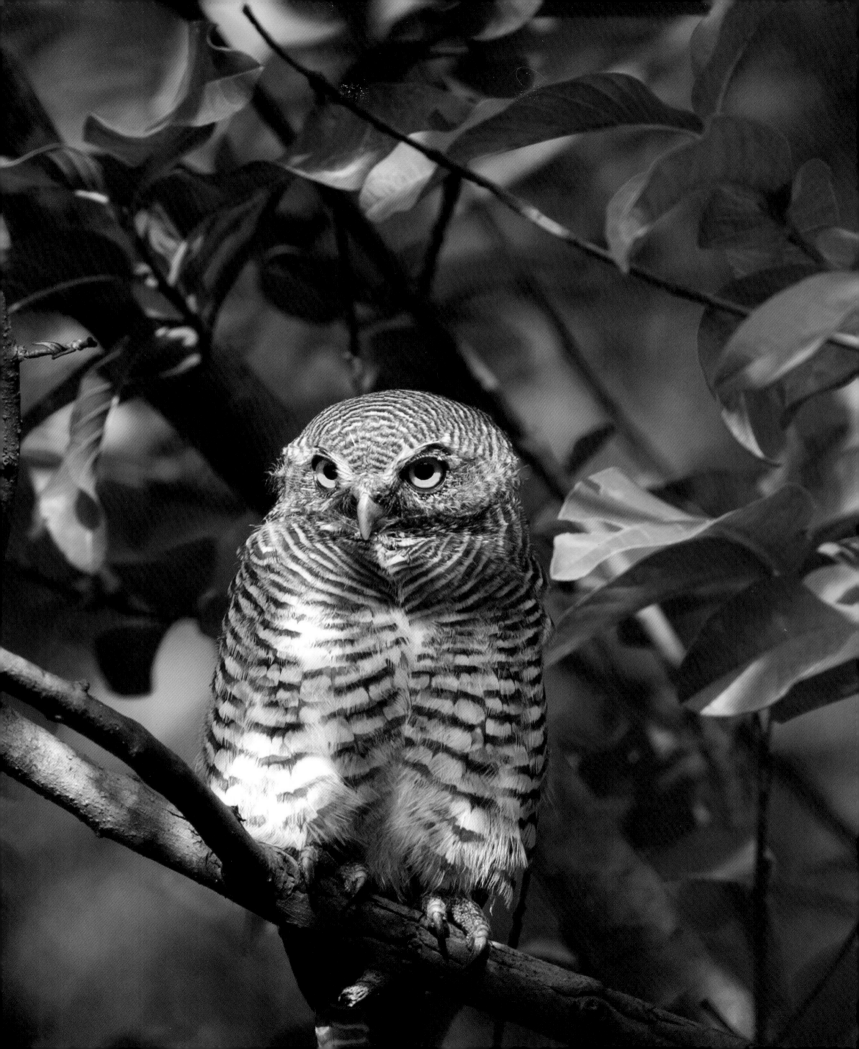

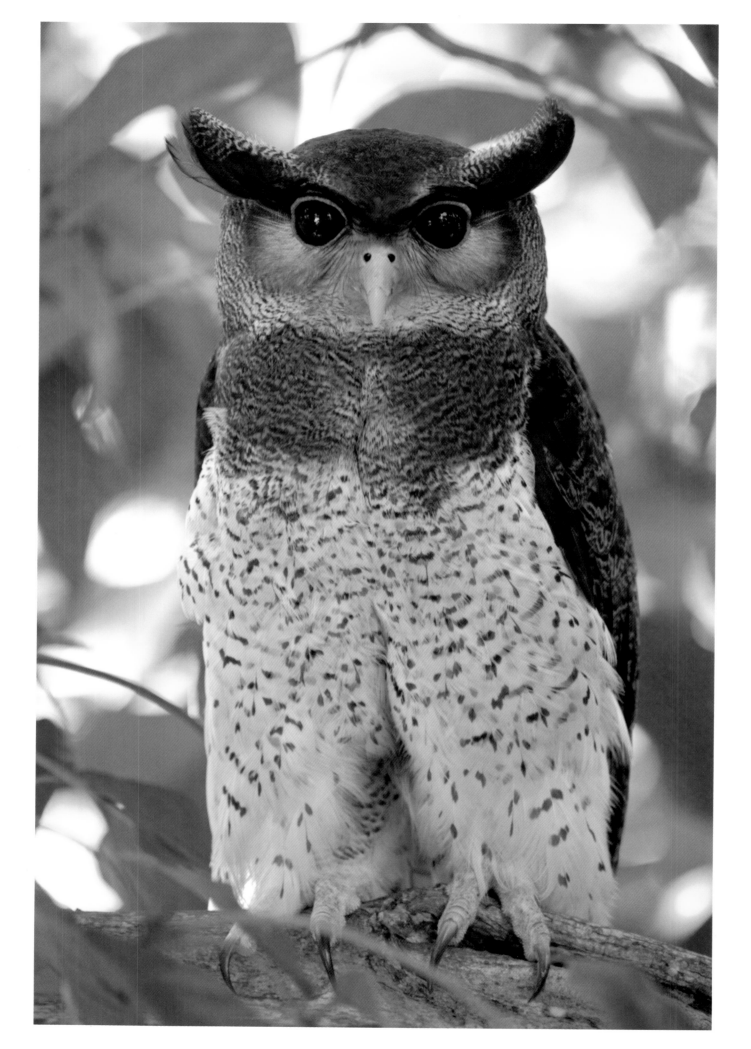

BARRED EAGLE OWL

BUBO SUMATRANUS

APPEARANCE
Medium-large; long, sideways-projecting ear tufts; dark brown eyes and pale yellow bill set in grayish facial disk; upper parts dark brown, finely mottled, and vermiculated; under parts paler and barred or spotted in dark brown; flight feathers barred in dark brown; tail dark brown with pale bars and white tip.

SIZE
length 16–19 in. (40–46 cm)
weight 1.3 lb (620 g)
from one record

DISTRIBUTION
Malay Peninsula to Indonesia islands of Sumatra, Java, Borneo, Bangka, and Bali.

STATUS
Least Concern

THIS MOST TROPICAL OF EAGLE OWLS is distinctly different from others of its kind. Smaller than most—although still large for an owl—it has the sideways-projecting ear tufts of a fish owl and striking barred markings like those of an owlet. Reasonably common throughout its range, it is nonetheless a bird that guards its secrets closely.

Also known as the Malay or Oriental Eagle Owl, the Barred Eagle Owl derives its scientific species name *sumatranus* from the Indonesian island of Sumatra, where the first specimen described—by Stamford Raffles in 1822—was located. Today, scientists believe the species is most closely related to the Spot-bellied Eagle Owl (*Bubo nipalensis*), which has an allopatric range to the north. In the field, however, confusion is more likely with the Buffy Fish Owl (P. 222), which has tawnier plumage, or the Brown Wood Owl (*Strix leptogrammica*), which is more rufous in tone. The Barred Eagle Owl is the southernmost of the *Bubo* genus in the Old World. Three subspecies are listed: found on Sumatra, Bangka, and the Malay Peninsula, the nominate *B. s. sumatranus* is the smallest. A larger race occurs on Java and Bali, and a more finely barred race on Borneo. Across its range, the Barred Eagle Owl frequents tropical evergreen forest with large, densely foliated trees and ponds or streams nearby. This habitat preference may extend to large parks and gardens. The bird also finds a home among groves of trees in cultivated country, often close to human habitation, and adapts well to the monocultural oil palm plantations that have replaced so much of Indonesia's native forest. Although generally ranging from sea level to 3,300 feet (1,000 m) elevation, it has been recorded at 5,200 feet (1,600 m) on Java's Mount Gede.

This owl is largely nocturnal. It roosts by day singly or in pairs, usually screened from view by dense foliage near the trunk of a large tree. By night, it emerges to hunt, probably swooping from a perch onto prey on the forest floor. It has a broad, opportunistic diet, feeding on large insects, birds, small mammals (notably rats), and reptiles (especially snakes). Its powerful feet suggest that it has, like most eagle owls, considerable killing power. One individual was seen to capture a young crab-eating macaque (*Macaca fascicularis*), which might easily have been as large as itself. In captivity, another killed and ate a changeable hawk eagle (*Nisaetus cirrhatus*), to whose aviary it had, unwisely, been introduced.

The territorial call of a breeding Barred Eagle Owl is a deep single or double hoot, "hoo" or "hoo-hoo," which falls slightly in pitch toward the end. The species is thought to form monogamous lifelong bonds, with pairs faithful to nest sites. Its nest may be in a large tree hole, or among the fronds of a large bird's nest fern (*Asplenium nidus*). Little is known about breeding biology, but the process generally takes place between February and June, varying from one island to the next, and the female is thought to lay only a single egg. In observations of one nest built in a planter box on the roof of a hotel in Johor, Malaysia, the female laid her single egg directly onto the soil. The male provided an average of three feedings per night, and the female was seen to tear up a rat slowly and feed it to her chick over thirty minutes. Other prey included birds, squirrels, and frogs, the last of these swallowed whole. The male never came to the nest unless the female was present.

This species has a conservation status of Least Concern. Although occurring only at low densities, it is widespread and not uncommon. On Java and Sumatra, however, it is less numerous than the Buffy Fish Owl.

Opposite: **The Barred Eagle Owl is one of the smallest and least known of the eagle owls.**

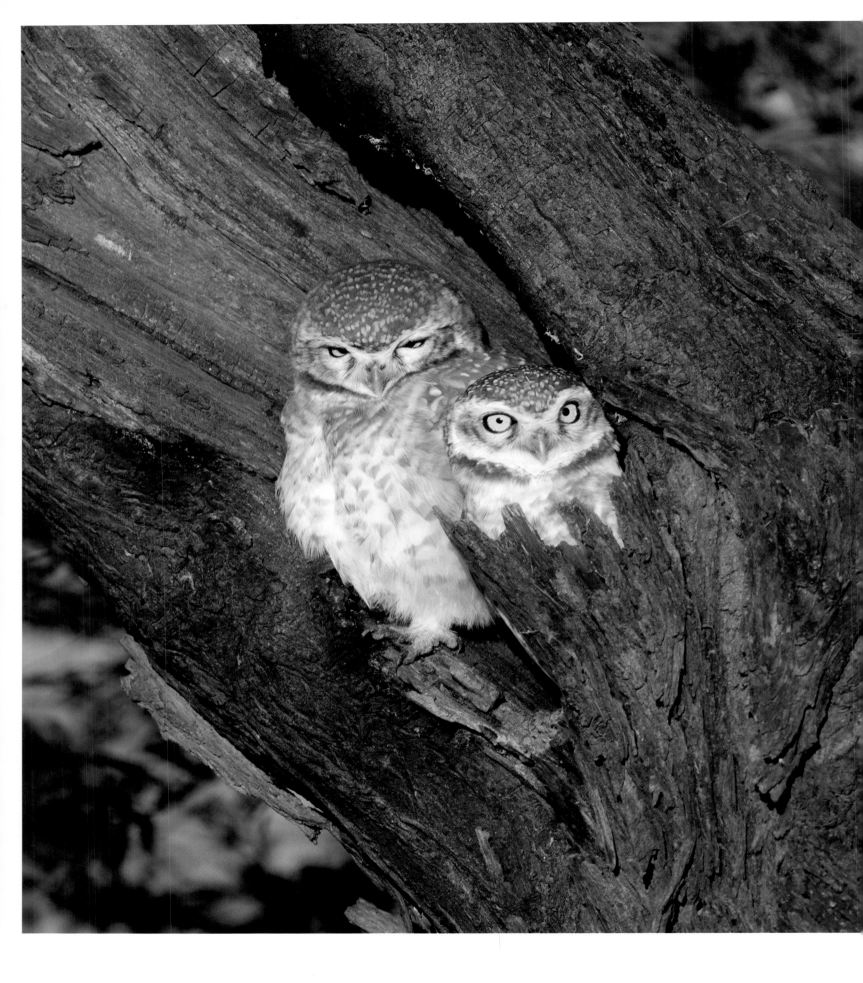

Above: A pair of Spotted Owlets on alert at their daytime roost.

SPOTTED OWLET

ATHENE BRAMA

APPEARANCE
Small, with round head and no ear tufts; bold white eyebrows, forehead, and collar; facial disk creamy-buff with darker brown markings; eyes yellow; head and upper parts warm brown to grayish-brown, marked with small white spots; larger spots on back, and on the nape form indistinct occipital face; under parts whitish, with brown spots and mottling densest on breast.

SIZE
length 7.5–8.3 in. (19–21 cm)
weight 3.8–4 oz (110–114 g)

DISTRIBUTION
Southern Asia south of Himalayas, from southern Iran to Vietnam and including the whole of India; absent from Malay Peninsula and all islands, including Sri Lanka.

STATUS
Least Concern

THIS DIMINUTIVE, CHARISMATIC OWL is India's equivalent of Europe's Little Owl (P. 114): it is not only similar in size and appearance but also lives happily side by side with people in villages and rural communities. Indeed, its alternative name of Spotted Little Owl is rather apt, because this species is more closely related to the Little Owl, to whose *Athene* genus it belongs, than to the "owlets" of the *Glaudicium / Taenioglaux* genus. In addition, like the Little Owl, it is venerated in local mythology: the scientific name *brama* refers to the Hindu supreme spirit Brahma, and in Hindu belief an owl serves as a *vahan* (vehicle) for Lakshmi, the goddess of wealth.

Whatever its evolutionary affinities, this species is easily identified. Slightly smaller than a Little Owl, it has a round head and bold white face markings, including prominent white eyebrows and forehead, which can create an almost spectacled effect. Otherwise, the facial disk is creamy-buff with darker brown concentric markings outside the golden-yellow eyes. The crown, sides of the head, and upper parts are a warm brown to grayish-brown, with a rufous tinge in some races, and marked with small white spots. These spots are larger on the back, and on the nape they coalesce into an indistinct occipital face. The under parts are whitish, with brown spots and mottling that are densest on the breast, often forming a dark bar that contrasts with the white chin and throat. There is no visible difference between the sexes.

The Spotted Owlet ranges across southern Asia, from southern Iran to Vietnam and including the whole of India, with its northern limit being the Himalayas. It is not found on the Malay Peninsula and is absent from islands, including Sri Lanka, even though it breeds at Rameshwaram, only 18 miles (30 km) away, on the other side of the Palk Strait. Across this range, there is some geographical variation, with five races recognized. The nominate subspecies *A. b. brama* is found in South India and is slightly smaller and darker than *A. b. indica*, which is common across north and central India. In general, the size of this species decreases toward the south of its range. Other owls with which it might be confused are the Forest Owl (*A. blewitti*), a rare bird that has more uniform upper parts and is endemic of north central India, and the Little Owl, with which it overlaps in Balochistan. The latter is slightly larger, with a longitudinally streaked crown and belly.

Typically, the Spotted Owlet is a bird of open or semi-open country, from sea level to about 4,900 feet (1,500 m), ranging from semidesert to open wooded areas but avoiding thick forest. It is often found within and around villages and cultivated areas, in groves with old trees and around ruins. Where suitable habitat is available, it even occurs in cities. Although largely crepuscular and nocturnal, the Spotted Owlet is often seen by day, typically peeking out of its tree hole, or from a nearby branch, and bobbing its head while staring intently at the intruder. If it makes itself too conspicuous, however, it quickly attracts a mobbing retinue of smaller birds. Pairs may roost together, and sometimes small groups gather. If approached too close, this owl will retreat in a deeply undulating flight, with long descending glides on closed wings between short volleys of rapid flaps.

The Spotted Owlet preys largely upon invertebrates, from earthworms to scorpions, beetles, moths, cockroaches, and other insects. It may also take small vertebrates, including lizards, mice, toads, small snakes, bats, and small birds. The usual hunting technique is to swoop down from a perch,

but this species may also take winged prey—moths, birds, and bats—in flight. It often hunts around streetlights, hawking prey drawn to the illumination, especially during mass termite emergences, when the air can be thick with winged insects.

This species breeds from February to April in northern regions and from November to March in the south. The male reasserts his territorial claims with a plaintive double-whistle call, "peuu-peuu," at intervals of fifteen to twenty-five seconds. Better known are the various harsh screeching and chuckling calls with which a pair communicates around the nest site. During courtship, a pair may grasp bills and preen one another, and the male presents ritual food gifts to his mate. Social organization in this species is poorly understood, however, and although it commonly forms monogamous pair bonds, one female may copulate with multiple males.

Generally, the nest is in a natural tree hollow, although holes in earth banks and even cavities in buildings will serve just as well. In areas of human habitation, the Spotted Owlet often finds itself competing with myna birds or parakeets for a desirable cavity. Once the nest site is chosen—and, sometimes, lined with grass and feathers—the female lays two to three eggs, up to an occasional maximum of five. She starts incubation from the first egg, which means that the clutch hatches asynchronously and there are often considerable size

differences among the brood. After hatching, the young are at first fed on small insects such as cockroaches. The male does most of the providing until, at twenty to twenty-eight days, the youngsters fledge. Often only one or two chicks make it to this stage. Higher breeding success rates around human habitation may reflect the fact that there are generally more rodents available to feed the young.

The International Union for Conservation of Nature lists the conservation status of the Spotted Owlet as Least Concern. It is locally common in many regions, adapts reasonably well to human development, and, with an estimated total range of some 2 million square miles (5.2 million sq km), is not thought to be under any immediate threat.

An interesting footnote to our knowledge of this species concerns a recent discovery that it possesses a pineal gland, previously thought to be absent in owls. This tiny, pine cone-shaped gland in the brain of many vertebrates produces the hormone melatonin, which regulates sleep patterns in both seasonal and circadian rhythms. A high melatonin level is associated with sleep, whereas low levels are associated with periods of high alertness and foraging activity. The Spotted Owlet, however, shows only a slightly lower melatonin concentration at night, with a small increase in the early afternoon. Further studies may shed more light on how this owl manages the demands of its nocturnal lifestyle.

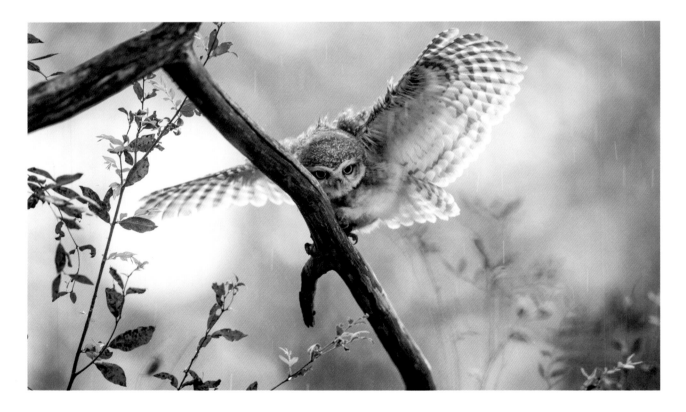

Above: A Spotted Owlet bathes in a rain shower.
Opposite: A banyan tree provides a hideaway for a Spotted Owlet.

RUFOUS OWL

NINOX RUFA

APPEARANCE
Medium-large, with longish tail; proportionally small, rounded head and ill-defined facial disk; rufous-tinged plumage; upper parts dark rufous with dense pale barring and mottling; face darker blackish-brown with rufous tint around bright yellow eyes; flight feathers and tail dark rufous-brown, barred in paler brown; under parts densely barred in rufous.

SIZE
length 18–22 in. (46–57 cm)
weight 25–60 oz (700–1,700 g)
wingspan 39–47 in. (100–120 cm)
males larger and heavier than females

DISTRIBUTION
Tropical northern Australia, from Arnhem Land and Northern Kimberley to North Queensland; also New Guinea and Aru Islands.

STATUS
Least Concern

FEW ANIMALS THAT FORAGE through the humid forest floor of Australia's Top End can count themselves safe from the Rufous Owl. Everything from sugar gliders to brushturkeys has fallen victim to its powerful talons, ambushed in a silent swoop from the canopy.

The Rufous Owl is Australia's second-largest owl species, after the closely related Powerful Owl (*Ninox strenua*), and the only one confined to the Tropics. It belongs to the *Ninox* genus of hawk owls, which comprises some thirty species across Australasia and Southeast Asia. About the size of a buzzard (*Buteo* species), it has a longish tail, a rather small, rounded head, and no clear rim to the facial disk: all features that are typical of hawk owls. Unusually for owls, the male is appreciably larger than the female.

The species was first described in 1846 by British naturalist John Gould. It is essentially a tropical rain forest bird, ranging from monsoon forest to gallery forest, as long as there are plentiful large, mature trees. It may also hunt in adjoining woodland or well-wooded savanna. Although less common in montane forest, it has been recorded in New Guinea at elevations up to 7,000 feet (2,150 m). Wherever it occurs, this species is shy and elusive. Generally nocturnal, it roosts by day in thickly foliated mature trees, either singly or in pairs. At night, it emerges in search of food. Indeed, the Rufous Owl is a versatile and powerful hunter, whose prey ranges from

beetles and stick insects to large birds and medium-size mammals. Among notable victims recorded are the Australian brushturkey (*Alectura lathami*), Papuan frogmouth (*Podargus papuensis*), black flying fox (*Pteropus alecto*), and sugar glider (*Petaurus breviceps*), as well as various species of heron, duck, parrot, and even crayfish. It follows several strategies in pursuit of prey, from swooping on ground-foraging marsupials to pursuing birds in flight and plucking large insects from the foliage. Prey preference appears to change with the seasons: when lush ground cover sprouts during the rains, more birds are caught than mammals.

The Rufous Owl is not very vocal and seldom calls outside the breeding season. The most common call is a deep, double hoot, "wook-hoo," with the second note usually pitched slightly higher than the first. Sometimes a single hoot suffices. In response, the female's call is a little higher in pitch, and she will also utter an excited bleating trill when flying to her mate during courtship. The pair will then roost close together and may converse quietly. The male preens the female's neck while she picks lovingly at his toes.

Generally, the male selects a large hollow in the trunk or a main limb of a big tree as the nest hole. It is often located at a considerable height, up to 100 feet (30 m) above the forest floor. Egg-laying varies according to local climate, from June in the Top End to September in northeast Queensland. The female enters the hole immediately before laying her two (or sometimes only one) eggs. She incubates them for thirty-seven days. The youngsters fledge fifty days after hatching and remain dependent upon their parents for several months. This period of care may extend into the next breeding season, which can cause the adults to defer breeding again until the following year.

The global conservation status of the Rufous Owl is Least Concern. However, its distribution is patchy and it is nowhere common. In New Guinea, it must survive the threats of hunting and deforestation and, in Australia, bush fires.

Opposite: The Rufous Owl, in common with other *Ninox* hawk owls, lacks a well-defined facial disk.

SOUTHERN BOOBOOK

NINOX BOOBOOK

APPEARANCE
Small to medium; rounded head without ear tufts; facial disk pale and poorly defined, with darker, mask-like patches around greenish-yellow eyes; upper parts pale to chocolate-brown, with irregular white spots on the wing coverts and an indistinct white scapular line; flight feathers and tail rufous-brown, with dark brown bars on the former and paler bars on the latter.

SIZE
length 10.5–14 in. (27–36 cm)
weight 5–12.5 oz (146–360 g)
females 2.2 oz (65 g) heavier.

DISTRIBUTION
Across Australia, on all coasts but absent from arid regions; islands to north, including Timor, southern New Guinea, and Lesser Sunda Islands.

STATUS
Least Concern

THE NAME "BOOBOOK" DERIVES FROM the distinctive two-tone cadence of this owl's call. It received the name in 1801 from English ornithologist John Latham, who took it from a local aboriginal term for the bird. The call has also been transcribed as "mopoke," and early British settlers knew this bird as the "cuckoo owl" because its call resembles that of the common cuckoo (*Cuculus canorus*). Naturalist John Gould had a theory for this: "The settlers in New South Wales are led away by the idea that everything is the reverse in that country to what it is in England," he argued. "And the cuckoo, as they call this bird, singing by night, is one of the instances they point out."

Whatever you call it, the Southern Boobook is Australia's smallest owl and its most widely distributed. About the size of a feral pigeon, it has a rounded head without ear tufts and a poorly defined facial disk, which is characteristic of *Ninox* hawk owls. In plumage, it varies significantly by both individual and geography. Also known as the Spotted Hawk Owl, it occurs across much of Australia. Today, some nine subspecies are recognized, of which the nominate *N. b. boobook* is found on the Australian mainland, from southern Queensland through New South Wales and Victoria into South Australia. However, the Red Boobook (*N. lurida*) of northern Queensland and the Tasmanian Boobook (*N. leucopsis*) are now thought by many taxonomists to be separate species. In addition, the Morepork (P. 271), of New Zealand, once thought to be another race of Southern Boobook, received its own unique species status in 2013. Clearly, the taxonomy of the Southern Boobook is complex and further revision is required. Within its Australian range, however, confusion with any other owl is unlikely: the Barking Owl (P. 246) is the closest in appearance and habits, but it is considerably larger.

Typical habitat of the Southern Boobook includes eucalypt forest and woodland, but it also inhabits mallee, mulga, semidesert, tree-lined creeks, offshore islands, leafy suburbs, and stands of timber on farmland, although it tends to avoid dense rain forest. By day, it roosts in dense foliage, sitting upright and compressing its form into a more slender shape when threatened, like an *Otus* scops owl. After dark, it sets out hunting, often taking up a perch on an open branch or treetop. Prey varies between individuals, but generally comprises small mammals such as the house mouse (*Mus musculus*) and birds such as the house sparrow (*Passer domesticus*). Insects are often hawked in flight, sometimes around streetlights, and the owl transfers the catch from talons to bill before bringing it to the nest or perch. The largest prey recorded is ringtail possum (*Pseudocheirus peregrinus*) and Baillon's crake (*Zapornia pusilla*).

The call from which this bird gets its name is a brief, cuckoo-like, double hoot "boo-book," with the second note pitched lower than the first. This is repeated at up to twenty times a minute and may, during the breeding season, continue for hours. Mated birds also communicate with a low, soft "pot pot pot pot pot pot" as they perch close together. The breeding season is August and September, and the nest generally a hole or hollow in the trunk or a main limb of a large tree, some 3 to 65 feet (1–20 m) above the ground. The male cleans out the nest site before the female lays two to three eggs, rarely up to five. Incubation lasts thirty-five days, the female on the eggs while the male fetches food, and the young fledge five to six weeks after hatching. Like other *Ninox* hawk owls, they leave the nest well below full size, still covered in down, and rely on their parents' care for another two to three months.

Opposite: This species is the most widespread of several very similar boobook owls found across Australasia.

Above: The Greater Sooty Owl shares its heart-shaped facial disk
with other members of the *Tyto* genus of barn owls.

GREATER SOOTY OWL

TYTO TENEBRICOSA

APPEARANCE
Medium-size with no ear tufts; heart-shaped facial disk grayish-brown with dark rim and paler edges; blackish eyes contrast with creamy-white bill; upper parts sooty blackish-brown, finely spotted in white; tail and flight feathers uniform dark grayish-brown; under parts grayish-brown and paler than back, with white spots and mottling; large feet; females paler than males.

SIZE
*length 14.5–15.5 in. (37–40 cm)
weight 17.5–41 oz (500–1,160 g)
wingspan 40.5 in. (103 cm)*

DISTRIBUTION
Coast and mountains of southeastern Australia, from the Dandenong Ranges to the Conondale Range, and possibly on Flinders Island in the Bass Strait; also New Guinea.

STATUS
Least Concern

IN THE DENSE NIGHT FORESTS of eastern Australia, any possum that lingers on an exposed branch does so at its peril. This fearsome predator hunts the trees after dark, using phenomenal low-light vision to zero in on unsuspecting targets. So silent is its approach that the marsupial will never know what hit it.

The Greater Sooty Owl belongs to the *Tyto* genus, alongside the Barn Owl (P. 127), and, indeed, it is sometimes known as the Dusky Barn Owl. Although the two species share some anatomical similarities, including the heart-shaped facial disk, they are very different birds. For example, the Greater Sooty Owl is dark in color, and rather than quartering over open ground, it often hunts more like a northern goshawk (*Accipiter gentilis*), ambushing prey among the branches of a tangled forest. It is an elusive and strictly nocturnal species, so not easy to observe. A good view, however, reveals a medium-size owl—a little larger than a Barn Owl—with predominantly dark plumage and no ear tufts.

In Australia, the Greater Sooty Owl frequents densely forested gullies, preferring moist forest, with old, tall, smooth-barked gums and an understory of tree ferns. It may sometimes hunt in drier forest but always returns to moist forest for roosting and breeding. In New Guinea, it occurs in lowland and mountain rain forest, also sometimes emerging to hunt over subalpine grassland and rocky ridges at altitudes of up to 13,000 feet (4,000 m). The Greater Sooty Owl is a territorial and sedentary species. It roosts by day, hiding away in rock crevices, hollow tree trunks, and the dense foliage of tall trees. After dark, it sets out hunting through the forest, where it captures much of its prey among the branches. This contrasts with other *Tyto* owls, which take most of their prey on the ground. The huge eyes of this species, proportionally larger than those of a Barn Owl, suggest that it hunts primarily by sight rather than by hearing. It is a specialist predator on mammals, including nocturnal marsupials such as the sugar glider (*Petaurus breviceps*) and ringtail possum (*Pseudocheirus peregrinus*), with powerful talons allowing it to capture and subdue surprisingly large prey. Among a wide variety of other mammalian victims recorded are bats and giant rats.

The territorial call of a male Greater Sooty Owl is a sliding downward shriek that lasts for two seconds or more and sounds like the whistle of a falling bomb, hence the bird's Australian nickname of "bomb owl." Adults also make a piercing trill and various other sounds associated with breeding and nesting. Males become more vocal at the start of the breeding season, which generally lasts from January through to June, although there are some records of birds laying in spring (August to September). The nest is usually in a large hollow in a tall, living tree at any height from 30 to 160 feet (10–50 m). The female takes up position in the hole for some weeks before laying, flying out only briefly at night. During breeding, the male does all the hunting and usually brings one large prey item per night. The female lays one or two eggs, which she incubates for around forty-two days. The young fledge in about three months, but remain dependent upon their parents for another month or more.

This species is classified as Least Concern because currently it is not threatened on a global scale. However, it is more common in New Guinea than in Australia, where it is listed as Threatened in the state of Victoria and Vulnerable in New South Wales.

BARKING OWL

NINOX CONNIVENS

APPEARANCE
Medium-size, with longish tail and relatively small head; facial disk grayish-brown, without clear rim; forehead, crown, and upper parts smoky-brown; flight feathers darker and faintly barred; tail gray-brown with narrow whitish bars; under parts cream with heavy gray-brown streaking; whitish throat feathers often puffed out; toes dull yellow.

SIZE
length 13.5–17.5 in. (35–45 cm)
weight 0.9–1.1 lb (425–510 g)
wingspan 33–39 in. (85–100 cm)

DISTRIBUTION
Australia: north, south, and, discontinuously, west (around Perth), but absent from central, arid regions; New Guinea and Maluku Islands.

STATUS
Least Concern

FIRST-TIME VISITORS TO AUSTRALIA might be forgiven for thinking that the local dogs climb trees at night. The high-pitched, yapping double bark of this hawk owl sounds uncannily like man's best friend, especially when a female joins in and the two birds set up an excited woofing duet. Furthermore, barking is not the only trick in this owl's vocal repertoire: a more seldom-heard sound, known as the "screaming woman" call, is so spine-chilling that it is thought to explain the aboriginal myth of the bunyip, a fearsome creature of swamp and billabong that reputedly mimics the cries of its victims.

The Barking Owl is a medium-size member of the hawk owl family. In common with its Australian *Ninox* relatives, such as the Rufous Owl (P. 240) and Southern Boobook (P. 243), it has a longish tail and relatively small rounded head, with no clear rim to the facial disk. All of this certainly creates a hawk-like demeanor when viewed from certain angles. However, the blazing, black-rimmed, yellow eyes are indisputably those of an owl. They stand out in a grayish-brown face, with this color extending over the forehead and crown to the smoky-brown upper parts, which are rather uniform save for a strong white scapular line down each shoulder and small whitish spots on the wing coverts.

This species, also known as the Winking Owl and Barking Boobook, was first described in 1801 by English ornithologist John Latham. It has a wide but fragmented distribution in Australia, found around much of the east and north, and again in western Australia around Perth. Four subspecies are listed: found on Maluku, New Guinea, northern Australia, and the nominate, *N. n. connivens,* in southern and eastern Australia.

Generally, the Barking Owl is a bird of open country, with its chief requirement being large trees, especially old hollow ones, in which to roost and nest. It is commonly associated with creeks and rivers, notably with stands of river red gums (*Eucalyptus camaldulensis*) in the south and with paperbark (*Melaleuca quinquenervia*) swamps in the north, but it may also take to more open country with isolated stands of trees. In addition, the Barking Owl does well around human habitation, given the right surrounding habitat, and may nest in farm buildings and even in streets in towns. Generally a bird of the lowlands, it has been recorded at an elevation of 3,300 feet (1,000 m) in New Guinea.

The Barking Owl usually roosts in pairs and may remain faithful to the same roosting spot for months or even years. Although this is largely a nocturnal species, its telltale yapping call is sometimes heard by day, especially during winter, when it occasionally sets out hunting before sunset. Indeed, it hunts earlier in the evening and later in the morning than any other Australian owl, and regularly visits water early in the morning to bathe. Observed by day, its undulating flight is rather hawk-like, with long glides between bursts of flapping.

This owl is a rapacious hunter that takes a wide range of prey, most of it captured on the ground or when perched. Feathered victims range from small songbirds such as the house sparrow (*Passer domesticus*) to larger species, including the laughing kookaburra (*Dacelo novaeguineae*), red-rumped parrot (*Psephotus haematonotus*), Australian magpie (*Cracticus tibicen*), and tawny frogmouth (*Podargus strigoides*). Mammals on the menu include small possums, bats, and rodents, although in southern Australia the European rabbit (*Oryctolagus cuniculus*), an introduced non-native species, has become the staple diet. The Barking Owl also crunches up beetles, crickets, and other insects, particularly outside the breeding season.

Opposite: **The doglike yapping of the Barking Owl may be heard after dark across much of Australia.**

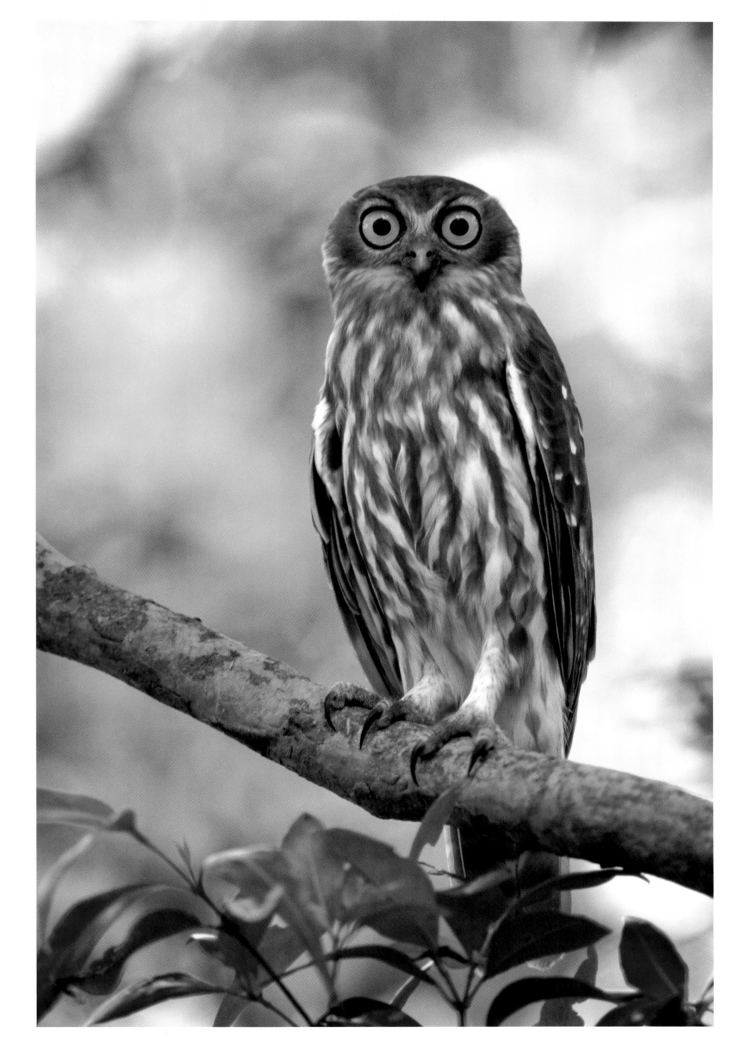

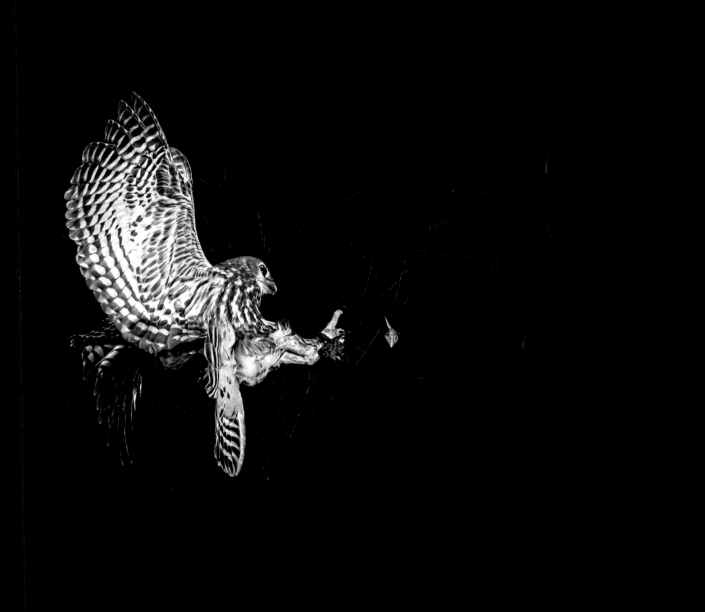

The nightly barking peaks at the start of the breeding season, when a male and female join in animated yapping choruses—usually perched close together—that continue for several minutes. However, this species does not call for such long periods through the night as does the Boobook. The female's call is higher pitched and tends to carry further than that of the male. At close quarters, a short low groan before the yapping is usually audible from both sexes.

Breeding is generally in late winter, with most eggs laid between July and September, although birds further north in Australia breed a little later than those toward the south. Studies in northern Victoria found that one pair occupied on average a home range that covered 5.4 square miles (14 sq km), with little overlap with other pairs. The nest site is usually a large hollow positioned up to 100 feet (30 m) from the ground in the trunk or large limb of a tree. Deep tree forks are also sometimes utilized, as are rock crevices and even rabbit burrows. The male generally chooses the site, although he rarely visits once the female is on the eggs. A successful site may be used repeatedly for many years.

The female takes up residence in the nest hole immediately before laying her two to three eggs (occasionally only one), at two- to three-day intervals. She is responsible for incubation,

and the eggs hatch at approximately thirty-six days. Some thirty-five days later, the young—still covered in a thick layer of fluffy white down—leave the nest and make their first flights. They will continue to roost nearby, enjoying their parents' care and benefiting from their hunting prowess, for several more months.

The global conservation status of the Barking Owl is Least Concern. However, it is declining across much of Australia, where it remains common only in the north. In New South Wales, it is listed as Vulnerable, and in Victoria, where no more than fifty breeding pairs are thought to remain, it is Endangered. The main threat that this species faces is the loss of its habitat. In particular, the removal of dead standing trees deprives it of key nest sites, and forest clearance also depletes the populations of the prey species on which it subsists. Rabbits have proved a valuable substitute food source in areas where the native mammal fauna has disappeared, but their decline in some regions may leave the owl overextended. In addition, the use of poisoned bait to control rabbits may have repercussion for the owls. Other threats that the Barking Owl must contend with include collisions with motor vehicles and barbed wire fences, as well as competition for roost sites and nest holes with swarms of feral honeybees.

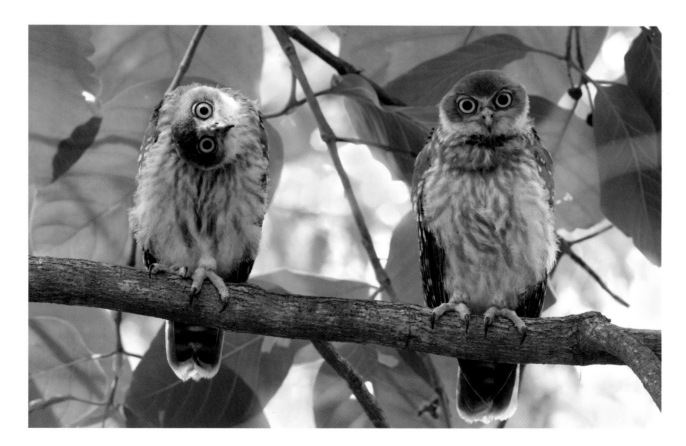

Above: Two fledgling Barking Owls on their perch.
Opposite: A Barking Owl swoops in silently to seize a moth.

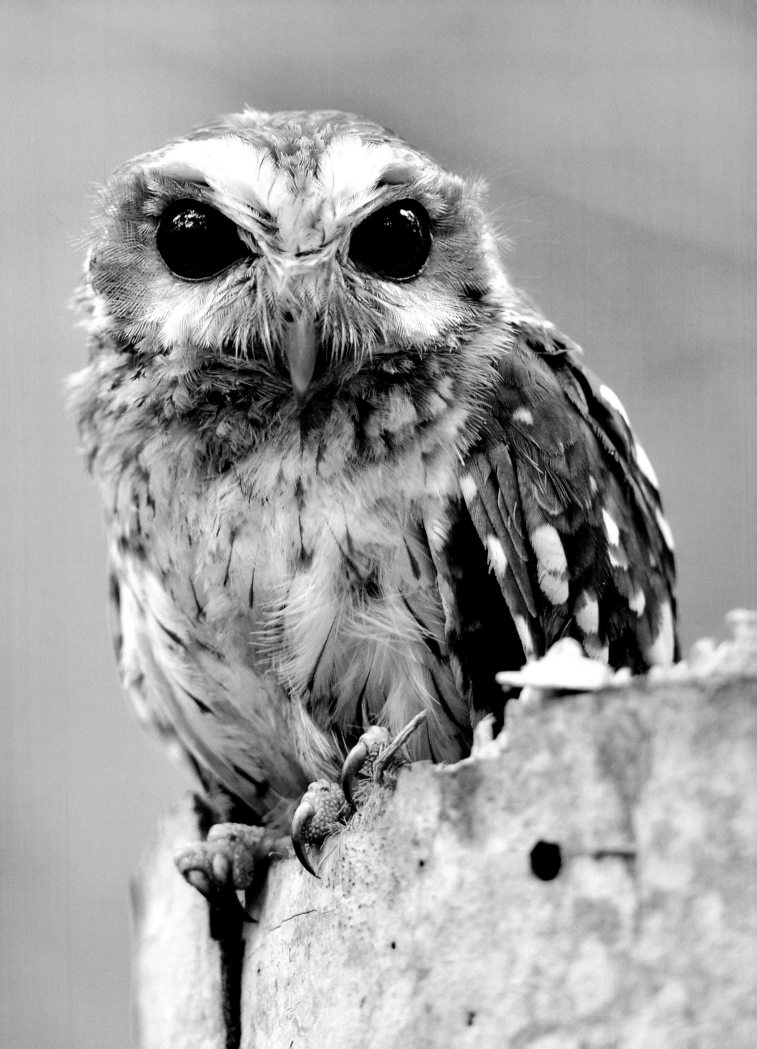

06 | OCEANIC ISLANDS

INSTEAD OF REPRESENTING THE OWLS of a single continent or biogeographical realm, this chapter gathers together a disparate collection of owls from all corners of the globe, from the Caribbean to the South Pacific. However, although these owls may not be contained within a single geographical area, they have one thing in common: they all live on islands. In some respects, this gives them greater affinities with each other than with their relatives on the nearest mainland.

Each of the owls described here is endemic to the island, or island group, on which it is found. It is, therefore, a perfect exemplar of the process of speciation, whereby an animal that finds itself separated from its relatives by geographical circumstance—in this case an unbridgeable expanse of water—continues its evolution in isolation until it becomes genetically distinct from the species it has left behind. It may look very similar to its ancestors, but it will have evolved subtle differences of form and behavior—and especially, with owls, of voice. Most importantly, it will have become genetically incompatible and so is no longer able to reproduce with them. In short, it will have become a new species.

It is no coincidence that it was on islands—the Galápagos Islands, to be precise—that Charles Darwin found inspiration for his theory of evolution in the nineteenth century. By confining species to a restricted area, away from the influences of the mainland, islands produce conditions that are ripe for the process of natural selection. Owls are largely sedentary birds. They do not, with a handful of exceptions, tend to travel long distances over water. Consequently, once they find

themselves on an island, perhaps blown there by storms, or having traveled across a land bridge that has since disappeared again beneath the waves, they are left largely to their own evolutionary devices.

Of the 250 or so owl species worldwide that are currently recognized by taxonomists, at least eighty—almost one-third—are endemic to oceanic islands. Many of them have only been "discovered"—which generally means separated by research rather than unearthed by exploration—in recent years, as the ever-improving science of molecular taxonomy has allowed scientists to draw distinctions between species that had previously been overlooked. The most prolific example of this is among the *Otus* scops owls, where at least thirty-five species—depending on which taxonomic authority you follow—are restricted to individual islands or small island groups. Other owl genera that have seen significant island speciation are the *Tyto* barn owls and the *Ninox* hawk owls.

The island groups that hold the greatest diversity of owl species are those of Indonesia and the Philippines, described in Chapter Five. However, there are many other islands and island groups around the world that provide just as good an example. The Caribbean, one of the world's great endemism hot spots, is an important one. This diverse collection of some 700 islands, arrayed across the Caribbean plate, has a separate geological history from the American landmass. It was once home to the largest owl ever known, the 3-feet-tall (1 m) Andros Island Barn Owl (*Tyto pollens*), a burrow-nesting giant that was exterminated on the Bahamas during the

Opposite: A Cuban bare-legged Owl emerges from its nest hole in a tree stump.

sixteenth century. Today, among various island species, you may find the Cuban Bare-legged Owl (P. 254), which occurs across Cuba and often feeds on frogs and snakes, and the Jamaican Owl (P. 262), which remains the subject of islanders' superstition. Both are endemic to their respective islands, and each is the only species in its own genus.

Madagascar is another hot spot of island endemism. Although nominally part of the African continent, which lies only a short distance away across the Mozambique channel, its unique cargo of endemic fauna and flora, including lemurs, chameleons, and baobab trees, reflects its very different geological history, having separated from the ancient Gondwana supercontinent some 165 million years ago. Among several owls unique to the island are the diminutive Madagascar Scops Owl (P. 265) and the Madagascar Red Owl (P. 257), the latter a handsome rufous relative of the barn owls on Africa's mainland. Numerous other endemic owl species are found on Africa's other offshore islands, from Pemba to São Tomé.

The South Pacific comprises a multiplicity of islands scattered across the regions of Polynesia, Melanesia, and Micronesia that together make up Oceania. Many are tiny, comprising little more than coral atolls, and best known by naturalists for their marine life. However, some also have a diverse avifauna, with its origins in Indonesia and Australasia. Most island owls of this region belong to the *Ninox* hawk owl group and include species such as the West Solomons Boobook (P. 268), one of several boobooks endemic to the Solomon Islands. The Palau Owl (P. 261), found only on Palau, among the Caroline Islands of Micronesia, has its own genus, *Pyrroglaux*, and enjoys perhaps the most remote existence of any owl.

Politically, New Zealand is part of Australasia. However, this remote archipelago is far from Australia, and its avifauna is among the world's most unusual, comprising numerous flightless species, such as kiwis and kakapos, whose evolution reflects the evolutionary opportunities available to birds on an island free from terrestrial mammals. The one native owl, the Morepork (P. 271), is another offshoot from the boobook lineage of *Ninox* owls that has radiated outward from Australia across the South Pacific. Its bizarre name comes from its call.

Island wildlife may be unique, but it is also extremely vulnerable. The Pacific has more threatened bird species per unit of land than any other region in the world. Island species that are under threat, including owls, have nowhere else to go, and unfortunately the threats that they face are legion. They range from the usual destructive forces of development wrought by humans, notably deforestation and the introduction of invasive non-native species such as rats, to natural disasters, including volcano eruptions and hurricanes, that can destroy an ecosystem — and, potentially, exterminate a species — overnight. With the perils of climate change also looming, it is island owls that present perhaps the greatest challenge for the world's conservationists.

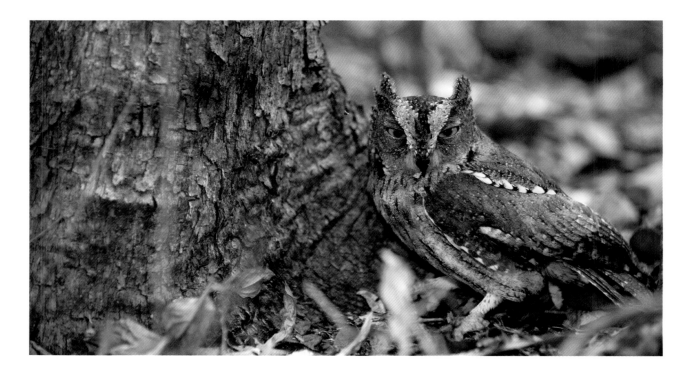

Above: A camouflaged Madagascar Scops Owl on the ground.
Opposite: A Palau Owl chick in its downy juvenile plumage.

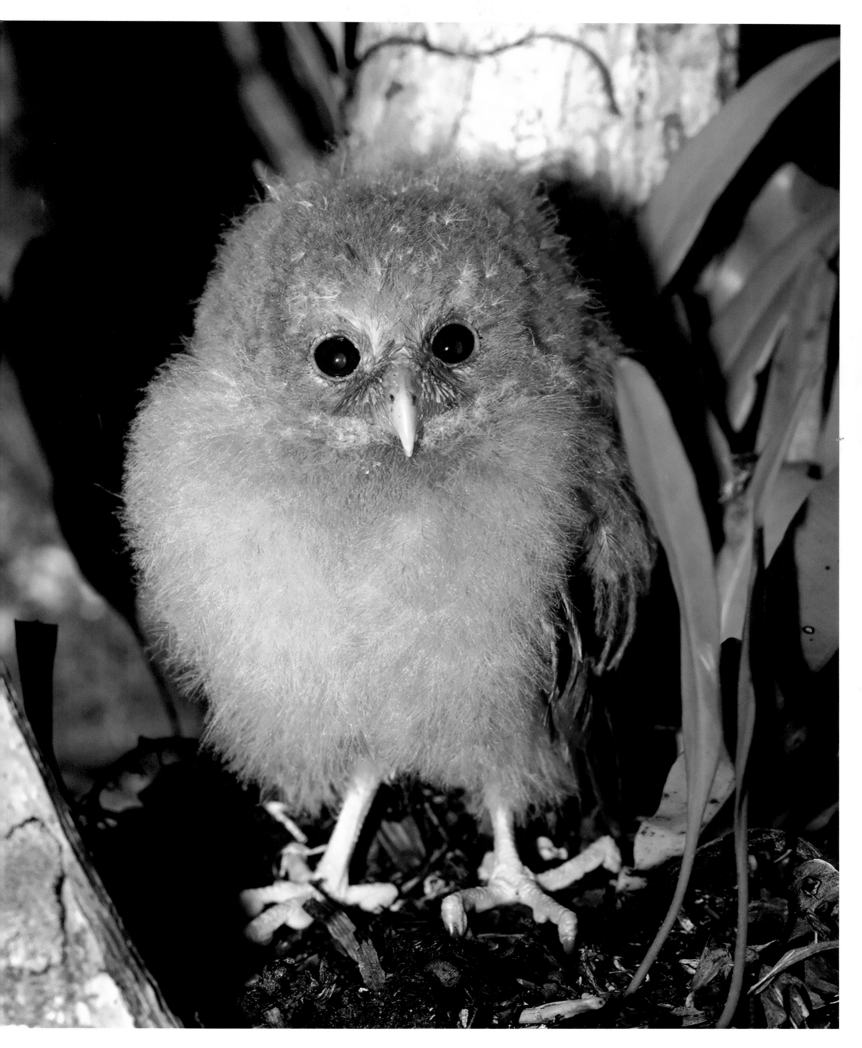

CUBAN BARE-LEGGED OWL

GYMNOGLAUX LAWRENCII

APPEARANCE
Small, with rounded head and no ear tufts; eyes dark brown to orange-brown, heavy whitish eyebrows; facial disk whitish-buff with indistinct rim; upper parts brown, sometimes rufous; flight feathers and tail lightly barred in white.

SIZE
length 8–9 in. (20–23 cm)
weight (one specimen) 2.8 oz (80 g)

DISTRIBUTION
Endemic to Cuba and the offshore island of Isla de la Juventud.

STATUS
Least Concern

THIS SMALL ISLAND OWL gets its name from its long, unfeathered tarsi. Formerly known as the Cuban Screech Owl, it acquired its new moniker when DNA research concluded that it did not belong among the screech owl genus. Given that there is nothing remotely screechy about this owl's call, the new common name seems not only more accurate but also more helpful to the non-scientist.

Whatever the name, this is a small species, about the size of an average screech owl but without the ear tufts. The upper parts are brown, sometimes rufous, with blackish spots on the crown and hind neck and irregular white spots on the mantle and wing coverts, although the scapular line is not clearly defined. The flight feathers are lightly barred in white, as is the tail, which comprises only ten retrices (tail feathers), by contrast with the twelve of most owl species. The under parts are creamy white, with distinct, finely spaced, dark shaft streaks. Not enough data exist to determine any consistent difference between the sexes.

An interesting taxonomic history surrounds the species. It became the Cuban Screech Owl in 1998, when the American Ornithologists' Union reclassified it in the genus *Otus*, which at that time comprised both the Old World scops owls and the New World screech owls. In 2003, however, the union reversed its decision — on the basis of various morphological and vocal differences — and reclassified the owl in its own genus, *Gymnoglaux*, in which it is the only species. More recent studies have suggested it may be more closely related to the owls of the *Athene* genus, such as the Burrowing Owl (P. 43),

with which it shares the island. Further DNA analysis may shed more light on this issue. Meanwhile, the only species with which the Cuban Bare-legged Owl might be confused within its range is indeed the Burrowing Owl. This bird, however, is rare in Cuba, and it is easily distinguished by its barred under parts and, of course, by its habit of living in burrows.

The Cuban Bare-legged Owl occurs widely across the island and inhabits a variety of habitat types, from dry forests and lowland moist forests to mixed palm forest and heavily degraded secondary forest. It also occurs in semi-open limestone country and has adapted well to human-modified landscapes, including plantations and other cultivated areas. A nocturnal bird, it roosts by day in densely foliaged trees, thickets, crevices, or caves. After dark, it emerges to hunt for a variety of small prey: mostly large insects and other arthropods, but also small frogs, geckos, small snakes, and, occasionally, small birds. It will swoop down from a perch onto its prey but also spends a lot of time hunting on the ground.

The call of the male has an accelerating rhythm like that of a bouncing ball. The soft "coo-coo-coo-guguguk" both speeds up and rises in pitch and, during the courtship season, may be answered by the female's higher-pitched, down-slurred "yiu-yiu-yiu." Little is known about the breeding behavior of this owl, but the breeding season appears to be from January to June. Nest sites are typically in palm or tree holes excavated by woodpeckers, although they may also be in cave entrances or sheltered rock crevices on cliffs. The female lays two eggs, on average, which she incubates alone. A pair has been known to occupy the same nesting territory for seven years.

This species is listed as Least Concern and the Cuban Bare-legged Owl is reputedly common across much of its range, although there is little reliable data on population numbers or trends. Weighing in the bird's favor is its proven capacity to adapt to human development and the fact that Cuba has no native predators that pose a significant threat.

Opposite: A Cuban Bare-legged Owl peeks from its nest hole in a hollow tree.

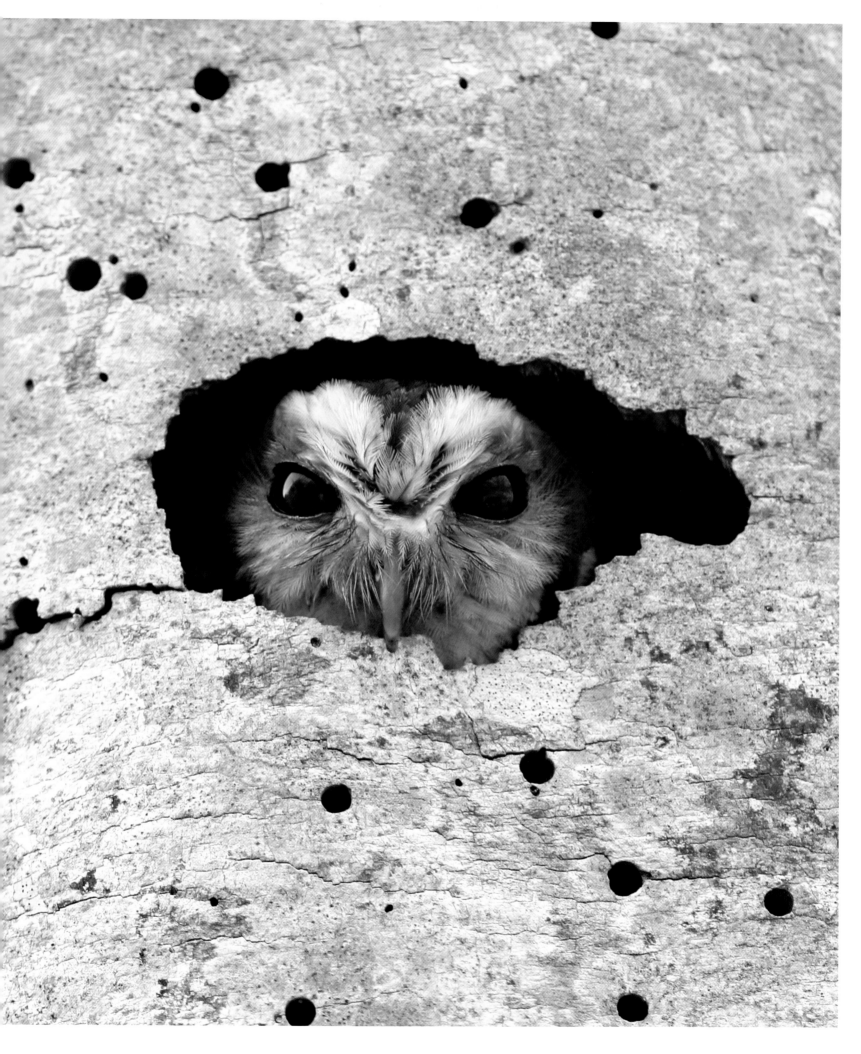

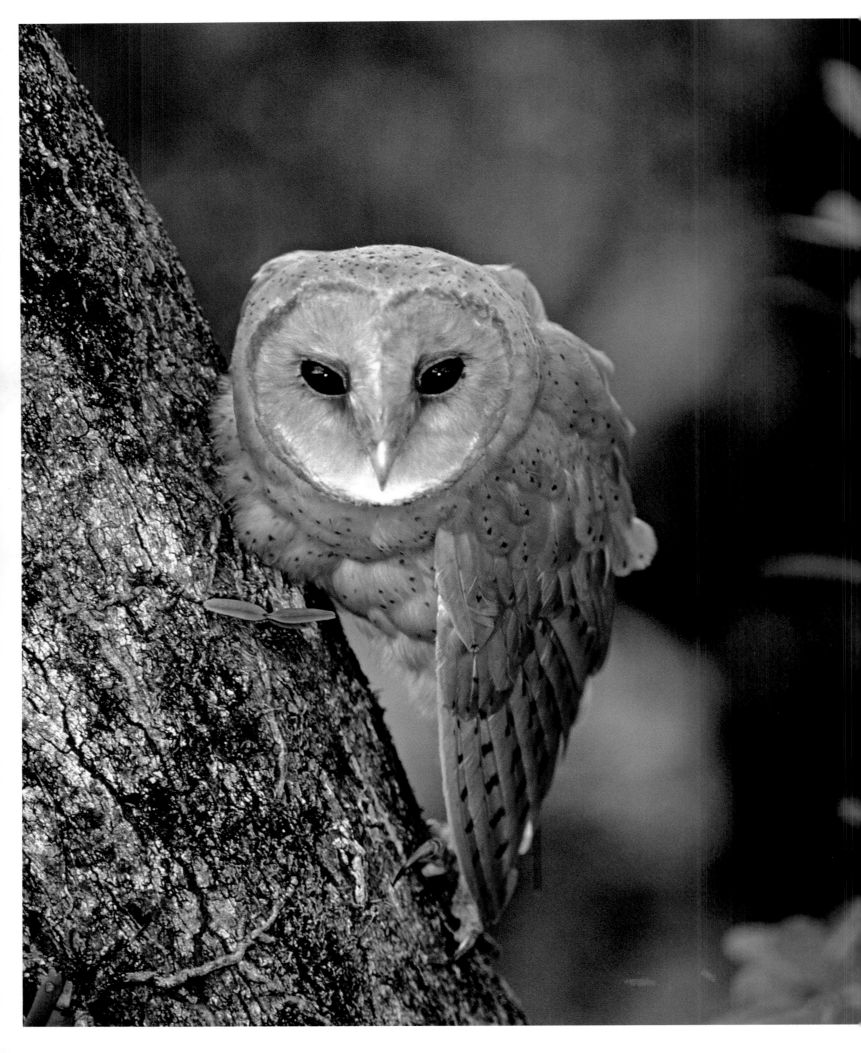

MADAGASCAR RED OWL

TYTO SOUMAGNEI

APPEARANCE
Medium-size, with large head and no ear tufts; facial disk white and heart-shaped, with large dark eyes; overall plumage ocher-reddish and sparsely freckled with fine dark spots; under parts paler; dark barring on flight and tail feathers.

SIZE
length 11–12 in. (28–30 cm)
weight 11.5–15 oz (323–435 g)

DISTRIBUTION
Eastern Madagascar, patchily distributed from north to south.

STATUS
Vulnerable

THIS OWL WENT MISSING for more than a century. First discovered on Madagascar in 1876, it was virtually unobserved until 1993, when a team from the Worldwide Fund for Nature rediscovered the owl during a research trip. Endemic to Madagascar and, like much of the island's unique wildlife, threatened by rampant deforestation, it is undoubtedly a rare bird. However, a recent increase in sightings suggests that it may previously have been overlooked in many regions, or confused with its close relative the Barn Owl (P. 127), and may be more widespread and more numerous than thought.

Confusion with the Barn Owl is understandable, because the Madagascar Red Owl belongs to the same *Tyto* genus and the two share many features: not least, the white, heart-shaped facial disk. However, the Barn Owl, which is widespread across Madagascar, is substantially larger and much paler in color. This species, by contrast, has an overall ocher-reddish color, from which it gets its name.

The Madagascar Red Owl, also known as the Soumagnes Grass Owl or Madagascar Grass Owl, is one of the smallest in the *Tyto* group. It was formerly thought to occur only in the northeast of the island, between Amber Mountain in the far north and Andasibe-Mantadia National Park in the center-east, but more recent sightings have extended the known range to the far southeast of the island, in the lowlands of Tsitongambarika. Scientists now believe that the species may occur in all suitably large tracts of moist evergreen forest in the east and north of Madagascar, and the results of further surveys are eagerly awaited.

This species frequents both humid rain forest and dry deciduous forest in eastern Madagascar. Although primary forest is probably the ideal habitat, it also occurs in secondary scrub, along forest edges and clearings, as well as in paddy fields, where it hunts along fence lines. Roost sites are often on rock ledges and inside cave entrances, typically at least 12 feet (3.7 m) above the ground.

As far as is known, it is a strictly nocturnal bird and feeds by quartering open areas in flight in search of small prey on the ground. It eats largely small mammals, reptiles, and insects. Interestingly, however, an analysis of its prey remains shows that it feeds almost exclusively upon forest-dwelling native fauna, ranging from indigenous rodents, notably tufted-tailed rats (*Eliuris* species), to tenrecs (*Tenrec* species), and even the eastern rufous mouse lemur (*Microcebus rufus*). The Barn Owl, by contrast, eats almost entirely introduced, non-native species, such as the black rat (*Rattus rattus*), which suggests that the two birds do not compete over food.

Vocally, the Madagascar Red Owl resembles the Barn Owl, with its a loud, down-slurred hissing screech that lasts about one-and-a-half seconds. It also uses a "wok-wok-wok" alarm call. Birds become more vocal toward the start of the breeding season. Breeding behavior is probably similar to that of the Barn Owl, with the nest usually in a tree cavity. In the only recorded nest site, the adults nested in July, at the end of the rainy season, and laid a suspected two eggs. The young fledged at about ten weeks and had left their parents' territory four months later.

This species is listed as Vulnerable, with an estimated population of 3,500 to 15,000 individuals. Its approximate total range of 20,000 square miles (52,200 sq km) is rather greater than was once thought. Nonetheless, the Madagascar Red Owl is highly vulnerable to the deforestation that is largely a result of illegal logging and slash-and-burn agriculture. These practices saw some 50 percent of the island's forest cover lost between 1950 and 2000, and they continue to this day.

Opposite: **The heart-shape face of a Madagascar Red Owl reveals its close relationship to the Barn Owl.**

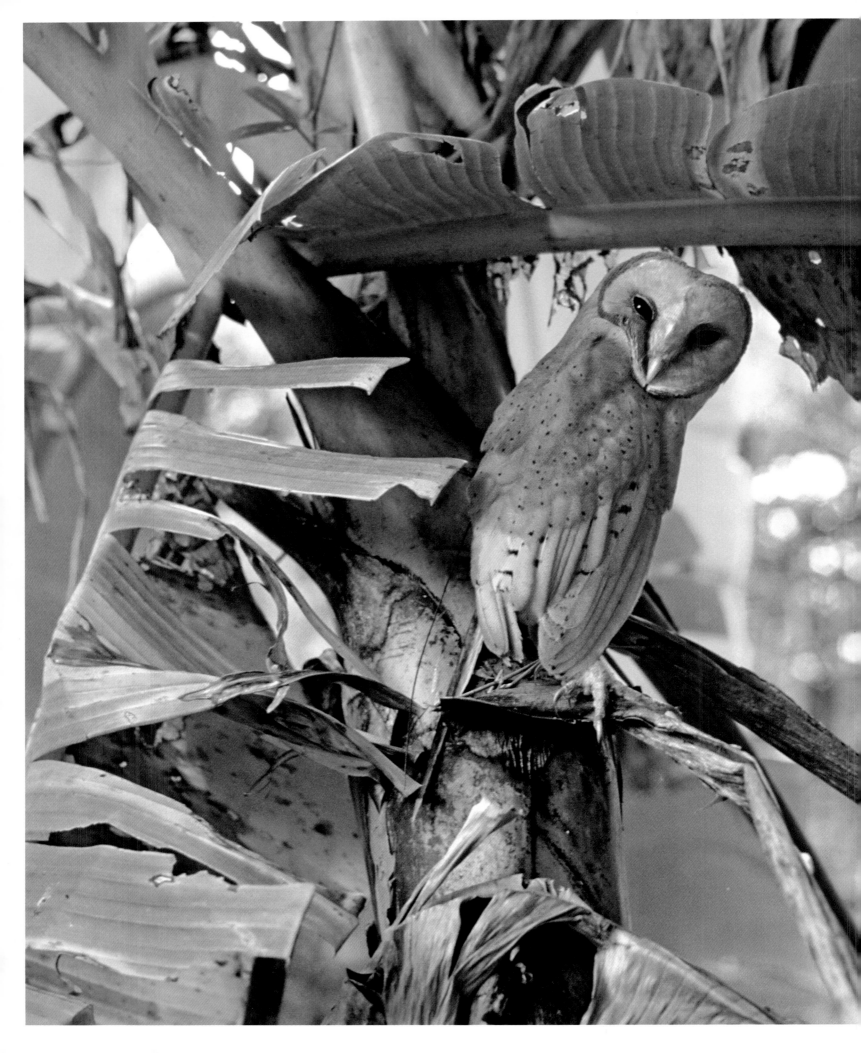

Left: Madagascar Red Owls have adapted to hunt around banana plantations and other cultivated land.

OCEANIC ISLANDS

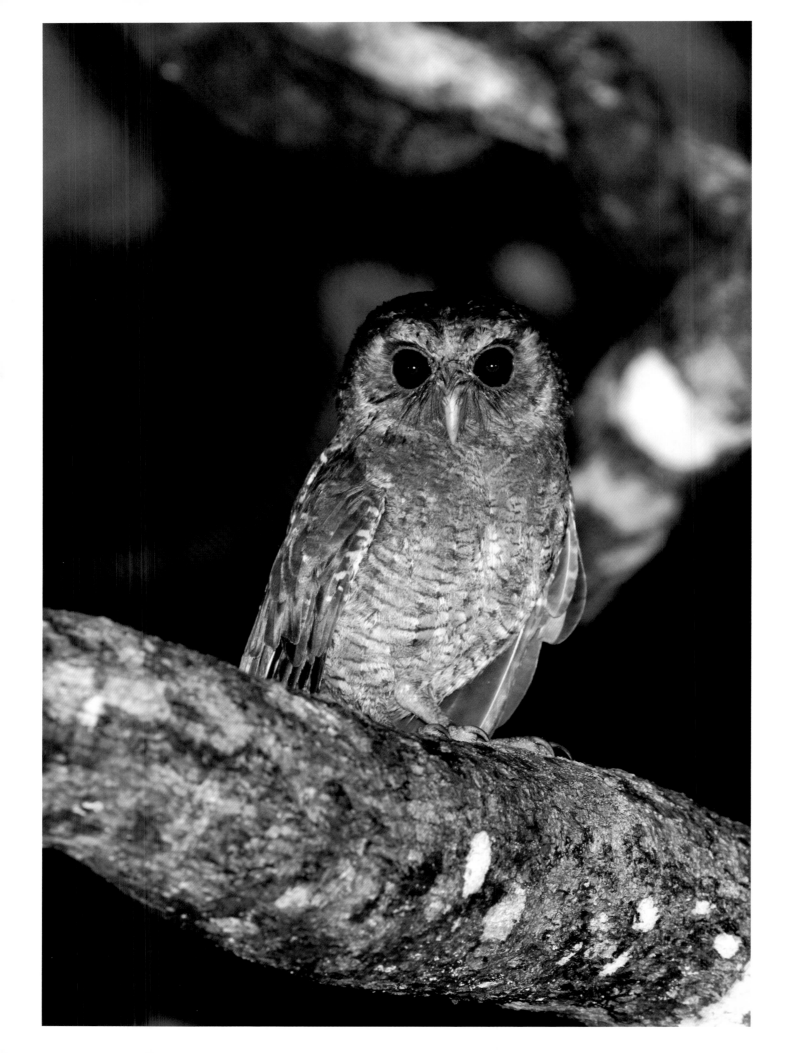

PALAU OWL

PYRROGLAUX PODARGINUS

APPEARANCE
*Small, with a rounded head
and no visible ear tufts; largely
rufous-brown in color; whitish
forehead and eyebrows, narrowly
barred dark brown; eyes brown to
orange-yellow; upper parts have some
fine white spotting and barring;
white barring on darker flight
feathers; breast pale rufous, finely
barred in white and black; darker
and lighter morphs occur.*

SIZE
*length 8–9 in. (21–23 cm)
no weight data available*

DISTRIBUTION
*Republic of Palau; primarily
on the main island of Babelthuap
(Babeldaob); also on the
islands of Koror, Urukthapel
(Ngeruktabel), Ulong, Peleliu,
and Angaur.*

STATUS
Least Concern

THE PACIFIC NATION OF PALAU defines remote. A tropical archipelago of some 250 islands, many of them tiny and uninhabited, it lies about 600 miles (965 km) north of New Guinea and 2,000 miles (3,200 km) south of Tokyo. This land of subsistence fishing communities, tropical reefs, and the occasional cyclone may not be the sort of place that is immediately associated with an owl. However, the dove-like hooting of this small bird rings out over many of the larger islands and—despite only occupying a tiny piece of the globe—it appears to be faring reasonably well.

The Palau Owl is about the size of a Little Owl (P. 114). Formerly known as the Palau Scops Owl, it was placed in the genus *Otus,* with other scops owls. It has since been assigned its own genus, *Pyrroglaux,* and is a monotypic species with no geographical variants. There are no similar owls on Palau with which it might be confused, although the much larger and unrelated Short-eared Owl (P. 141) also inhabits the archipelago.

This species is endemic to the Palau Islands. It inhabits lowland rain forest, occurring in ravines, forested lagoons, and mangrove swamps, and can be common around villages at night, notably on the island of Koror. Small groups are often observed, the birds roosting in mangroves and other deep cover by day then emerging to feed at night, when they may move around some distance. The diet consists largely of insects, centipedes, and other arthropods, as well as earthworms.

The male Palau Owl has a distinctive territorial call, comprising a series of clear single notes spaced at intervals of about one second—"kwuk kwuk"—that gather speed and intensity as the owl becomes more excited, and eventually become double notes before fading away. The female's song is similar but higher in pitch, and both resemble that of the Palau fruit dove (*Ptilinopus pelewensis),* another species endemic to the islands, which calls by day. Very little is known about this owl's breeding habits. The breeding season is February to March. Pairs remain together throughout the year and will duet during courtship. Nest sites are generally hollow trees or tree holes, and the female lays a single egg.

BirdLife International estimates the global distribution of this species to comprise a mere 170 square miles (440 sq km). However, its status is currently listed as Least Concern, as within this restricted range it appears to be thriving. This has not always been the case. The Palau Islands have seen their share of difficulties: during World War II, numerous naval skirmishes were fought in the region, including the Battle of Peleliu, which cost the lives of 2,000 Americans and 10,000 Japanese and ended with the United States taking control of the islands. This conflict took its toll on the fragile environment, and a survey in 1945 found that the Palau Owl was one of three bird species—the others being the Palau ground dove (*Gallicolumba canifrons*) and Palau fantail flycatcher (*Rhipidura lepida*)—that were under threat of extinction. The owl's decline continued into the 1960s, exacerbated by the introduction of a rogue rhinoceros beetle (*Oryctes rhinoceros*), which caused problems for the birds when they attempted to ingest it.

Concerted conservation action, including a campaign to eradicate the alien beetle, has since born fruit. Surveys conducted from 1976 to 1979 found that the owl was once again abundant throughout the archipelago, and it has continued to prosper. Like all low-lying islands in the Pacific, however, Palau is highly vulnerable to the effects of climate change, which could yet trigger another downturn in the owl's fortunes.

Opposite: The Palau Owl has unusually uniform plumage for an owl, with few distinct markings.

JAMAICAN OWL

PSEUDOSCOPS GRAMMICUS

APPEARANCE
Small to medium-size owl, with prominent ear tufts, dark eyes, and blueish-gray bill; well-defined, rufous facial disk with black and white border, paler outer edges and eyebrows; under parts rufous, with fine dark shaft streaks and pale belly.

SIZE
length 10.5–13 in. (27–34 cm)
no weight data available

DISTRIBUTION
Endemic to Jamaica, in the Western Antilles.

STATUS
Least Concern

"SALT AND PEPPER FOR YOUR MAMMY!" goes the phrase, one of several traditional mantras uttered by Jamaicans whenever they hear the strange frog-like growl of the Jamaican Owl over their house. They need to be quick about it, too: tradition holds that unless you complete the incantation before the owl has called three times, some evil will befall you or your family.

This superstition is thought to have its roots in Africa and to have traveled to Jamaica with the slaves, who were shipped across the Atlantic as labor for the sugar estates after the British wrested the island from the Spanish in 1655. The slaves finally received their freedom in 1838, and in 1962 the island celebrated its independence from colonial rule. However, in the Blue Mountains and other parts of the rural highlands, many ancient beliefs persist to this day. Indeed, so feared are owls in some Jamaican communities that one chanced upon during daylight hours may still find itself stoned by villagers. This fate is more likely to befall the Barn Owl (P. 127), known as the "jumbie bird" and a more common species around the island than the Jamaican Owl, which is known locally as a "pattoo" or "duppy bird."

For the birdwatcher, there is no mistaking a jumbie bird for a duppy bird. The latter, an island endemic, is smaller than the much paler Barn Owl, which ranges all over the Americas, and more closely resembles one of the *Asio* genus of eared owls. Indeed, scientists once considered the Jamaican Owl conspecific with the Striped Owl (P. 80) of this genus, which occurs on the Central and South American mainland, just across the Caribbean from Jamaica. Today, however,

most authorities place the Jamaican Owl in its own genus, *Pseudoscops*, a classification based on differences in the structure of its skull. This species is therefore thought to have no close relatives.

Jamaica is the Caribbean's third-largest island and one of its richest for bird life. This owl is one of at least twenty-nine endemic birds, among more than 300 species recorded on the island. It is a bird of montane and lowland forest, and is reasonably widespread in suitable habitat, which also includes forest edges, large gardens, and semi-open country with trees. Typically, the Jamaican Owl is a nocturnal species that emerges after dark from its daytime roost to hunt for a variety of mostly fairly small prey, ranging from insects—beetles, in particular—to spiders, mice, lizards, tree frogs, and a number of small birds.

Little is known about the breeding behavior of the Jamaican Owl. The breeding season extends most likely from December to June and it is heralded by a more intense period of vocalization. In addition to the guttural, frog-like growl, this species has a high, quivering "to-whooo" hoot, which it repeats at varying intervals. The nest is generally a cavity in the trunk or large limb of a mature tree, well concealed by vegetation. On average, the female lays two eggs. Youngsters leave the nest before they can fly, still clad in fluffy white down, and beg food from their parents with a high piercing squeal. They grow to be a small to medium-size owl, with prominent ear tufts, dark eyes, and rich rufous plumage that is marked with black barring above and fine black streaks below.

Although the Jamaican Owl is restricted to a single island, with an estimated range of no more than 4,250 square miles (11,000 sq km), its population is stable and not thought to be in immediate danger. The main potential threat is the loss of habitat due to ongoing development to serve an ever increasing human population. At present, it is listed by the International Union for Conservation of Nature as Least Concern.

Opposite: The Jamaican Owl resembles the eared owls of the genus *Asio*, but has recently been assigned its own separate genus.

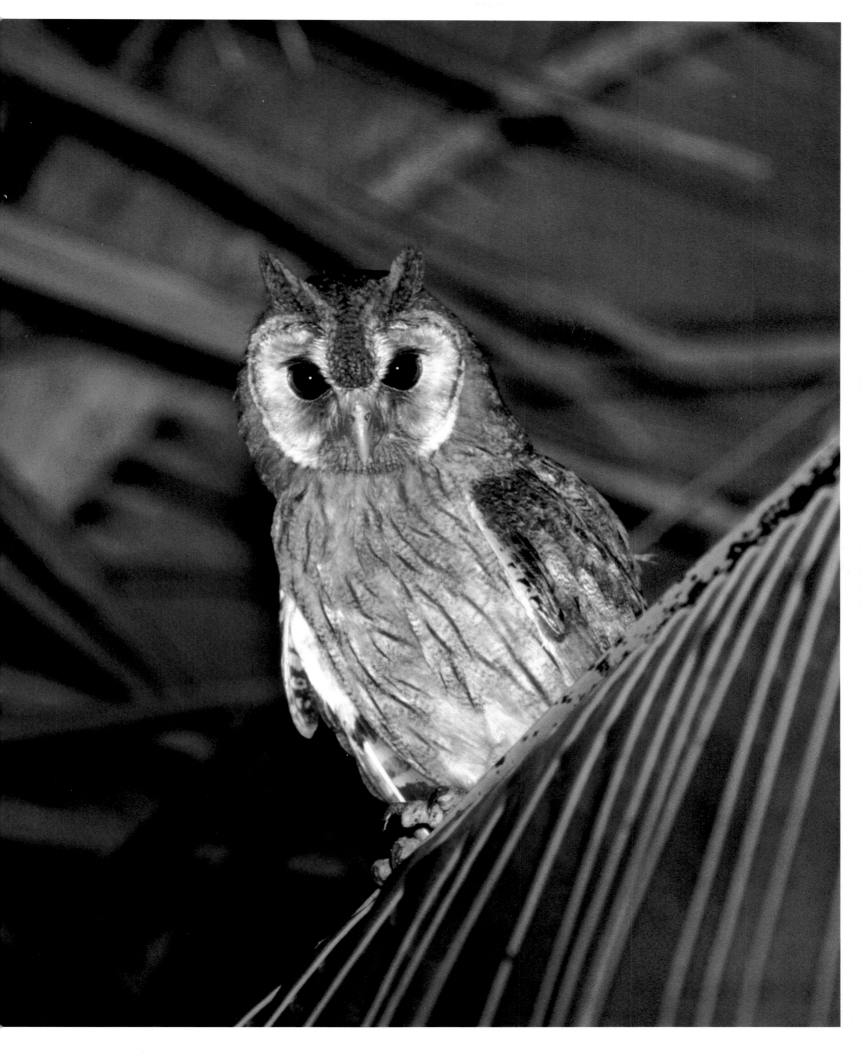

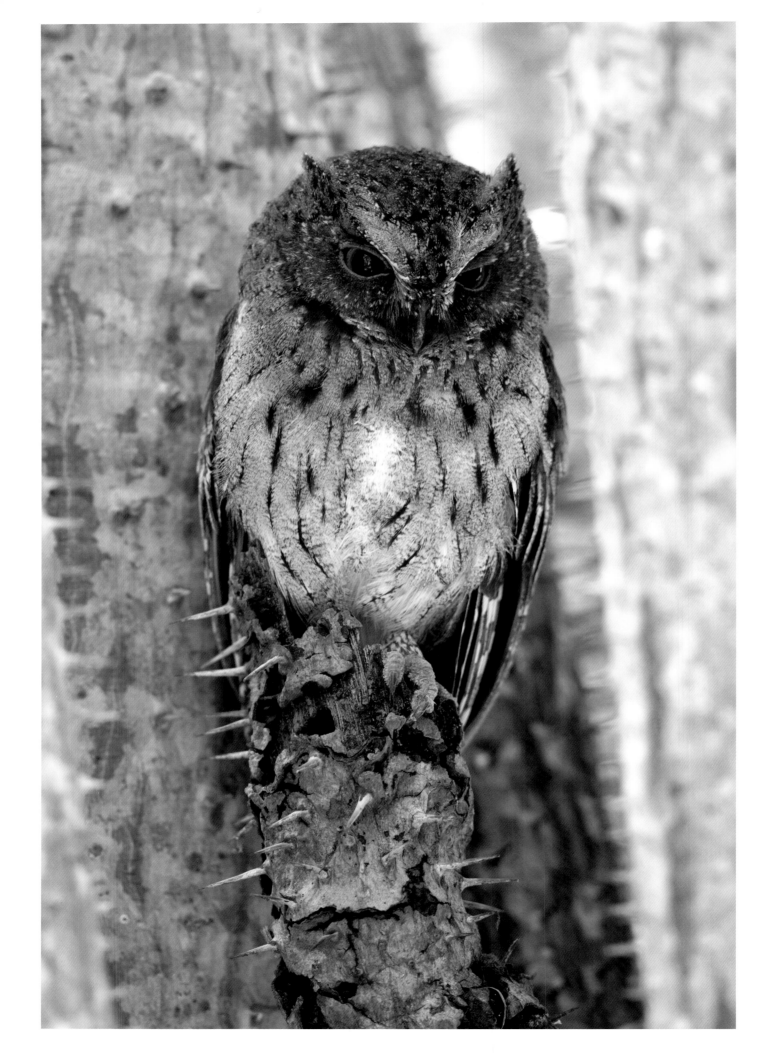

MADAGASCAR SCOPS OWL

OTUS RUTILUS

APPEARANCE
Small owl, with small, erectile ear tufts; facial disk brown, with dark brown rim; eyes yellow; bill and cere pale grayish-brown; upper parts and crown pale brown, mottled in ocher and off-white; flight feathers and tail grayish-brown, with lighter and darker barring; under parts ocher to grayish-brown; *gray, brown, and rufous morphs occur.*

SIZE
length 8.5–9.5 in. (21.5–24 cm)
weight 3–4.2 oz (85–120 g)
wingspan 20.5–21.5 in. (52–54 cm)

DISTRIBUTION
Northern and eastern Madagascar.

STATUS
Least Concern

The Indian Ocean island of Madagascar is home to some of nature's most impressive examples of cryptic camouflage. An apparently empty thicket in the northeastern rain forest might reveal, on closer inspection, a nose-horned chameleon (*Calumma nasuta*) frozen on a twig, a leaf-tailed gecko (*Uroplatus* species) flattened against the lichen-covered branch, and—if you are lucky—one of these diminutive owls, blending perfectly into the play of dappled forest light on a mossy, fissured tree trunk.

The Madagascar Scops Owl, also known as the Rainforest Scops Owl, is a typical member of the *Otus* scops owl genus. Slightly larger than the Common Scops Owl (P. 159), the species was once thought to be present across the whole of Madagascar. However, scientists now believe that it is found only in the northern and eastern parts of the island, where it is tied to rain forest and associated moist habitats. Populations in the drier west and south of the island represent a different species, the Torotoroka Scops Owl (*O. madagascariensis*), which looks extremely similar but has a longer tail—best visible in flight—and a very different voice. The precise limits of distribution between the two species are not entirely clear, but essentially reflect the very different rainfall patterns that occur to the east and west of the island's central highlands. The Mayotte Scops Owl (*O. mayottensis*), endemic to Mayotte Island on the Comoros and formerly considered a subspecies of Madagascar Scops Owl, is now classified as a species in its own right.

The preferred habitat of the Madagascar Scops Owl comprises tropical and subtropical rain forest as well as humid bushy country, from sea level up to about 5,900 feet (1,800 m) in elevation, perhaps higher. It may also frequent disturbed secondary forest and forest edges. By day, it roosts in dense foliage, between branches, among thick creepers, or up against a tree trunk. It seldom roosts very high above the ground and even hunkers down among fallen trees on the forest floor. A good roost site may be used repeatedly for many years. After dark, it emerges to hunt, targeting mostly large insects, including moths, crickets, mantises, and beetles. It hunts by flitting from tree to tree, taking flying prey either on the ground or on the wing. Small vertebrates, such as frogs, rodents, and chameleons, are also sometimes targeted.

The Madagascar Scops Owl's distinctive song comprises a series of five to nine short clear "oop" notes, given at a rate of about three notes per second, with a break of several seconds before the next series begins. It may call from high in the canopy or from low down in the thickets. Males become more vocal as the breeding season gets under way, which observations suggest is during November and December, although little is known about this bird's breeding biology. Nest sites are generally natural tree holes, some 13 to 23 feet (4–7 m) above the ground, but they have also been observed on the ground, in depressions in the leaf litter. Typically, the female lays three to four eggs, which she incubates herself. There is no further information available about the length of incubation or fledging, but these are unlikely to be significantly different from those of other *Otus* scops owl species.

The International Union for Conservation of Nature lists this owl as Least Concern. It occupies an estimated range of 228,000 square miles (591,000 sq km) and is thought to be fairly common within that range. The population dynamics of the species have not been well studied, however, and like much of Madagascar's rain forest wildlife, it is likely to be vulnerable to the ongoing threat of habitat loss through deforestation.

Opposite: A grey-morph Madagascar Scops Owl. There is also a rufous morph variation of this species (overleaf).

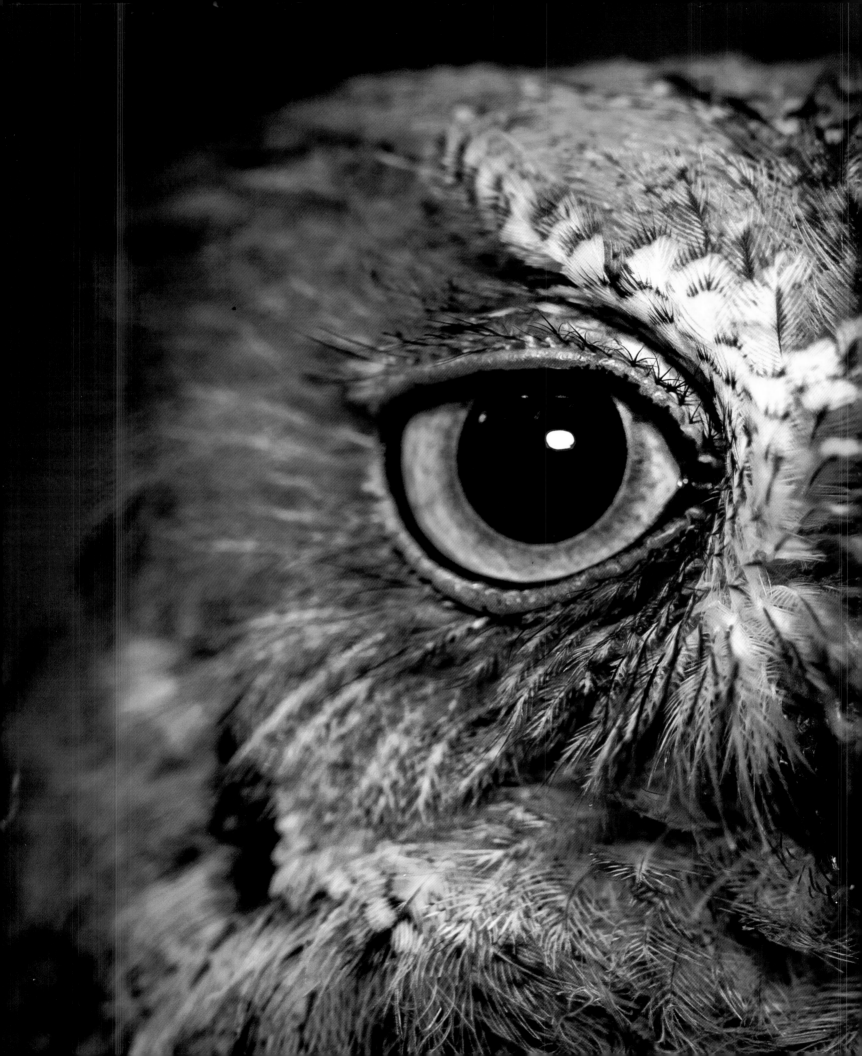

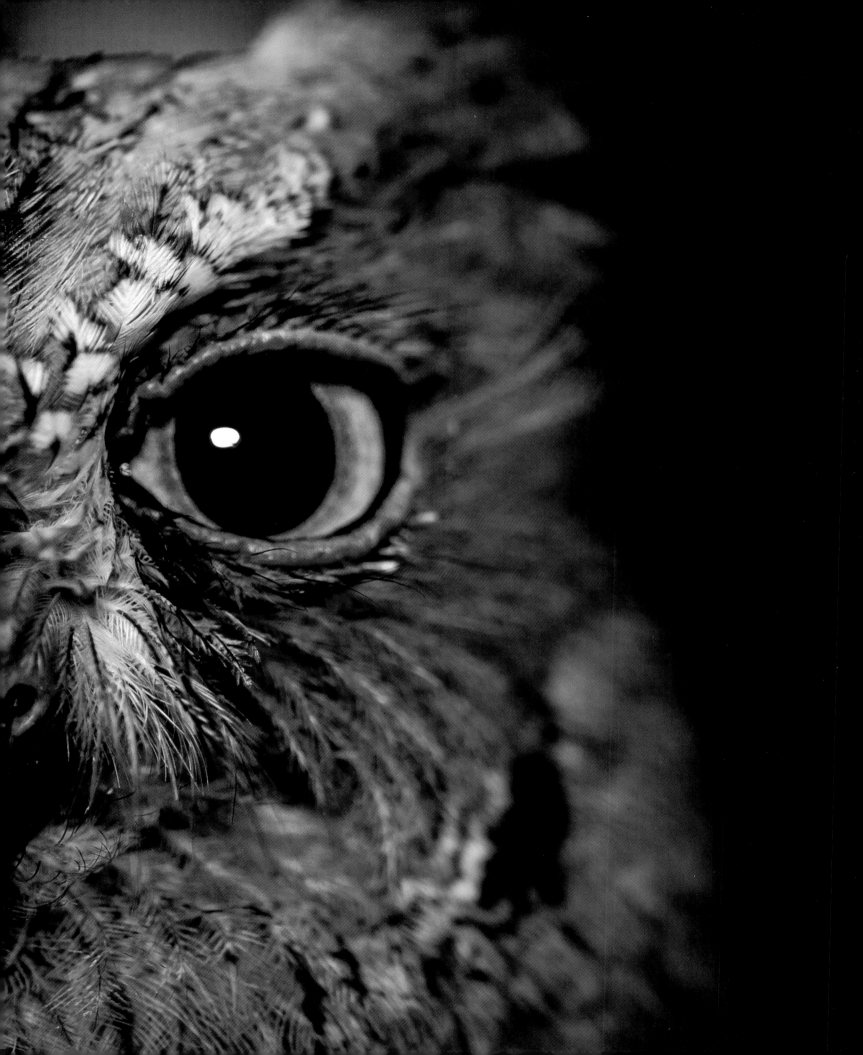

WEST SOLOMONS BOOBOOK

NINOX JACQUINOTI

APPEARANCE
Small to medium-size; large, rounded head with no ear tufts; upper parts rusty-brown, spotted or barred in white; under parts creamy-buff, mottled to a varying degree in brown, with creamy belly unmarked; facial disk gray-brown, with bold white eyebrows and white throat; eyes greenish-yellow.

SIZE
length 10–12 in. (26–31 cm)
weight 7 oz (200 g)

DISTRIBUTION
The western Solomon Islands, including Santa Isabel, St. George, Bougainville, and Buka (the last two belonging to Papua New Guinea).

STATUS
Least Concern

THIS SMALL PACIFIC OWL acquired its scientific name in honor of French explorer Charles Hector Jacquinot. Best known for his Antarctic voyages in the late 1830s, when—as commander of the expedition corvette *Zélée*—he surveyed the Straits of Magellan and navigated the Weddell Sea, Jacquinot also spent considerable time exploring the South Pacific. The owl was named for him in 1850 by French ornithologist Charles Lucien Bonaparte.

The Solomon Islands, to which this bird is confined, are spread across some 930 miles (1,500 km) of the South Pacific, east of New Guinea. The westernmost islands of Bougainville and Buka form a section of the Autonomous Region of Bougainville, which is administered as part of Papua New Guinea. Consequently, although the West Solomons Boobook is endemic in biogeographic terms to the Solomon Islands, its range in political terms spans two countries and it cannot be considered a country endemic.

In appearance, this species resembles other boobook owls, such as the Southern Boobook (P. 243) and Morepork (P. 271). However, its taxonomy is complex. In Bonaparte's first description, he assigned it to the genus *Athene*, alongside the Little Owl (P. 114), for example. Like other boobooks, the West Solomons Boobook is now known to belong to the *Ninox* genus of hawk owls, and indeed it is sometimes known as the Solomons Hawk Owl. It occurs in at least four subspecies, with the nominate race *N. j. jacquinoti* found on the islands of Santa Isabel and St. George. However, at least three other boobook species have been proposed on more easterly islands within the Solomons, including the Malaita Boobook (*N. malaitae*), Guadalcanal Boobook (*N. granti*), and Makira Boobook (*N. roseoaxillaris*). Further studies are therefore required. The only other owl with which the West Solomons Boobook shares its range is the Fearful Owl (*Nesasio solomonensis*), but the latter is quickly distinguished by its greater size and pale ocher-buff coloration.

Throughout its island range, the West Solomons Boobook frequents tropical or subtropical moist forest, from the lowlands up to an elevation of 4,900 feet (1,500 m). It is also found along forest edges and in gardens with large trees. A nocturnal species, this owl roosts by day in the cavity or hollow of a large tree and comes out after dark to hunt for a variety of small prey. This ranges from arthropods, such as crickets and grasshoppers, to small vertebrates, including rodents and geckos.

Little is known about the breeding behavior of the West Solomons Boobook. The male utters his distinctive territorial call all year around, but becomes more vociferous during the breeding season when pairs may call together in duet. The call comprises a kind of down-slurred purring hoot—not unlike that of a dove—which lasts for about a second and is repeated several times with clear pauses. From scientists' knowledge of other boobooks, it seems likely that this owl nests in a tree cavity and that the female lays some two to three eggs.

The West Solomons Boobook enjoys a conservation status of Least Concern. Despite its restricted range, it is reported to be widespread and common. In some areas, both adults and young birds are reputedly taken from their nests and kept as pets. Other potential threats include deforestation and the uncontrolled use of pesticides. Like all limited-range island endemics, this species is also vulnerable to local environmental catastrophe, and on the Solomon Islands both tropical cyclones and volcanic eruptions are rare but genuine hazards.

Opposite: The bold white markings on the face of a West Solomons Boobook can create a bespectacled appearance.

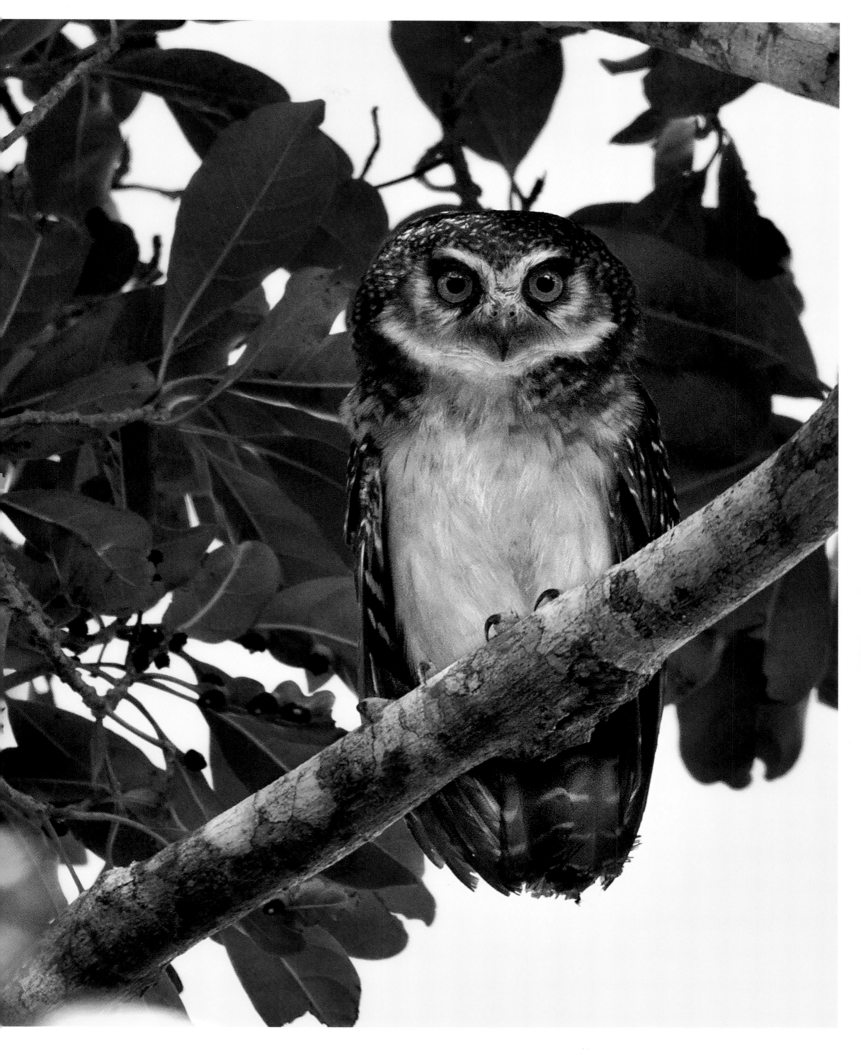

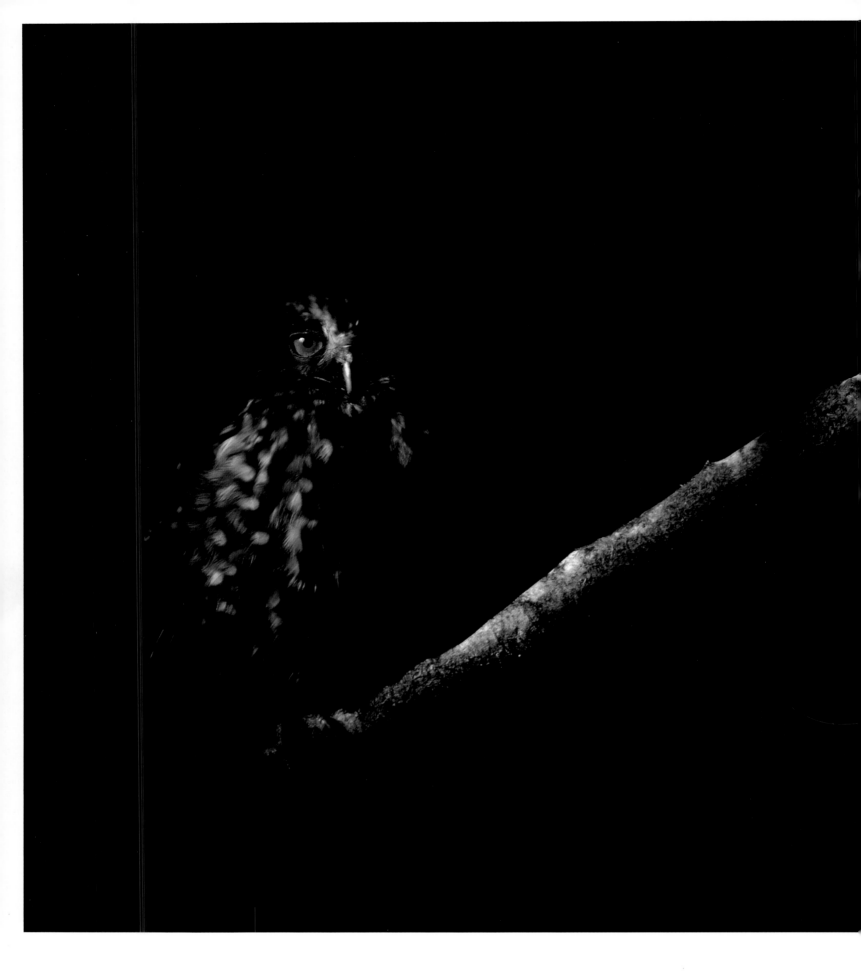

Above: A Morepork, barely visible amid the dark interior of a New Zealand forest.

MOREPORK

NINOX NOVAESEELANDIAE

APPEARANCE
Small to medium-size, with relatively long tail, rounded head without ear tufts, and indistinct facial disk; variable plumage, typically overall chocolate-brown; bright yellow eyes; upper parts dark brown, mottled and streaked in ocher and cream; flight feathers and tail dark brown; under parts heavily mottled in brown, white, and ocher.

SIZE
length 10–11.5 in. (26–29 cm)
weight 5.2–7.6 oz (150–216 g)
females larger than males

DISTRIBUTION
Widespread across New Zeland, including its forested offshore islands, but absent from Poor Knights Islands and Chatham Islands.

STATUS
Least Concern

THE BIZARRE NAME OF THIS OWL does not reflect its dietary preferences. Rather, it is an onomatopoeic moniker derived from the bird's distinctive, melancholy, two-note hoot, in which the second note is lower in pitch than the first, like that of a cuckoo. "Morepork" is, however, only one of some twenty common names. In Māori tradition, this bird is known as Ruru; it is seen as a watchful guardian of the spirit world, its two-note call heralding good news but its occasional piercing whistle signifying something more sinister.

The Morepork is New Zealand's only native owl, and it is a very close relative of the Southern Boobook (P. 243), with which it was once thought conspecific. It is a small to medium-size species, with a relatively long tail, a rounded head without ear tufts and, like other *Ninox* species, an indistinct facial disk. The taxonomy of this species is complex and remains the subject of ongoing research. One subspecies, the Lord Howe Boobook (*N. n. albaria*), became extinct during the twentieth century, whereas another, the Norfolk Island Boobook (*N. n. undulata*), only survives as a hybrid population (with *N. n. novaeseelandiae*), after two males of the nominate race were introduced from the New Zealand mainland to breed with the island's single remaining female. DNA studies show that the Morepork is very closely related to the Tasmanian Boobook (*N. leucopsis*), which has only recently been recognized as a species in its own right. The only other owl with which the Morepork could be confused is the Little Owl (P. 114),

a completely unrelated species that was introduced—along with several equally non-native European songbirds—by British settlers during the nineteenth century. Although roughly the same size as the Morepork, the Little Owl is grayer, with a shorter tail and bold white eyebrows. It lives in more open country and has a very different call: a high-pitched squeal that is sometimes mistaken for that of a kiwi.

The Morepork is widely distributed across New Zealand, although uncommon in the drier eastern and central regions of the South Island, especially in the Canterbury and Otago districts. It occurs in both native and exotic forests, including farmland and other open areas where suitable stands of trees remain, as well as in urban parks and gardens. This owl also inhabits most forested offshore islands, from the Three Kings Islands south to some of the small islands off the southwest tip of Stewart Island, but it is naturally absent from the Poor Knights Islands and Chatham Islands.

By day, the Morepork usually roosts in dark, well-vegetated forested areas, often hiding in a tree cavity or on top of a tree fern, but it may sometimes use derelict buildings. It is seen singly, in pairs, or in small family groups of an adult pair and up to three young. Hideaways are often betrayed by the vigorous mobbing of small birds, such as New Zealand robins (*Petroica* species), grey warblers (*Gerygone igata*), and New Zealand fantails (*Rhipidura fuliginosa*): species that at other times might end up as prey but during the day may succeed in driving the predator from their territory.

Although largely nocturnal, the Morepork may emerge to hunt at dawn and dusk; indeed, if the weather is bad, it may sometimes hunt during the day. Its principal hunting technique is to find a convenient perch and pounce upon prey that it spies below, but it may also use its fast, agile flight to hawk for insects or capture birds in midair. Much of the prey comprises large invertebrates, including scarab beetles, moths, cicadas, caterpillars, spiders, and weta. However, vertebrates are also taken, including rodents (which are not native to

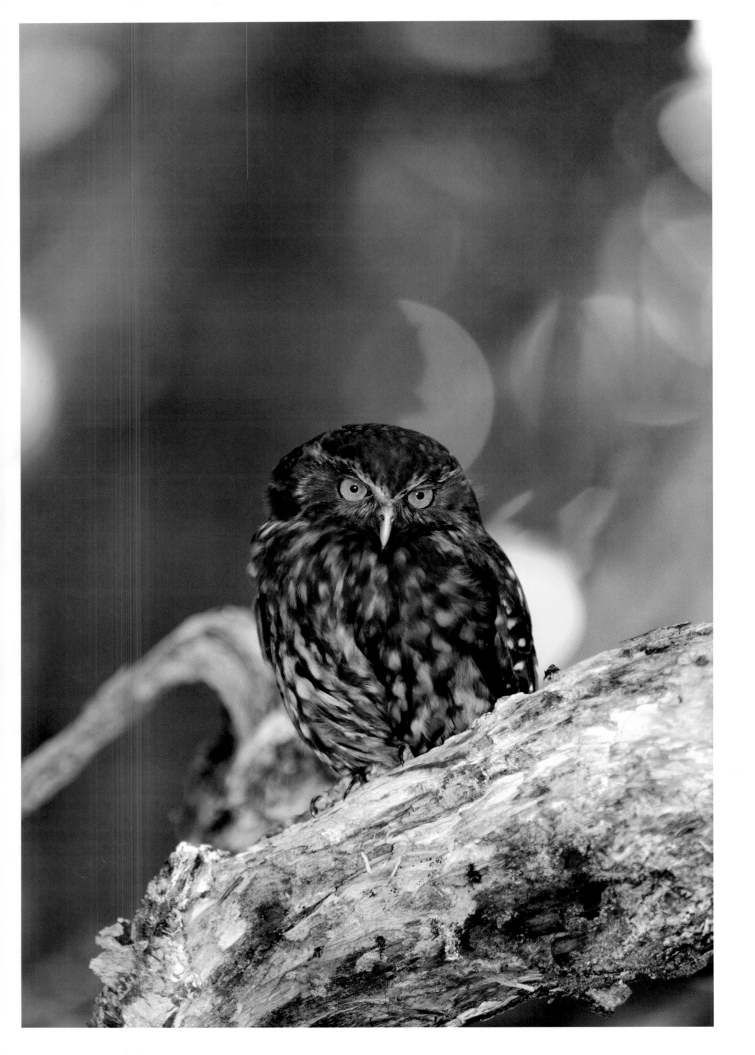

New Zealand) and small birds, among which the silvereye (*Zosterops lateralis*) is a common catch. The Morepork often takes advantage of streetlights or lights outside buildings in order to hunt the moths that they attract.

The breeding season starts in October and sees the male stepping up his vocal activity as he competes with calling rivals to defend a territory that usually measures some 8.5 to 19 acres (3.5–7.8 ha). The two-note "more pork" (or "ru-ru," if you prefer) is repeated at ever shorter intervals, and sometimes extended into a repetitive and more prolonged "more-pork-pork-pork…" At this time of year, birds also utter a high-pitched scream and a more frog-like "cree-cree-cree."

Once a pair has reestablished its ties, the birds choose a nest site in a hollow tree, tree hole, or dense clump of vegetation, sometimes on top of an old sparrow nest. They may also use earth banks and, on offshore islands, have been known to take over the old nest burrows of petrels (Procellariidae species). The female lays two, occasionally three, eggs, with an interval of three days between them. She incubates her clutch for thirty to thirty-one days, while the male hunts to keep her fed. Once the female is able to leave her brood, she helps the male to provide for them. By thirty-four days, the chicks have left the nest, and by seven weeks they have fledged, although both parents continue to care

for them for some time afterward. The youngsters reach sexual maturity in their first year, although males will not usually breed until their second year and females not until their third.

Birdlife International calculates the total breeding range of the Morepork at 103,000 square miles (269,000 sq km), confined entirely to New Zealand and some of its offshore islands. The species is relatively common across its range and, with no significant current threat or documented decline, is listed as Least Concern. Nonetheless, it faces a number of dangers. As with most of New Zealand's native bird species, especially the flightless ones, it is prone to predation by the rats, possums, stoats, domestic cats, and other non-native mammalian predators that European settlers introduced to the islands. The Morepork can, of course, escape these predators by flying, but it is particularly vulnerable when on the nest and its newly fledged young may fall prey to pigs and even hedgehogs. Another threat is that of secondary poisoning, suffered by the owls when they feed on rodents that have ingested poisons set out to control the spread of non-native pest species. However, it seems that this danger can be reduced by conducting pest control operations at times of the year when the Morepork is not targeting rodents. As with many owls worldwide, road traffic accidents also take their toll.

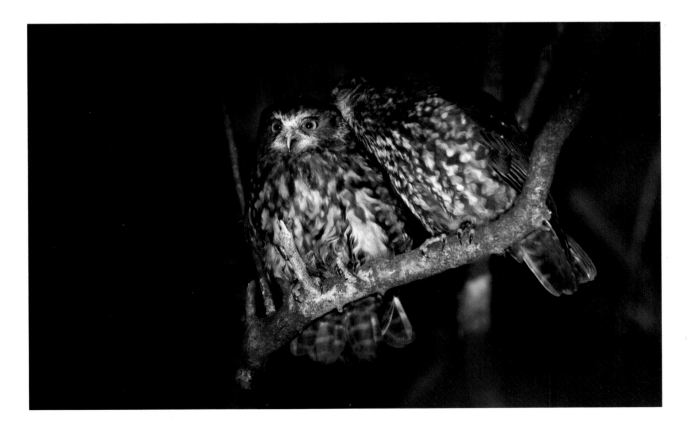

Above: Moreporks reinforce their pair bond with mutual grooming.
Opposite: The Morepork is New Zealand's only native owl species.

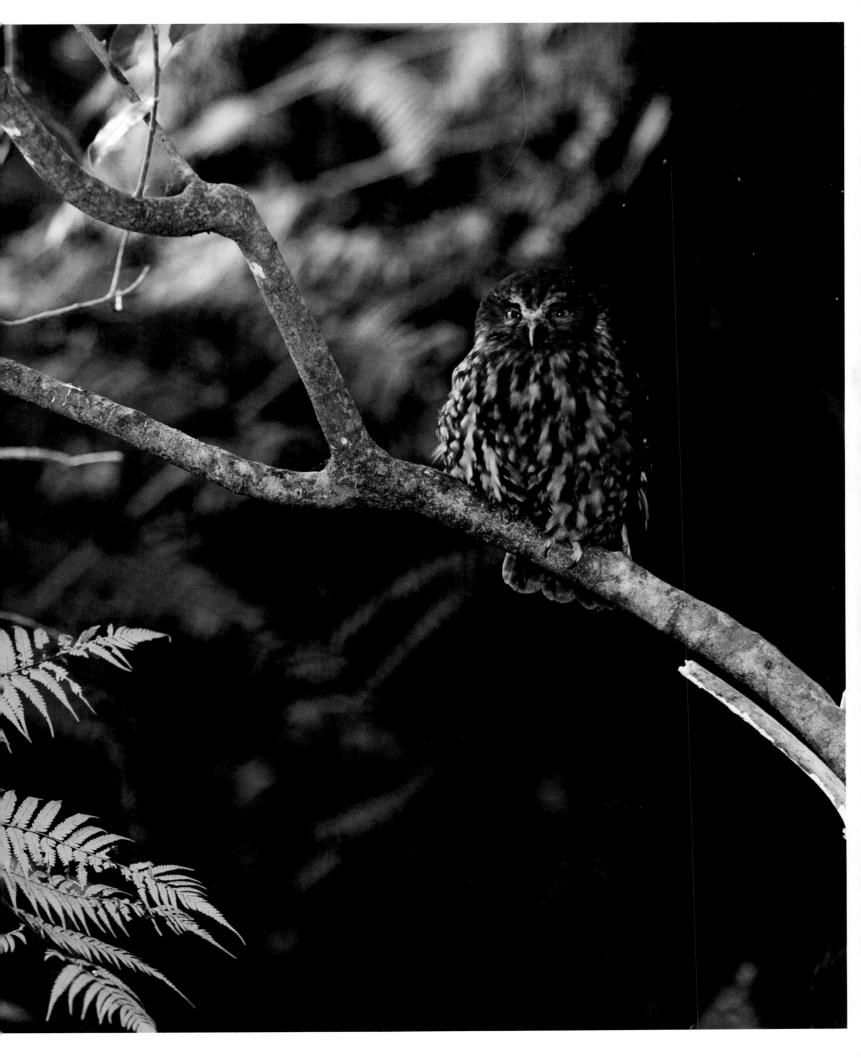

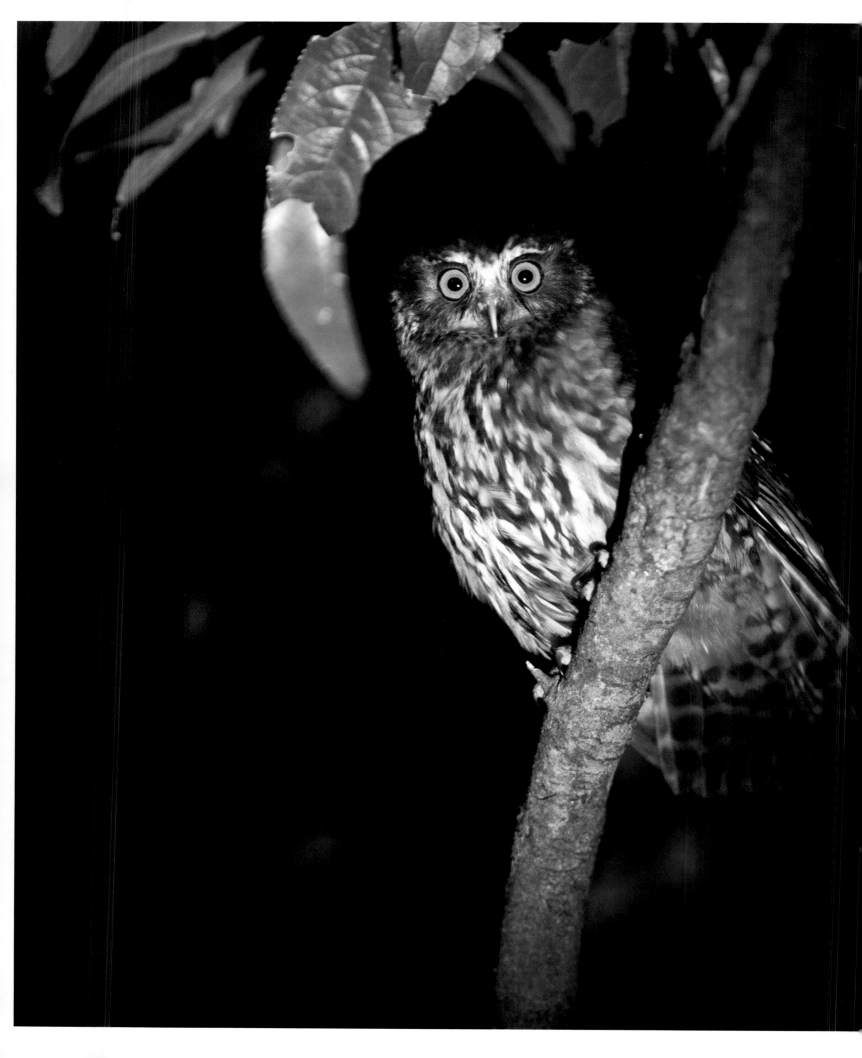

Left: Moreporks tend to pounce on their prey from a favorite perch but may also pursue it through the trees in agile flight.

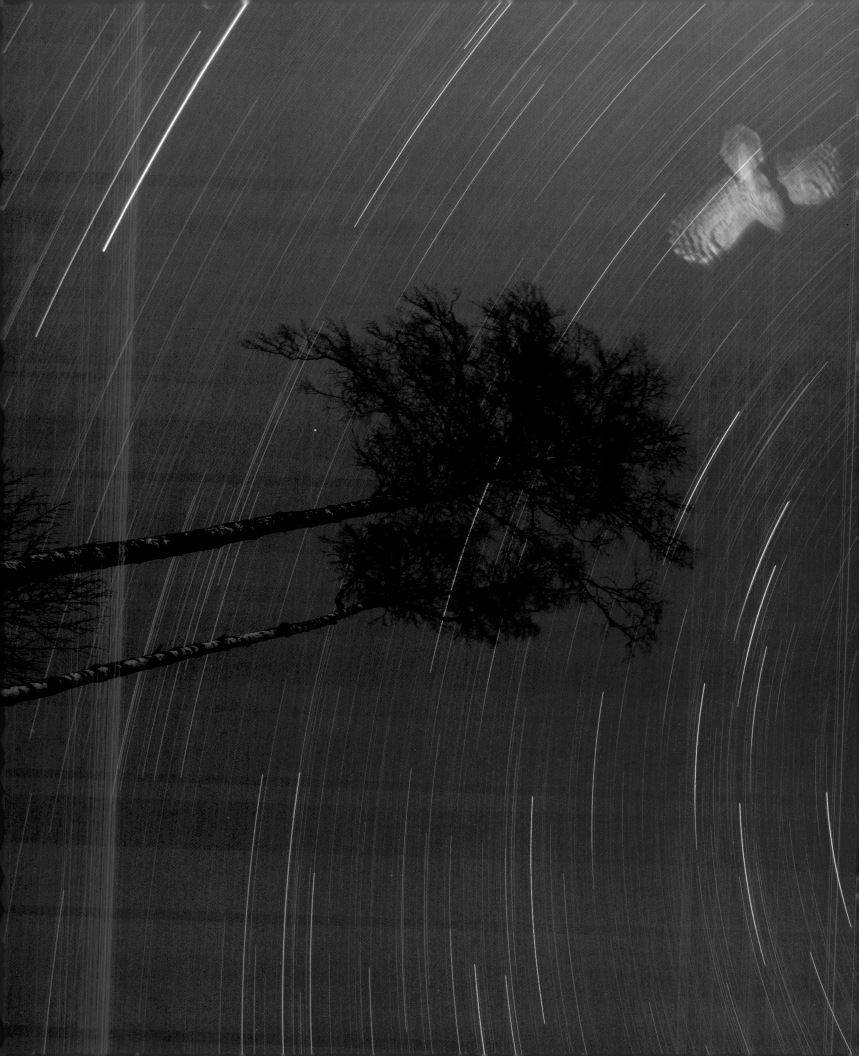

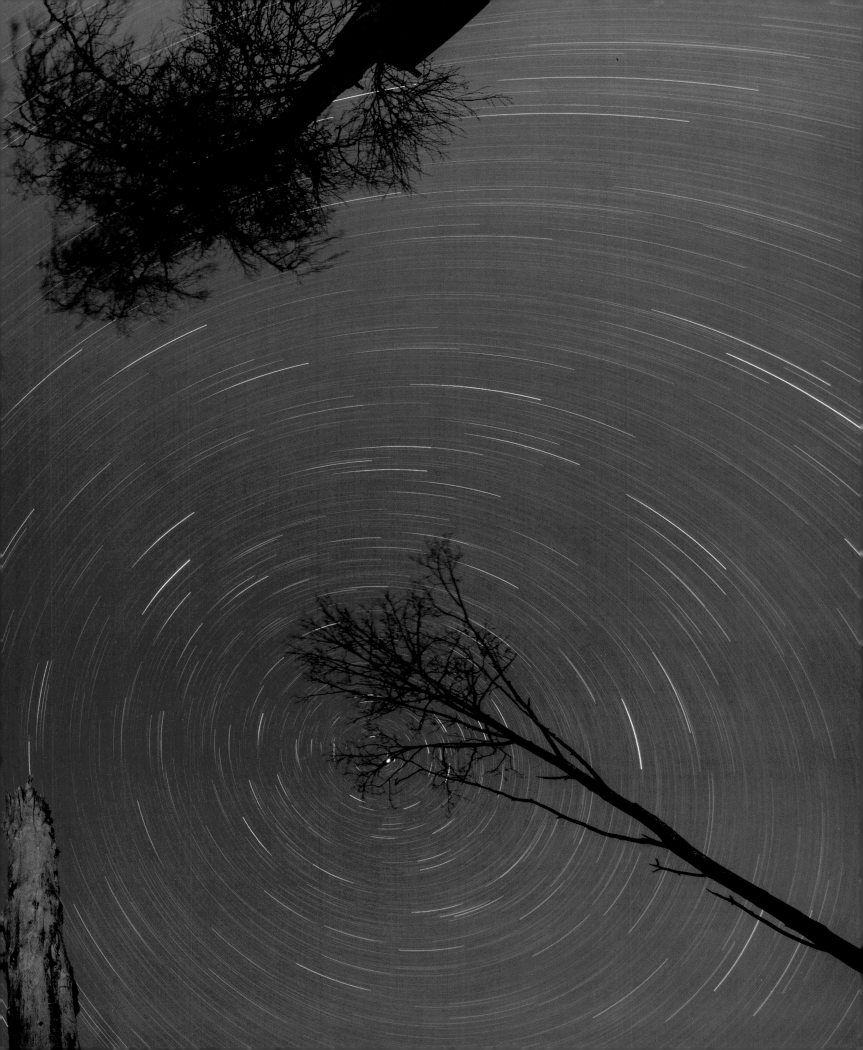

GLOSSARY

Allopatric
Occupying separate, non-overlapping geographical areas—used principally of closely related animals or other organisms. In North America, for example, the Eastern Screech Owl and the closely related Western Screech Owl are largely allopatric species, as their ranges barely overlap.

Biogeographical realm
Large geographical region, also known as an ecozone, within which all living things share a broadly similar evolutionary history. The world's eight biogeographical realms correspond largely, but not exactly, to the continents. They are: the Nearctic (North America), the Neotropical (South and Central America), the Afrotropical (Africa south of the Sahara), the Palearctic (Europe, North Africa, and Asia north of the Himalayas), the Indomalay (Southeast Asia), the Australasian, the Oceanic (Pacific island groups), and the Antarctic.

Biome
Broad ecological region, such as tundra, desert, or tropical rain forest. Each comprises a community of plants and animals with shared characteristics that reflect the prevailing habitat, weather, and soil type. Each biome may be found in several different biogeographical realms (see above), although the species composition will differ from one biome to another. A biome comprises numerous different habitats.

Boreal forest
Large region of northern Eurasia and North America lying immediately south of the Arctic tundra and characterized by dense coniferous forests, consisting largely of firs and spruces. Also known by the Russian name *taiga*.

Caatinga
Arid, sparsely forested habitat of the northeastern Brazilian interior, comprising thorny, stunted scrub. Originally a Tupi word, meaning "white forest" or "white vegetation." Gives its name to the Caatinga region.

Carpal patch
Well-defined patch of color around the carpal (wrist) joint of a bird, which is most visible on the underside of the extended wing. In owls, such as the Long-eared Owl, it is typically darker than the surrounding plumage and can offer a key identification feature.

Cerrado
Large tropical region of wooded grassland that covers around 20 percent of Brazil, located between the Amazon rainforest to the north and the Pantanal wetlands to the south. Home to a rich biodiversity, it is one of the most threatened and over-exploited regions in South America.

Color morph
Distinct color variant within a species—also known as a phase. The Tawny Owl, for example, comes in rufous, brown, and gray color morphs. The term does not apply to color difference between the male and female of a species (sexual dimorphism) or between adult and young. Neither does it correlate with subspecies, to which greater genetic distinctions apply.

Conspecific
Of animals or plants: belonging to the same species. The Great Grey Owl of Eurasia, for example, is conspecific with the Great Gray Owl of North America.

Crepuscular
Habitually active at twilight. The Short-eared Owl, for example, is a crepuscular species as it hunts largely at dusk or dawn.

Distraction display
Actions performed by a bird to draw the attention of a potential predator away from its nest or offspring. It generally takes the form of a feigned injury, with the bird moving awkwardly and often dragging a wing as though unable to fly. The predator may then switch its approach toward this apparently easier target, which makes its escape once the attacker is a safe distance from the nest.

Epiphyte
Plant that grows harmlessly upon another plant, such as a tree, and derives moisture and nutrients from the air, rain, and sometimes from debris accumulating around it. Examples include mosses and liverworts in temperate regions, and ferns and orchids in the tropics. They differ from parasites in that they use other plants for physical support without any detrimental effect on the host. They also provide a rich habitat for other organisms, including animals, fungi, and bacteria.

Facial disk
Concave arrangement of feathers on the face of certain birds, most notably owls. It surrounds the eyes and serves to collect and direct sounds waves toward the ears. The feathers can be adjusted to alter the focal length of the disk, enabling the bird to focus at different distances. Other birds, including harriers, have less prominent facial discs.

Family
Taxonomic level above genus and below order. The owls order (Strigiformes) comprises two families: the true or typical owls (Strigidae) and the barn owls (Tytonidae).

Fynbos
Heath and shrubland habitat exclusive to the Cape region of South Africa, characterized by a Mediterranean climate and winter rainfall. Fynbos species dominate the Cape floral kingdom, which is one of the world's richest areas for plant biodiversity.

Genus (plural: genera)
Taxonomic level above species and below family, which forms the first part of a binomial species name. The two owls families, Strigidae and Tytonidae, comprise between them twenty-six genera, each of which contains a number of different species. The Tawny Owl (*Strix Aluco*) is one of twenty-one species in the *Strix* genus of wood owls.

Gondwana
Ancient supercontinent that formed the southern half of the prehistoric landmass Pangaea. Gondwana separated from Luarasia, the northern half of Pangaea, around 200–180 million years ago. It subsequently broke up into many of the landmasses that occupy today's southern hemisphere, including Antarctica, South America, Africa, Madagascar, and Australia, as well as India and the Arabian Peninsula, now in the northern hemisphere.

Holarctic
Terrestrial ecozone that encompasses most habitats found throughout the northern hemisphere. It is divided into the Nearctic (North America as far south as central Mexico), the Palearctic (North Africa and all Eurasia), Southeast Asia, and the Indian subcontinent. The floristic boreal kingdom corresponds to the Holarctic ecozone.

Intraguild predation
Among animals, the killing and eating of potential competitors. This behavior combines predation and competition, because both species rely on the same prey resources and also benefit from preying upon one another. Many owls are significant intraguild predators. The Eurasian Eagle Owl, for example, has been known to prey on all other European owl species and numerous other raptors, from sparrowhawks to eagles.

Kleptoparasitism
Form of feeding in which an animal takes prey or other food from another animal that has caught, collected, or otherwise prepared it. Also used to describe the theft of nest material or other objects from one animal by another.

Laurasia
Ancient supercontinent that formed the northern half of the prehistoric landmass Pangaea. Laurasia separated from Gondwana, the southern half of Pangaea, around 200–180 million years ago. It included most of the landmasses that occupy today's northern hemisphere, including North America and Eurasia.

Lores
Region between the eye and bill on either side of a bird's head. Lores are often marked with a colored stripe of either feathers or bare skin.

Mesoptile
Describes the second set of juvenile plumage in certain birds, in which the feathers are intermediate in stage between down and full maturity.

Nominate
First-named race of a species, in which the scientific name is the same as the species name. Thus *Bubo virginianus virginianus*, which occurs from eastern Canada south to Florida, is the nominate race of the Great Horned Owl *Bubo virginianus*.

Occipital face
Eye-like markings on the back of the head of certain owl species that create the impression of a face. This is a form of defense—like the eye markings on the wings of some butterflies. It serves to make the owl appear larger and more intimidating to a predator that approaches from behind.

Order
Taxonomic level above family and below class. Thus the owls order, Strigiformes, is one among some twenty-eight orders in the class Aves (birds).

Pleistocene Epoch
Geological time period that lasted from 2.6 million to 11,700 years ago. Many animals and plants that developed during the Pleistocene were extremely similar to those found on Earth today. It was during this time that the development and expansion of our own species took place.

Polygyny
Pattern of mating among animals, in which a male has more than one female mate. The opposite—in which a female has more than one male mate—is polyandry.

Scapular line
Prominent pale line visible on a bird's shoulders when perched, that is typical of many owl species. It is formed by the alignment of several scapular feathers, each of which has the outer web colored white or pale. The scapular line may appear broken or irregular when the bird's plumage is ruffled.

Sympatric
Describes animals and other organisms that share the same geographic area and thus regularly encounter one another. The opposite of allopatric (see opposite).

Taxonomy
The science of classification. Taxonomists trace the evolutionary heritage of each organism, determining which can be classified as species, which species make up a genus, which genera form a family, and so on.

Vermiculations
Very fine, wavy markings, typically found on the breast feathers of an owl. The word is derived from the wave-like motions of a worm.

FURTHER INFORMATION

BIBLIOGRAPHY & FURTHER READING

A wide range of published sources, both in print and online, has provided the factual material in this book. The following list includes books that have been an important reference for the author, and also recommends further reading for those who wish to know more. The internet offers a wealth of resources about owls, including where to see them, how to identify them, and how to become involved in their conservation.

Angell, Tony, *The House of Owls* (Kindle Edition, 2015)
Personal account by a leading U.S. nature writer about living with owls (notably a family of Western Screech Owls) around his family home in the western United States. Includes the author's own superb illustrations and compelling insights into humankind's relationship with the natural world.

Duncan, Dr. James R., *Owls of the World: Their Lives, Behavior and Survival* (Firefly Books, 2003)
Comprehensive study, with detailed portraits of 205 owl species and their place within the avian order as both predators and prey. Includes chapters on conservation and owls in culture.

Mead, Chris, *Owls* (The British Natural History Collection, Whittet Books, 2011)
Detailed study of the owls of the United Kingdom, with explorations of owls in culture and conservation and photographs by bird photographer Mark Hancox.

Kermp, Alan & Meg, *Sasol Birds of Prey of Africa and its Islands* (New Holland, 1998)
Useful, well-illustrated reference to all African birds of prey, including owls.

Mikkola, Heimo, *Owls of the World: A Photographic Guide* (Christopher Helm, second edition 2013)
Excellent comprehensive and up-to-date account of all the world's owls, with each species individually described and illustrated. Follows the latest taxonomy—and is the basis for the taxonomy used in this book. Interesting opening chapters on owl biology and conservation.

Taylor, Marianne, *Owls* (Bloomsbury, 2012)
Comprehensive, highly readable, and well-illustrated account of the owls of the northern hemisphere. Engaging text brings the science to life. Broad selection of photographs includes many unusual images of owl behavior.

Tipling, David & Peltomaki, Jari, *Owls* (Evans Mitchell Books, 2013)
Beautifully illustrated celebration of owls by the photographer of this book and one of his chief photographic collaborators. Covers the owls of Europe, with many images taken in either Finland or the United Kingdom. Text enlivened by personal anecdotes from the photographers.

Toms, Mike, *Owls* (Collins New Naturalist Library, 2014)
Comprehensive account of the owls of the United Kingdom, from their biology to folklore, by a leading ornithologist.

www.owlpages.com
Comprehensive and accessible collection of information about all the world's owls; a valuable resource during the research for this book.

www.owling.com
Largest U.S. website dedicated to owls and those who go in search of them. Covers all the owls of North and Central America, with extensive biology and multimedia sections.

CONSERVATION ORGANIZATIONS

Numerous conservation organizations around the world are working to protect owls. Some are dedicated to the welfare of owls in particular, including many that focus on an individual species; others aim to safeguard a broader cross-section of birds and nature, of which owls are an integral part. There are many ways in which you can offer support or become more directly involved.

Audubon Society (www.audubon.org)
North America's leading conservation organization, with over 450 chapters across the United States. Promotes the protection of owls, among other wildlife, with publications, wildlife preserves, and citizen science projects.

Birdlife International (www.birdlife.org)
Global partnership of conservation organizations that works to conserve birds (including owls), their habitats, and global biodiversity.

Blakiston's Fish Owl Project (www.fishowls.com)
International project dedicated to research into and the conservation of Blakiston's Fish Owl in Russia.

Owl Research Institute (www.owlinstitute.org)
Based in Montana, United States, with more than twenty-five years dedication to the scientific research of owls and the promotion of their conservation.

ACKNOWLEDGMENTS

Project Owlnet (www.aviary.org/project-owlnet)
Coordinates the monitoring of owl population trends in the United States by banding migrant owls, notably the Northern Saw-whet Owl.

RSPB (www.rspb.org.uk)
The United Kingdom's largest nature conservation charity. Lobbies for conservation, encourages citizen science, and manages nature reserves around the United Kingdom to save birds—including owls—as well as other wildlife and their habitats.

The Barn Owl Trust (www.barnowltrust.org.uk)
U.K. charity, based in the southwest, that aims to conserve the Barn Owl and its environment through research, practical conservation, education, and advisory work for landowners. Also runs a sanctuary for sick and injured owls.

The Global Owl Project (www.globalowlproject.com)
Long-term, worldwide project to resolve foundational aspects of science and conservation for the world's owls, run by a team of international scientists.

The Hungry Owl Project (www.hungryowl.org)
U.S. project that aims to reduce the need for harmful pesticides and rodenticides while promoting owl and wildlife conservation. Encourages natural predators and alternative methods of sustainable pest management.

Hawk and Owl Trust (hawkandowl.org)
U.K. charity dedicated to conserving owls and other birds of prey in the wild, and to increasing knowledge and understanding of them. Creates and manages nesting, roosting, and feeding habitats; carries out practical research; and runs wildlife reserves, education centers, and outreach projects.

The Owl Foundation (www.theowlfoundation.ca)
Canadian charity focused on helping injured or orphaned wild owls. It operates an owl rehabilitation center in Ontario, Canada.

Wildlife Trusts (www.wildlifetrusts.org)
U.K conservation charity comprising forty-seven separate regional trusts, with information and advice on all aspects of British wildlife (including owls), and a wide network of reserves.

World Owl Trust (www.owls.org)
U.K. conservation charity that works on owl conservation in several countries around the world, protecting populations of endangered owls until their habitat has been restored.

Mike Unwin
I would like to thank all those whose hard work and encouragement lie behind this book. It was a pleasure working with the team at Quarto, and I am grateful to Ruth Patrick for presiding over the project, Elspeth Beidas for her editorial expertise, and Michelle Kliem for her gorgeous layouts. Along the way we had some entertaining debates about how best to capture on the page the magic of owls (is a pink sunset "evocative" or "girly"?). The final result is a tribute to the whole team's passion and flexibility, and, I hope, speaks for itself.

It was pleasure and a privilege working with David Tipling, whose stunning pictures not only reflect an extraordinary dedication in pursuing these elusive birds, but also reveal the eye of both an artist and a true owl aficionado. His intimate knowledge of and feel for his subject is there to see in every image.

I am grateful to all those naturalists and conservationists whose study of and concern for owls has brought us a deeper understanding of these birds. Without them, there would be far fewer to photograph. And, finally, I would like to thank my own family: my parents, who encouraged my love of nature from the earliest days; and my wife Kathy and daughter Florence, with whom I have shared many memorable wildlife moments—not least with owls.

David Tipling
Photographing owls is challenging. Largely nocturnal, much of what they do goes unnoticed by us and when they can be observed, photographing their natural behavior requires ingenuity and patience. Many species, including a number featured in this book, have only ever been photographed perched at a daytime roost or peering from a nest hole. There is still much to do for intrepid photographers wishing to break new ground.

I am grateful to a number of people for help in tracking down pictures of some more elusive species. They include Nils Bergmann, Tim Loseby, and Nick Bevan. My own owl photography has been enhanced by assistance from Frederic Desmette, Jari Peltomaki, Roger Sanmarti, Oscar Dominguez, Dave Richards, and Gareth Malone.

Choosing the final selection of images to be featured was very much a team effort. I would like to thank author Mike Unwin for his huge input into this process. Thanks also to Michelle Kliem for her wonderful design and her understanding when we wanted things changed, and to Elspeth Beidas for her guidance in keeping everything moving.

INDEX

PICTURE CREDITS

Every effort has been made to credit the copyright holders of the images used in this book. We apologize for any unintentional omissions or errors and will insert the appropriate acknowledgment to any companies or individuals in subsequent editions of the work.

1 Neil Bowman / FLPA **2** Jari Peltomaki **5** David Tipling **6** David Tipling **7** Jari Peltomaki **8–9** © Remo Savisaar / Alamy Stock Photo **10** David Tipling **12–13** Anup Shah / naturepl.com **14** David Tipling **16** © FLPA / Alamy Stock Photo **18 tl** David Tipling **18 bl** David Tipling **18 r** David Tipling **19** David Tipling **20 l** Jim Cumming / Getty Images **20 r** Jari Peltomaki **21** Jari Peltomaki **23** Illustrious / Getty Images **24–25** David Tipling **26** © All Canada Photos / Alamy Stock Photo **28 l** Wayne Lynch / Getty Images **28 r** © Cultura RM / Alamy Stock Photo **29** Visuals Unlimited, Inc. / Bence Mate / Getty Images **30** David Tipling **32** Jari Peltomaki **33** Glenn Bartley / BIA / Minden Pictures / Getty Images **34** Jari Peltomaki **35** David Tipling **36** Jari Peltomaki **37** Jari Peltomaki **38** Robbie George / Getty Images **40–41** Michael S. Quinton / Getty Images **42** David Tipling **44–45** Jill Fromer / Getty Images **46** ZUMA Press, Inc. / Alamy Stock Photo **47** mlorenzphotography / Getty Images **49** Lynn Koenig / Getty Images **50–51** © All Canada Photos / Alamy Stock Photo **52** Jack Dykinga / naturepl.com **53** © Rick & Nora Bowers / Alamy Stock Photo **54–55** Brian E. Kushner / Getty Images **56** Michael D. Kern / naturepl.com **58–59** Jon Bower / Getty Images **60** Tom Vezo / Minden Pictures / FLPA **61** Tim Fitzharris / Minden Pictures / FLPA **62** © Rick & Nora Bowers / Alamy Stock Photo **64–65** Tom Vezo / Minden Pictures / Getty Images **67** © All Canada Photos / Alamy Stock Photo **68** George Sanker / naturepl.com **70** Ron Bielefeld / BIA / Minden Pictures / Getty Images **71** Jim Cumming / Getty Images **72** Damien Laversanne / Biosphoto / FLPA **74** © Ivan Kuzmin / Alamy Stock Photo **75** © Rolf Nussbaumer Photography / Alamy Stock Photo **77** Chris Jimenez / NIS / Minden Pictures / Getty Images **78** Michael & Patricia Fogden / Minden Pictures / FLPA **79** © Terry Whittaker / Alamy Stock Photo **81** Luiz Claudio Marigo / naturepl.com **83** Photo Researchers / FLPA **84** Wayne Lynch / Getty Images **86** © Rolf Nussbaumer Photography / Alamy Stock Photo **87** Alan Murphy / BIA / Minden Pictures / Getty Images **89** Nick Garbutt / naturepl.com **90–91** © All Canada Photos / Alamy Stock Photo **92** Glenn Bartley / Getty Images **94** © Nature Picture Library / Alamy Stock Photo **96–97** Christopher Jimenez Nature Photo **98** David Tipling **100** David Tipling **101 t** David Tipling **101 b** Jari Peltomaki **102** David Tipling **104–105** Klaus Echle / naturepl.com **106–107** David Tipling **109** Jari Peltomaki **110** Jari Peltomaki **111** David Tipling **112–113** David Tipling **115** David Tipling **116** Peter Barritt / robertharding **117** David Tipling **118–119** Lisa Geoghegan / Getty Images **121** David Tipling **122–123** Stephen Dalton / Minden Pictures / Getty Images **124** David Tipling **125** David Tipling **126** David Tipling **128** David Tipling **129** David Tipling **130** David Tipling **131** David Tipling **132–133** David Tipling **135** Jari Peltomaki **136–137** Jari Peltomaki **138** Jari Peltomaki **139** Jari Peltomaki **140** Ben Queenborough / Getty Images **124 l** Nature Production / naturepl.com **142 r** David Tipling **143** David Tipling **144–145** David Tipling **147** David Tipling **148** Ben Queenborough / Getty Images **149 tl** David Tipling **149 tr** David Tipling **149 bl** David Tipling **149 br** David Tipling **151** Jari Peltomaki **152** David Tipling **153** David Tipling **154–155** Jari Peltomaki **156–157** Jari Peltomaki **158** © BIOSPHOTO / Alamy Stock Photo **161** Markus Varesvuo / naturepl.com **162** Markus Varesvuo / naturepl.com **163** Jari Peltomaki **164–165** Sven Zacek / Getty Images **166** David Tipling **168** James Lowen **169** David Tipling **170–171** Claude Balcaen / Biosphoto / FLPA **172** © imageBROKER / Alamy Stock Photo **174 l** Arno Meintjes Wildlife / Getty Images **174 r** © Frank van Egmond / Alamy Stock Photo **175** Ann & Steve Toon / naturepl.com **177** © robertharding / Alamy Stock Photo **178** Lars Petersen **179** David Tipling **180–181** Nigel Dennis / Getty Images **182** © AfriPics.com / Alamy Stock Photo **184** Tony Heald / naturepl.com **185** © FLPA / Alamy Stock Photo **186** Pete Oxford / naturepl.com **188–189** Will Burrard-Lucas / naturepl.com **190–191** © AfriPics.com / Alamy Stock Photo **192** © blickwinkel / Alamy Stock Photo **195** Daryl Balfour / Getty Images **196–197** Daniele Occhiato / Buiten-beeld / Minden Pictures / Getty Images **198–199** © blickwinkel / Alamy Stock Photo **200** © Jason Gallier / Alamy Stock Photo **202–203** Richard Du Toit / naturepl.com **205** Will Burrard-Lucas / naturepl.com **206–207** Dewald Kirsten / Getty Images **209** Thomas Dressler / Getty Images **210–211** Sergey Gorshkov / naturepl.com **212** David Tipling **215** © David Hosking / Alamy Stock Photo **216** David Fettes **217** Utopia_88 / Shutterstock **218** Photo Researchers / FLPA **220** Mary McDonald / naturepl.com **221** David Tipling **223** David Yeo / Getty Images **224–225** © blickwinkel / Alamy Stock Photo **226** David Hosking / FLPA **228** Christian Hutter / Imagebroker / FLPA **229** Yuri Shibnev / naturepl.com **230** © HIRA PUNJABI / Alamy Stock Photo **232–233** Satyendra Kumar Tiwari / Getty Images **234** Con Foley **236** David Tipling **238** Janette Hill / robertharding / Getty Images **239** Anna Henly / Getty Images **241** Ian Montgomery **242** Auscape / UIG **245** Nik Borrow **247** © Corbis Super RF / Alamy Stock Photo **248** © Fotoflair Animals / Alamy Stock Photo **249** Martin Willis / Minden Pictures / FLPA **250** Sergey Uryadnikov / Shutterstock **252** Inaki Relanzon / naturepl.com **253** Mandy Etpison **255** Neil Bowman / FLPA **256** Russel Thorstorm **258–259** Russel Thorstorm **260** Rob Hutchinson **263** © Rick & Nora Bowers / Alamy Stock Photo **264** Bernd Rohrschneider / FLPA **266–267** Fin Belcher / Getty Images **269** Lars Petersen **270** David Tipling **272** David Tipling **273** David Tipling **274–275** David Tipling **276–277** David Tipling **278–279** Sven Zacek / naturepl.com

(Key: top = t; bottom = b; l = left; r = right)